DOROTHEA LANGE

A Photographer's Life

MILTON MELTZER

DOROTHEA LANGE

A Photographer's Life

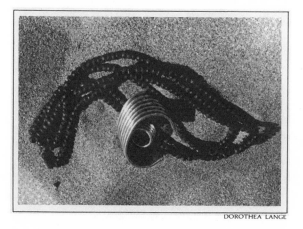

DOROTHEA LANGE

With a Foreword by Naomi Rosenblum

Syracuse University Press

Copyright © 2000 by Syracuse University Press
Syracuse, New York 13244-5160

All Rights Reserved

First Syracuse University Press Edition 2000

00 01 02 04 05 06 6 5 4 3 2 1

Originally Published in 1978 by Farrar, Straus, & Giroux

The paper used in this publication meets the minimum requirements of
American National Standard for Information Sciences—Permanence of
Paper for Printed Library Materials, ANSI Z39.48–1984. ∞ ™

Library of Congress Cataloging-in-Publication Data

Meltzer, Milton, 1915–
Dorothea Lange : a photographer's life / Milton Meltzer. — 1st Syracuse University Press ed.
p. cm.
Originally published: New York : Farrar, Straus, & Giroux, c1978.
Includes bibliographical references and index.
ISBN 0-8156-0622-2 (pbk./: alk. paper)
1. Lange, Dorothea. 2. Women photographers—United States
Biography. I. Title.
TR140.L3M445 1999
770'.92—dc21
[B] 99-26674

Manufactured in the United States of America

For Hildy, Jane, Amy
—and their sisters

You put your camera around your neck in the morning, along with putting on your shoes, and there it is, an appendage of the body that shares your life with you.

The camera is an instrument that teaches people how to see without a camera.

—Dorothea Lange

CONTENTS

ILLUSTRATIONS

PART ONE
PAGES 35–42

Dorothea's birthplace, 1041 Bloomfield Street, Hoboken, New Jersey.

Dorothea and her brother Martin. (*Courtesy Helen Dixon*)

Hester Street on the Lower East Side. (*The Byron Collection, Museum of the City of New York*)

Dorothea's mother, Joan Lange Nutzhorn. (*Courtesy Helen Dixon*)

The young Dorothea (two photographs). (*Courtesy Helen Dixon*)

Aunt Caroline. (*Courtesy Helen Dixon*)

Uncle John Lange. (*Courtesy Joy Lange Boardman*)

Clarence White with students. (*Courtesy Ruth Lavers White*)

Cartoon of Arnold Genthe, made by his friend Maynard Dixon, c. 1911.

Ethel Benedict, 1916. (*Museum of Modern Art*)

PART TWO
PAGES 107–22

Dorothea's mother, Joan, 1922. (*Courtesy Helen Dixon*)

Maynard Dixon, c. 1921. (*Courtesy Edith Hamlin*)

Maynard Dixon in his studio, 728 Montgomery Street, San Francisco, c. 1920. (*Courtesy Edith Hamlin*)

Constance Dixon, c. 1923. (*Courtesy Constance Dixon*)

Hopi Indian, New Mexico, c. 1923. (*The Oakland Museum*)

FOREWORD

THIS BOOK, WHICH FIRST APPEARED IN 1978, IS MORE THAN A PERsonal biography of a gifted and industrious photographer; it is a work of cultural and social history as well. As such, it deals with a number of issues that have received considerable critical attention in the past two decades. One is the role of women in American culture. In that Dorothea Lange was a woman active in a professional field largely occupied by men, the story of her life is of interest; it is especially so in terms of the reemergence of feminist ideology and thought that surfaced as the book was being written. Another theme revolves around changing perceptions with regard to the documentary mode of interpreting social reality. Because Lange chose to work in this mode at a time when it was just beginning to be transformed by the popular picture magazines, her story also touches on the relationship between the documentary genre and photojournalism.

To turn first to the question of women's role in photography: women had been interested in the medium from its inception, and they became increasingly involved after the invention of simplified cameras and easier processing methods in the last decades of the nineteenth century. They were active, and some cases achieved fame, both professionally and as recreational photographers, but over time (and with several notable exceptions) the extent of their contributions and, often, the work itself became hidden from view. Women's work was less likely to be seriously discussed or reproduced in the histories of the medium or collected by museum photography curators who, by and large, were men. Certainly the problems generated by disparities in pay scale and male attitudes toward female colleagues in the work place were seldom raised. Those engendered by the pressure on women professionals of family obligations were little known or thought about before the emerging consciousness of the late 1960s confronted these and other matters. That Lange was supremely sensitive to the difficulties faced by women, especially those

who worked in the industrial and rural sectors of the economy, is evident in many of her pictures for the Farm Security Administration (FSA), in the images of the working force in the California shipyards, and in a late project that focused on the inner strength of American farm women.

Lange, however, was never entirely forgotten nor was her work entirely obscured. It had gained her acclaim during her years of activity for the photographic program of the Historical Section of the Agricultural Administration—later to become the FSA. Her sensitivity to those caught up in the era's agricultural upheaval was highly prized by Roy E. Stryker, its director, who held that her woman's vision, typified by the image called "Migrant Mother," embodied the aspirations of this government agency (even as her demands for control of her work aggravated him). Stryker sought venues for its reproduction as did Lange's second husband, economist Paul Taylor, who was instrumental in placing her work in *Survey Graphic* magazine and in the California daily press. For most of the 1950s and into the 1960s, Lange's photographs, along with much else in the documentary genre, were not particularly visible, but in 1966, she was given a major retrospective exhibition at the Museum of Modern Art (MOMA). However, in the decade that followed, her work often received less critical examination than that of male colleagues, and the details of how she accommodated both family and personal obligations and dealt with the demands of work in the field were rarely explored. *Dorothea Lange: A Photographer's Life* was the first publication to do so in depth. In treating these issues, author Milton Meltzer was surely in the forefront of social thought regarding women's roles in American cultural life.

The relationship of social documentation to photojournalism is another aspect of photographic culture touched upon in Meltzer's biography of Lange. In western industrialized nations, the introduction of illustrated periodicals meant for a wider class than just the well-educated reader more or less coincided with the discovery of how to make photographs. Because they satisfied both the need for pictorial material and the demand for descriptive realism, camera images shortly became the basis for many of the graphic illustrations in nineteenth-century journals and socially-oriented tracts about the lives of the working class. With the invention of half-tone printing toward the end of the century, the Progressive Era's faith in the innate truthfulness of the photograph became wedded to this new print technology. By the early twentieth century, the individual silver image of social conditions in need of correction became less important for itself than for its reproduction in printers' ink.

The aim of photographs reproduced in the popular and specialized press was to inform and educate, which meant that the images had to reach the public in a particularly focused manner. For example, Lewis Hine's images of child workers and the texts that accompanied them, which had appeared frequently in *Survey* magazine, also were printed in

brochures published by the National Child Labor Committee—the agency for which he worked. For the most part, the NCLC or the photographer himself controlled layouts and captioning. The emphasis was on presenting the facts in a manner that would evoke an emotional response and, it was hoped, lead to ameliorative action. Sensible to this historical approach, Stryker recognized that the popular picture magazines of the era could provide the instruments that might evoke a similar response. With their large readerships, *Life* and *Look,* as well as the daily press, were sought out as vehicles for images that conjoined instruction and persuasion. (FSA photographs also were made available as illustrations for the full-length works that took up the theme of rural displacement).

By 1936, photographs by Lange and other FSA photographers were being reproduced in these magazines, but the print media of the 1930s were strikingly different from those utilized during the earlier era. *Survey Graphic* (the illustrated edition of *Survey*) remained a congenial but very specialized venue, aimed at those directly involved with programs for social change. *Life* and *Look,* on the other hand, were mass-circulation magazines not greatly sympathetic to the agricultural or welfare programs of the Roosevelt administration. They refused at times to use FSA photographs or printed them without credit lines. Certainly, they were loathe to give up editorial privileges concerning choice of images, layouts, captions, and body text. As a result, Agency photographs that did find their way into these journals were subject to an editor's notion of what constituted an interesting picture essay. Furthermore, the very nature of pictorial journalism required that a captioned sequence of images carry the narrative, whereas the FSA archive was geared toward single photographs. Lange's well-known "Migrant Mother," for instance, did result from a series of exposures, but her purpose was to find the one most telling image in terms of facial expression and formal resolution rather than to enlarge the story in temporal terms.

The popularity of the picture press was such that the social-documentary mode was becoming subsumed into the photojournalistic strategies of publications whose primary objective was not to bring about social action, but to maintain or increase circulation. By the late 1940s, documentary, as photographic historian Beaumont Newhall put it, had "passed into the bloodstream of photojournalism." Magazines had become the prime means (before television) through which the kind of social imagery that engrossed Lange could reach a wide public, as she herself recognized in opting to work on two picture stories for *Life.* Having spent the major part of her career producing images for use by others (her portrait clients, the FSA), she understood that *Life* would be the primary vehicle for the pictorial representation of the major struggles of the post-war decades, whatever its social or political stance and its editing practices.

The thirties concept of social documentation itself came under attack

during the 1950s. Indeed, the history of the genre suggests that even in its heyday it was never entirely free of confusion about its character. Hine had called his photographs of tenement dwellers and child workers "social photography," but by the late 1930s, "documentary"—a term popularized by Newhall, who had helped elevate photography to the status of art through his activities at MOMA—had become accepted to describe a truthful yet poetic visual record of social conditions. In this way, the genre was seen to embrace both the recording capabilities of the camera and the photographer's ability to evoke an emotional response through the choice of moment, vantage point, and lighting. In other words, "documentary," as then used, united the concepts of art and utility, usually thought to be in opposition.

Even during the 1930s, however, this conjunction of art and usefulness was questioned by a range of photographic opinion. While recognizing that the divide might be bridged by individuals with an exceptional eye and strong feelings, Newhall himself posited a dichotomy between photographs meant as records and those meant as art. There were differences of opinion among the participants in the FSA project. Artist Ben Shahn— active in articulating the ideology of the Historical Project—was convinced that merely factual records of, say, eroded soil would be insufficient inducements to action; instead, he campaigned for images that concentrated on human reactions. Walker Evans, a member of the team whose work found immediate favor in artistic circles, claimed that documentation should be "a stark record" but at the same time, preferred to think of "documentary" as a style, denying that it had any usefulness at all, since to his mind art was "useless." Conventional pictorialists of the time sought to tether the documentary mode so closely to uninflected record-making as to deny its expressive intentions altogether; some denigrated socially concerned photographers as the "ash-can" school. Ansel Adams, representing modernists for whom the formal problems of light and pictorial structure were of primary concern, regarded the documentation of social conditions as politically suspect. To her credit, Lange was unwavering in her belief that camera images could depict adverse social conditions, could celebrate the humanity of those being forced to undergo them, could fulfill the formal requisites of picture-making, and could evoke a feeling response.

By the late 1940s, the documentary mode had lost most of its government sponsorship and to some extent had become co-opted by the corporate sector. Subsumed into photojournalism on one hand and, on the other, reconstituted as a means to brighten unappetizing images of American industrial companies (in particular a project headed by Stryker for Standard Oil of New Jersey), its nature changed. Now accepted as worthy of museum exposure, the new direction was summed up in the 1955 exhibition "The Family of Man," curated by Edward Steichen (who had re-

placed Newhall as MOMA's director of photography). Work by social documentarians, photojournalists, street photographers, and aesthetic or pictorial photographers was assembled in a format suggestive of a three-dimensional magazine layout. In emphasizing the desires of people everywhere to live in peace and enjoy their work and families, this exhibition manifested an inarguable humanism, but it lacked the purposive mission that formerly had characterized the social documentary genre. It also steered clear of the edginess and sense of alienation beginning to pervade the work of those critical of the nation's rampant consumerism and racism.

The new social pulse brought about a further change in attitudes toward social documentation. In an era that prized individualism and was less involved with community effort or the social good, the purposeful humanist outlook of the 1930s came to be seen as both sentimental and intrusive. As television took over the burden of presenting the public with the pictorial narrative of their times, photojournalistic stories in *Life* and *Look* were judged to be bland and superficial. A different social sensibility emerged. Among whose agents were photographers Diane Arbus, William Klein, and especially Robert Frank; all viewed American public life with irony and even savage disapproval rather than idealism. Their images seemed to speak to those disaffected by political assassination, the violence of the civil-rights struggles, and involvement in the war in Vietnam.

They were followed by a generation of post-modern artists and thinkers, some of whom denied altogether the possibility of truthful visual representation. Others held that the documentary mode of the thirties had produced a symbolic rather than a realistic representation of the actual social circumstances of the era. With its focus on irony or parody, the visual arts of the 1980s had little use for the distinction Lange had made between sentiment and sentimentality, nor did it credit the validity of the aesthetic ambitions of the documentary genre.

For Lange, however, the "visual life" (which she felt she had only just touched) involved a commitment to both the aesthetic and the humanist potentials of her medium. Perhaps a reaction to the alienated and didactic nature of much of the camera imagery of the 1980s and 1990s made her dedication to these goals appealing. Her interest in politics and social action, in women's roles in the family and as professionals and workers, which are so cogently explored in this biography, have been further amplified in the numerous articles, books, and films that have issued forth in this time frame. The social implications of the documentary genre are the theme explored by Robert Coles in his essay in *Dorothea Lange,* a monograph published in 1982. The interrelationship between Lange's vision and the ideology of social documentation is the primary focus of *Dorothea Lange and the Documentary Tradition* by Karin Ohrn (1983). *In Mind's Eye,*

Mind's Truth: FSA Photographs Reconsidered (1989), author James Curtis de-
votes a chapter to "Migrant Mother," around which has centered much of
the negative and positive comment about the agency's concepts and the
photographer's strategies. That it was structured to evoke religious feel-
ings associated with traditional madonna imagery, and retouched (at
Lange's instruction) to remove an irritating visual element, was emblem-
atic in some minds of its dishonesty and exploitativeness; others recog-
nized that it fulfilled the FSA's need to give social disaster a human face.

Other publications deal with the broad scale of social documentation of
the thirties in general. *Documenting America, 1935–1943* edited by Carl
Fleischauer and Beverly W. Brannan (1988), *Symbols of Ideal Life* by Maren
Stange (1989) and *American Photography and the American Dream* by James
Guimond (1991) all discuss issues of manipulation and truthfulness as
they relate to the practice of government-funded social documentation.

Lange also has been the subject of a number of exhibitions, both in the
United States and, more recently, abroad. These include a major retro-
spective in 1994 at the San Francisco Museum of Modern Art; the exhibi-
tion catalog, titled *Dorothea Lange: American Photographs,* provides a new
generation of viewers with a summary biography and a social context for
understanding the images. In keeping with the current interest in person-
alities and their private behavior, a more narrowly focused publication,
Dorothea Lange: A Visual Life, edited by Elizabeth Partridge (1994), ex-
plores the personal dimension. Essays by family members, friends, and
scholars deal with Lange's relationships with her children and with her
attitudes about women and toward her own disability.

All of these works enrich one's understanding of the photographer and
her times, but *Dorothea Lange: A Photographer's Life* remains singular in its
vivid and all-encompassing exploration of the connections between art,
public service, and individual sensibility. For this reason its reappearance
after so many years is a welcome event.

Naomi Rosenblum

ACKNOWLEDGMENTS

I WISH TO THANK THOSE PEOPLE WHO WERE OF GREAT HELP IN the making of this biography. They gave me information and advice, often sacrificing many hours of their time for interviews or correspondence. I am particularly indebted to the members of Dorothea Lange's family, to her close friends, to the several photographers who at one time or another were her collaborators or assistants, and to the men and women who worked with her on her various assignments.

I am grateful above all to Paul Schuster Taylor, who encouraged me to write this book, gave me free access to his wife's archives, and patiently replied to my endless questions. It should be clear that he in no way suggested how or what to write, nor did he reserve any right of approval. There are many other members of Dorothea Lange's family to whom I owe a great debt, especially her sons, her stepdaughters, their wives and husbands, and her cousins on her mother's side. (Their names are given in the Bibliography.)

In addition, a number of people loaned me files of correspondence with Lange which provided invaluable evidence of her actions, her thoughts, and her feelings. Here I single out for special thanks Beaumont Newhall, John Szarkowski, and Margot Taylor Fanger. The many others who loaned me one or a few letters will forgive me, I hope, for not thanking them by name.

In the course of research I interviewed nearly one hundred people. I am especially obligated to them for sharing with me their knowledge and impressions. Their names will be found in the Bibliography, under Interviews. I am also grateful to many people who generously responded to an infinite variety of requests for help—from running through local-history documents and newspaper clippings in search of a stray item to photocopying old photographs or translating criticism from foreign journals. Some supplied me with eyewitness accounts of single incidents in which they observed Lange, or wrote me their impressions of a histor-

ical event or period in which they figured as associates of Lange. Others built for me lists of people who might have some clue to contribute toward the solution of an unanswered question or described what it was like to attend the same schools Lange went to or to work for the same agencies that employed her. My deepest appreciation to Dorothy Allen, Lillian Baldwin, Susan Bartolucci, Jack Delano, Joan Doherty, Alice Erskine, John Fischer, Laura Gilpin, Hansel Mieth Hagel, Alice Hamburg, John Heaney, Helen Hosmer, Romana Javitz, John Kouns, Sam Kronman, Russell Lee, Pare Lorentz, Richard Merritt, Gjon Mili, Barbara Morgan, Helen Nestor, Hank O'Neal, Emmy Lou Packard, Gordon Parks, David Perlman, Peter Pollack, Samson Raphaelson, Jane Cassels Record, Naomi Rosenblum, Bernarda Bryson Shahn, Julius Shaw, Carl Siembab, Aaron Siskind, Margaret Sloss, Luisa Sofaer, Kate Steichen, Elaine Steinbeck, Paul Vanderbilt, Tom Vasey, Mac Volz, Phyllis Wilson, Donald Winks, and Marion Post Wolcott.

The cooperation of the institutions which contain Lange material was indispensable, of course. It helped considerably to have the friendly assistance of their archivists and librarians. I wish to thank Willa Baum, head of the Regional Oral History Offffice, the Bancroft Library, University of California at Berkeley; Therese Heyman, Senior Curator, Prints and Photographs, The Oakland Museum; Jerry L. Kearns, head, Reference Section, Prints and Photographs Division, Library of Congress; Jemison Hammond of the Archives of American Art, New York; James C. Anderson, Curator, Photographic Archives, University of Louisville; Diane Edkins, formerly Research Supervisor, and Susan Kismaric, Research Supervisor, the Photographic Library, Museum of Modern Art, New York; and Stephen L. Schlesinger, Secretary, the John Simon Guggenheim Foundation.

Finally, my gratitude to Anne Grandinetti and Jane Meltzer for typing the manuscript in its many stages.

M.M.

PART ONE

1895-1918

1 HOBOKEN IS ONE OF THOSE IMPROBABLE TOWNS out of which so many eminent Americans have come. It is squeezed into a square mile of flatland between the rump of the Jersey Palisades and the Hudson River. Who's from Hoboken? I ask, and almost everybody in town has the same answer—Frank Sinatra. A few recall that Hetty Green became "the richest woman in America" by speculating on Wall Street while living in a cold-water flat in Hoboken which cost her $19 a month. The others do not know, or care, that Alfred Stieglitz, the photographer, came from there too, as well as another Alfred, Kinsey, author of the liberating sex report. And Dorothea Lange.

Stieglitz and Lange, born a generation apart, came from German stock, in his case Jewish, in hers not. Hoboken was crowded with Germans in the nineteenth century. It was a transatlantic port which handled much of the passenger and freight traffic for the giant city across the river. When the great German shipping lines made Hoboken their American terminus, some of the German immigrants who flooded in stayed right where they landed. Either they liked being so close to downtown New York and its opportunities, or the adventurous spirit that had brought them to the edge of the continent was extinguished by the brutal crossing in steerage, and so they never worked their way inland. At the time of Dorothea's birth, near the close of the nineteenth century, half the town's population of 45,000 was of German parentage.

Dorothea Lange was born Dorothea Margaretta Nutzhorn on May 25, 1895. She was named after her paternal grandmother, Dorothea Fischer. In the Greek from which it is derived, Dorothea means "gift of God." Like many who are unhappy with their surname, she dropped Nutzhorn (and her middle name) in favor of her mother's maiden name, Lange. Not just because Nutzhorn sounded harsh or comic in some ears. It seems to have been a name she wanted desperately to forget. Only after

her death did her husband and children discover what her true name was, and then by chance.

Not much is known about the father, Heinrich (later Henry) Martin Nutzhorn, partly because his daughter did her best to conceal his very existence. He was born in the United States in 1868, the son of Bernard F. and Dorothea Fischer Nutzhorn, German immigrants. Bernard Nutzhorn had a grocery store in Hoboken, managed with the help of his oldest son, Frederick. Henry, the second son, studied law and was admitted to the Jersey bar in 1891. He opened a law office in Hoboken, practicing for several years with a partner, and then alone. He seems to have done well, or at least wanted to be thought of as doing well, for he paid to have his name printed larger and bolder than all the other lawyers in the business directory. On May 27, 1894, when Henry was nearly twenty-six, he married twenty-one-year-old Joanna Caroline Lange in St. Mathews-Trinity Lutheran Church, Hoboken. He took her to live in a handsome new brownstone he rented at 1041 Bloomfield Street, the house where Dorothea would be born almost exactly a year later. Bloomfield is block after block of varied row houses just west of Washington Street, the main thoroughfare.

Where or how Henry met his wife-to-be we do not know. Joanna (she would shorten it to Joan) Lange's mother, Sophie Vottler, had come over from Stuttgart, probably in the 1860's. She took ship with a sister, three brothers, and their mother, Ottelia. Migrating as a solid family group, uncommon among many ethnic groups, was typical of the Germans. The three brothers were in their twenties; one of their sisters, Caroline, was only six; the other, Joan's mother Sophie, was somewhat older. They traveled in steerage, the cheapest and roughest passage, and the family's pretensions were such that they kept this a secret for a long time.

Dorothea once said she wondered what kind of people these could have been to come so far "and then plump themselves down in Hoboken? Didn't they have the gumption to go to Cincinnati or Milwaukee? They just stayed right there in Hoboken." Perhaps projecting her own feelings about her hometown, she added, "They must have been dying to go back." But they didn't.

The three brothers, trained as lithographers in Germany, where the art had been invented by a Bavarian, quickly established themselves here. "Art" was soon what they came to call their trade, for in the city directory they listed themselves as "lithographer" for a year or two, and then as "artist." (Later, two of Joan Lange's brothers became lithographers, too.) When Caroline came of age, she found work in the public schools, teaching generations of seventh-graders. She never married.

Her sister Sophie (born in 1848) married Frederick Lange (born in 1836), who, with his brother Carl, was in the tea trade in lower Manhat-

tan, crossing in the ferry from Hoboken to work. Frederick probably died before Dorothea's birth, for she never mentions him. His widow, Sophie Lange, is the very first person Dorothea speaks of in the opening passage of her Berkeley oral-history interviews.

"My grandmother," she says, "was a temperamental, difficult, talented woman. She was a dressmaker, a very good one, but she was difficult. She was one of those people that have many legends and stories clustered around them. My mother was a much better person than my grandmother, but there aren't any legends about my mother; about my grandmother there are dozens . . .

"I very early remember that my grandmother told me that of all the things that were beautiful in the world there was nothing finer than an orange, as a thing. She said this to me as a child, and I knew what she meant, perfectly. My mother needed an explanation for that. And I've caught myself, many years later, with my own grandchildren, showing them what a beautiful thing is an eggshell, forgetting where I had gotten that. And I realize, too, so often I cook the way she did, though she never actually taught me how to cook." It was, Dorothea said, a certain kind of very particular, fastidious way. "It had to be just right; you threw it out if it wasn't just right."

Once, when Dorothea was a child of about six, she heard her grandmother say to her mother—in the German dialect she always spoke—"That girl has line in her head." To Dorothea it meant her grandmother knew "I had that sense very early of what was fine and what was mongrel, what was pure and what was corrupted in things, and in workmanship, and in cool, clean thought about something. I had that. I was aware of that."

It was not the example of her grandmother that taught her this, she said, though she did recognize in the older woman some things that made them closer in their relationship than Dorothea and her mother were. "My mother was her only daughter and they were devoted to each other, but my grandmother knew I was smarter than my mother . . . My grandmother had a way of protecting me from my mother. She was more sensitive than my mother. It was an awareness of things."

Dorothea's mother, Joan, had four brothers, one older than she. The last-born, John George Lange, was some six years younger than Joan. Both Joan and John showed an early interest in music. John began giving cello recitals while still a child and became a professional musician. Joan's soprano was good enough to earn her a place on local concert programs in New Jersey. When Dorothea was two, "Mme H. M. Nutzhorn" was singing a Tchaikovsky solo at St. Mathews Church in Hoboken (with violoncello obbligato by Mr. John Lange). Young John per-

formed by himself too on such occasions, as well as playing with the Hoboken Quartet Club, the Haydn Orchestra, and the Dvořák String Quartet.

But in the years just before her marriage to Henry Nutzhorn, Joan made her living as a clerk or as a librarian. She gave up outside work upon the birth of her first child, Dorothea. Four years later the Nutzhorn family moved to Weehawken, the river town immediately north of Hoboken. It was there that a second child was born in 1901, and given his father's name, Henry Martin.

A year later, Dorothea, at the age of seven, came down with poliomyelitis. There is no evidence of a polio epidemic at that time. She was probably one of a few isolated local victims, and the doctors were helpless in the face of the fearful disease. Unfortunately for Dorothea and many thousands more, the development of a polio vaccine came too late. There were no really effective ways to stop the acute infection once it had started. And not much could be done to prevent residual paralysis.

In Dorothea's case, the damage was to her right leg, principally from the knee down, though there was some injury to the upper leg, too. She could not flex the front part of her foot, and this made her limp, from the age of seven until her death at seventy. Although orthopedic surgeons had developed trusses, splints, and braces as mechanical aids to locomotion, there is no record that she ever used them—certainly not as an adult. She had to wear a right shoe a half size smaller than her left. What therapy or exercises, if any, were given her as a child, she never said. But at sixty-five, she did speak of what it meant to her to be physically disabled:

"No one who hasn't lived the life of a semi-cripple knows how much that means. I think it was perhaps the most important thing that happened to me. [It] formed me, guided me, instructed me, helped me, and humiliated me. All those things at once. I've never gotten over it and I am aware of the force and power of it."

Growing up with it meant being called "Limpy" by the other children. This hurt her. Dorothea recalled that when she was out walking with her mother and some friend approached them, her mother would say, "Now walk as well as you can!" It took decades for Dorothea to learn that this was a common reaction, and bitterness toward her mother, begun so early, lasted long. In the last year of Dorothea's life she came to her door one day to greet another photographer whom she had talked with on the phone but had never met. Helen Nestor walked with brace and crutches, and explained that she had had polio. Dorothea said, "I too—and you know, my parents were ashamed of me." She thought this concern for outward appearances was very important to her mother, and blamed it on Joan's German upbringing. "Germans," Dorothea said, "are always

being aware of what other people would think of them." Years later she saw the same trait operating in another aspect. Whenever Dorothea's name appeared in the press, her mother would say, "Oh, I'm proud of you!" It bothered Dorothea because what the article praised her for wasn't anything Joan would take pride in unless someone else approved it first. To Dorothea this indicated dependency, a Germanic respect for authority that she didn't like. "When I had polio she was that way with the doctors, and although I was a little child, I hated it. She was slightly obsequious to anyone in authority. I never liked it."

Polio's crippling effect upon her seems rarely to have been out of Dorothea's consciousness. But her many friends in the years after childhood saw it variously. One said the limp, though "quite pronounced, went with her, like her beret and her silver brooch." A woman who knew her for the last forty years of her life believes that Dorothea didn't limp unless she was tired. Twice, when couples who worked with her professionally were being interviewed, one partner said, "Of course she limped," and the other, "I never noticed it." Which probably means that the degree of limp varied with her general condition. Her daughters-in-law both thought her polio was a strong factor in her demanding nature, a characteristic which could make her magnificent in some instances and destructive in others.

What matters too, of course, is the way she felt about it. She found the handicap could sometimes be a help to her as a photographer.

"Years afterward, when I was working, as I work now, with people who were strangers to me, being disabled gave me an immense advantage. People are kinder to you. It puts you on a different level than if you go into a situation whole and secure."

Her lameness was important to her development, she felt. "We all have those things that form us. They are of what we are built; they are our architecture. And there's much we don't know. I mean this is only a part of it. But the explanation of a person's work sometimes hinges on just such a succession of incidents . . . and those incidents dictate our responses. My acceptance, finally, of my lameness truly opened gates for me."

When Suzanne Ries, interviewing Lange, suggested that a disabling illness often gave people a certain strength, while at the same time warping their personality, so that they refused help from anyone, Dorothea replied that that might be true of her, but if it was, she did not know it.

For many years her son Daniel Dixon believed her polio was no problem to her. Naturally he could not imagine his mother without it, it was so much a part of her. Her only concession to it seemed the wearing of long dresses and slacks. Later, however, when he began to write with

her and about her, he became aware of her intense concern as a photographer with the theme of "The Walking Wounded." And he saw that it must always have been on her mind.

As Dorothea grew older she came to feel, she said, that her mother "was more dependent on me than I was on her." Joan's children called her "The Wuz" because she was "wuzzy." Although intelligent, she was indecisive, timid, self-effacing, vague to the point of exasperation. Dorothea recalled her mother saying to her, "You have much more iron in you than I have." And Dorothea believed that was true. "I have more iron; maybe I can be more cruel. Maybe it is in my independence, which is more than she had." Then, thinking of her own relationship as a mother to her children, she said, "I suppose if one of my children were here discussing their relationship to me they would be able to think of things that were quite horrifying, dreadful, that I did, that I was and am unaware of, as she [Joan] was unaware . . . I'm sure my sons would tell me things that I would want to justify."

When she was twelve years old, the marriage of Dorothea's mother and father broke up. "My father abandoned us." Dorothea never offered a reason. But an old friend who had known the family in its Hoboken days suggested that Henry Nutzhorn had done something wrong or illegal and had been forced to leave town. The most common speculation is that he may have abused his trust as a lawyer and taken funds not his own. Such a theory is at least plausible because of the secrecy about her father Dorothea maintained to the end of her life. Why would she have buried this part of her past unless there were something in it she was deeply ashamed of? It was only after her death that the friend who had known her since childhood revealed what her family name was and who her father had been. But whatever his offense may have been—embezzlement, fraud—there is no record of her father ever having been censured, debarred, or indicted.

In some 250 pages of transcribed interview Dorothea mentioned her father only three times, and briefly. She remembered that when she was about ten, her father took her to a performance of *A Midsummer Night's Dream*. They went in a coach (it was around 1905), and when they got there discovered there wasn't a seat left. Her father stood in the back, hoisting Dorothea up on his shoulders so she could see over the crowd. At home they had one of those huge one-volume Shakespeares, which Dorothea had read. Her mother and father would laugh at her and say she couldn't have read all that fine print, and then they'd quiz her to see what she knew about this play and that. Of course, she'd read the big book hungry for story, not because it was Shakespeare. "And because of that, my father took me. That was a magic thing to do for me, to see that. Magic! I've always been grateful to him for that. And that coach."

Some years after her father left home, she went to hear Woodrow

Wilson speak, and came away thinking, He looked like my father . . . I had great respect for him. Long after, traveling through Germany in 1959, she jotted these words down in a journal she kept: "I wonder if I could ever write of my father. So hard that would be . . ."

The breakup of her parents was a terrible blow to her. She couldn't bear to speak of it, even to her husband Paul Taylor. "I couldn't pry into it . . . The weight of it was apparently too much . . . It was too painful to her, and I saw no point in pressing," he said.

The Nutzhorns were living in Highwood at the time they separated. In 1907, Joan Nutzhorn took Dorothea and Martin, and went back to Hoboken to live with her mother. Apparently Henry Nutzhorn offered no aid and Joan had to support all of them. She found a job in a branch of the New York Public Library on the Lower East Side. It had recently been opened on East Broadway to serve the huge mass of immigrants arriving from Eastern and Southern Europe.

Every day Joan rose early, prepared breakfast for the family, then walked with Dorothea to the ferry which carried them across the Hudson to Manhattan. From the landing at Christopher Street they walked across town to the East Side, mother depositing daughter at P.S. 62, before starting work at the library.

She was lucky to find work in the library. Her pay, the equivalent of about $12 a week, was double the average family pay—the earnings of parents and children combined—of the immigrants surrounding her on the Lower East Side. Equally lucky was her daughter, able to go to school instead of obliged to go to work. Half of New York's school-age children were not in classrooms. At factory labor or in street trades they helped their families survive, sometimes bringing home as little as 30 cents a day. Almost none of them—including Joan with her $660 annual income—earned enough to reach the $800 a year declared the minimum needed for a decent way of life in New York City.

The branch library stood in the most populous district of the city, a first stop for the immigrants who poured off Ellis Island by the thousands daily. Lewis Hine's photographs made in those years caught the trust and hope in the immigrants' faces. The library's windows looked out upon the six-story dumbbell tenements of the Tenth Ward, "Jewtown," as the reporter-photographer Jacob Riis called it. Just before Dorothea's birth he had published How the Other Half Lives, with his own photos documenting the terrible conditions of the 300,000 people entrapped in the most congested square mile in the world.

Although Dorothea had visited New York before, she had never been to the Lower East Side. This part of East Broadway housed three institutions which played a great part in interpreting American life to the immigrants—the library where her mother worked, the Education Alliance (a settlement house), and the Jewish Daily Forward. Plunging from quiet

little Hoboken into this exotic bedlam every morning must have been an astounding experience for the child. At Chatham Square, where East Broadway began, two elevated railways thundered over her head. Along the grimy streets she saw Chinese, Irish, Hungarians, Bohemians, Negroes, Italians, and, above all, Jews. On park benches and doorsteps sat old men with beards and earlocks and women in wigs and babushkas. Her ears were assailed by the foreign-tongued clamor of the streets and her nose by the penetrating smell of pickles, herring, and garlic or the stink of sewage. Hester, Jefferson, Orchard, all were crowded with push-carts, the stage for the daily battle between housewife and vendor. In the spring, horse-drawn merry-go-rounds began to appear, offering children rides for a penny. A penny each was the price of the enormous dailies, too, sold at the corner newsstands. Signboards were everywhere, promoting product or service in Yiddish, English, and a variety of other languages, for over a third of all New Yorkers were now foreign-born.

At Public School No. 62 Dorothea learned what it was to be in a minority. "I was the only Gentile among 3,000 Jews," she said, "the only one." An exaggeration, no doubt, but it felt like that to the child. Over 95 percent of the pupils came from non-English-speaking homes. P.S. 62 was the first intermediate grammar school in New York, a forerunner of the junior high school. It stood on Hester Street, between Norfolk and Essex, and was close to the library. It embodied the most advanced ideas of its time in education. The white granite building, pillared, porticoed, and five stories high, contained a large auditorium, two manual-training shops, two gymnasiums with shower baths, science laboratories, and large airy classrooms. There were separate classes for girls and boys. P.S. 62 was the pet project of Julia Richman, the first woman to be made a district superintendent of schools. Choosing the Lower East Side for her district, she drew staff for P.S. 62 from the most experienced teachers of the surrounding elementary schools. The course of study at 62 was flexible, but training of future citizens was the first duty. And to learn to speak and write English well was the first necessity. Because the pupils were of fresh immigrant stock, the teachers (most of them not Jewish) were urged to be concerned with personal and home problems as well as classroom work. The school soon earned a reputation for producing students who ranked well above the city's average for scholarship.

Going through the seventh and eighth grades at P.S. 62 "was hard in some ways," said Dorothea, "because I had always taken it for granted that I was bright, and I was, until then, one of those who in school was reliable. Well, when I got to P.S. 62, I fell from my perch because I couldn't keep up with them. They were too smart for me . . . aggressively smart. They were hungry for knowledge and achievement . . . fighting their way up . . . like their parents. To an outsider it was a strange group because of the overwhelming ambition."

She did not understand the ancient roots of that zest for education. Universal education, at least for males, was a critical goal of a people who saw study of the Bible and Talmud as the pathway to God. And now, with free education a cherished right, the fervent dedication to religious education was transposed to secular education, the door to success in the New World.

The pupils were by no means dedicated solely to learning. There was a passionate interest in athletics, and P.S. 62 produced championship basketball and track teams. Nor were the students all saints. In one issue of the student paper, *School Sixty-Two,* Julia Richman published an open letter to her "Dear Boys," lamenting the amount of crap shooting seen near the school. Better than this game of chance, she said, is the test of a skill at other kinds of games which "the honest, manly boy prefers . . . Don't be a gambler!" To help build character and culture the banker Felix Warburg gave the school 115 engravings and five busts. When the children looked up from their books or their dice, they could see the likenesses of great authors, statesmen, and musicians, and views of such inspiring sites as the Colosseum by moonlight or the ruins atop the Acropolis.

On one cover of *School Sixty-Two* was blazoned this quotation:

Be strong! We are not here to play, to dream, to drift.
We have hard work to do, and loads to lift.
Shun not the struggle: face it. 'Tis God's gift.
Be strong!

There is no knowing how well or how badly Dorothea did at P.S. 62; the school records no longer exist. A file of the school paper which recently turned up, shows that in her last term Dorothy (she changed the "ea" ending, temporarily at least, to "y") Nutzhorn was one of thirty-eight girls in Miss Garretson's 8B class. The same issue contains the results of a student poll for the most ladylike girl, the most scholarly girl, the most graceful dancer (her name is not among the winners), and the best-liked authors. Here Mrs. L. T. Meade ran first, with Dickens a close second; then bunched behind them, with about half as many votes, ran Shakespeare, Louisa May Alcott, and George Eliot. As for what the girls expected to do after graduation, nearly half listed high school; a fourth, business school; and the others put down normal school, Hebrew Technical, and work.

Two more items in the same issue may have caught Dorothea's eye. Mr. Shapiro gave the Physical Improvement Club a talk and demonstration, advising the members that, with the judicious selection of corrective exercises, "everyone can improve his physical condition. The boy with uneven shoulders, the drooping posture, and the pale face will soon

be a thing of the past." and D. GOODMAN, THE AMERICAN PHOTOGRAPHER, urged everyone "to go where the crowd goes—his portrait studio at 159 Rivington Street.

Thinking back on those two years, Dorothea said, "I was unhappy there . . . But I had to stay. Nobody knew who I was, what the color of my existence was, but there I was. And I had to meet that competition. I was an outsider." Unlike all the others, she didn't live on the Lower East Side. She did recall one friend, at least "a kind of a friend," who sat in front of her all through P.S. 62, a tiny, curly-haired girl who looked like little Bo-peep. The school had all kinds of extracurricular clubs, more than a score of them (including a camera club), but Dorothea must have felt so isolated among these immigrant Jewish children she apparently never joined.

Still, she absorbed the life around her, educating herself outside the classroom. She took long walks on the Lower East Side, in all seasons of the year, and always alone. When school closed in mid-afternoon, she went to her mother's library, presumably to study. But instead, with an appetite for knowledge as insatiable as the immigrants', she sat in the staff room and read the books around her. "The room had windows that looked out and into tenements and in the spring and summer, until the winter, the windows were open and I could look into all those lives. All of a tradition and a race alien to myself, completely alien, but I watched." She was, she said long after, acting "like a photographic observer." Neglecting what she was expected to do—she never studied textbooks hard—she spent endless hours studying all kinds of pictures, and made a practice of pinning on her wall the best she could find.

Often her concentrated "looking" focused on a significant detail. Soon after the young Leopold Stokowski came to America in 1905 he got a job as organist and choir master at St. Bartholomew's Church. Though Dorothea's mother wasn't a churchgoer, she loved music and on a Sunday afternoon took her daughter to church to hear an oratorio. The child couldn't see the conductor from where she sat—"I could just see his hands. Those hands of that man, ah, that I remember. Years later I read about his hands and I knew who he was! It could only have been Stokowski's hands that I saw on that winter afternoon."

She discovered early a way to look, and yet appear not to be looking, a method cultivated years later as a documentary photographer. Twice a week her mother had to work the night shift at the library and Dorothea went home alone after school. Sometimes she headed across East Broadway to Park Row, then down through City Hall Park to Barclay Street and the ferry slip on the Hudson. But at other times she preferred the much longer walk north to the Christopher Street ferry. It meant turning from Chatham Square into the Bowery and walking up its shabby length

for nearly a mile before heading west across Greenwich Village to the river. She was only twelve or thirteen then, and scared, which was perhaps why she did it.

I remember how afraid I was each time, never without fear. I thought of it recently when I was in Asia, quite often, because in Asia there are places where you have to look where you step because the sidewalks are unspeakably filthy and you never take it for granted where you walk. Well, on the Bowery I knew how to step over drunken men. I don't mean that the streets were littered with drunken men, but it was a very common affair. I know how to keep an expression of face that would draw no attention, so no one would look at me. I have used that my whole life in photographing. I can turn it on and off. If I don't want somebody to see me I can make the kind of face so eyes go off me . . . a self-protective thing . . . I learned that as a child in the Bowery. So none of these drunks' eyes would light on me. I was never obviously there. And you can see what equipment that was for anyone who later found herself doing the kind of work I do, or maybe it took me into it. I don't know. This was a preparation, hard as it was, but it was a preparation.

Once, in her sixties, she said, "I can remember everything." And she told of one event that meant a great deal to her when she was turning ten. A granduncle had given her a bunch of lilacs on her birthday:

I sat on the 23rd Street crosstown car, with those lilacs on my lap, jammed in with people, on my birthday, sitting there, feeling so wonderful. I can see myself . . . I can hear the sounds of the horsedrawn crosstown. It was under the elevated. I remember the darkness and the light under the elevated and the crosstown car. I sat there with those lilacs in one of those sharp instants of realization of the moment. And the flowers—all my life I don't think I did get over it. I am a passionate lover of flowers. And that's the moment that did it. Curious? And I had a straw hat on.

She also remembered significant snatches of conversation from childhood. When she was about fourteen, she was looking out the window, toward the Hackensack Meadows. She saw the red brick houses, with little yards between, wooden fences separating them, and wash lines hanging everywhere against the late-afternoon sky, tracing vivid patterns and squeaking rustily in the wind. She turned to the woman standing behind her and said, "To me, that's beautiful." The woman replied, "To you, everything is beautiful."

It startled Dorothea "because I hadn't realized it. It also helped me. I thought everyone saw everything that I saw and didn't talk about it. But when this person said, 'To you everything's beautiful,' that made me aware that maybe I had eyesight."

Another time a woman she admired but had never met was brought

into her family's home as a guest, with great fuss over preparations. Dorothea was introduced to her and then, as she left the room, she overheard the guest say, "That child has a spiritual face."

At sixty-five, she still remembered it. Such things, she felt, gave you direction. For the child it was like having a seed sown in the ground, when the soil, the time of year, and the seed itself were just right.

Thirteen for Dorothea was a time of change. She was at her most impressionable. The year was 1908, and she was just coming to the end of her stay at P.S. 62. Somehow—she couldn't recall the means—she went by herself to the Metropolitan Opera House to see Isadora Duncan dance, and had an experience she described as "like getting religion . . . an experience that affected me throughout my life." She went again and again during those December performances. Duncan, then thirty, was on her second American tour, high on the crest of her career. Accompanying her was an orchestra of eighty men, conducted by Walter Damrosch with such "marvellous sympathy," Duncan wrote, "that to each one of his gestures I instantly felt the answering vibration."

Those performances were for Isadora the most joyous time of her life, and to almost everyone who has written about them they seem to have given equal joy. They took thirteen-year-old Dorothea for the first time "into the upper reaches of human existence. It was something unparalleled and unforgettable. To me it was the greatest thing that ever happened," she said long after. "I still live with that, not as a theatrical performance, but as an extension that could electrify thousands of people at once."

The vision of Isadora Duncan marked the end of 1908 and of Dorothea's years in grammar school. On February 5, 1909, she entered Wadleigh High School. This was the time, she said much later, when "I became a solitary . . . I was fighting the world then. I didn't have what it took to enjoy life very much."

There were only three high schools in New York in the early 1900's: De Witt Clinton—for boys; Wadleigh—for girls; and Morris—for both. Wadleigh was a four-storied red brick building with white trim extending from 114th to 115th Street, west of Seventh Avenue. It was flooded with girls—over 3,600 of them—and Dorothea remembered it as a "miserable high school." At that time the neighborhood—Harlem—was a district of handsome new homes, occupied by families recently risen into the middle class, many of them Jewish immigrants who had prospered quickly enough on the Lower East Side to escape its slums. Only a small percentage of grammar-school graduates in her day went on to high school. "When I went uptown," Dorothea said, "the whole pattern broke. I was no longer the only Gentile."

How this New Jersey girl was admitted into Manhattan schools is a minor mystery. Students were required to be residents of the neighbor-

hood or city. On Dorothea's Wadleigh record two entries are made for her address, one at 691 Lexington Avenue and a later one at 1043 Southern Boulevard, in the Bronx. (Her father, long gone, is listed as parent or guardian, not her mother.) But these addresses were undoubtedly "borrowed," with the connivance of family or friends, so that Dorothea could continue her schooling in Manhattan while her mother worked at the library.

Her record shows that she did not perform brilliantly. Her major was Latin, a subject in which she did her worst, barely passing in each of the three years she studied the language. Her other courses included algebra and geometry; biology, botany, and physics; English, history, drawing, and music. She made her highest marks—in the 80's—in English, drawing, and music, but her record is littered with lots of 60's. What Wadleigh stressed was preparation for admission to college, or the special teacher-training schools. Teaching was one of the few careers easily accessible to women and for which professional education was free. Discipline at Wadleigh was strict. If a girl failed a course, she was flunked out. The dropout rate was high in the secondary schools, for many girls and boys were able to stay only until they could find a job.

"Miserable" high school? For Dorothea, yes, but many graduates of that time whom I have talked to recall it happily. Few of them, however, were born to be artists. "When I think now," said Dorothea, "what important years those are and what could have been done for me—because I loved books and I could get things fast—that wasn't done!"

The school was traditional, with nothing like the progressive curriculum or liberal approach taken by some of the private schools of that day, such as Ethical Culture. There was a student organization, there were class picnics, the girls managed their own assembly programs and edited a literary paper. But there was no special attention given to the arts. The teachers were mostly women, none of them married. They were, as one graduate told me, "in large part from the better women's colleges, and most of them were starchy New Englanders. They expected good manners. When a teacher spoke to you, you stood up straight!" She recalled that white dresses were required for the graduation exercises, and that when the principal finally permitted the girls a choice of color, many of the teachers were shocked. This was too radical an innovation.

But Wadleigh did provide one or two teachers Dorothea liked: a woman interested in Yeats, who opened Dorothea's mind to the new poetry; and a physics teacher, Martha Bruere, "the first scientist that I had met, a good, clean-cut brain, tremendously interested in physics. That was something." (For the three terms Dorothea studied physics her grades wavered from 75 to 60, and then up again to 78.) Miss Bruere came from a distinguished family. Her father had been a surgeon in the Union Army, her brother Henry, a leading banker, was constantly in the

newspapers for his leadership in liberal reform politics, and her sister Mina, against great odds, had become an executive of a major bank (not her brother's). Dorothea was "very proud" of the family. "In my mind I adopted these people because I liked them." Martha was a plain-looking woman, who dressed plainly too, and wore her hair "screwed back." Other graduates remember her as a good teacher, "warm but not overly friendly."

Known for her high principles, Miss Bruere did something extraordinary for Dorothea:

> She upgraded a paper so that I wouldn't fail because I had done so dreadfully on an examination where I knew so much better. It would have meant failing that course. And in my presence she went over that paper and upgraded it. She deliberately gave me what I had no business to get, in order to help me out, which I knew at the time was completely undermining her principles. But she did it out of some kind of feeling for me. I don't know what it was, exactly, but I've always thought of that with the greatest respect.

Martha Bruere gave her not only the chance to finish school but something more. Later, Dorothea would do generous things, too, for what she called "the undeserving." She was convinced it wasn't so much the things that happened to you which formed you but the persons you chanced to meet. And not those who deliberately tried to influence you, but those whose simple existence changed your own. Emily Sanderfield, like Martha Bruere, imparted something to the young Dorothea; in her she sensed what serenity meant. Emily Sanderfield was a nurse, working for a Viennese doctor and living in the big brownstone house on Lexington Avenue he used as a private hospital. "Aunt Emily," as Dorothea called her, had been godparent to Dorothea at her baptism. Once in a while Dorothea would visit her, climbing the high staircase and going down the long linoleum hallway to her dark and quiet little room, like a nun's cell. There was no chair, and they sat on the bed, Aunt Emily's starched uniform crackling when she moved. Dorothea couldn't recall what they said to each other, personal chitchat, it seemed unimportant, but she looked at the big plain face, head to one side, and she remembered "how red and big her hands were, great red, big hands. And peaceful, peaceful. She had healing in her . . . Complete self-abnegation, like a nun. All my life I have been wondering whether that abnegation isn't an essential thing for real serenity. No one else was like that, no other person that I'd met."

Home life knew no such calm. Dorothea's grandmother was still living with them in Englewood, New Jersey. She was a tiny woman with a terrible temper. She could speak some English but broke into German when excited. If she got mad she would say, "Woe is my shawl!" In a family crisis, with everyone upset, she would say menacingly, "You hear

me not saying anything?" To get rid of company she disliked she would blurt out, "Let's go to bed so the people can go home." She was likely to hit Dorothea whenever she was frustrated. Once she told the child to run down to the corner grocery for some macaroni. Dorothea brought it back wrapped in a long package and handed it to Grossmutter. The old lady grabbed it angrily and broke it over the child's head. "Dummer!" she yelled, "macaroons, macaroons, not macaroni!" By the time Dorothea was an adolescent, Grandma Sophie had become a messy, disorderly old woman who drank too much and quarreled with Dorothea all the time. Seeking refuge from a broken marriage, Joan had subjected her young family to a tyrant. "I fled," said Dorothea. "I couldn't take those things." Joan had not been able to flee. She retreated into her timid personality.

Dorothea stayed at home as little as possible, and was out of school as much as possible. She felt no connection with Wadleigh, and made friends with only one classmate, Florence Ahlstrom, a girl born in Hoboken whose family thought the local high school inferior and faked the residential requirements to get their daughter into Wadleigh. There they met for the first time and quickly forged a lifelong friendship. It started, Dorothea said, when she saw "Fronsie" pass in the corridor and liked the way she swished her starched petticoat. The Ahlstroms had a family life that seemed in many ways more normal than her own. Nothing about Dorothea's environment—her home, her school—seemed right to her, and she rebelled against it, trying to find a way out. The best she could do was to "bum around . . . I just would get so far on the route to school and then I'd turn and walk around the streets, and I'd look at pictures." She spent many spring days in Central Park, just south of the high school, once walking through it and all the way down to the Battery, carrying her school books. She never told her mother she was cutting classes and must have forged excuses. She induced Florence to overcome her fear of truancy and join her. They often went to concerts, especially to the free music offered mornings in the Wanamaker auditorium. Once they saw Sarah Bernhardt perform, not because they loved the theater; it was more a matter of seeing what great personalities were like. They saw exhibits at the Museum of Natural History, the Metropolitan, and the Art Students League. Florence tried the league's Saturday-morning classes in painting for a while, then quit because she decided she had no special talent. (Later she would show considerable talent in a long career as a decorator.)

Dorothea's truancy was a load on her conscience, but she didn't think it was unproductive. She came to know the city well, and found she was not afraid to be alone in it, as she had once been on the Bowery. With camera or without, later in her career, she would know no fear of cities, at any hour of day or night. Now she was learning to feel all parts of the

world were her natural element. "I was essentially neglected, thank God! But very neglected! Not deprived of love but they just didn't know where I was nor how I was living . . . I realize how enriched I am through having been on the loose in my formative years. This may sound very conceited and maybe it is—but I have known all my life so many people, my contemporaries, who have been 'regulars' and always done what they should do, have gone down the regular roads, followed the channels, been proper, made the grades—and lost."

Again and again in her reminiscences she speaks of herself as a loner. "I always felt and acted as though I was an outsider, a little removed. I never was in the middle of any group . . . I was a lost kid." Linked to it was her conviction that she had always been self-taught. "I have learned from everything, and I'm constantly learning. It's part curiosity, I think, trying to discover why things happen the way they do, watching everything, my own activities included." She rarely would say that this person or that taught her something, but when she did, she usually acknowledged someone obscure.

In June 1913 Dorothea would graduate from Wadleigh. "And after high school, what?" her mother demanded to know. What was she going to do? What was she able to do?

Dorothea knew. "I want to be a photographer," she said.

2 WHEN DOROTHEA DECLARED HER AIM WAS TO become a photographer, she was living with her family in Englewood. It was a small group: her mother, her brother Martin, her great-aunt Caroline, and her grandmother Sophie, who soon died. Joan Nutzhorn quit her library job shortly after Dorothea left Wadleigh and began a new career which she would maintain for the rest of her working life. Probably through some political connection, which was the way most such jobs were obtained (certainly in Frank Hague's domain of Hudson County), Joan was appointed attendant to a juvenile court judge, and then made an investigator, responsible for probation work. Neither she nor anyone else had special training for the job; the juvenile court system was a new development, not yet a facet of professional social work.

As a court investigator Joan often had to look up families in their homes, working people who couldn't be interviewed during the day. Dorothea recalled:

> I remember my mother going out on streetcars and making night interviews, alone, in all kinds of wretched old Polish tenements in the winter, standing on the windy, snowy streetcorners at night until late because sometimes she would have to wait until the drunken father came home. I used to like to go with her, to see her walk up the stairs, and knock at a door where "nobody" would be in. She'd listen and she'd know if they were in and not answering. I found myself later sometimes having to knock at a door when I was working and I used to remind myself of my own mother many a time.

What Dorothea said of her mother, when she, the daughter, was in her sixties and her mother was some ten years dead, reveals Dorothea's complex feelings:

> She was reliable and good, responsible, compassionate, but I don't think she threw light on any areas as the result of her presence. I mean she contributed,

she was part of the machinery, but she really didn't have any developed understanding of her work. Things were pretty backward in Hudson County. She was unique in that she had integrity, and no one ever tried to break that down. But in nothing that she did was there originality—no style. Everyone liked her though.

This can be read as a cool appraisal of her mother's qualities. Or it can be read as a grudging tribute in which the daughter gives a little, then takes a little. Whenever Dorothea talks of her mother, it is with the same mixture. Elsewhere she comments that Joan was "rather sentimental, which I have been too, but I loathe it in other people." And then she immediately says to the interviewer, "I must show you the portrait of my mother some day, because she was a very handsome woman, very well spoken of, my Lord!" It was a photograph Dorothea had made of Joan— one of her earliest efforts at portraiture—which she felt was "through and through my mother, and it reveals that I loved her very much." (Others in the family have said that Joan had a beauty Dorothea did not match.) Looking at this picture long after she had made it, Dorothea may have discovered in it her deeper feelings about her mother. But overlaying it perhaps was resentment born in those early years when, at a time a child normally leans on her mother, she felt her mother was leaning on her. The expected parent-child roles were reversed when her mother and father separated, and under the stress Joan, as Dorothea saw it, failed to bear up.

Aunt Caroline was an important member of that household. By this time she had been teaching in the Hoboken schools for some thirty-five years. The ties between her and Joan and Joan's brother John were very close. Observing the internal family life, Dorothea saw Caroline as the only one who could hold the fractious and heavy-drinking grandmother in line. "She was the only completely reliable person," Dorothea said, "to me and to the whole family. She lived a systematic, regular, quiet life and was a fine teacher, one of those adored teachers." On Friday afternoons, toward the last half hour of class, she used to read to her students—*The Woodcarver of Linz, Toby Tyler, Peck's Bad Boy*. She was known for her two hats, a spring one and a winter one, and her black shoes, with a hole cut in one in order to give a bunion breathing space. Every spring Grandmother Sophie, a skillful seamstress, made her a new dress and every winter another one. Caroline would never give up an old dress, wearing it until the black turned green and shiny. Then Sophie would rip it apart and turn it. Sophie was always trying to introduce a new note in the remade dress, just for a change, but Caroline would resist to the last stitch. They fought in German, the language commonly used at home for quarrels or secrets.

Caroline was a warm woman with a round face, a plump body, small

red hands, blue eyes, a sweet smile, and strong opinions. She carried a drawstring bag always loaded with mints or pennies to hand out to the children. On the birthday of the younger members of the family, she would get crisp new dollar bills from the bank for the celebrants. She never forgot such occasions; she kept lists of everything about everybody. Later, when Joan remarried and the others had gone off, Aunt Caroline went to live with another woman.

When Grandmother Sophie died in 1914, Joan, said Dorothea, "took care of her youngest brother John in the same way her mother had taken care of him, watched over him, did *too* much to take care of him. Temperamental son-of-a-gun he always was! One of the figures of my life, this Uncle John. He was the favorite, and a spoiled pup." John, always the musician, accompanied Fritzi Scheff, the popular singer of the early 1900's, and later became the contractor for Flo Ziegfeld, hiring musicians for the pit orchestras at the Ziegfeld Follies.

John Lange's daughters, Minelda and Joy, saw Dorothea's mother from another aspect. Much younger than Dorothea, and living in the East, they spent time with Joan after her daughter had gone to live in California. They thought their father and Joan looked very much alike, with the same prominent nose, mouth, freckles, and high coloring. Joan's hair was chestnut, worn in the 1890's style, with a big knot on top. She was a Wagnerian type, an Isolde, but not too buxom. She had the gracious manner of a great lady. Neither Joan nor John showed their age as the years passed. Like all the Langes, her nieces said, Joan was sensuous, loving the taste, touch, and smell of things. She had a great feeling for music, collecting both classical and jazz recordings and going often to concerts and the opera, where her noisy enthusiasm often embarrassed her companions. The hallway in her apartment was stacked high with books. She was aware of what was going on in the world, liked to talk politics, and, when she saw an injustice, tried to do something about it. She would become deeply involved with the children she encountered in the courts. Her nieces suspected she was able to connect with a stranger's children more easily than with her own (a characteristic Dorothea would not escape when she had her own children). She was domineering in her relationship with her brother John, and he gave precedence to her over his own family. When she wanted him, he came; that was where his first allegiance lay. It made for intense friction between John and his wife, Minette, an actress some twenty years younger than he. When John died, his family no longer saw much of Joan. They thought her a fascinating woman, but "not the kind of aunt you could cuddle up to and confide in." Once Joan asked her niece Minelda if she wanted to go to college. If she did, and would study to become a social worker, then Joan would help put her through. Think it over, she said, and remember that it's a devouring job. When Minelda came back to her

a week later and said no, she didn't want to be a social worker but hoped to go to college, Joan replied, "Then I won't pay for it." She was like that, Minelda said, authoritarian.

There are slightly varying versions of Dorothea's birth as a photographer. In the 1960's she gave the date as 1914, which would make her eighteen or nineteen. But in a letter written several years earlier, she said: "I started to be a photographer when I was 17 years old, before completing my education." Whatever the precise date of her declaration, she says that at the time "I had no camera and I'd never made a picture." The news must have astonished her mother. Lacking any confidence in her daughter's wish, she replied, "But you have to have something to fall back on!" Security was not what Dorothea wanted. "I knew it was dangerous to have something to fall back on." (Yet many years later Dorothea heard herself respond in exactly the same way to a stepdaughter, and was shocked to hear her voice echoing her mother's.) Her family said she must be prepared to earn her own living in a surer way, and insisted she go on with school—to Barnard College, Dorothea said late in her life. She had claimed attendance at Barnard earlier, when filling out a job form handed her by the Resettlement Administration in 1935. And over the years she mentioned more than once to a stepdaughter that she had gone to Barnard. But the records at that college contain nothing to indicate that a Dorothea Nutzhorn or a Dorothea Lange ever attended it. It may be the not unusual case of upgrading one's education to enhance a job prospect, and then coming to believe the fiction, especially when it sounds so good.

The fact is that she went to the New York Training School for Teachers, as did her friend Florence Ahlstrom. The school, which was not far from Wadleigh, on 119th Street west of Seventh Avenue, prepared students for teaching the elementary grades. Most of those who went were women. All it took to enter was certification by your high-school principal of your "character, habits, posture and use of English." The free school required eighteen months of class work and six months of practice teaching. To obtain a teaching license you then took written and oral examinations, which were considered easy because the city needed teachers badly.

How Dorothea did we can't tell, but again, as in high school, her heart was not in her studies. Teaching children was not what she wanted to do, even if it meant a sure living. So while going to class daily she spent every spare moment she could working in photographers' studios in New York—nights, Saturdays, and Sundays. That youthful devotion to learning her craft is expressed in something she said long after: "I've never not been sure that I was a photographer, any more than you would not be sure that you were yourself!" It came slowly, she said; it was no

sudden decision. We know she had early shown an intense awareness of the visual world, and a love for pictures, all kinds of pictures. Growing within her must have been the ambition to create her own visual images. "My mind made itself up. It just came to me that photography would be a good thing for me to do. I thought at the time I could earn my living at it without too much difficulty. I'd make modest photographs of people, starting with the people whom I knew. I had never owned a camera, but I just knew that that was what I wanted to do."

Once the desire crystallized, she set about her apprenticeship. She got herself one job after another working for commercial portrait photographers in Manhattan. From this distance it seems a remarkable thing for a seventeen- or eighteen-year-old girl of that time to have done. Her family had committed her to learning the teaching profession. She made her way from New Jersey to Harlem every morning, reaching the first class at eight-forty. And when school was out at three, she went downtown to learn the profession she had committed herself to.

In choosing which master to serve in her first apprenticeship she started at the top, and quite by chance. She was walking on Fifth Avenue one summer day when she noticed some portrait photographs in a display case at street level. They were the work of Arnold Genthe, whose studio was at 562 Fifth Avenue, on the corner of Forty-sixth Street. She went upstairs and asked him for a job. Genthe, then forty-five, had come to New York from San Francisco only a few years before, in 1911. He was a German-born aristocrat with a Ph.D. in philology. (He sometimes signed his photographs "Dr. Arnold Genthe.") He had gone from Berlin to California in 1895 for a temporary job tutoring, but, teaching himself photography, had stayed on to become "the king in portrait work on the Coast." His sitters included the leading Bay families and the famous artists, writers, musicians, and actors who lived in or visited San Francisco. At the same time he made studies of life in the city's Chinatown district. When the earthquake and fire destroyed much of San Francisco in 1906, including his own equipment, he borrowed a camera and wandered the streets making the photographs which are among the most celebrated documentary records of the century. Genthe moved to New York because business promised to be even better there. He went on photographing the great—Presidents Roosevelt, Taft, and Wilson, Ralph Blakelock, Eleonora Duse, Sarah Bernhardt, Sothern and Marlowe, Nellie Melba, John McCormack, Paderewski, Mary Pickford, John Barrymore, Garbo, Galsworthy, Edna St. Vincent Millay, Eva Le Gallienne.

Why Genthe took this utter novice on we do not know. There must have been plenty of young people eager to work for little in such a setting. Perhaps she made the same blazing impression on Genthe that others recorded a few years later. But if she did, he could still look at her with a critical eye. "I wish you'd take those red beads off," he said the

first time he saw her. "They're not any good." She took them off. "He was absolutely right. I never wore costume jewelry again."

She was the youngest of three women on his staff. His studio, she said, provided "a look into a world I hadn't seen, a world of privilege, command of what seemed to me the most miraculous kind of living." Genthe was a collector of art, principally Oriental, as well as celebrities, and both were all around the studio.

Genthe, who never married, had a reputation for innumerable love affairs. "I have never been bored," he said. To the young Dorothea he was "an unconscionable old goat who seduced everyone who came into the place. He was a real roué, a real roué. But what I found out when I worked for him was that this man was very properly a photographer of women because he really loved them. He wasn't at all a vulgar man; he loved women, understood them, could make the plainest woman an illuminated woman. When he photographed her, he understood her. I watched him do it. He was in love with the kind of life he lived, he was in love with himself as a human, and his effect upon other people." She learned from him that "you can photograph what you are really involved with." He was a real artist, Dorothea thought, digging a narrow trench, as she put it, but a deep one.

Dorothea came up to the top-floor studio every afternoon after school and often worked into the evening. Genthe paid her fifteen dollars a week, a decent wage for that time. When his receptionist was out, Dorothea handled her own job, and also took the phone calls. She learned which women Genthe was too busy for and which not. She made proofs, did the spotting (covering dust flecks or white spots on the negatives with India ink), and learned retouching technique. The glass-plate negatives were often retouched, she said, by using an etching knife to make slight modifications in a sitter's features. She mounted the photographs, too.

Genthe today is valued less for the portraits he was making when Dorothea worked in his studio than for his street work—the San Francisco photographs of Chinatown and the earthquake's devastation. Using a small hand camera, he could catch people on the street unaware. Such unposed pictures had become possible only around 1880, when the dry-plate process was introduced. The photographer could see the moment he wanted to preserve and make his exposure almost simultaneously. The freedom of movement the hand camera and the dry plate permitted made Genthe one of the pioneer users of candid-camera technique. It was documentary photography which Dorothea would one day equal and surpass, though she never saw Genthe at work with it. As her photographs of the Dust Bowl wanderers of the 1930's would do, Genthe's images of the disruption of normal community life by a natural catastrophe helped bring aid to the victims. His documentary work seems

picturesque now, for he was influenced by the pictorialists of his day. And his portraits, of course, are romantic. Still, he claimed he never took anything but a "candid" photograph. He believed he gave his sitters pictures that were more than surface records. He said his were portraits "that in a pictorially interesting composition, in a carefully considered pattern of light and shadow, showed something of the real character and personality of the sitter." In the finished print he tried "to subordinate detail and emphasize the essential characteristic features." It was early in his San Francisco years that he developed what he called this "new Genthe style" of portraiture.

Thinking back on it, Dorothea felt she had learned a good deal from Genthe, but not really photography. His best work had been completed before she came along. Now he was "working within a good commercial formula and making a lot of money." His technique she thought quite limited, "relying on a certain battery of lights and very controlled conditions." She owed her first camera to a gift from Genthe, it is often said. He did give her one, but she couldn't recall whether or not she had owned one before.

It was about this time that she dropped out of teacher-training school. The turning point was an unfortunate experience while practice teaching. She was working with fifth-graders one day in a classroom on the uppermost floor of the school. Her pupils, quickly aware that she could not control them, got up from their seats one after the other, walked to the window leading onto a fire escape, and descended the steps to the yard, leaving Dorothea in tears. The training supervisor entered the room, took in the situation, stepped out on the fire escape, and looked down at the children below. They saw the supervisor standing there and, without a word being said, filed back up into the classroom. A few days later Dorothea quit. Her mother had to accept the decision.

She left Genthe—for no good reason except that she wanted to get all kinds of experience—and spent the next six months working for Aram Kazanjian's studio at 32 East Fifty-seventh Street. Born in Armenia of a prosperous family, Kazanjian had been sent to Paris to study. When the Turks began massacring the Armenians, he sailed for America and opened a portrait studio, first in Boston and then in New York. Like Genthe, he photographed persons of distinction, such as the royal family of Broadway, the Barrymores, and Enrico Caruso. He was often commissioned to make the frontispiece portraits for biographies and autobiographies.

At Kazanjian's Dorothea learned how to run a portrait studio as a trade. She began as one of a battery of young women who solicited business on the phone: "Good morning, Mrs. DuPont, this is the Kazanjian Studio calling. Mr. Kazanjian is so interested in making a portrait of you and your son together, and we will be in Wilmington on Saturday

morning, and is there any possibility, if you have the time . . ." That was how it was done. The DuPonts were among the old and faithful customers whose portraits Dorothea printed and retouched. She remembered one picture Kazanjian made of a DuPont matriarch surrounded by all her grandchildren. Upon her lap was a big book, supposedly the family Bible. But when Dorothea saw the sharp print emerge, the Bible turned out to be a telephone directory, with all the names readable. It was that pose the DuPonts wanted dozens of—at $200 the dozen—and Dorothea had to retouch the picture so the print couldn't be read.

That studio was like a big show to her. She could see how it worked from beginning to end, what the tricks of the trade were, what customers wanted and what they didn't want. She learned much she could apply years later when she opened her own studio—but not yet how to take pictures with the big camera. Genthe did his own photography, and Kazanjian employed many operators. So Dorothea moved on to a studio at 461 Fifth Avenue run by a woman named Mrs. A. Spencer-Beatty. This time the pay was $12 weekly. Mrs. Beatty was a contractor, really, not a photographer. She employed one staff photographer and farmed out her printing and retouching. Soon after she took on Dorothea for minor chores, her photographer quit—probably because the business was falling apart and the sheriff was after Mrs. Beatty. At that moment of crisis a commission from the prominent Irving Brokaw family fell into her lap. It meant hundreds of dollars, but who would make the portraits? In sheer desperation, knowing nothing about how to operate a camera herself, Mrs. Beatty sent Dorothea out. The Brokaws sent a car for her, with a chauffeur and a footman. "It was the first big job I ever did," Dorothea said. "But I had enough insight by that time to know how professionals behaved on these jobs. I was scared to death for Mrs. Beatty's sake because I knew she had to have that money—not scared of the people, but that I wouldn't be able to do the pictures that would be acceptable to them, hard-boiled pictures, the formal, conventional portrait. There I was, this obscure little piece, with a great big 8 × 10 camera, scared to death—but I did it! It was sheer luck and maybe gall."

That experience, she said, "precipitated me into being a camera operator." A few weeks later her second chance came. Mrs. Beatty sent her to photograph Sir Herbert Beerbohm Tree. It was 1916, and the leading actor-manager of the British stage was touring America with lavish productions of *Henry VIII* and *The Merry Wives of Windsor*, as well as a fiery speech designed to rally America in support of the Allied cause in the war with Germany. Returning from Hollywood where he had played Macbeth in a silent film, he opened at the New Amsterdam on Broadway in March. His productions were rated high for spectacle and low for acting. In one review George Jean Nathan said, "Shakespeare's plays fall

into two distinct groups: those written by Shakespeare and those acted by Beerbohm Tree."

Dorothea's job was to make a portrait of the star in the role of Cardinal Wolsey. She had never been backstage before, and this was the first time she was to photograph an actor. But sensing the young woman's uncertainty, he joked with her to put her at ease and made plain that she could have all the time she needed. He posed onstage seated in an elaborately carved armchair, wearing the cardinal's magnificent robes and holding an orange in his left hand. It made a good picture. Good enough for Mrs. Beatty to make Dorothea her regular operator.

By this time Dorothea's mother was resigned to her being a photographer. Besides, her wages lessened the financial pressure on the family. Joan was getting used to her daughter's independence. As Dorothea made more and more photographs, she became surer of herself, and that confidence reduced family nagging.

It was in these apprentice years that Dorothea met an itinerant old photographer—he is never named—who came to their door in Englewood with samples of his work under his arm. He was the first of several strays who influenced her, a procession of unofficial teachers she termed "lovable old hacks"—unimportant people in the public sense, but people who put themselves out for her and to whom she was deeply indebted. The man at the door in New Jersey displayed pictures that weren't much good, a whole range from the glossy deckle-edged postcard variety to the big portrait in horrid color. Learning that he had no darkroom, she said he could use the old chicken coop in back of the house. She worked with him to clean it out and rebuild it into a darkroom, learning how it was done and what equipment was needed. When he unpacked his stuff she discovered he had worked all over Europe and had a much richer experience than she had guessed. They became good friends. He helped her develop her negatives, showing her how to set up wet negatives on a drying rack, the folding type he had brought from Italy. He gave her one, which she kept using until glass plates went out. He taught her many things—old-fashioned techniques perhaps, but useful ones. And now she was very proud that she had her own "studio"—the converted chicken coop.

Charles H. Davis was another of her informal instructors, "a broken-down fellow" who used to photograph opera singers, actors, and society people. Long before, he had run a portrait studio at 246 Fifth Avenue, making so much money, he said, he could buy a big house on Seventy-eighth Street and keep all the lights burning. Dorothea met him after his success had fled, and became a pet of his. When he showed her his old portraits, she thought to herself, "Perfect, and completely empty." He

blamed his troubles on one of his many wives who sued him and took everything he had, including his studio. Now he was living downtown in a loft above a saloon, struggling to start over again. He had converted the barren space into a studio, with drapes and odd props salvaged from his grander days. But the smell of beer from below hung in the air. Once in a while he got a commission, usually from an old customer. Such a rare assignment meant a great deal, and he would pull himself together to carry it off. She remembered his toupee, his small, neat feet, and his double-breasted gray vest—a single touch of elegance to offset the dismal atmosphere of a saloon-studio. "It was heartbreaking to watch him there," she said. He was lonely and used to take Dorothea out for a meal at night, always to the same place, where he would order a fine dinner and pretend it was just like the old days when some of his theater or opera people came by their table.

Davis showed her how to "pose the model," something she had never seen done his way in the few places she had worked. He would place the sitter's head precisely as he wanted it, insist it be held, and then position each finger. The fingers are important, he told her, and so are the knees, which he called "the eyes of the body." When everything was fixed just so, and he had induced the right atmosphere (often with operatic recordings), he would take his photograph. She observed that his sitters thought they were getting a great deal for their money. He would spend two hours on a pose, working with every fold of the drapes, manipulating props, furniture, backgrounds. The results all looked alike to her—a hard-boiled commercial product—but he didn't think so. He loved what he did and the way he did it. He sensed that she didn't approve of his kind of photography. Although he liked her very much, she knew he had no faith in her as a photographer. He would tell her, "You don't *know* what it is to make a good negative!" But she knew she was learning, learning in reverse, learning what not to do.

She thought much of her apprenticeship was just such negative schooling. Back then, professional schools of photography were almost nonexistent. "I invented my own photographic schooling as I went along, stumbling into most of it," she said. But she did find her way into one professional course in photography, taught by Clarence H. White at Columbia University. It seems to have been chance again that led her to his class. She knew his name, of course. White, born in 1871, had begun photography and gained recognition for it while earning his living as head bookkeeper in a wholesale grocery firm in Newark, Ohio. For the past twenty years he had exhibited in almost every major photography show. With Edward Steichen, Gertrude Käsebier, Alvin Langdon Coburn, he was one of the American photographers at the turn of the century who formed the group their leader, Alfred Stieglitz, named the Photo-Secession. It meant secession from the accepted idea of what a

photograph was. They considered their work a challenge to the conservatives in photography, who were imprisoned by the belief that photography and painting could be the same. They abominated imitations of the painter's art or the copying of non-photographic methods. To strive for painterly effects in a photograph was to produce a bastard product, neither painting nor photography. They wanted to make the most out of their medium's true photographic qualities. What they opposed was called "pictorialism" or "art photography." What they supported they called "straight photography." It requires that the photographer "face the challenge of severe limitations: light acting in a flash on a chemistry of silver a micron or two deep. He does not have the painter's opportunity to consider, transpose, eliminate, augment. He must, in an instant, create enduring beauty out of transient actuality."

As with any new school of thought, the idea became dogma, but even in its earliest years, the Photo-Secession permitted exceptions. Stieglitz himself tolerated others like White, who sometimes manipulated their prints or who aimed for an impressionist softness. Some fifty years after Clarence White's death, his work was valued by John Szarkowski as the best done by the artist-photographers of 1900. "His range was narrow: He did not photograph the large outside world, or even real people; his work seems dedicated to the hope that an abstract, attenuated grace and elegance might continue to exist, in miniature, even in the modern industrial world, provided one did not focus too sharply. White's work redeemed his hope. He renewed the shopworn schema that he had inherited by virtue of his appreciation of the ornamental qualities of light, and especially by his sure and original graphic sense."

To Dorothea, White stood for a certain kind of photography no one else had produced. There was poetry and luminosity in his work and a fine sense of the human figure. If you could liken photographers to the qualities of musical instruments, she said, his counterpart was the flute. White had moved to New York in 1906, and the next year began a teaching career that lasted until his death in 1925. At Columbia he taught Art Photography I and II in the extension division. The first course included lectures and laboratory work. The aim was to show the application of art to photography and to provide instruction in the use of the camera in the field and in the studio. The students were taught developing, printing, and mounting. In the second course White promised to take up "the making of negatives, positives and enlarged negatives; the manipulation of negatives, printing papers, coating of papers; photography in landscape, architecture, illustration and portraiture; mounting, framing and lantern-slide making." Again practice in the use of cameras in field and in studio was provided.

Dorothea is not mentioned in Columbia's student directories for the school year listed later in her Guggenheim application as 1917–18, under

either Nutzhorn or Lange; probably because she enrolled as a non-matriculated student. White permitted that if the applicant's preparation was equal to that of the other students. Hers certainly must have been. She discusses her study under White in considerable detail. She began the course early in February 1917, in a dreary classroom she hated as she had all such places connected with formal education. There were about a dozen students, mostly middle-aged and earnest. In the winter light the class seemed isolated in space and time, it seemed to have no relationship to anything else. White looked like a "young-old man" (he was about forty-four then), with a special quality it took some time to define. She found him to be an extraordinary teacher, but why extraordinary, she said, "has puzzled me ever since because he didn't do anything. He was an inarticulate man, almost dumb, and he'd hesitate, he'd fumble. He was very gentle and had a sweet aura." All she could remember him saying was, "Well, you know . . . to be sure . . . to be sure . . . that's quite right . . . that's quite right." He told the students to go out and photograph something, and bring in a print. Sometimes he assigned them to a specific place, the Sather Gate at Columbia, for instance, which was undistinguished wrought iron, nothing you'd really notice, she thought. Dorothea went out and looked, and decided there was no use in her photographing it. The rest of the students did, but she didn't. (She says she never did her assignments, and he didn't seem to mind.) But she thought, coming from Clarence White, this was an odd assignment. *He* never would photograph that gate. Dimly, however, she began to realize there was some kind of underlying wisdom in a man who would choose this banal thing rather than a more romantic object. He made you see all there was in that gate. Whatever a student might bring back from such an assignment, he accepted it. "He always saw the print in relation to the person, and then he would start to stammer and writhe. He was most uncritical. But the point is he gave everyone a feeling of encouragement in some peculiar way, a nudge here, a nudge there. You walked into that room knowing that something was going to happen."

She couldn't recall his ever mentioning technique—how it's done, shortcuts to take, manipulations to try. She thought the camera was like a musical instrument he played naturally when it was in his hands. What Szarkowski has noted about White bears this out: "During his long fruitful career it seems that he made not one memorable statement concerning his sources, his intentions, or his methods."

Long after White died, Dorothea could still hear his voice, and wish that he were around so that she could show him something she had just photographed. Clarence White made her wonder, What makes a good teacher? Here was "this little, gentle, inarticulate man," yet a man with personal influence, whose work had endured a great many years. "He

was a man of very great tenderness and very little passion. There was a certain chastity about him, an extraordinary refinement that wasn't weakness. And he knew absolutely when something was beautiful." She thought often of his photograph of a woman, taken in the studio, the figure enveloped in a delicate, restrained light coming in from the window. The figure flowed, she said. She liked his portraits too, usually gentle faces, quietly done. He used uncorrected lenses by choice, obtaining a soft focus effect. But she didn't think he had made up his mind to work that way; he simply found himself doing it before he knew it. He was a professional, but nothing like the pragmatic commercial photographer who developed new techniques he could apply for profit.

Not that there were no commercial photographers of that decade whom she could appreciate. She spoke of Baron de Meyer, Paul Outerbridge, Karl Struss, and others who had links of some kind to Clarence White. Some of the best had been his students at Columbia or in his own school of photography. (They included women, like herself, who would achieve great distinction—Doris Ulmann, Laura Gilpin, and Margaret Bourke-White among them.) Yet their work did not look like his, which is a great recommendation for any teacher. The essence of it, she concluded, was that Clarence White had "an uncanny gift of touching people's lives, and they didn't forget it."

When her course with White ended she bought a big camera and two lenses, and worked day and night by herself. She used the converted chicken coop to learn darkroom techniques. She felt no passion to become an "artist." Rather, she was simply finding ways to learn what she thought was a very interesting job, a trade. "It was a good trade, I thought, one I could do. It was a choice. I picked it. But I never picked the role of artist. I have never had much faith in that category [this said in her sixties] nor the slightest interest in the argument, Is Photography an Art?" The people whose work she knew best and respected most—whether photographers or painters—she never heard call themselves artists. Stieglitz would not call his photographs "art" and he spoke of the painters in his circle—Marin, O'Keeffe, Hartley—not as artists but as "workers."

She, of course, wanted to be first-rate, and looked for ways to do her job well. Such people were the ones she admired. They usually had within them a peculiar quality, a "plus" that fascinated her. Where did it come from? Was that the source of art? Whatever it was, the most elevated language she would permit herself to use to describe it was "this plus thing."

In her last season in the East, the winter of 1917–18, when she attended White's classes, she took portraits, not on order, but completely on her own—and without a real studio to work in. She was eager to

make portraits of anyone. "They were very uneven," she recalled, but one that did stick in her mind was of a granduncle, probably one of her lithographer-uncles. She made pictures of her own family (this must have been when she photographed her mother), of friends, of near-strangers, and especially of children. "It was a restricted range of people," she said. "I was just trying it out and terrified to develop it. The fear of failure, those darkroom terrors—they still remain. It's a gambler's game, photography."

Few of those photographs have survived. When she left home she placed her negatives, carefully identified, in boxes, and stored them in a cupboard. Her family was now living in a house at 1143 Bloomfield, next door to the Hoboken house she had been born in. She never saw the photographs again. As her mother moved from place to place in the next several years, she carried the boxes with her. But they finally disappeared. "Destroyed," Dorothea said; "my mother threw them out. She didn't attach importance to them." She also threw out a lithographic stone Dorothea had treasured (symbol of the family's tradition of craftsmanship), and the oval walnut table Grandmother Sophie had made dresses on, cutting tiny designs into it as she moved her pattern wheel over the surface. Dorothea had loved that table. It was a place where good things had been made.

The men with whom Dorothea had relationships outside the family circle and her apprenticeship reveal something of the young woman's nature. Later she spoke of them as "people I left behind, on that side of the curtain of the past . . . half myth." One was a sculptor who fell in love with her when she was seventeen. He was many years older than she, and "slightly a madman," she said, never writing, suddenly appearing at her home without warning, at all hours, sometimes drunk when he came. But her mother was understanding, and would let him in and take care of him. This strange, unpredictable man impressed Dorothea—was he the first "real" artist she had known? "I knew something was expected of me but I didn't know what that was. I represented something; I didn't know what I was supposed to be, but I was it!"

And then there was John Landon, whom she met when she was twenty, while vacationing at a lake in upstate New York. He too was an older man, perhaps thirty-five, a printer who lived in Brooklyn and worked hard at his trade. He made her the center of his life for two years, sending letters sometimes three times a day, writing her poetry, taking her to a farewell dinner for Marlowe and Sothern where they read Shakespeare's sonnets. Yet, she said, he was "not a boy friend, and certainly not a lover of mine. There wasn't anything that he could give me that he didn't try to give me." He bought her records, and then a gramophone for Christmas, which her mother allowed her to accept, and

it was for a special date at his Pleiades Club that she got her first evening dress. The Pleiades members considered themselves "the best exponent of clean, right-minded Bohemianism in the city." She often went with him to the club's Sunday-night suppers at the Hotel Brevoort, then an Edith Whartonish hostelry, on Fifth Avenue down near Washington Square. The Pleiades had a boast: it "caters to bon vivant and ministers to the mind intellectual and artistic; it is a place where men and women mingle in social intercourse, where the difference between liberty and license is recognized—and sharply insisted upon; a place where poverty and riches, success and failure, rub shoulders without offense . . . It stands for an honest heart and a clean mind, and upholds Bohemianism in its broad, catholic sense." The Sunday suppers were fun to go to, for the room was full of writers, artists, actors, musicians, lawyers, judges, politicians, all of whom, presumably, could discriminate between liberty and license.

It was an exciting relationship, one-sided though it remained. He demanded nothing of her, "nothing," she said somewhat regretfully long after, "and that was a big mistake. He should have—or I was too young."

If there were not many men in young Dorothea's life, there were even fewer women. She mentions just two in her Berkeley interviews, giving only the nickname ("Fronsie") of Florence Ahlstrom and scarcely a line to the anonymous other—the unnamed friend she met in her apprentice years in New York, where they shared an apartment for a few months. Thinking back on her relationship to her closest friend, she felt Florence had subordinated her own inclinations to Dorothea's. She was quick to say she had not dominated Florence—"she was Swedish and you couldn't budge her"—but that Florence had shaped herself to Dorothea's interests out of love and understanding of the younger girl's necessities.

It was in the winter of 1917-18 that the two young women "just knew" they had to go away from home. "I wanted to go away as far as I could go," said Dorothea. "Not that I was bitterly unhappy at home, or doing what I was doing. But it was a matter of really testing yourself out. Could you or couldn't you?"

Their cash was little ($140), but their ambition was big—to go around the world. Dorothea's mother and Florence's parents angrily opposed what they thought was a crazy idea. But the two young women left their homes with suitcase in hand even as shouts of "You're not going!" followed them out the door. Florence was a Western Union clerk; her company promised they would see she was hired in their offices at any city she might stop in. Dorothea had nothing but a camera and the brash confidence that wherever she went she could earn a living at her trade. The first leg of the globetrotters' journey was by boat to New Orleans. Friends came to see them off in New York harbor, but the ship just lay

there for three days, perhaps ordered to stay in port because this was January 1918 and there were German submarine scares. From New Orleans they took a train west, stopping briefly to visit a soldier in camp near El Paso and to taste ranch life in New Mexico. After a few days in Los Angeles they went on to San Francisco—where "everything sharply changed."

Dorothea's birthplace (*on right*), 1041 Bloomfield Street, Hoboken, New Jersey
JANET FLETCHER

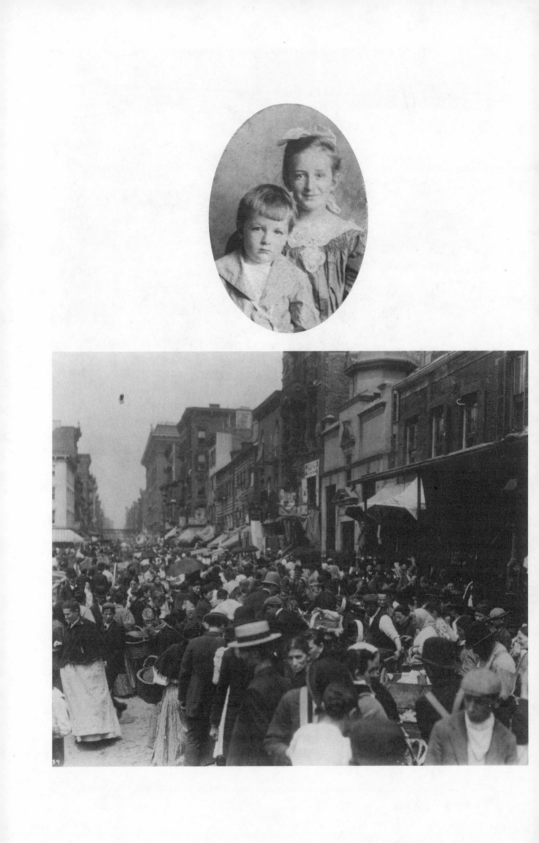

Dorothea's mother, Joan Lange Nutzhorn

Dorothea and her brother Martin (*opposite*)

Hester Street on the Lower East Side. In distance is P.S. 62, the school
Dorothea attended
PHOTOGRAPH BY BYRON

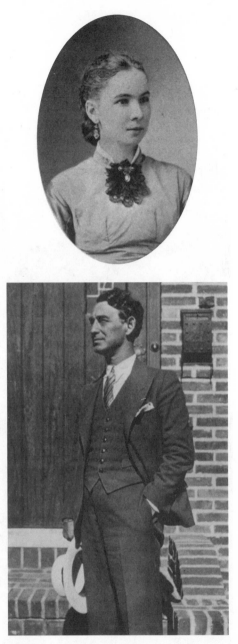

The young Dorothea (*opposite, and left above*)
Aunt Caroline
Uncle John Lange

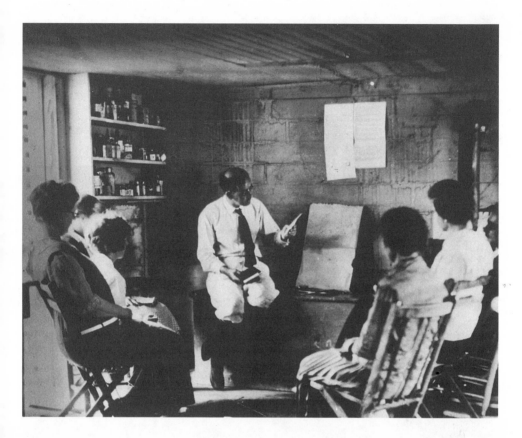

Clarence White with students

Cartoon of Arnold Genthe, made by his friend Maynard Dixon, when Genthe
was leaving San Francisco for New York, c. 1911 (*opposite*)

Ethel Benedict, 1916
DOROTHEA LANGE

PART TWO

1918-1935

3 ON THEIR FIRST DAY IN SAN FRANCISCO—MAY 18, 1918—they were robbed. Checking in at the YWCA, they had gone up to their room and counted their money. About a hundred dollars left. Putting most of the money into Florence's purse, they went out to eat at a cafeteria. When they went to pay the bill they found the purse open and the money gone. They had only four dollars and some change between them. A woman at the Y recommended they move immediately to the Mary Elizabeth Inn, an Episcopal hostelry for working girls who didn't earn much money. The deaconess at the inn welcomed them and installed them in tiny but clean and pleasant rooms. If the Mary Elizabeth demanded little in rent, it asked much in discipline. The newcomers found it hard to be in at ten every night, Dorothea couldn't stop smoking, and Florence carelessly burned out the electric iron in the laundry room. So they were asked to leave. It didn't matter by this time, for they had both found work the second day in town. Florence got a job at Western Union. Dorothea went to the yellow pages and looked up Photo-Finishing. She jotted down the address of Marsh & Company at 712 Market Street. Up front they sold all kinds of stuff, and in the back took orders for photo-finishing. Customers bringing in film had to risk the temptations of luggage and umbrellas in order to reach the rear counter. Dorothea was hired and put to work at once. It was a shlock shop: quick turnover, high counters so the customers couldn't steal things easily, and a boss who pushed the clerks to sell hard and fast. Dorothea's job was to take the orders for developing and printing, and to sell as many enlargements and as much framing as she could. When not too busy, she did the framing herself. The printing was farmed out to a lab.

Routine as the job at Marsh's was, it was at that counter she met many of the people whose lives would come closest to hers in the years ahead. It was a dividing line between past and future. Here in San Francisco she

felt her youth had suddenly receded into a dim, remote time. In the West she would be known to everyone as Dorothea Lange—Nutzhorn was a name she left behind her in the East. Her mother secured her final divorce decree in 1919, on the ground of desertion, and with it permission from the court to return to her maiden name, Joan Lange.

Marsh's counter, then, "was the beginning of my life here," Dorothea said. One of the first people she met was Roi Partridge. He was an etcher who had recently taken a job with Foster & Kleiser, an outdoor advertising agency. Partridge was married to Imogen Cunningham, who had begun to make photographs in 1901, at eighteen. She was perhaps the first woman photographer to do nude studies of the male, using her husband as model. His firm had asked Partridge to get his wife to take photographs of their billboards from time to time. Since they had no darkroom at home, he would bring the negatives to Marsh's. "Usually," he said, "the girl behind the counter would be one of those gum-chewers who'd write up the order and then you'd go. But one day I found a new girl there, one who showed an interest in what you were doing. When I came back for the prints she said they were good pictures." Imogen added that when Roi came home that evening he said to her, "There's a girl down at Marsh's who comes halfway across the counter!" She was just as sociable on the next visits, and soon she had new friends in Roi Partridge and Imogen Cunningham.

Dorothea began making photographs of the people she was meeting. To get the use of a darkroom, she joined the San Francisco Camera Club, where she made more friends—Lou Tyler, who later became her darkroom man; Percy Neymann; Consuela Kanaga, a photographer for the San Francisco *News*; and Sidney Franklin. Franklin, a prospering young man looking for investments, offered to set her up in business as a portrait photographer. She agreed, and in 1919 found a place she liked at 540 Sutter Street. It was a handsome little building. Up front was the Hill-Tollerton Print Room; passing it, you came into a courtyard, with a pool and a fountain on the east side, and on the south side a flight of stairs going up to the second story. There were French doors on the north side through which you entered Dorothea's studio, a large rectangular room with a fireplace on one wall. Dorothea had just leased half the space when two men intervened to change her arrangements. They were Joseph O'Connor, a young lawyer, and his wealthy friend, Jack Boumphrey. They had taken a strong liking to Dorothea and Florence, and wanted to see Dorothea start her studio free of an investor who would share the income from her work. Franklin generously released Dorothea from their agreement and Boumphrey handed her three thousand dollars to finance the opening of the studio.

She would work at 540 Sutter until 1925. "That place was my life," she said. In front of the fireplace she installed a long, luxurious sofa

upholstered in dark-brown velvet with down-filled velvet cushions—the "matrimonial bureau," it was soon called. Behind the sofa was a long table with a lamp on it and vases of flowers. On the east wall was another table with an old brass samovar, highly polished and kept steaming with coals from the fireplace. Dorothea lit the samovar in the late afternoon, and by five, friends started dropping in. In bobbed hair, sandals, and a Fortuny gown, Dorothea welcomed them. The beautiful young Chinese-American woman who worked for her as combination secretary, retoucher, errand runner, and maid served tea in tall glasses, together with delicious cookies and tea cakes bought from Eppler's, one of the town's finest old bakeries. On another table sat a portable phonograph and a big stack of records. The guests would turn back the carpet, put on the Mound City Blues Blowers, and two-step or fox-trot into the evening.

In the basement Dorothea built her darkroom, and a smaller room next to it where the retouching of portraits was done. She got her customers in the usual ways. Satisfied sitters told others, and people who came into Hill-Tollerton to buy prints and etchings saw her work on display and asked to have their own portraits made.

One such stranger was a wealthy woman who noticed Dorothea's portraits in a showcase as she walked up Sutter Street. She came in to arrange sittings for herself and her children. The family's pleasure in the results made Dorothea the photographer of choice for the circle of Jewish merchant princes the woman came from. Their forebears had reached California in the Gold Rush of '49 and had become leaders in San Francisco's civic and cultural life. Such families as Haas, Elkus, Lilienthal, Salz, Arnstein, and Zellerbach became Dorothea's first patrons and the cream of her trade. She believed they had much to do with creating the city's essential character, shaping the beauty it is treasured for. Unlike the rich of most communities, they did not hold themselves apart. They shared a warm interfamily life, but not at the cost of isolation from others. Their concern for children and education, for architecture and painting and music, and their intense response to philanthropic calls bound their personal life to their public life. "They were great helpers in building an interesting city," Dorothea said, "yet the ones who are talked about are the Comstock Lode people, the silver kings. The Jewish community hasn't had the recognition it merits, as far as I know." Reflecting in old age, she found it ironic that she who had felt so alone among the thousands of Jewish children at P.S. 62 had become a favorite of this Jewish community. She remained close to some of them for the rest of her life.

Her portrait photography was not always confined to the studio. Occasionally she went to people's homes in the Bay area, and even to such distant places as the state of Washington, where she once spent weeks

living with the Weyerhaeuser lumber family as she photographed them. There were families that had to have a Lange portrait to celebrate the birth of each child. The Closens were one of them. When Mr. Closen was discharged from the U.S. Army in 1919, he showed up in uniform on Sutter Street to become one of Dorothea's first sitters, "looking uncomfortable in his doughboy collar," his daughter Christina notes. As he and his wife raised their family on a dairy ranch in the north California coastal country, each of the children made the 600-mile round trip to the city to have a first-birthday portrait made. Looking back at those family prints nearly fifty years later, Christina had this to say:

They are a marvelous record of the development of an artist during what you might call her artistic adolescence. They show traces of habit which you would never see in any of Dorie's work after about the Thirties—slight evidences of retouching or soft focus camera work where it is almost impossible to make out the details of clothing or the exact texture of objects. At one sitting Dorie handed my mother a kimono to throw over her suit, probably to soften the "harsh" lines. At that time, Dorothea had not been graduated from the Clarence H. White school of photography for very long. In some of the prints my mother stands there dramatically looking away in order to show the line of the psyche knot at the back of her head, but the baby leaning against her is undeniably a real baby and the grip of the hand to keep the baby from slipping during the exposure is real enough in spite of Clarence H. White . . .

Her prints, in spite of their difference in technique from her later work, mostly came out with Dorie's own feeling. They had qualities of humanity that far exceeded the style of the day. The prints were generally mounted on hand-made Japanese paper, creamy and rich, with a bona-fide deckle edge The deckle edge is a sign of its time—Dorothea loved signs of the times: "Signs of the Times" was one of her favorite categories for thinking of photographs. In the San Francisco of that day, with the activity of the Grabhorn and Tomoyé and other presses, you might say this was a deckle edge era, much as the Mauve Decade signifies something else in literature.

Our sittings extended into the thirties. As Dorothea once told my mother, "Gertrude, you are my best customer. Every year you come back with a new baby." There were five of us, though not one a year, and by the time the last baby was old enough for its portrait, the world had changed considerably from its hopeful mood of 1919 . . .

Dorothea was soon busy enough to work day and night, Saturdays, Sundays, holidays, making portraits in the studio and doing the developing and printing in the basement darkroom. She said that she came to California with print sense. "I knew something about what a good resonant photographic print is. Print sense—some people never have it," she said. "It's almost something that can't be cultivated. If you have it, you've got something! You must start with a good negative, of course, but the print in its range, in its vibration, is impregnated with a life of its

own. You can compare it with a full fine chord of music in its richness and depth."

All her portrait work was done on commission; she did no personal photography for years. "It never occurred to me. People like Imogen Cunningham, whom I knew very well by that time, worked for name and prestige, and sent to exhibits. But I was a tradesman. At least I so regarded myself." True, said Elizabeth Elkus, one of her customers. "Dorothea had a very good business head. Just compare her with Imogen Cunningham. Imogen would always be angry about money. She would let herself swap one of her portraits for her sitter's belt, a thing she had no use for, and so she was always out of pocket, at least until the last few years when she put her work in an agent's hands. Dorothea, on the other hand, set her prices, told you in advance what they were, and collected payment systematically. She had a very keen sense of property." Her training in the commercial studios of Fifth Avenue told. She was expensive. Christina Gardner recalls that her mother had to scrimp for the fee the next baby's portrait would require.

Imogen Cunningham agreed. "Dorothea was exact about money matters. She could be generous, yet once when I needed it she offered me the use of her studio, then promptly gave me a bill for it."

Dorothea thought of herself in those years as "a professional photographer who had a product that was more honest, more truthful, and in some ways more charming. At any rate, there was no false front to it. I seriously tried, with every person I photographed, to reveal them as closely as I could." Sometimes it took several sittings before she felt she had succeeded. She did not drape her subjects. There was no posturing, no dramatics; these were intimate portraits that came out of getting to know the sitter. "I used to try to talk people into having their pictures taken in their old, simple clothes. I thought if they did, the images would be timeless and undated. Now, I feel I was mistaken, and think that to have any real significance, most photographs have got to be dated. Also I worked a lot closer to the subject than I do now." Only the head is in the frame in many of these early prints; there is no background, no sense of time or place.

Dorothea was working with a big camera then. When you used 8 × 10 plates, she said, every shot was carefully made. It was nothing like the 35mm camera, with which photographers began clicking pictures by the dozens, believing "there surely will be something coming out of all this." You stood in a different relationship with the big camera, making a time exposure. It called for a more deliberate response to the sitter. "No subject can hold for a long time anything that is false for them. It can't be done. You can try, but it's ghastly. You have to wait until certain decisions are made: first by the subject—what he's going to give to the camera, and then by the photographer—what he's going to choose to take. It

is a much longer inner process than putting the camera between you and the subject and reeling off shots in every imaginable aspect, all made between split sections of a second." She believed such nervous, electric work never quite arrives; it is only on the way. She did concede that many people handle the 35mm quite well, but usually because they had grown up with the camera and learned over the years how to use it. She would point to the photographs made by the early great ones, such as Hill and Adamson and Julia Margaret Cameron. These were examples of work done with the big camera which produced "recordings of human beings you can look at and into." By contrast, she said, the camera annuals of the mid-twentieth century were full of what she called "grab shots"—photographs that fall in between, work not quite arrived, not fully achieved. "Speed is not everything."

In the 1920's she was not trying to be a great photographer, she said. "I didn't do anything phenomenal. I wasn't trying to." She simply did all she could to make her own work as good as it could be. "Good meant to me being useful, filling a need, really pleasing the people for whom I was working . . . My personal interpretation was second to the need of the other fellow." This seeing of the other person's needs before her own was something she had always to contend with, she said, not intending to have this taken as self-praise but the reverse. Long after she quit commercial portraiture, this attitude remained. She did not make any portraits for their own sake. "It was a kind of diffidence that I couldn't make use of people for my own purpose, ever." She was never interested in photographing for publicity value the celebrities who came her way.

Beyond San Francisco, Dorothea's portrait work was unknown. In those earlier years she was not invited to show her work. Cunningham, who was twelve years older, had her first one-man show at the Brooklyn Institute of Arts and Sciences in 1912. She didn't see anything she considered good come out of Dorothea's studio. "Yes, she went to school with Clarence White, but what came of it? Her pictures were that softened portraiture. Beautiful. But not what the people were really like." Yet Cunningham herself, as Hilton Kramer has pointed out, "was at the start and for some years thereafter, very much the romantic, producing dreamy, soft-focus pictures in the Whistlerian mode." The early work of both women was influenced by the pictorialism of the pre-World War I period. And when the new Pictorial Photographic Society of San Francisco was formed in 1920, Dorothea was one of the founding members.

It was in her studio that Dorothea was introduced to Maynard Dixon by Roi Partridge. And some six months later, on March 21, 1920, they were married. She was almost twenty-five, he was forty-five. Dixon was a painter of the Western wilderness: its people, animals, and landscapes.

He was largely a self-taught artist, like his friend Charles Russell. His father, a Confederate veteran, had moved to the San Joaquin Valley in California a few years after the Civil War. Maynard Dixon was born in Fresno, a pioneer town, in 1875. He started to draw at seven, trying to realize on paper the ranch life around him. At ten he began making camping trips to the High Sierras and Yosemite, where he came to know the diminishing Indian tribes. At sixteen he quit school to study art on his own, taking as his models the engravings in the illustrated magazines of the time. There he first saw the work of Frederic Remington, one of the best-known and most authentic illustrators of the old West. When the young Dixon sent Remington two sketchbooks for criticism, the artist wrote back encouraging him to draw draw draw, only from nature, and to have confidence in his own judgment. In the next few years Dixon made sketching trips into the mountains and deserts, often visiting with the Indians and studying their camp life. In 1893 he moved to San Francisco to begin, at eighteen, a professional career as an illustrator. His work soon appeared regularly in the distinguished *Overland Monthly*. He was hired as staff artist by the San Francisco *Morning Call*, which had him painting Sunday-supplement covers on Western themes and illustrating the serialized novels of Jack London. Two years later he joined the staff of Hearst's San Francisco *Examiner*, for which Jack London, Frank Norris, Edwin Markham, and Ambrose Bierce wrote. Dixon illustrated their fiction and entered their circle of friends. But he found the pressure of deadlines and the loss of freedom in "that madhouse" hard to bear. He abhorred "wage slavery" and feared that the "Hearst poison" was beginning to work on him. Taking his savings, he made the first of many extended trips through the West, from New Mexico on up through Oregon, developing close friendships among the Hopi and the Navajos, and making drawings and paintings based upon his direct observation of cattlemen on the open range. His work appeared not only in the *Overland* but in *Harper's Weekly, McClure's, Scribner's,* and *Sunset.*

In San Francisco, which remained his base, he joined the Bohemian Club, dedicated to the "Burial of Care." Started in 1872, it was a convivial hangout for people in the arts, politics, and business. It required wit as well as celebrity to be an admired member. At midsummer weekend outings in its own redwood grove, original plays were produced by and for the members, with costumes sometimes designed by Dixon. He won his first recognition as a painter in a Bohemian exhibit. His cartoons and paintings still hang in the club. (One of his cartoons, made in 1911 as his friend Arnold Genthe was leaving for New York, pokes fun at the photographer's avid interest in women.)

In 1905 Dixon married Lillian Tobey, a graduate of the California School of Arts and Crafts. Losing many of their possessions in the 1906 earthquake, he and his wife left San Francisco for New York, where he

freelanced magazine and book illustrations while exhibiting his paintings in major galleries. Their only child, Constance, was born in the East in 1910. He grew dissatisfied with the distortion of Western life his editors demanded of his illustration and in 1912 decided to "go back home where I can do honest work." But even as he enjoyed a few years of professional success, he saw the most remote corners of the old West he loved disappear in a flood of Fords and gas pumps and hot-dog stands. His wife had developed the habit of drinking with San Francisco's old Bohemia crowd, and was unable to stop. The painful disorder of a collapsing marriage brought Dixon to a nervous breakdown. He left his wife. For a year he was unable to work. To meet his bills he took a job with Foster and Kleiser, doing billboard posters and advertising designs.

A year after his divorce, Dixon met Dorothea. He was a striking-looking man, "a San Francisco figure" who knew how to act up to his reputation. "You would know him for a Westerner anywhere," said a local columnist, anticipating the Gary Cooper type. "He is tall and lean from the trails. The desert sun has burned his face; his eyes are those of a man used to looking across wide spaces." He wore cowboy boots with a high arch that showed off his slim feet. The first few times he came to the print room on Sutter Street, Dorothea avoided meeting him. "I was a little afraid of him," she said. Dixon was respected for his work and popular because he suited people's idea of how an artist should look and act. Dorothea thought him intelligent, original, and witty. "He was the kind legends cluster about," she said, "without his making any particular effort to nourish them." They met at a time when the daily round of his commercial work had become nothing but drudgery. Her response to him gave him hope and encouraged him to a new direction in his painting, which one critic welcomed as a departure from illustration and for "its exceptional daring, freedom of conception, and originality." Dixon felt that because of Dorothea he could start life again at forty-five, anticipating a domestic peace he had long missed. She announced their engagement in January, at a tea in her studio, and apparently told a reporter she believed an artist should seek marital happiness with one of the same temperament and ideals. "My marriage with Mr. Dixon," she said, "will not interfere with my work, as I shall continue in my profession."

The marriage took place on a Sunday evening in her studio, with her old friend Florence Ahlstrom as her maid of honor and Roi Partridge as Dixon's best man. The Reverend Henry Frank of the People's Liberal Church performed the ceremony. The only decorations were soft candles and a few branches of flowering peach and hazel. The newspaper spoke of Dorothea as "a prominent member" of the city's art colony and "the best-known exponent of portrait photography on the coast," which may

have been stretching it, for the copy desk spelled her name wrong in both headline and story.

The Dixons took a four-day honeymoon and then moved into a small place at 1080 Broadway, on Russian Hill. It was within walking distance of Maynard's studio and easy cable-car distance of Dorothea's. They called it the "Little House," out of whimsy and sentiment. It was one of the many cottages slapped together as emergency housing after the earthquake and fire of 1906. Looking like oversize army tents made of wood, they were meant to be temporary, but some can still be found in the back yards of North Beach. To reach the Little House, they climbed a steep flight of stairs, emerging on a bricked walk which ran through a garden of marigolds, Shasta daisies, geraniums, nasturtiums, pinks, bachelor buttons, run riot in typical local style. The house was primitive—one room plus small bathroom and kitchen. They installed a brick fireplace at the north end of the room and cut a big window into the east wall to give themselves a view of the garden. They furnished it thriftily with a couch, bookcases, a chest of drawers, and a round drop-leaf table. Probably on Dorothea's initiative they painted the floor and the chest a deep indigo blue, the other furniture orange or yellow, and dyed the curtains yellow. It was a good way to fight off the city's dim gray fogs. Because the rent and furnishings were so cheap, they could better bear their financial burdens—she the debt incurred in launching her studio and he the obligation of alimony and hospital bills for his ex-wife, and child-support and boarding-school bills for his daughter, Constance.

The Dorothea Lange of that time is described by one friend as "a very attractive woman, not beautiful, and certainly you'd never call her pretty, but a face with much character. Once while waiting for her in her bedroom as she was dressing I was surprised to see how good a body she had, a beautiful one. Perhaps it was the awareness of her crippled leg that made the shapeliness of her body so unexpected. Her eyes were greenish blue, more green than blue. She dressed beautifully, if eccentrically for that period. She often wore jeans at work, and dress pants or long skirts otherwise, partly to minimize her limp, I'm sure. Her shoes were the comfortable kind; she was always strong for comfort. She wore heavy jewelry: a squash-blossom necklace and a Navajo ring and bracelet."

Imogen Cunningham remembered Dorothea's lameness as very apparent in those first California years. Once Dorothea said to Imogen, "I was in an elevator the other day and a girl came in with a limp that was much worse than mine. I decided then and there this would fall off me." She asked Imogen and Roi if they would join her in engaging a teacher for private lessons in ballroom dancing. "Roi knew how to dance but we went into it with her anyway, sharing the cost for the evenings we took

lessons. It was after one of these lessons that Dorothea said she was going to marry Maynard Dixon. I told her he was too old for her." Dorothea paid no attention to the advice of friends who were upset because she was twenty years younger than Dixon. "She was strong-willed," said Imogen, "always fixed in what she thought. Never hesitated about anything."

When Dixon married Dorothea, his daughter, Constance, was ten years old and often in his charge while her mother was undergoing a cure for alcoholism. The first time Constance saw her stepmother-to-be was when Dorothea took Maynard and his daughter with her for a weekend visit to the Mill Valley home of Mary Ann and Joseph Wilson. It was in 1919, not long after Dorothea had met the Wilsons when she had vacationed nearby. A close friendship with the Wilsons sprang up, which would last till Dorothea's death. When Constance, not quite ten, took in the Dutch bob, the disreputable pair of worn-out riding pants, and the sneakers, she thought her father had brought along another kid, maybe sixteen. She could not believe this was her father's date; she thought it a joke. Maynard had introduced her to so many charming women who were apparently eager to become the second Mrs. Dixon. Surely her father was too clever to get into another marriage, a relationship the child knew only as the extremely painful one she had been the victim of from infancy. Besides, she was so much in love with him herself. For years she had hoped to break free of her mother and move in with her father. But there wasn't room enough for them both in his studio, he would tell her, and he boarded her out again and again. When it became plain that Maynard and Dorothea were serious, the child could only detest the young interloper. There was small chance that she and this new wife would get along. And Dorothea herself was only in her mid-twenties, focused upon a professional career, married to a man almost twice her age who had failed his own child, and that child—mad at her, mad at the world—now her responsibility.

Ignoring what the child had been put through almost all her young life, Dorothea demanded too much of her. The ten-year-old child must be able to clean, sew, wash, iron, and cook. Unable to understand Constance's bitterness and anger, her deep-rooted frustration, her need for warmth and affection, Dorothea erupted in rages. And when she lost her temper, she hit out, just as Grossmutter had hit out. She would come home from her studio about five each day (Maynard would not show up until seven). If Constance hadn't scraped the carrots, just so, there was hell to pay. Dorothea had the notion that she could straighten out this wild child, tame her with tasks. It was not that she meant to make only a kitchen slavey out of her. No, she wanted to make her into some kind of artist as well. She dragged Constance around to museums, galleries, concert halls. Whether the child wanted it or not, she was to be pumped

full of culture. Signs of resistance were met with anger and, when Dorothea failed to have her way, sometimes with blows. As she moved into adolescence, Constance came to understand that Dorothea wished earnestly to do something for her but did not know how, and, unable to find a way, fought constantly with the child. After such scenes she would break down and weep, begging Constance not to tell her father. And the child never did, managing for long years to conceal the truth from him.

About a year after his marriage to Dorothea, Dixon began to taper off at Foster and Kleiser. He reduced his commercial work to one day a week and then quit altogether, determined to devote himself entirely to painting. She gave strong support to his decision. "I have never watched a person's life so closely, up to that time, as I watched his, what it held, how he lived it." She saw him as an artist "with a remarkable facility and an extraordinary visual memory, beyond anything I have ever encountered. That very narrow, flexible hand of his could put anything he wanted to on a piece of paper." The world she would know for the fifteen years of their marriage "was a world totally different from the world I had built for myself, up to that time." She feared total absorption in him and his work, and consciously "reserved a small portion of my life [her photography] out of some sense that I had to." But the larger part of her energy and her deepest allegiance, she said, went to his work and their children.

Looking back on their marriage, long after, she felt she had failed him. San Francisco had damaged him, she thought, enjoying the figure he cut, spoiling him, minimizing his real talent, making a myth out of him, never asking or expecting the most of him. "I participated in that, quietly I think. I always felt that as his wife—and I was devoted to him when I was his wife, and he to me—I failed him because I never pushed hard enough so he would work with his life's blood." He and his work gave many people a great deal of pleasure, "but he could have been a greater man. He had it in him. He never was bogus, far from it. But never quite what he could have been. If more people could have taken Maynard really seriously . . . I think now that I should have been a more critical and less agreeable wife. I should have held him harder to his own standards, rather than trying to keep life pleasant and satisfying to him." If that would have meant taking energy from her own work, it would not have been much more than she wasted anyhow, she said. "I had a family to hold together, and little boys to rear without disturbing him too much, though he was very good to us. But it was sort of myself and the little boys, and he. It wasn't so much he and I, and the little boys. I thought I was protecting him, helping him in his work. He was a very fine man, Maynard . . ."

Dixon and his young wife enjoyed an envied place in San Francisco's

bohemia. But while they were part of the crowd, they were still independent of it. The bohemians of that era were not like the beatniks or hippies of later generations. Dorothea remembered them simply as "free and easy. They were people who lived according to their own standards and did what they wanted to do in the way they wanted to do it." To be a bohemian was not necessarily to be an artist, but most people regarded artists as bohemians, mistakenly associating them with an amoral life.

In the twenties the Dixons were never poor. In the four years after he quit advertising, Maynard carried out four commissions for murals and painted over 140 canvases, selling more than half of them. Their income was uncertain, Dorothea said, and though Maynard thought it was hard going, they never went hungry. Maynard had a studio in the "Monkey Block," on Montgomery between Clay and Washington Streets, in a historic four-story structure of 1853 which was once the biggest building and "the best address in the West." Distinguished lawyers, judges, financiers, actors, writers, and artists occupied its suites, but in the first half century after the earthquake its rents declined steeply and its 125 small rooms became principally studios for artists and writers—a little bohemia like the Greenwich Village of the same era in New York. The Dixon circle included—besides Imogen Cunningham and Roi Partridge—Ed Borein, Ralph Stackpole, Gottardo Piazzoni, Gertrude Albright, George Sterling, Sidney and Emily Joseph, Charles Duncan, Fremont Older, Charles Erskine Scott Wood, Sara Bard Field, Lucien Labaudt, Timothy Pflueger, Albert Bender. They were never an organized group, nor were they all close friends, but, living in the same world, they saw one another often.

Albert Maurice Bender was the first to view Dorothea's photographs as art and to collect them. In his early fifties when Dorothea met him, he was the son of a Dublin rabbi who had emigrated from Ireland as a youngster and had worked himself up from errand boy to one of the leading insurance brokers in California. "Mickey" Bender was the patron saint of the city's artists, encouraging beginners, financing them by buying their works, helping them win recognition by donating his purchases to museums. Long before he died he distributed valuable collections of books, prints, and paintings to institutions in the Bay Region and throughout the world. In his time he was undoubtedly the greatest single influence on the city's cultural life. Annually on St. Patrick's Day his bachelor studio home at 1369 Sutter Street was the scene of a colossal party to celebrate his own birthday (though it wasn't) and the guests floated home on streams of Irish whiskey. Dorothea described him as a plain little man, a professional Irishman who walked about town with presents in his pockets. Anywhere you met him he would fish into his pockets as though he'd been looking for you all day and he'd give you

some quite beautiful thing. Once, when she passed him on the sidewalk as he was talking to someone else, he put out his hand to stop her for a moment and said, "Dorothea, you grow in importance." He constantly prodded the rich to buy the work of his artist friends. And when he would ask the artists to give him something for himself, at little cost, they couldn't refuse him. "He got away with murder," she said, but because of his fine taste and his congeniality it was not resented. He was not a man to play it safe, confining himself only to certified art. At a time when almost no one was thinking of collecting photographs, he bought some of Dorothea's—"the first group I ever sold to anyone"—and gave them to the Museum of Modern Art. The photographer John Collier, Jr., remembers Bender as "a prince of the city's intellectual society, a beautiful man, in league with Dorothea," as he put it. Ansel Adams thought him "an extraordinary person, a true philanthropist who did an enormous amount of good in many fields of art." It was Bender who, meeting Ansel Adams, then a young professional pianist, had encouraged him in photography, helped him publish his first portfolio, introduced him in New Mexico to Paul Strand, and finally persuaded him to give up music for a career in photography.

Attractive as life in San Francisco was, Dixon could never stay there long. He made many painting expeditions into the Southwest, sometimes with Dorothea, more often without. The first trip he took with Dorothea in the summer of 1921 was unique. He piloted his daughter Constance, Dorothea, her mother Joan, and Joan's new husband George Hollins Bowly over the High Sierras and the glacial meadows by pack train. (Bowly, too, worked in the Hudson County courts, and he had married Joan after her divorce from Nutzhorn.) More typical were what Dixon called his "sketching trips." He would announce he would be gone for a month or six weeks, and then disappear for four months. Dorothea joined him on only a few of those expeditions. Even when she had no children, there were other commitments she felt bound to fulfill, and after the children came it wasn't easy for them all to go. Besides, she was never quite sure what their income would be. She wanted to help him by protecting him from economic difficulties. "My thought was that if there wasn't any money my work would keep us afloat." Later, consenting to such separations seemed to have been the wrong thing to do. "I should have helped him in other ways. The things you do when you want to do what's right, so often are so wrong." She came to see their frequent separations as the mark of a failing in their relationship. She knew that while Maynard loved her and was very good to her, he didn't "share the depths of his life with me. When he went away, he didn't need me. At that time I didn't know what it was to live with a person who shares his life with you." She missed him when he was gone and

life was more exciting when he returned. "But I wasn't really involved in the vitals of the man, not in the vitals," as she would be, she said, in her second marriage. "Perhaps the reason I was never able to give Maynard an uncomfortable time, which he should have had at some juncture, was that I never felt courageous enough . . ." If you had that courage to probe, she said, "you might encounter some part of the other person which would disturb your balance." And so she was afraid to attempt it.

In the summer of 1922 Maynard took Dorothea with him to the Navajo reservation in Arizona. They lived at a trading post called Kayenta. It was eighty miles from the nearest postal station. Toward the end of their four-month stay they moved to Redlake, another trading post on the reservation. On one trip into Tuba City they visited an Indian school. It was Dorothea's first insight into the shocking mistreatment of Indian children by the government. While Maynard sketched, she made photographs. They rode into Monument Valley and studied the Mesa Verde cliff dwellings under the guidance of Jack and Ned Wetherell, who had rediscovered them. In his notes Dixon recorded his wife's delight and her exaltation in the color and space of this West she had not seen before.

Seeking wider recognition of his painting, Dixon tried to arrange exhibits of his work in the Midwest and the East. With Dorothea he traveled to Chicago early in 1923, but failed to get a show. They moved on to New York, where his paintings were shown at the Macbeth Galleries in February. The notices were favorable, but there were no immediate sales. Still, Robert Macbeth was enthusiastic and succeeded in promoting other shows for him in Philadelphia, Pittsburgh, Cleveland, Cincinnati, and at the Corcoran in Washington. Dixon was not happy back in the New York he had last seen ten years earlier. Going to a Georgia O'Keeffe show, he encountered Alfred Stieglitz, and in his notes jotted down: "Listening to Stieglitz expatiate. Impression of cleverness and futility; hot-house atmosphere . . . Stale-air existence. Glad to get away." One wonders whether Dorothea saw any of Stieglitz's photographs and what she thought of them. Only two years before, his one-man retrospective, showing 145 of his prints, had caused a sensation. The critic Jack Tennant had written of it: "A revelation of the ultimate achievement of photography, controlled by the eye and the hand of genius and utterly devoid of trick, device, or subterfuge!"

That summer of 1923 brought an invitation from the California millionaire Anita Baldwin McClaughry to join her on an extended trip into the Navajo and Hopi country. The daughter of E. J. "Lucky" Baldwin, a flamboyant mining tycoon, she had had a mild flirtation with Maynard long before he had met Dorothea. A silent recluse, with strange ways, she bought Dixon's work for high prices, and was kind to his new wife.

Dorothea found her "a beautiful and wonderful creature—if you came up on one side of her." It was a happy surprise when they were asked to go with her—all expenses paid—to camp at the base of the Walpi mesa. She wanted to study Indian music and hoped to compose an opera about their life. Dorothea and Maynard went down to the Baldwin home in Los Angeles and stayed overnight. The next morning they started for Arizona in a private railway car with two chefs, two stewards, and Anita's bodyguard (she also carried a pearl-handled revolver in her handbag). The windows were kept shut and the blinds drawn because they were traveling incognito. They were never allowed to get off the car. (The rich, the very rich, Dorothea thought, are so afraid; how can they enjoy anything?) They reached Flagstaff at two in the morning. Waiting for them was a mountain of packing boxes with AB stamped on them and two trucks to move them to the campsite. It rained furiously all through the night; the rivers rose and washed out the wilderness road. The trucks couldn't go on and the boxes—and Anita herself—had to be packed across high water on the backs of the two drivers. The boxes were full of elaborate equipment never used in the wilderness and the food was mostly tinned delicacies, including caviar. There were tents, shaped like Chinese pagodas.

Since the stewards and chefs were left behind at the railway siding, Dorothea became the cook. She made photographs while Dixon painted. Almost every night the Indians who lived at the top of the mesa would begin beating their drums and come down the path en masse to sing for them. They were paid by Anita Baldwin, whose weakness was to overdo everything; she also imported a huge amount of the white sand and the peacock feathers which were woven into their myths and rituals. The annual snake dance came during their stay but Dorothea found that the tourist-photographers were more intent on focusing on the Baldwin party than on the Indians. After a month, Maynard staying behind to continue painting, Dorothea and the others left for Gallup to meet the railway car; they found the stewards drunk, the chefs AWOL, and the car filthy. Pulled together again, the party detoured to the Grand Canyon, where a fine collection of Indian art was on exhibit at the Harvey House. When Anita Baldwin appeared, the young Navajo in charge spotted her for a wealthy woman and proceeded to entertain her with a hilarious story of some foolish whites who had pitched an incredible camp up in the Hopi country. They stood there listening silently to it all, including his description of a woman who appeared at the snake dance wearing pear-shaped jodphurs, an Egyptian helmet, and a long chiffon veil—Anita herself, of course. She listened politely, said yes when he finished, and then bought $8,000 worth of Indian art in about ten minutes, never telling the Navajo what he had done. Dixon stayed among his

Indian friends for four months, returning home with many drawings and over thirty canvases.

What photographs Dorothea made on that trip we know little about. She did not discuss them and few have been exhibited or reproduced. But this must have been the beginning of her documentary photography.

On May 15, 1925, Dorothea's first child was born. He was named Daniel Rhodes Dixon. In his father's autobiographical notes there is an entry about Dorothea's "fear of handling him" and then Maynard's advice to her: "Treat him just the same as a puppy." A second son, John Eaglefeather Dixon, was born on June 12, 1928. Dorothea has made only brief references to her experience in early motherhood. She was interviewed by a woman reporter for a series of articles on the "silent partners" of outstanding San Franciscans. Identifying Dorothea as "one of the best photographers in town," the reporter said, "When one artist marries another it is generally regarded as a temperamental version of 'when Greek meets Greek.' In local bohemian circles the marriage of Dorothea Lange and Maynard Dixon, noted painter, stands as a shining exception to the proverbial tug of war." Asked how she did it, Dorothea replied, "Simple. Simple, that is, when an artist's wife accepts the fact that she has to contend with many things other wives do not. She must first realize that her husband does not work solely to provide for his family. He works for the sake of his work—because of an inner necessity. To do both of these things successfully, he needs a certain amount of freedom—freedom from the petty, personal things of life. An artist's work is great only as it approaches the impersonal. As Maynard's wife, it is my chief job to see that his life does not become too involved—that he has a clear field."

The interviewer said Dorothea and Maynard maintained separate existences and studios on Montgomery Street for their work. But home they considered a sanctuary "which they share and on equal terms." Dorothea told her she usually got household chores done before leaving for her studio in the morning—planning the day's schedule for their children, deciding on the meals and ordering the food. When she returned from the studio "she would shut the door on her work, get dinner and devote the evening" to her two boys and Constance Dixon. Maynard, she said, divided his evening between the children and more work.

But there are other views of those early years of marriage and motherhood. John Collier, Jr., who later became a photographer, was apprenticed to Maynard Dixon to learn painting when he was about twelve and Maynard and Dorothea had been married only four or five years. The boy's family and Dixon were bound by a common interest, for Maynard was a strong supporter of John Collier, Sr.'s, efforts to help the Indians protect their land rights. About the time young Collier began to work with Maynard, his father commissioned Dorothea to do a portfolio of family photographs. Young Collier got to know her and was drawn by

her warmth, although his brothers were put off by what they thought was an aggressive manner. He was often in the Dixon home, enjoying the spaghetti, wine, and fresh bread of their table. He admired the way Dorothea dressed, her embroidered berets, her vivid green clothes. He thought she was not unhappy to be in her husband's shadow. She did not show any particular ambition then, except to be a good wife to Maynard.

But it did not go on that way. A continuing trouble was Dorothea's failure with Maynard's now-adolescent daughter, Constance, who was still living with them, at least when she was not being stowed at the Wilsons or somewhere else so that Maynard and Dorothea could go off on their own. When her own children came Dorothea tried to make a good home for them, but there were forces working against it. Maynard, in his fifties when his sons were little, must have found it hard to cope with the demands of a young family, and then he was often gone for long periods on his painting expeditions. And Dorothea, as Collier saw it, was so concerned with her own work that she could not or would not give the children what they needed. During those years it was an article of faith that a woman belonged in the home looking after her husband and children. Few women could free themselves of that social conviction. Even when they tried, by choice or necessity, they still carried the double burden of working women in whatever field of activity—the need to be deeply involved with their careers and at the same time to maintain a home and fulfill the demands of close family ties. Tensions were almost inevitable in the family of such a woman, and quarrels between Maynard and Dorothea broke out again and again. Among their friends it was soon common knowledge that both were having affairs. Both were strong-willed. When Maynard held an opinion it was almost impossible to override him. Yet Dorothea tried to, and sometimes succeeded. She had a great desire for security and stability, perhaps a need growing out of the twin disasters of her childhood: the abandonment of his family by her father and the permanent injury polio had left her with. That desire sometimes took the form of "making everything nice," staging a gracious social life with herself in the center. It was, however, a quality that rubbed Maynard the wrong way. There are numerous stories of his outrageous reactions to her social arrangements. One family friend recalls that he would get very tense every time Dorothea had a number of people to dinner. He would always spice her gracious meals with painful sarcasm. And he did not limit it to his own table. In other people's houses, too, he could be rude and nasty—not because he was ill at ease, but because he had contempt for what he considered "the fancy life." He would even have a go at close friends if they were of the upper class.

On one occasion, when Dorothea invited a wealthy couple (patrons of Maynard) to dinner, Maynard helped prepare the roast leg of lamb, and

then carved it beautifully, serving out helpings to all but taking none for himself. Dorothea looked at him suspiciously, but he only shrugged and raised an eyebrow. Then he began to belch very noisily, got up and left the table, heading for the kitchen. From his angle at the table a guest could see what was going on in the kitchen. Maynard filled a big basin with water and put about a dozen potatoes in it. Then he began making vomiting noises and spilled water and potatoes on the floor so that it made an awful sound, as of someone spilling his guts. There was horror in the dining room, Dorothea ready to die, the guests trying to freeze their faces. It was Maynard's way of putting down Dorothea for what he thought of as cultivating the rich. Such "practical jokes" were not uncommon. Once when Rondal Partridge was four and staying with the Dixons, people came to visit. Maynard took the child aside, taught him a short obscene verse, and then sent him out before the company to recite it. Dorothea was furious, but Maynard couldn't resist embarrassing her both publicly and privately.

Continuing to make trips alone, Maynard traveled to Arizona in 1926 in an unsuccessful attempt to promote the building of a pueblo-like tourist hotel of his design on the old Apache trail. That year the family left the Little House on Russian Hill and moved to 1607 Taylor Street. Late in 1927 Maynard was gone again, this time for four months, making landscape studies in the volcanic country of Nevada. He left Dorothea with the baby, Dan, and Constance, now seventeen. Dan was being fed on a special formula by the housekeeper, and the bottle had to be scrupulously washed before and after each feeding. It was Constance's job to wash the 4 p.m. bottle when she got home from school each day. This time she was held up by some school activity and had not done the chore when Dorothea arrived from her studio. Seeing the dirty bottle in the sink, Dorothea started a terrible row, which led to an exchange of blows and left them both with minor injuries.

That night Dorothea left with Daniel to join Maynard for a while in Nevada. Alone at home, and frightened by the violence of her latest fight with her stepmother, Constance telephoned an older friend whose job it was to help girls in trouble find work. The friend placed Constance as a mother's helper, with time off to continue her schooling. Maynard and Dorothea agreed that she should move out and begin to earn her own way. It was the end of Constance's life at home.

In the summer of 1928 Maynard worked in Sacramento, painting a mural in the main reading room of the State Library. These were flush times. The radio crackled with reports of the national political conventions, which nominated Herbert Hoover and Alfred E. Smith, and Maynard had fun making impromptu speeches from the scaffold before his huge 69 × 14-foot mural. Thrown together with other workmen in the building, he began to feel "almost a union man—a healthy experience."

But he sensed "something wrong with the nation." With Dorothea he made a quick trip to Phoenix, where he had been asked to present designs for four murals in the Arizona Biltmore Hotel. Given free rein by the architect, he felt his "Legend of Earth and Sun," completed in 1929, was his best work to date. (The onset of the Depression would cancel plans for the other three murals.) Late that summer of 1929 the whole family packed up for a vacation in the back country of California. With her studio a success, Dorothea thought she could afford to close it for a month or two to travel with her family. They went up to Lone Pine, into Inyo and San Bernadino Counties, to see the old mining camps. But radios blared everywhere and tourists' cars overran the countryside. Maynard felt caught in a trap, with no escape from what he called "tin front" progress, not even in the wilds of Inyo. Still, he could take joy in watching Dorothea with their sons. She had already begun to use her camera beyond her studio walls. Almost unconsciously, she was heading in a new direction. Looking back on those last years of the twenties she said, "Much more than my earlier work, I think this work had a documentary feeling. You were able to sense, if not see, a good deal more about the subject than just faces. They were *larger* photographs." But her camera work of the landscape on this trip was "terrible," she later told her son Daniel, and she was beginning to feel depressed by the disappointments, until one day "I was given a big boost by a turbulence of nature. That afternoon I had gone to be by myself for a while, when I saw a thunderstorm piling up. When it broke, there I was, sitting on a big rock—and right in the middle of it, with the thunder bursting and the wind whistling, it came to me that what I had to do was to take pictures and concentrate upon people, only people, all kinds of people, people who paid me and people who didn't." This, she told her son, was one of the great spiritual experiences of her life.

The family was back in San Francisco early that fall of 1929. Then, on October 24, the stock market crashed.

4 IN THE WEEKS THAT FOLLOWED THE MARKET'S crash the economic news became worse and worse. But so attuned were most Americans to the theme of permanent prosperity sounded in the twenties they could not realize what an overwhelming disaster the Wall Street collapse signaled. Washington experts talked of it as only a "temporary readjustment" in the economy and President Hoover denied any deep crisis was possible. Production slowed down in the winter of 1929–30 and unemployment rose to several million. Still, a business revival, said even the liberal weeklies, was "sure to come" by summer. It didn't. Construction ground to a halt. Banks tightened up on credit, business and industry ran dry of funds, pink slips appeared in pay envelopes, the jobless shuffled onto bread lines. An army of young transients who could not find work near home took to the road, sleeping in hobo jungles.

Dorothea Lange and Maynard Dixon, self-employed professionals, were hit like the rest. When the stocks owned by patrons of the arts shot down in value, the rich stopped ordering photographs and buying art. Commissions for murals were canceled, plans for exhibits were dropped, painters could not collect for work sold earlier. Maynard felt no personal failure in the face of the common disaster. But there was a sense of "something ominous and unavoidable impending," he wrote, "of being caught in the slowly closing jaws of a vise, of complete helplessness in the face of fate." This feeling became an obsession, and in the need to free himself of it he tried to externalize it on canvas. When he showed his "Shapes of Fear" at the Art Association Annual, its grim foreboding touched a common chord.

Again in 1930 he left his family, this time to paint in the Tehachapi Mountains, on the edge of the Mojave Desert. He returned to the city in the hope of winning a commission to paint a mural for the San Francisco Stock Exchange Club, but was not even asked to submit designs. He learned that Diego Rivera, the revolutionary Mexican artist, had been

brought north by Albert Bender and others to do the Exchange Club mural as well as a fresco for the Art School. Meeting Rivera, Dixon responded warmly to his personality but scorned the celebrity seekers who toadied to him. When Rivera said that California painters should create an authentic American art by painting their own time and country and in their own way, Dixon was in hearty agreement. "A few of us," he observed, "had been saying the same thing for twenty-five years. And how did our young painters respond to this? By imitating Rivera!" That style of fresco painting quickly became orthodoxy in the art world. To Dixon mental independence was "of first importance to an artist. To be real he must be honest and keep his own integrity. He should beware of schools, cults, dogmas, isms; learning from all, but giving obedience to none. All we mean by American art is that our work bear some evident relation to the world we know, and contain a common denominator of human understanding."

As he would not countenance slavish imitation, so he would not tolerate censorship. This same year he broke his quarter-century connection with the Bohemian Club because its officials barred the work of radical artists from an exhibition. The club's action, he said, "is unjust and dictatorial. It does not make for furthering the aims for which its organizers founded it—which included encouragement of artistic progress. Freedom of speech, it seems to me, ought to imply also freedom of artistic expression. And freedom of the mind is essential to the arts."

In the first four years of the Depression Dixon would paint over a hundred easel pictures and make about as many oil sketches and drawings. He sold only two dozen of them. Time and again he would present preliminary drawings for murals, only to be told the sponsor no longer could afford them.

It was Dorothea now who insisted that the whole family needed a change of scene. The boys, then six and three, were not living at home but with a family in Watsonville. The farming-out policy which Constance had suffered from was being continued. Constance, now twenty-one, who had been working as a reporter for the San Francisco *Examiner*, had been laid off with many others in a Depression cutback and had been forced to move in with Maynard and Dorothea. Asked by the family friend John Collier, Jr., to accompany him on a trip to Taos, she went along and got odd jobs, typing the manuscript of Mabel Dodge Luhan's autobiography and waiting on table. She was hungry much of the time, but putting the best face on it, she wrote such glowing letters home about the wonders of Taos that Maynard and Dorothea decided it was the place to go.

They bought a secondhand Model T Ford, their first car, and learned to drive it just before starting out. In the Santa Cruz mountains, on their way to pick up the boys, the flivver went into a skid and flipped over. Maynard, the only one hurt, was taken to a hospital with a broken jaw and a

twisted arm. His injuries still not healed, they gathered up Daniel and John and drove on to Taos. On the edge of a pueblo they found an old Mexican adobe house of two rooms, without water, plumbing, or telephone, but with a well in the yard. It wasn't the Depression which made them go, Dorothea said later. "There was money enough to see us through. But Maynard wanted to paint . . . and the outside world was full of uncertainty and unrest and trouble so we got in that car and we went."

Maynard needed two months to recuperate from his injuries and they saw little of the Taos art colony at first. Later he met many of his old artist friends and sometimes went off painting with them. They bought a pony and the children learned to ride. John Dixon, a little child then, remembers Taos only for a winter's day when he sledded down a hill and fell off, cutting his face. He got chicken pox there, too. Maynard renewed his old acquaintance with Mabel Dodge Luhan, "the queen of the Southwest at that time," as Dorothea put it. Mrs. Luhan owned many buildings that she let people use, and Maynard borrowed a big studio. He went there every day to paint, while Dorothea took care of the family. They lived the life of most visiting artists in what was then the hamlet of old Taos. It had not yet become a tourist mecca.

The stay in Taos—they were there about seven months—"was a very good time for me," Dorothea recalled. "I learned many enriching things. I photographed once in a while, when I could—buildings, architecture—but people have done that much better before and after me." A San Francisco newspaper reported in October that "Mrs. Maynard Dixon will bring back some unusual Camera Notes from New Mexico. It is said that they have a quality of originality about them, for besides Ansel Adams, there have been few real photographers in Taos." But there was at least one other. While they were in Taos Dorothea used to see a man in a Ford pass by almost every morning, looking very sober, driving with serious purpose down the road. She wondered who he was. "I thought he was an artist, but he went by always at the same time and at the same time at night he would come back." She asked his name. It was Paul Strand. "It was the first time I had observed a person in my own trade who took his work that way. He had private purposes that he was pursuing, and he was so methodical and so intent on it that he looked neither to the right nor the left. He went down that road and he came back at night. I've seen many of the photographs that he produced then and that was one of his good periods. I always feel that I know something about them . . . I didn't until then really know about photographers who went off for themselves . . . Later on when I met Paul Strand in New York he told me he knew I was there. But he never spoke to me." If Lange and Strand had become friends in Taos she might have been influenced by him earlier, as in 1930 Ansel Adams had been. Meeting Strand in New Mexico, he found his prints

such a revelation he began to photograph the Sierra Nevadas in a straight, unromantic style.

Dorothea did not yet think of her work as important enough to require the concentration a Strand gave to his photography. Her first obligation was still to Maynard, and she helped him, she said, "mostly by keeping everything smooth and being happy and making it an enjoyable time and taking care of the three children. I cooked and kept busy. The gloves, the galoshes, the wet clothes, you put them on and you take them off. And I used to drive him to where he was working, and drive him back. In the summertime we had guests . . . I couldn't work then, really. When I say I couldn't work . . . of course, if I had stated my terms with life I could have, and to this day [thirty-five years later] I would say the same. Maybe I kept myself too busy. But what Paul Strand was able to do, I wasn't. Women rarely can, unless they're not living a woman's life. I don't know whether I was temperamentally insufficiently mature at that time to have done it."

As the winter of 1931–32 arrived, Taos and the other towns were cut off by snow. The people around them who had no money lived from day to day, bartering for what they needed. On Saturday afternoons the Indians, the Mexicans, and the poor whites would come to the square in Taos on their horse-drawn wagons, bringing their produce—beans, nuts, dried corn, flour, eggs, lamb, hides, weaving—and make their exchanges. It became hard for Maynard to go on working in the big freezing studio. He had to wear three layers of clothes and two pairs of gloves. So on a beautiful January day the inexperienced drivers shared the wheel of the Ford for the 75-mile distance from the high plateau of Taos down through the deep and glittering snow to Santa Fe. They were the first to risk breaking the trail that winter. If they had gone off the road, it would have meant tumbling into the Rio Grande way below.

Driving home the southern route, they crossed the Huachuca Mountains, passing Apache villages, reaching the desert and warm country again, and finally into California and across to San Diego. All along the way they saw the unemployed and homeless on the roads. There had been signs of the deepening Depression in Taos too, but the village somehow seemed remote from the outside world spinning into chaos. Now they were going back into it again, not knowing what was going to happen.

What were they returning with? Years later Dorothea couldn't remember clearly the work Maynard had done there, or what it meant to him. (He had produced about forty paintings.) But she knew he liked it there. She had felt somewhat closer to him in Taos, where the pressures of city life were absent. And it seemed to have been good for the boys, too. As for herself, there had been the chance to observe a new environment, to taste a different way of life. Of the photographs she made, few as they may have been, no prints survive. Before leaving for New Mexico she had

written to Eastman Kodak to inquire about handling film under the extreme conditions of heat she anticipated. The company assured her their film would stand up to it. But the heat, it turned out, dissolved the film. On her return home she wrote Eastman, threatening to sue them. She was always a superb letter writer who could get results. Eastman's reply was the gift of a dry mounting press (and perhaps a tripod, too), calculated to quiet her down. Unfortunately, there was still nothing to show for the many months in Taos.

In an interview Dorothea gave the San Francisco *News* that February, she is described as wearing blue working jeans and a beret, and looking "lithe, firm, tanned as a gypsy." She told the reporter they were "reorganizing life a little," giving up their Taylor Street home. Much later, she remembered that, coming back home, "we were confronted with the terrors of the Depression. Not that we didn't have enough to eat, but everyone was so shocked and panicky. No one knew what was ahead." She and Maynard decided to put their sons in a boys' day school at nearby San Anselmo, which had special provisions for boarding some pupils. "John was only four and Dan was only seven and this was very, very hard for me to do. Even now when I speak of it I feel the pain. I carry these things inside and it hurts me in the same spot that it did then." She and Maynard drove down nearly every weekend to be with the boys. For one or two hours before their mother and father were expected, Daniel and John would stand by the road and watch for the old black Ford, as though waiting would make it come faster. There was a terrible, empty feeling at the end of the short visit when the car would go off without them. Before they were two they had been sent to a nursery school on Pacific Avenue which had been started in the early twenties. It took children from the age of twenty-one months and kept them a full day. Later they were sometimes placed with the Wilsons, as Constance had been, or with a woman in Carmel, or people in El Cerrito, or with Dorothea's brother Martin and his wife, who came to live in San Jose. If there had been grandparents to take them, or a loving aunt—the same person each time—it might have been much less painful and disruptive for the children.

There is a classic photograph of Lange's which says much about her relationship to her children. Called simply "John, San Francisco, 1931," it centers on a small gathering of daisies held outstretched in the hand of a small boy. Only the arm, hand, and flowers are in the frame. It is a sweet offering, yet when her three-year-old son made the gesture, she obviously reached for a camera and photographed it. It reminds one of Edward Weston's photograph of his eleven-year-old son, Neil, taken when the child, suffering from an attack of migraine, had run into his father's studio and thrown himself face down on the couch. That parent, too, had run for his camera to give us a great photograph. The artist was at work in both cases; one wonders what the children thought. Still, there were good days,

too. In the front yard of the Dixons' second home, at 1607 Taylor, Maynard had nailed two old saddles to the fence so that the boys and their friends could climb aboard and ride them. Sometimes his sons would sneak their pals into Maynard's studio, charging them a dime to watch an artist paint. Often on Sundays, when Maynard and Dorothea were not at their studios, they would take the boys across the Bay on the ferry into Marin County, then by the red trolley to Sausalito, where they would picnic. Noodle soup taken from an old recipe of Grandmother Lange's would be set simmering, and when it was ready they would feast on the soup, tongue in sauce, and French bread.

To save money, Dorothea went to live in the studio she had taken at 802 Montgomery in 1928, and Maynard in his, three doors down, at 728 Montgomery. The new turn in family life could not but affect her work. "Although my mind was over in San Anselmo most of the time and I didn't like to be separated from the children, it drove me to work. And I worked then as I would not have done, I am sure, if I had gone back to my habitual life." Now there was a difference to be seen in the portraits coming out of her studio. Christina Gardner's mother came down to the city that Easter weekend to have another baby's portrait made. Two days before, a strong wind had blown down their plum tree in full blossom, "just in time," Christina's mother said. So this portrait series had a smiling toddler clutching an Easter basket under a branch of plum blossoms. Christina noted that "the 1932 prints are sharply focused and are also mounted differently, on white board, and dry-mounted as prints still are today, without any embellishments. There are no protective coatings of rice paper, no deckle. The prints are signed in the same lovely signature, however, the 'Dorothea Lange' pencilling in a fast-looking signature, getting more and more unreadable as the years go on. And from 1919 each print is dated. At least this much documentation went with her from the beginning of her portraiture."

To Maynard this was a bleak time, "work and worry . . . no headway . . . prospects dark . . ." Then, ironically, the very painting that expressed his "Shapes of Fear" was bought by the Ranger Fund and given to the Brooklyn Museum. The artist got his two-thirds of the $1,500 sale price. And they were safe for the moment.

In her Montgomery studio Dorothea was making portraits for the diminishing number of people who could still afford them. But the habitual pattern of life was broken. From her corner window one flight up she could watch the flow of street life. It was no longer firm and purposeful; it was erratic, drifting, uncertain. "One morning," she said, "as I was making a proof at the south window, I watched an unemployed young workman coming up the street. He came to the corner, stopped, and stood there a little while. Behind him were the waterfront and the wholesale districts; to his left was the financial district; ahead was Chinatown and the Hall of

Justice; to his right were the flophouses and the Barbary Coast. What was he to do? Which way was he to go?" She thought again of that time in the mountains when she had realized she had to take pictures of all kinds of people, not only the rich and the comfortable who could pay her. And said to herself this day, "I'd better make this happen." She felt compelled to leave the studio and go down into the streets to photograph. If her life had not been shaken up by the Depression, "if the boys had not been taken from me by circumstance, I might have said to myself, 'I *would* do this, but I can't because . . .' as so many women say to themselves over and over again, which is one reason why men have the advantage. I was driven by the fact that I was under personal turmoil to do something."

Actually, the change had been fermenting in Lange for years. Going by the fragmentary evidence of her negatives in the Oakland Museum, she did not confine herself solely to commercial portraits in her earliest studio years. In 1922 there is the nude torso of a young woman. In 1924 there are photographs of a young black man, wearing a cap and a sweater, and in the same year scenes of Chinatown in Carson City, Nevada—its houses, yards, streets. Some of these made, no doubt, on the several occasions when she left the studio to travel with Maynard and used her camera in a different way. Around 1925 there was a significant decision to move from her expensive Sutter Street studio. She had begun to feel that the secure living from her portrait studio, this small personal business, wasn't really what she wanted. "I had proved to myself I could do it, and I enjoyed every portrait I made in an individual way . . . But I wanted to work on a broader basis." So she had closed the Sutter studio and moved to 2686 Union Street at the corner of Broderick. The top floor had been the studio of Theodore Kitka, a forensic photographer, whose widow rented his space and equipment to Dorothea. The facilities were much better than at Sutter, though the neighborhood was not fashionable. But now she had the right clientele, and it was willing to follow her. She found she did not miss the social hoopla of Sutter. A few years later, in the fall of 1929, just before the stock-market crash, came the almost mystical experience on that stormy day in the mountains. She always insisted that such decisions were instinctive (like her decision to become a photographer) and not the product of conscious planning for a career. And to the end she would say she trusted her instincts because they had never led her astray. It was when she made up her mind to be efficient that things went wrong.

In 1932, the depth of the Depression, when at least fourteen million people were out of work, Dorothea felt "the discrepancy between what I was working on in the printing frames and what was going on in the street was more than I could assimilate. I knew that if my interests in people were valid, I would not be doing only what was in those printing frames." Many unemployed drifted about the streets with no shelter, no prospect of jobs, helpless because there was no planned relief—certainly not on the

scale required. Nearby Dorothea's studio, a rich woman called the "White Angel" had set up a bread line, and Dorothea decided to photograph it, taking along her brother, Martin, for protection, for she had no knowledge of how the down-and-out would react to a cold-eyed camera. As it turned out, she needed no bodyguard. "Almost at once she discovered that photography inside and photography outside were even more sharply different than she had thought. Before, she had been able to arrange her subjects, but now she had to train herself to select them; before she had been concerned chiefly with *detail*, now she was also concerned with *situation*. All of the tidy routines and methods to which she had been accustomed were, in the streets, swept away by shocks, intrusions, and elusiveness. But even so, it was an easy change for her to make—so natural to her, in fact, that on that first day she took what has since become one of her best-known photographs." A photograph which, but for a happy chance, would never have been seen by anyone. She made twelve exposures on the streets that afternoon with a 3¼ × 4¼ Graflex, three of them of the bread line. When she got home she removed the film from the magazine holder, handing the holder to her assistant, Roger Sturtevant, so that he could reload it later. The next day he took the holder into the darkroom and with the light out reached in and found at the bottom a film not pulled out. He put it in the box and developed it. It was the picture she would call "White Angel Bread Line."

What were her feelings when she observed that man on the bread line? "I can only say I knew I was looking at something. You know there are moments such as these when time stands still and all you do is hold your breath and hope it will wait for you. And you just hope you will have time enough to get it organized in a fraction of a second on that tiny piece of sensitive film. Sometimes you have an inner sense that you have encompassed the thing generally. You know then that you are not taking anything away from anyone: their privacy, their dignity, their wholeness." She did not think of those hungry men as "subject matter with large possibilities." It was more, she said, her "tendency to want to be useful for some immediate reason."

She took the print of "White Angel Bread Line" and put it up on the wall of her studio, to see how people would react to it. Her portrait customers came in, glanced at it, turned away. The only comments she got were "What are you going to do with this kind of thing?" Remembering that, in years to come she would tell young photographers, "Don't let that question stop you, because ways open that are unpredictable, if you pursue them far enough."

She herself couldn't answer that question. She didn't know what to do with a photograph like "White Angel Bread Line," but looking at the photograph on her wall, she knew it was worth doing. Now, some fifty years later, it has become one of the great images of the Depression era, of

people in trouble. As George P. Elliott has pointed out, this was "her first photograph to become widely known and her first important one to provide the viewer with something of the context of the lives of the people in it. What has made the picture celebrated is in large part the image of the unshaven, hunched-up little man in the foreground, leaning on a railing with a tin can between his arms, his hands clenched, the line of his mouth bitter, his back turned to those others waiting for a handout. This image does not derive its power from formal elegance so much as from its being inextricably entangled with the comment it is making. It is art for life's sake."

The family was reunited at the end of the spring school term. Anita Baldwin gave them the use of a rough cabin on her 2,000-acre estate at Fallen Leaf Lake, a few miles south of Lake Tahoe. They took the red-headed twin sons of Imogen Cunningham and Roi Partridge with them, and had a fine summer with absolute privacy. They built a sweathouse in Indian style. The boys ran around naked all summer. Maynard did landscape and tree studies, although it was not his kind of country—too closed in with pine woods. He preferred to go up to the timberline, where he could see the shape of land and rock. Dorothea tried to photograph forms in nature—the pines, tree stumps, the late-afternoon sunlight as it came through big-leaved plants—but she didn't do it well. She felt free only when photographing people her life touched, not these things which weren't somehow hers.

Again there were no sales for Maynard; "a dark period," he called it, noting the "kindliness of Jewish friends," which may have meant financial help given the Dixons. Then he sold his painting "Navajo Land" for a thousand dollars and things looked better. They did for political reasons, too. That summer the Democrats nominated for President, Franklin Delano Roosevelt, a man as hopeful as the Republican incumbent, Herbert Hoover, was discouraged. The make-it-on-your-own philosophy which had raised Hoover from farm boy to multimillionaire had failed most of the President's countrymen. As the election campaign began that fall, the word "depression" seemed to have a permanent sound to it; the unemployed climbed toward sixteen million. One out of every four American families had no regular income. And there was still almost no relief for anyone. Only federal funds could rescue the hungry; the cities and states were in no position to do so. Yet surplus food was being spilled into the ocean or piled high in grain elevators while men were breaking store windows to steal a loaf of bread. Families went in rags while farmers could not market millions of bales of cotton. The country was bitter at the spectacle of want amid plenty. But the Roosevelt grin, the battered old felt hat, the jaunty clenched cigarette holder were a happy contrast to his gloomy opponent. The courage Roosevelt had shown in surmounting the polio which had crippled him made many feel that, rich though he was, he

could understand their suffering and poverty. And while his platform spelled out little, he talked about "the forgotten man at the bottom of the economic pyramid" and he promised experimentation and change. That November FDR carried all but six states, getting 22 million votes against Hoover's 15 million.

Returning to her studio after the summer at Fallen Leaf, Dorothea sent out a fresh announcement to customers and friends. She headed it *Pictures of People* and underneath was printed *Season of 1932–33. Dorothea Lange, Photographer, 802 Montgomery Street.* Maynard in his record of that year jotted down, "Dorothea begins work photographing Forgotten Man." And added, "No paintings of this subject."

It was in this season, the fall of 1932, that what came to be known as Group f/64 was formed in the Bay region. It was short-lived, but it represented a powerful influence in the development of photography. It started in Oakland, in an old studio at 683 Brockhurst, which Willard Van Dyke and his friend Mary Jeanette Edwards (who worked for Dorothea Lange in her darkroom) had taken over from the photographer Annie W. Brigman and turned into a gallery. Van Dyke had been going to classes at Berkeley while working at a filling station. Interested in photography as a boy, Van Dyke had discovered that Mary Jeanette's father, John Paul Edwards, a member of the Pictorial Photographers of America, knew Edward Weston, whom Van Dyke considered the greatest of photographers. Mr. Edwards introduced them, and after Van Dyke showed Weston some of his photographs, Weston let him come down to Carmel for a couple of weeks to work for him. After that intense apprenticeship Van Dyke drove down every weekend he could get off his job, often bringing with him Preston Holder, another student photographer he had met at Berkeley. Weston, then in his mid-forties, liked these "intelligent, positive" young men; he wrote in his Daybook that they were "of the youth who will rediscover America.'" Van Dyke and Holder would get to Weston's place on Friday night, drink with him and Sonya Noskowiak, the photographer he was living with, till about one in the morning, then get up late on Saturday and have breakfast. Bach fugues were almost always on the record player. On Saturday night they talked, read poetry, looked at Weston's new prints, and gave him their reactions. He always wanted to know what they thought. "It was just beautiful," Holder says, "providing us with photography and food." They made these weekend trips maybe thirty-five times in the next few years, Holder thinks.

Working with Weston, Van Dyke became absorbed in the straight approach to photography. The Brockhurst gallery was soon a hangout for Bay photographers who had turned away from academic pictorialism. Holder remembers the gallery as small, about 20 × 30 feet, but "a very lovely place, very primitive, dank and spooky." The people in the original group included Ansel Adams, Imogen Cunningham, John Paul Edwards,

Henry F. Swift, Edward Weston, Sonya Noskowiak, and Willard Van Dyke, of course. One evening in the fall of 1932 as they were talking in the gallery, Adams and Van Dyke suggested they join together to advance the approach to photography that they all shared. Adams has said that as early as 1930 he had been trying to get a group together that would function with straight prints. Weston's biographer, Ben Maddow, says the group of seven was formed on Weston's expressed theory of previsualization, which means the photographer imagines the print in the instant he looks at the scene. Weston "called for direct contact printing, absolutely no manipulation . . . and he prescribed absolute optical sharpness from front to back of every plane, the use of large cameras to provide large negatives, and, what is a consequence to all these, a rich infinity of detail."

Although the fountainhead, Weston hesitated to join. "I see it as purely educational," he noted in his *Daybook*. "We are all friends, free from politics, and I have no desire to be the founder of a cult!" When the others finally persuaded him, Adams asked that membership be limited to "those workers who are striving to define photography as an art form by a simple and direct presentation through purely photographic methods." The group would advance its missionary purpose by offering sympathetic photographers a place to exhibit and discuss their work. Van Dyke proposed calling themselves Group U.S. 256, thinking of the uniform system of calibrating diaphragm openings. But Adams objected to the name, arguing that a group that stood for a modern approach to photography ought not to identify with an obsolete calibration system. Adams suggested instead Group f/64, Van Dyke recalls, because "U.S. 256 is equivalent to f/64, both are the smallest stop commonly available on lenses, and we often stopped down as far as possible to gain depth of field." They accepted the name and Adams designed the graphics for it.

Group f/64's first show opened at the M. H. De Young Memorial Gallery in San Francisco on November 15, 1932. The members exhibited sixty-four prints and non-members (Preston Holder, Consuelo Kanaga, Alma Lavenson, and Brett Weston) sixteen. The response was good, and in 1933 Ansel Adams opened a gallery on Geary Street so that straight photographers now had both his and Van Dyke's places to exhibit their work. That September the Ansel Adams Gallery exhibited the work of Group f/64. Van Dyke showed prints and drawings too, with the intention, he says, of linking photography to the other more respected arts. Group f/64 made sufficient headway for a spokesman of the pictorialists, William Mortensen, to denounce these "purists" in *Camera Craft*, provoking defenses by Adams and Van Dyke. For the pictorialists the original negative was simply the jumping-off point for the final print. They modified the image manually, using pencil, etching knife, and other non-photographic means. The purists, on the other hand, believed "the technical means of straight photography allowed almost limitless departure from

mere recording without resort to manual processes which only obscured the unique beauty of the photographic image." As Weston put it, "My final results are fixed forever with the shutter's release."

But though followers would convert f/64's ideas into frozen dogma, the group's members did not abide by any rigid rules. George M. Craven, who has studied f/64's history, writes:

Technique and viewpoint varied within the Group. Edward Weston worked largely with an 8 × 10 view camera and natural light, never cropping his images, always making contact prints. Others were less stringent in their methods, using smaller hand cameras and all of the optical controls permitted by enlargement. Although they favored sharply resolving lenses, the members of Group f/64 were never committed to the invariable use of the small aperture as some critics imagined. What did underlie their use of the medium, of course, was the realization that personal vision and expression were more important than technique, and that the power of photography to communicate that expression lay within its own optical and chemical characteristics rather than with subsequent retouching, etching, pigmenting or diffusion of the image.

Ansel Adams insisted that "a diamond-sharp glossy print does NOT represent f/64 unless there is that most-important-something-else in it—the quality of art in perception and execution." He did not like what many came to believe Group f/64 stood for: a mere technical habit of work. To him "it signifies an *attitude* towards a clean, straightforward approach to photography."

Dorothea Lange knew the f/64 photographers, but she did not join the group. Ansel Adams recalls that "she did participate in a few informal discussions, but I don't think she shared in our objectives and I don't think she was troubled by not being included." Paul Taylor, who met Dorothea soon after f/64 was formed, says, "She was friends with the members but never joined the club. I don't know that she ever asked to join. Dorothea was not an f/64 type of photographer. She was taking pictures on the wing, quick, with the minimum time to focus and to adjust the instrument." Besides, he adds, she was no joiner. "She didn't belong to anything." It was not that she was opposed to their principles, he says, but that "other criteria were more important for the kind of work with people that she wanted to do. The criteria were her own, serving the kind of work she wanted to do."

Preston Holder (whose camera became an instrument in the service of his anthropology) said long after that he pushed hard in the hope of getting f/64 to do some "socially aware" work. "But I was the only one in the group who agreed on my plan of what f/64 should be." Dorothea Lange was already on San Francisco's streets, documenting the impact of the Depression, he remembers, but Weston was "off into this business of rarely taking pictures of people except for portraits to make a living." Van Dyke

was "mostly serious about landscapes and forms," and Peter Stackpole "was doing that work on the Bridge for the Establishment, he wasn't taking pictures of the working stiffs." Commenting on Holder's statement, Van Dyke said that to have tried to make f/64 into a socially active organization "would have been unrealistic . . . and a miscalculation . . . of the extent of Edward Weston's dedication to the formal elements of his work."

Although Dorothea didn't join, she was invited to exhibit with the group. "From them," wrote Beaumont Newhall, "she learned much about technique. Her conscious aim was less esthetic than informational: the greater the detail, the more her photographs carried that conviction so essential to her needs."

Van Dyke recalls Dorothea as a short, slight woman, pale skin with freckles, dark hair, and a strong face and profile. She had a pronounced limp, he said, but carried herself so that you were never conscious of it as a handicap. To Van Dyke, who was twenty-five, this thirty-seven-year-old woman seemed part of an older generation, "not one of us. Her crowd made most of us young people somewhat uncomfortable. We were more dogmatic and doctrinaire than they were. The younger photographers in f/64 were concerned about every aspect of the work, including the technical side. They with the whole process: she with subject."

After that first day in the streets and "White Angel Bread Line," Dorothea got out of the studio every chance she had. It wasn't easy; she was just gathering her forces. "I wasn't accustomed to jostling about with a camera in groups of tormented, depressed and angry men." But she quickly forgot her fears. Soon, she said, "I'd begun to get a much firmer grip on the things I really wanted to do in my work. This photograph of the man with his head on his arms, for instance—five years earlier, I would have thought it enough to take a picture of a man, no more. But now, I wanted to take a picture of a man as he stood in his world—in this case, a man with his head down, with his back against the wall, with his livelihood, like the wheelbarrow, overturned."

5 ON MARCH 4, 1933, ROOSEVELT TOOK OFFICE, and on that first day a depositors' panic forced the closing of every bank in the country. The President acted as though America were at war, and in his first hundred days in the White House made whirlwind changes in the old order. Bill after bill went through Congress without challenge, touching almost every aspect of the national life. Above all, FDR showed his concern for human suffering by taking swift measures to provide relief and jobs. Behind the smile and the soft words he had shown in the role of candidate was a man who in just fifteen weeks proved himself to be a master of practical politics.

Rapidly as the Roosevelt Administration moved, it couldn't solve overnight the crushing problems of the Depression. (It never did solve them, not in peacetime; only the coming of World War II ended mass unemployment.) When FDR came into power the demonstrations by the unemployed, begun during Hoover's Administration, continued—accelerated even, for now there was hope the appeals would be listened to. On May Day, 1933, the traditional international day for labor rallies, Dorothea Lange assigned herself the task of photographing the demonstration of unemployed in San Francisco's Civic Center:

> I said, "I will set myself a big problem. I will go down there, I will photograph this thing, I will come back, and develop it. I will print it and I will mount it and I will put it on the wall, all in 24 hours. I will do this to see if I can grab a hunk of lightning."

Pickets and placards dominate her photographs of that May Day demonstration. The slogans speak for the issues the radical movement was pressing: AMERICAN WORKERS—JOIN HANDS WITH THE GERMAN WORKERS. DOWN WITH GERMAN FASCISM. DEFEND THE CHINESE SOVIETS. STOP MUNITIONS TRANSPORTS TO JAPAN. DOWN WITH AMERICAN PRESS SLANDERS

AGAINST THE SOVIET UNION. REPEAL THE CRIMINAL SYNDICALISM LAW. DE-MOCRACY? WE WANT FOOD. DOWN WITH ROOSEVELT'S HUNGER PROGRAM. DOWN WITH SALES TAX. It was on this day that she made her famous photograph "Street Demonstration, San Francisco, 1933," showing a big policeman standing with his back to a line of pickets holding aloft their slogans, his legs wide apart, his head to one side, hands laced together over his belly, the star of authority shining on his chest.

More of her time and energy were going into street photography than she felt the family could afford. Her way of handling it was to set a 24-hour time limit. Shoot it fast and back to the studio . . .

Now that people were beginning to talk about her documentary work, she was approached by Communists who hoped she would join them. Her photographs were valuable, they said; she and the party had common interests. They sought to convince independents like Dorothea that the liberal reforms of the New Deal were but a way of deflecting revolt by patching up the system. The intellectual's true task, they said, was to expose the basic contradictions of capitalism and organize the discontented masses to take part in the struggle for a new and rational social order. It was flattering to Dorothea to hear great praise for her work and to be told how useful it was in exposing social injustice. The failure of the New Deal to get the stagnant economy moving in those first Roosevelt years had dampened liberal enthusiasm. Many writers and artists, disgusted with stopgap measures, moved rapidly to the left. But she never joined the Communists because, she said, "Maynard was so leery. He was less socially moved than I . . ." She had friends who did join, and much later she wondered if it wouldn't have been the right thing to have done. But if she had taken this step, it is unlikely that she would ever have submitted to party discipline for long. Authoritarian as she herself could be, she was not one to give in to anyone else's authoritarianism.

She was still doing portraits, mostly to finance the photography she wasn't getting paid for, and to contribute her share to the support of the boys. There was no real division in family finances: "I did everything that I could, and Maynard did what he could." She didn't know what would happen to her documentary photographs. She thought often in the early thirties how good it would be if she could get paid to do that kind of photography and be spared the strain of trying to maintain it on her portrait business.

The family left the city when the summer of 1933 began and traveled through southern Utah, camping in Zion National Park, visiting Mormon towns. In Toquerville they saw poverty, but found the people kindly. Each family was a self-sufficient economic unit. One Mormon told them, "We get pretty ragged but you can't starve us out." On the way home in the fall they stopped to watch construction work on Boulder Dam. Out of the summer's sketching Maynard completed more than forty paintings. How

much work Dorothea did with her camera we don't know; there are only a few prints on hand: Utah scenes, Nevada cowpunchers, Indians at a Fourth of July celebration.

The year 1934 began with the Dixons moving into a two-story house at 2515 Gough Street. Economizing on rent, Dorothea gave up her studio and converted some of the top-floor space into her workrooms. The change of address announcement she sent out still described her work as "Photographs of People," and carried on it the quotation from Francis Bacon which came to stand as her credo: "The contemplation of things as they are, without substitution or imposture, without error or confusion, is in itself a nobler thing than a whole harvest of invention." Later she placed the words on her Christmas card and then tacked them on to her darkroom door.

For Maynard, the turn of the year began well. The U.S. Treasury Department stepped in to become the artist's patron. Under the guidance of an old friend of the Roosevelts', Edward Bruce, Treasury set up a Public Works of Art Project, making funds available for murals and sculpture to adorn public buildings. (There were specific instructions *not* to employ photographers.) This was a forerunner of the WPA arts projects which would be created the next year. PWAP, however, was not a relief project; artists did not have to be needy to qualify for assignments. Maynard Dixon was asked if he would serve as coordinator of the work in San Francisco, but he declined the administrative post. In April he got an assignment from PWAP to go down to Boulder Dam and paint whatever he wished there. The giant project had been under construction for three years. Completed, it would be the tallest dam, largest man-made lake, and most complex water-delivery system of its time, designed to protect the vast fruit and vegetable produce of the Imperial Valley. The chaotic construction city bewildered him at first. It was strange material for him to paint, but he soon found his theme: Man *vs.* Rock. The men seemed like robots to him. They worked in the blazing sun, scaling the stupendous cliffs, riding cement buckets over canyons a thousand feet deep. He boarded with a worker's family, meeting many young men forced by the Depression into manual labor they were poorly fitted for. Among them was Dorothea's brother, Martin Lange. The job was very dangerous: four men were killed in the month Maynard spent there and the hospital was full of maimed workers. The atmosphere was company-town—armed guards, company stores, stool pigeons to keep out the unions. He made paintings, drawings, and watercolors of the men at work, exhibiting them in the administration building of Boulder City. The favorite among the workers themselves was his "Tired Men," a truckload of laborers returning from battle with the rock. He got $450 for his thirty-six days of work; the results were sent on to Washington.

After a lifetime of painting the wilderness he, like Dorothea, had dis-

covered new themes in the Depression and labor. Like the other artists of his generation, Dixon said, he had "dodged the responsibility of facing social conditions. The Depression woke me up to the fact that as an artist I had a part in all this . . . Painting, as I see it, must be human rather than arty—it is a means to an end. It is my way of saying what I want you to comprehend. It is my testimony in regard to life."

When he got back home, he found San Francisco in the first stages of a turbulent maritime strike and Dorothea already at work photographing it. The great port city's employees had always had a brutal labor policy. Seamen were among the worst-exploited of all workers. And to be a long-shoreman was almost worse than being a slave—the men worked like pit donkeys for twenty-four to thirty-six hours at a stretch, then starved for weeks or months until they got another job. The strike, which began early that May, was led by Harry Bridges, the Australian-born longshoreman who had emerged from the rank and file. Now their union was demanding higher wages, better hours, steadier work, an end to the employers' "slave market," and the recognition of the union's hiring hall. The shipowners had brought in strikebreakers, and violence broke out at once. As the strike wore on, hundreds of people were injured in bloody clashes. The strike spread to other maritime unions, and soon the port was shut down tight. With business at a standstill, industrial and financial leaders of the city determined to force the port open. The mayor pitted police against the pickets. Bricks and tear-gas grenades filled the air. Police, strikers, horses, spectators were wounded in street battles and two men killed on the "Bloody Thursday" of July 5. The governor declared a state of riot and ordered the National Guard to occupy the waterfront. United in bitter rage, labor called a general strike on July 16, and everything except essential services came to a halt. To the business community this was the beginning of revolution; the mayor demanded federal troops to put down the "insurrection," but Roosevelt saw the general strike as the only means left to labor to win recognition. In four days arbitration was agreed to, and in the end the longshoremen won essentially all their demands. As one of the strikers said, "We experienced the unaccustomed luxury of being men." The victory spread the idea of industrial unionism everywhere.

Both Maynard and Dorothea, drawn to the waterfront struggle, shared the public's anger at the overwhelming show of force against the strikers. Maynard did a series of paintings with such titles as "Law and Disorder," "Pickets," "Free Speech," "Scab," "Keep Moving." This did not mean he was deeply committed to labor or the left. Lacking the money to make his expeditions into mountain and desert, he painted and drew what was around him in the city. Dorothea, apparently before the strike began, had photographed what she captioned "Slave Market: Howard Street between 3rd and 4th." Next to the contact prints she wrote these words by the government official, John G. Winant: "Where industries are chaotic and dis-

organized the wage earners take up the shock of a brutal competitive system." With the strike under way, Dorothea went down to the waterfront to photograph pickets and police. Her file of work done in the same year includes pictures not only of people in specific situations, such as men on state relief doing pick-and-shovel work on the roads, but closeups of significant details. There is a series of shots of women's legs, from the knees down, revealing mended stockings. Another photograph is of a pair of ruined shoes.

Maynard found that although his paintings on labor themes evoked an immediate and lively response from people who viewed them, nobody wanted to own pictures of strikers nursing broken heads or homeless men trudging the highways. No matter how skillful or moving such art was, it was not deemed suitable as "wall decoration." Even the art critics who usually paid attention to his new work managed to ignore these paintings when they encountered them in galleries. Maynard's anger died away quickly and he stopped painting social themes. Some artists, like Ansel Adams, shied away from what they dismissed as "soapbox art." Adams wrote Stieglitz that spring that he was getting "dreadfully tired of being used as a tool for radical interests—artists in the main are asked to do 'Proletarian' work, photographers are asked to photograph May Day celebrations, old human derelicts in a dingy doorway, evictions, underpaid workers, etc. I grant that the times are portentous, but I'll be damned if I see the real *rightness* of being expected to mix political economy and emotion *for a purpose* . . . I do not like being expected to produce propaganda. Half my friends have gone frantic Red . . ."

It was about this time, in the summer of 1934, that Willard Van Dyke gave Dorothea an exhibit at his gallery in Oakland. It was the first public recognition of her documentary photography. More, it was the occasion which led to her meeting Paul Schuster Taylor. Taylor, who like Dorothea was thirty-nine years old then, was an associate professor of economics at the University of California at Berkeley. Born in Iowa and imbued with the prairie farmer's pride in his own land and labor, Taylor had taken his undergraduate work at the University of Wisconsin, which his parents had graduated from, too. The Robert La Follette spirit of progressivism fired the campus, igniting in young Taylor a concern for the oppressed which became the driving force of his life. His chosen department was led by the pioneering economic and labor historian John R. Commons. Taylor served with the Marines in World War I, barely surviving a German gas attack, and for his graduate work went to Berkeley, because doctors suggested California's climate would benefit him. He took his Ph.D. in 1922 and stayed on to teach. From the beginning he showed a tenacity in pursuit of principle rarely equalled in academic circles. He never accepted frustration; he always believed you could get results, you could bring about change, if you took the trouble to find out what to do and organized

the support for it. He constantly needled colleagues and congressmen to take a stand. As the historian Paul W. Gates put it, "Paul Taylor's ability to get to the heart of a question, to marshal the facts, and to draw conclusions clearly based on the most careful and detailed examination, made him a most valuable public servant, very different from the conventional picture of the scholar removed from public issues and isolated in his ivory tower."

In the late 1920's Taylor began his detailed studies of migratory labor. A Guggenheim fellowship enabled him to spend six months studying the roots of the problem in Mexico. While there he began using a camera as an aid to recording what he was seeing and learning. Following the Mexican migrant workers north of the Rio Grande, he wrote an article for *Survey Graphic* (May 1931) which was illustrated by a dozen photographs taken by Ansel Adams. The Adams pictures were requested by editor Paul Kellogg, not Taylor, who had never heard of Adams. Kellogg had founded the magazine in 1923 to provide serious analyses of contemporary social problems. It had become a pioneering force in the development of documentary photography. To the original *Survey*, published in mid-month, Kellogg had added a first-of-the-month issue called *Survey Graphic*, which made strong use of photographs to complement text or to stand only with captions. (Kellogg was one of the first editors to commission photographs from Lewis Hine.) It was Taylor who introduced Kellogg to the problem of immigrant Mexican labor, taking him on a field trip into South Texas, where the editor saw for the first time what would soon become a huge political as well as economic issue.

Taylor had stumbled into the use of photography by himself, starting in 1927 with an old Eastman postcard-size Kodak. He never meant to pursue it as a medium for its own sake but as a tool of social research. He was not of course the first to see this application of the camera. As far back as 1850, eleven years after photography's birth, Harvard professor Louis Agassiz had commissioned a South Carolina photographer to daguerreotype slaves for purposes of documentary identification of race.

When Taylor got a Rolleiflex in Mexico the work spurted ahead. "No amount or quality of words," he said, "could alone convey what the situation was that I was studying." The camera gave him another language.

One of Taylor's colleagues who shared his enthusiasm for the Rolleiflex told him that a man named Willard Van Dyke had a gallery in Oakland where he sometimes put on exhibits which reflected his social concerns. Taylor went down to 683 Brockhurst; the current show turned out to be Dorothea Lange's recent photographs. Taylor had just finished collaborating with Norman Leon Gold on a piece for *Survey Graphic* analyzing the San Francisco general strike, whose outcome was still in arbitration. Along with the manuscript Taylor had sent Kellogg some photographs of his own, plus several gathered from news sources. But here on the wall he saw

"this striking array of relevant photographs by Dorothea Lange whom I had never heard of." One of the most powerful was a shot of a speaker at a microphone. He telephoned Dorothea to ask if he could have that photograph to go with his strike article. She was agreeable, though she didn't sound the least bit excited—she had never heard of this professor, nor probably of the magazine—and simply asked about the terms. That lay with Kellogg, who offered $15. The photograph became the full-page frontispiece for the article, which appeared in the issue of September 1934. Underneath, the editors printed their own caption, "Workers, Unite!" and the credit line, "Photograph by Dorothea Lange, San Francisco."

For Taylor it was the beginning of a brief relationship with Van Dyke, and a lifelong one with Lange. When Taylor realized how intense Van Dyke's interest was in the social applications of photography, he discussed with him approaches to the study of migrant labor which would integrate photographs with text. Taylor impressed the younger Van Dyke as the typical intellectual—"always examining issues from every side before forming an opinion, never letting his emotions show on the surface. I was a hot-tempered and impatient young man; I wanted to charge in and change things right away. Taylor was so bright, so judicious, so hard-working, he made me nervous and impatient. I guess I was a bit afraid of him." He remembers Taylor as a tall, solidly built man, but a cerebral, not a physical type, with speech and movement that of a schoolmaster.

Late that summer, again on Anita Baldwin's invitation, Maynard and Dorothea went to the cottage at Fallen Leaf. Maynard did some oil studies, while Dorothea came to the decision that her independent photography was the direction she wanted to pursue. There was no name for such photography; soon they would be calling it "documentary," a name that has stuck but which she never liked. Often people would tell her that she was the "first" documentary photographer, but "of course that's nonsense," she said. "When you are in a thing you find there were people there a hundred years ago! It does seem as if whatever the thing is that the world is ready for, happens. You think you yourself have chosen, but you haven't; it's a part of your time."

The impulse to try this new photography didn't stem from anyone else, she said. She knew of the work of Lewis Hine and Jacob Riis, but she was discovering for herself what a good documentary photograph was. Thinking back to those first years, she said she was beginning then to see that "a documentary photograph is not a factual photograph per se." The documentary photograph "carries with it another thing, a quality [in the subject] that the artist responds to. It is a photograph which carries the full meaning of the episode or the circumstance or the situation that can only be revealed—because you can't really recapture it—by this other quality. There is no real warfare between the artist and the documentary photog-

rapher. He has to be both." Yet, unlike the artist who may be concerned most with showing just how he feels, "the documentary photographer is trying to speak to you in terms of everyone's experience."

Soon after the family returned from Fallen Leaf, the October issue of *Camera Craft* appeared with the first serious criticism of Dorothea's photography. The article, written by Willard Van Dyke, reproduced five of her documentary photographs. It is so perceptive, and so obviously reflects Van Dyke's personal knowledge of Dorothea's ideas and methods at the time, that it must be quoted in full:

Dorothea Lange has turned to the people of the American Scene with the intention of making an adequate photographic record of them. These people are in the midst of great changes—contemporary problems are reflected on their faces, a tremendous drama is unfolding before them, and Dorothea Lange is photographing it through them.

She sees the final criticism of her work in the reaction to it of some person who might view it fifty years from now. It is her hope that such a person would see in her work a record of the people of her time, a record valid of the day and place wherein made, although necessarily incomplete in the sense of the entire contemporary movement.

One of the factors making for this incompleteness is the camera itself. It must make its record out of context, taking the individuals or incidents photographed as climaxes rather than as continuity. In approaching the subject or situation immediately before her she makes no attempt at a personal interpretation of the individual or situation. Neither does she encompass her work within the bounds of a political or economic thesis. She believes and depends more on a certain quality of awareness in her self. This awareness although perhaps inarticulate through herself (in words) is apparent in her adherence and approach to certain subject material. She is not preoccupied with the philosophy behind the present conflict, she is making a record of it through the faces of the individuals most sensitive to it or most concerned in it. Her treatment of this type of human subject shows her in turn sensitive and sympathetic to the uncertainty and unrest apparent at the present time.

Naturally the range of human emotions which Dorothea Lange now photographs are not those which a sitter expects in a studio portrait. Sixteen years as a portrait photographer have shown her that the subject of a commission rarely sees himself as the camera does, even at its best, and is unlikely to be convinced of the objective truthfulness of the camera. Sitters mistake the lens for a mirror wherein they are wont to see themselves colored by the glamour of their romantic ideas. Of course, in order to please patrons, one must make concessions and this limitation led Dorothea Lange to photographing people with or without their knowledge, outside the studio.

Most photographers under similar circumstances would have turned to photographing other subject material, or away from photography entirely, but Miss Lange's real interest is in human beings and her urge to photograph is aroused only when values are concerned.

For equipment she uses two cameras. On any given trip she takes one or the other of these with her, never both. One of these is a 3¼ × 4¼ Graflex equipped

with a 7½ inch focal length anastigmat lens and magazine film holders, the other a Rolleiflex which she considers to have a general advantage in that it is less obtrusive and can be operated at closer quarters. The latter, of course, by virtue of the smallness of the film does not permit of as great a degree of enlargement. She also uses a Weston exposure meter to test the general light conditions once or twice during the expedition.

Miss Lange's work is motivated by no preconceived photographic aesthetic. Her attitude bears a significant analogy to the sensitized plate of the camera itself. For her, making a shot is an adventure that begins with no planned itinerary. She feels that setting out with a preconceived idea of what she wants to photograph actually minimizes her chance for success. Her method is to eradicate from her mind before she starts, all ideas which she might hold regarding the situation—her mind like an unexposed film.

In an old Ford she drives to a place most likely to yield subjects consistent with her general sympathies. Unlike the newspaper reporter, she has no news or editorial policies to direct her movements; it is only her deeply personal sympathies for the unfortunates, the downtrodden, the misfits, among her contemporaries that provide the impetus for her expedition. She may park her car at the waterfront during a strike, perhaps at a meeting of unemployed, by sleepers in the city square, at transient shelters,—breadlines, parades, or demonstrations. Here she waits with her camera open and unconcealed, her mind ready.

What is she seeking—what is the essence of the human situation and through what elements or items does it reveal itself? The scene is a panorama, constantly shifting and rearranging. For her it is transformed into a pageant of humanity across the ground glass—the drama moves, the individuals stir and mill about, by what motivation she cares little. It may be hours before a climax arrives worthy of the decisive click of the shutter. Suddenly out of the chaos of disorganized movement, the ground glass becomes alive, not in the human sense alone, but in the sense that only a photographer can recognize—a scene, a negative, finally a print that is itself alive. And here is where the photographer becomes the creator, feeling all the thrills and all the responsibilities of the creative artist. A dozen questions of possible technical failure flash simultaneously through the mind and resolve themselves into: "Has the touch upon the shutter release killed something that was palpitating and real a moment ago, or has it preserved it for others to share and enjoy?"

Perhaps the impulse that causes any photographer to open his shutter finally to the object before his lens is the conviction that the demands of the basic photographic values which give life to a plate have been satisfied, whether the objects which he is photographing be living or inanimate. For Miss Lange, the final clicking of the shutter has the added thrill that she has recorded another climax in the turbulent drama of human relations. Her individual shots cannot tell the whole story, nor has she any plan of sequence—it is only in the broad scope of her life's work, the constant reiteration of the climaxes, that her commentary upon humanity is to be found.

There is no attempt made to conceal her apparatus, Miss Lange merely appears to take as little interest in the proceedings around her as is possible. She looks at no individual directly, and soon she becomes one of the familiar elements of her surroundings. Her subjects become unaware of her presence. Her

method, as she describes it, is to act as if she possessed the power to become invisible to those around her. This mental attitude enables her to completely ignore those who might resent her presence.

Perhaps we can arrive at a better evaluation of her record in terms of a future observer than as contemporary critics. We ourselves are too poignantly involved in the turmoil of present life. Much of it is stupid, confused, violent, some little of it is significant, all of it is of the most immediate concern to everyone living today—we have no time for the records, ourselves living and dying in the recording.

We can assume the role of that future critic by looking back to the work of Mathew Brady, who in the dawn of photography made a heroic record of another crisis in American life. Brady and Lange have both made significant use of their common medium—they differ mainly in terms of the technical advancement of the medium itself. Lange can photograph the split-seconds of the dynamic surges of the scene about her—Brady, carrying a complete darkroom about with him through the northern battlefields of the Civil War, sensitizing his own plates before each shot, making twenty-minute exposures, had to wait for the ample lulls between engagements. The implications of his record are retrospective, the scene after the battle, the dead that were once living, the ruins that were once forts, faces still and relaxed. Both Lange and Brady share the passionate desire to show posterity the mixture of futility and hope, of heroism and stupidity, greatness and banality that are the concomitants of man's struggle forward.

Technical data:

The negatives are made on fast panchromatic film and developed in Metol-hydroquinone. The prints are enlargements on matte or semi-matte paper. There is no retouching on negatives or prints which are printed as sharply as the limitations of her way of working will permit. Most of the exposures are made at 100th of a second or faster.

It was through Van Dyke that Dorothea got an opportunity to photograph an extraordinary aspect of the Depression. Paul Taylor was studying the self-help cooperatives which had sprung up as one way of meeting the problems of the unemployed. Around the slogan of "Self-Help Beats Charity," thousands of families had begun to barter their labor for the fruits and vegetables the owners of truck gardens and orchards could not sell. Soon bakers, barbers, cobblers, carpenters, mechanics, and even professionals were exchanging their services for food. In the next year or two the barter movement took several forms throughout the state. One project called the Unemployed Exchange Association (UXA), had developed around a sawmill in the foothills near Oroville, about 125 miles northeast of San Francisco. When the owner couldn't run it profitably any longer, UXA got a federal grant to buy it and turned it into a cooperative producing unit, organizing and operating it on democratic principles. It refused donations from outside (fearing chiseling and corruption), and the members, who included people of all ranks and skills, contributed their services, accounted for by so many points per hour of labor. The ex-

perimenters' hope was to educate themselves to stand on their own feet, and to build a working model of a new way to live in a time of crisis. With Clark Kerr, who was taking his doctoral work under him, Taylor had already visited UXA and published an illustrated article on the self-help movement in *Survey Graphic* (July 1934).

When Van Dyke said he had friends eager to photograph the human impact of the Depression, but who were uneasy about going into the streets and pointing their cameras at people in trouble, Taylor arranged to have them photograph the Oroville project. He was glad they were interested, because he wanted to encourage photographers to document social change. The group of photographers met at Taylor's home early one morning. Besides Van Dyke, they included Imogen Cunningham, Preston Holder, Mary Jeanette Edwards, and Dorothea Lange. That was when Dorothea and Paul Taylor met for the first time. They drove to Oroville and were put up for the weekend in the lumber workers' cabins. Taylor recalls that the photographers went to work in the very first few minutes, each in his or her own way, and on the subjects of their own choice. The UXA members had been told they would be visited and they acted, so far as Taylor could tell, in their normal ways.

To Dorothea, the sawmill cooperative seemed a "heartbreaking effort. I remember that whole business up there as something very sad and dreary and doomed," she said, although she could see the people themselves didn't feel that way. "You know there are always a few enthusiastic souls in such things who carry the others along with them in spite of everything that goes wrong . . . Not enough oil to run the engine, not enough shingles for the roof, not enough of anything excepting courage on the part of a few. It was a sad thing."

They photographed what they saw. Her own pictures show men at work—laborer, machinist, engineer, painter, lumberman—as well as groups of women, children, and a mother with her baby. "I didn't do it very well," she said. "I went up there thinking I could photograph something that would help them and get more people interested. I did it optimistically, and I didn't know enough at that time. I did it the way a photo-journalist would if he had an axe to grind. I didn't realize what I do now. Had I, I'd have a real document, a real record. But I have none because I didn't really see it."

They stayed two days and nights. In the evening, Taylor, who made some pictures himself, went to the cabins to talk to the UXA people when their chores were done. Dorothea came over to watch. She had never seen a social scientist conduct an interview. She was absorbed in the way he drew facts and feelings from people without their being aware of how much they were telling him. Even though he wrote in his notebook while they talked, they didn't seem to be made self-conscious by it. She saw how eager most people are to talk even to strangers, and "especially if

they are talking about themselves, about their own experience, their own involvement." He used his notebook unobtrusively, and didn't make them stop talking while he wrote. They liked the fact that he was taking down at least part of what they said; it implied he thought they had important things to say.

If Dorothea observed Taylor at work on that expedition, he noticed her, too. She went quickly and quietly at her work, he said, intent, inconspicuous. He contrasted her way with that of Imogen Cunningham, who "set up and made a few studied, well-organized, well-executed photographs." He remembered Dorothea using a Rolleiflex, and Imogen a Graflex 4 × 5. When he saw the Lange and Cunningham prints he thought "both of them very fine, but very different." Each photographer saw with her own eyes. Dorothea at that time did not talk to the people she photographed. Significantly, the first photograph he remembered she made at Oroville was of the back of a woodcutter standing, resting for a moment on his ax, as a man would on a cane, facing the forest before starting to chop down the trees. "It is the expression of the man's back that is telling," he said. Imogen, he recalled, "was soon photographing a man working at a power saw, where he was in a more or less fixed position and she could take plenty of time to set up for a photograph with her great skill." The distinctive characteristics of the two photographers were evident to him right there.

In November Taylor arranged for a two-week exhibit of photographs and etchings descriptive of California's self-help cooperative movement, securing for it the joint sponsorship of the University of California and the State Emergency Relief Administration. It was held in Haviland Hall on the Berkeley campus. He asked the photographers who had made the UXA trip to provide prints and told them he would welcome it if they would sign all their work. All put their name to some of their prints but refused to sign others because, they said, however useful to him, not all the work came up to their own professional standards. (About a third of the prints were signed.) Dorothea signed fourteen of her prints, despite her conviction years later that she had not done very well. There were eighty pictures by seven photographers in the show; she seems to have had more than her share.

That experience of a "double standard" applied by the photographers interested Taylor. He saw that in their minds there was one standard for "art" photography and another for "documentary" photography. Some of their photographs they thought met both standards. A generation before, the work of Riis and Hine in documenting the slums and child labor held no interest for art critics and little for art photographers. But this group he had taken to Oroville at least "recognized the importance of documentation. They weren't concentrated or fixed exclusively on exhibition photographs." Group f/64's ideas on straight photography surely influenced them toward superior documentary work.

Taylor, so open to the camera's possibilities in his own field, brought Dorothea in the early months of their acquaintance a reprint of an address made in 1902 by Charles R. Van Hise, one of America's leading geologists. Van Hise had criticized geologists for their faulty observation of nature and their failure to extract the meaning of what they observed. Their scientific reports contained details that were too minute and inconsequential to justify the attention given them. In the most cogent paragraph of his talk on the training of a geologist he said:

> Suppose a man to be standing before some complex geological phenomenon. The whole intricate interlocking story is engraved upon the retina of his eye with more than photographic accuracy. The image on the retina is absolutely the same in the eye of this experienced geologist and that of a child. Yet if the child be asked to state what he sees, his statements will be of the most general kind and may be largely erroneous. The experienced geologist with a knowledge of the principles of physics and chemistry and biology interprets the phenomena imaged in terms of these subjects. The engraving on his retina is the same as that of the child, but his brain perceives the special parts of the picture of interest to him in their true proportions. He understands what is important, what is unimportant; he must select and record the things which are important. If he attempted to record all that is imaged in his eye, a notebook would be filled with the phenomena to be described at a single exposure; and yet half the story would not be told. Good descriptive work is discriminative. Good descriptive work picks out certain of the facts as of great value; others of subordinate value; and others of no value for the purposes under consideration. How then can this discrimination be made? How can the facts be selected which are of service? Only by an insight into the causes which have produced the phenomena. Without this insight to some extent at least a description is absolutely valueless. So far as the geologist has such insight, his description is valuable.

Just take out the word "geologist" and write in the word "photographer," said Taylor, and Van Hise's remarks apply. Dorothea found it had meaning for her; later she would use it in her own teaching of photography.

That fall of 1934 was a season of political hysteria in California. In the state elections the muckraking novelist and old-time socialist Upton Sinclair was running for governor on the Democratic ticket. His EPIC platform (End Poverty in California) called for taking over idle factories and land and putting them to use through cooperatives of the unemployed. His mild utopianism panicked the business interests and they mustered unprecedented money and talent to smear Sinclair with a mass-media campaign that set a new low for dirty politics. Sinclair was defeated. Not until 1938—nine years after the onset of the Depression—would a New Dealer win the governorship.

That December, a second exhibition of Dorothea's photographs was held, this time at the public library branch on Vallejo Street. Looking at

these photographs, Ansel Adams saw in them something different from the soapbox art he had decried. She is "an extraordinary phenomenon in photography," he wrote. "She is both a humanitarian and an artist. Her pictures of people show an uncanny perception, which is transmitted with immense impact on the spectator. To my mind, she presents the almost perfect balance between artist and human being. I am frankly critical of her technique in reference to the standards of purist photography, but I have nothing but admiration for the more important things—perception and intention. Her pictures are both records of actuality and exquisitely sensitive emotional documents. Her pictures tell you of many things; they tell you these things with conviction, directness, completeness. There is never propaganda . . . If any documents of this turbulent age are justified to endure, the photographs of Dorothea Lange shall, most certainly."

Where did that understanding come from? Dorothea, like many artists, was reluctant to admit the influence of others upon her work. She saw in her own way, she would insist. It is hard to disprove such a claim. But the photographer John Collier, Jr., who was in a position to observe both Dorothea and Maynard closely, beginning in the 1920's, is convinced otherwise. Maynard Dixon's passion for the men and women of the West, whose nature and vitality he shared, and his great skill in recording their life, had a strong influence on Dorothea's photography, Collier believes. On their Western travels together, especially after the Depression began, Maynard's style began to change. He shifted from a romantic way of painting the Westerners to an attempt to depict the reality of the Depression, its effects upon people,, the drifters, the bindle stiffs, the migrants—always with sympathy and with respect for their dignity. Looking at Dorothea's documentary photography—both her early personal images of the Depression and those to come when she worked for the government—Collier sees in them a historical understanding she absorbed from Maynard and what he put into his painting.

Much as they had to give one another, it was a marriage that was nearing its end. Dixon was going on sixty now, and his health was deteriorating. In childhood he had suffered from an asthma so bad it was thought he would not survive. Now he had developed emphysema, another lung condition crippling in its effect and incurable. He had to have oxygen treatments to be able to go on. Despite his weakened condition, with his disciplined work habits and his powerful will he was able to make the best of what he had left. The life of a freelance artist was never easy, and now with the Depression its uncertainties were multiplied. Dorothea, too, by this time was shifting from a commercial studio business to the irregular work of a freelance documentary photographer. Their children, with both parents artists and living irregular lives, could scarcely avoid the psychological difficulties such a family life induces. The calm, the quiet, the everyday regularity that most children need to thrive on was not there. It

was probably the heightening of family conflict which led Dorothea to suggest the long stay in Taos in 1931. She must have hoped that in the new setting the marriage would mend. It seems not to have worked. Maynard's physical condition grew worse in the freezing cold of the studio. And when they came back to California it was not to their old home but to live and work separately in their studios, and they sent the boys away. They do not seem to have told friends this was a trial separation. Most of their circle was unaware of the cracks in the marriage. Then came an attempt at reconciliation. They moved into the Gough Street house, to try rebuilding a family life.

6 IT WAS IN THE MEAN, COLD WINTER OF 1934-35 that people working in a dingy government office on Fourth Street in San Francisco turned to Paul Taylor for help. They were worried about the number of hungry and bewildered men, women, and children who were wandering about California's rural counties. A dozen, a hundred, a thousand such families the state might somehow take care of. But these strangers were streaming in by the tens of thousands. They were not the "habitual" migrants—mostly single men—California was used to; rather, could not do without. Such a supply of migrant labor following the crops had long been essential to the state's huge fruit and vegetable farms. Most of them were low-wage workers from abroad—Chinese, Japanese, Hindus, Filipinos, and especially Mexicans. But these newcomers were white Americans and were arriving in family groups. The counties responsible for taking care of them were doing it very inadequately. They had poor facilities, if any, to shelter and feed the poverty-stricken migrants. "Undesirables," they called them, and thought only about how to get rid of them. The policy of some counties was to give the migrants a tankful of gas and a few dollars and tell them to move the hell on. Other counties gave shotguns to deputies and posted them on county lines with orders to keep the "bums" out. That was the going notion of "relief measures."

What was the trouble? Why were the migrants coming so many and so fast? When would they stop? What could be done right now? If anyone had the answers, it was the Berkeley scholar whose perceptive studies of poverty and migration among agricultural laborers had earned him a national reputation. Professor Taylor quickly demonstrated that this was no isolated episode of only local significance. It had deeper roots in America's misuse of her soil. It was a catastrophe transcending state and regional limits. The old notion that, no matter how bad things got, the farmer could always feed himself had proved a myth under the blows of the Depression

and the steady mechanization of the farm. One out of four rural households was now on relief. But there was a third complicating force at work—natural disaster. During and after World War I, through a belt of over a hundred counties, starting in Kansas and running into Texas, farmers lured by quick profits had plowed submarginal land. Then late in 1933 a series of disastrous droughts and dust storms began. On into 1934, wind and searing heat stripped the farmlands from the Dakotas to Oklahoma. The topsoil blew away in huge clouds, darkening the skies, burying houses and barns and fences and machinery. The "black blizzard" cost the nation hundreds of millions of tons of soil and desolated thousands of farm families in the Great Plains states. They took to the roads. Within the next five years 350,000 Dust Bowl farmers would desert the homesteads they or their pioneer ancestors had thought to root themselves in forever and head for California.

This was the problem confronting the Division of Rural Rehabilitation of the State Emergency Relief Administration (SERA). What California was looking at, Taylor said, was the leading edge of a large regional migration of destitute rural people from the drought-blasted fields. And he warned that this human flood would become so broad and so deep it would swamp the resources of the agricultural counties and even of the state itself.

Taylor agreed to do the research work to help determine what rehabilitation program would meet the need. If few people in California were aware of what was happening, then almost no one in Washington could be expected to understand the state's peculiar conditions. Taylor would tackle the key questions: who was in distress, what was the nature of the distress, and what practical program would relieve the distress. Staying on at the university, he worked for SERA as a part-time consultant. He knew it would take a massive, federally funded program to do the job for the migrants. Since they were moving in family groups, it would need to be a comprehensive plan for food, shelter, medical care, and job opportunities. Knowing what he did about migrant farm labor, he could sketch the outlines for such a plan even now.

A documented statement of need was required. But facts, figures—they poured into the New Deal agencies every day. So when the state officials asked Taylor what staff he wanted, he said a certain number of field workers, a few office workers—"and," he added, "I would like a *photographer*."

A photographer? Why a photographer?

His answer came slowly. He had already done a good deal of research among the Mexican migrant workers. Just a few months ago he had gone down to the San Joaquin Valley as part of the governor's fact-finding commission to study the strike of migrant cotton pickers against the growers—the most extensive farm strike in American history. (Unions of farm workers were virtually unknown then.) So he was quite familiar with the

situation in rural California. But knowing the conditions and reporting them in a way to produce action are two different things, he said. "I'd like the people in the relief administration, who will read my reports, and evaluate them, and make the decisions, to be able to *see* what the rural conditions are like. My words won't be enough to show the conditions visually and accurately."

In those days photographs of a social problem made either by professional or amateur photographers were extremely rare. There were Riis's pictures, to be sure, and Hine's, but most people in California had never heard of either man. As for the social scientists themselves, only the anthropologists had begun to use photographs. The other social scientists feared photography was too emotionally loaded to be scientific. It would be distracting. And, said Taylor, "there was then—even more than now—a resistance to facing people as human beings. You free yourself from some responsibilities if you can reduce people to numbers. You don't have to bother with people. They are just numbers you can manipulate any way you want."

It took a lot of talk before the agency got used to the idea of using a photographer for social research. Still, there was no authority to hire one, no slot for a photographer in the table of organization, and no funds. It seemed an impasse, until "in a sort of defiant euphoria," as he put it, the office manager, Lawrence Hewes, Jr. (a Dartmouth graduate whose young career in stocks and bonds was abruptly terminated by the Wall Street debacle), broke the rules and hired Dorothea Lange at $1,560 a year, listing her as a clerk-stenographer. To get around the problem of expenses in the field, he increased Paul Taylor's per diem allowance for travel and entered the cost of her film under "clerical supplies." Since the agency had no darkroom, supplies or staff for it, she was to develop and print her own work. The division director, told that Dorothea was on the payroll, lectured Hewes sternly on proper procedure and warned, "We'll try it for a month, then we'll see."

Hewes himself is an example of Taylor's and Lange's personal influence. He had been a young businessman, a staunch Republican, when he was offered his Depression job. Surrounding him both in California and later on in Washington were many young men like himself, "county agent types," staffing the Rural Rehabilitation Division and the RA. Most of them were graduates of agricultural schools, indifferent to social problems. They believed each man was responsible for his own condition, not society. And generally they were blind to the issue of racial equality. When Taylor proposed a Chinese woman for the staff, some were so shocked they tried (and failed) to keep her from being hired. Paul Taylor and Dorothea Lange, Hewes says, opened many an eye to the real world. "I can thank them for making an ardent New Dealer out of me."

When Dorothea learned her job was safe only for a month, it was a

strain on her. What did she have to do to prove she was worth keeping? Her test came quickly, when disaster threatened the pea pickers in Nipomo. Several hundred migrant families had flocked into the small valley in San Luis Obispo County, on the south-central coast, seeking work in the early pea crop. But bad weather had set in, spoiling the crop, and an endless cold rain fell on desperate families huddling in their old jalopies or under makeshift tents of blankets and tarpaulins. Like the crop, they rotted in the empty, sodden fields, without shelter, sanitation, food, or the gas to move on. Taylor realized at once the drama of the pea pickers' plight. In Nipomo he could find the documentation necessary to attract national attention and force action to help the migrants. He chose a team of four to go into the field—three men and Dorothea. Two of the men— Edward Rowell and Tom Vasey—were graduate students in economics at Berkeley. Taylor told Rowell this would be the first time they'd have a photographer in the field. He didn't know how she would be received. He instructed Rowell to stick with her, to help carry her cameras, and to see that nothing bad happened. He told Dorothea not to worry on her first day out. No one knew how the people at Nipomo would feel about someone shooting pictures. "If you don't make a single photograph the first day," he said, "that's all right with me."

When they got to Nipomo, she went straight to the migrants and started taking pictures. Right from the beginning, Taylor said, she showed she could use not only her eye but her ear. Their first times out she would take pictures and talk with people, listening intently to what they said, then sidle over to Taylor and repeat what she'd heard as he scribbled it into his notebook. Later she herself jotted down the phrases people used, the often vivid words in which they distilled their experience. There is, to cite but one example, her photograph of a pea picker leaning against his flivver, and under it what the man said: "This life is simplicity, boiled down."

How she worked the first few times in the field is recalled by Tom Vasey: "She was a small person with a slight limp. The characteristic pose was with the Rollei on her left shoulder, held by the left hand. From here it always seemed least distracting to the subject as she brought it down for use after a bit of talk. She was particularly adept in getting closeup cooperation with the women and children." In break periods and at mealtime Vasey found her conversation "always stimulating. Dorothea shared easily but did not dominate."

It was on one of those first trips that the reality of the mass migration hit home. Returning from a day's shooting in the field, she stopped to get gas and watched the car full of people ahead of her as she waited her turn at the pump.

> They looked very woebegone to me. They were American whites. I looked at the license plate on the car and it was Oklahoma. I got out and asked which way were they going, were they looking for work? And they said, "We've been

blown out." I questioned what they meant, and then they told me about the dust storm. They were the first arrivals that I saw. These were the people who got up that day quick and left. They saw they had no crop back there. They had to get out. All of that day, driving the next miles, I saw these people; and I couldn't wait—I photographed them.

Dorothea was amused by Taylor's intense concentration on the job before him. They would be on the road by six in the morning these first expeditions, and he would have them going all day without thinking anybody should bother to eat or rest. The staff went along until it got too much and they called a halt. When they did stop to eat, she was upset when she saw the men ordering dinners (on their per diem) that cost $1.75. In those days you could get a pretty good meal for a dollar. She thought it was "sheer self-indulgence, inhuman," to be in the field all day studying migrant labor conditions and then go into a hotel to spend on your meal what it took the workers six hours to earn.

To secure useful interviews and photographs it was essential to win the confidence of the migrants. Taylor's approach was casual and indirect. He'd get out of his car, walk over to the people, and put a simple question, such as, "How far is it to the next town?" After they answered him, it was easy to ask, "What's the work going on here?" And then, "Where do the people come from who do the work?" He wanted to avoid any suspicion that he was an agent intending harm. After a series of such questions, people would sometimes begin to wonder why he wanted to know so much, and they'd start to question him. He would immediately explain that he was from the State Relief Administration and had been asked to find out the conditions and what the people said about their conditions. People accepted him and his staff in that role. When Dorothea was with Taylor or one of the other men as they talked to the migrants, she would stand around quietly and, when she saw anything she wanted to photograph, get her camera ready and do it, unless they objected. The interviewer would keep the talk going, making it easier for her to work unobtrusively.

But she quickly proved she could do it all by herself. When she was shooting alone, her method was often to walk up to the migrants, look around quietly, wait until they appeared to be used to her and wouldn't mind, and then take pictures. Sometimes she did it while talking with them, sometimes not. She said she wore her "cloak of invisibility"—the same protective look she had adopted while walking the Bowery as a child. Recalling the way he saw her working in this period, Taylor said, "It made her feel she could go up and do things which otherwise seemed to be intruding on their privacy. It gave her a feeling of confidence in working with the camera." It was almost like playing a game—"they can't see me"—but what made her successful was her natural skill in relations with

people, an ability to put them at ease, to make them feel she cared. She would never intrude her camera upon anyone's privacy. If a person refused to be photographed she would not find some sneaky way to shoot him. If nothing was said but she felt unwelcome, she would fool around with her equipment or just go sit down in a corner and let them look her over. She was aware that some people withdrew because they felt she did not belong with them. Tactfully then she would speak to them about who she was and what her family was like, where she came from, what she represented, so that she told them much about herself, and truthfully. Then, if she asked questions, it was a fair exchange. It took more time to work that way, but she thought it a human way of meeting her fellows on the same level.

When they spoke to her, she wanted to get down their exact words. Knowing the limit she could hold in her head, she would find some pause in which to scribble down the words in her own shorthand, relying on the rhythm of the speech, and knowing that if she lost just one word it often meant that rhythm would collapse. She believed strongly in the use of those words. To her they were not a repetition of or an intrusion upon the images, but their extension: "What the right words can do for some photographs is enormous."

Later, she commented on the difference between what she was doing in the field and what she had done in the streets of San Francisco. "I had begun to talk to the people I photographed. For some reason, I don't know why, the people in the city were silent people, and we never spoke to each other. But in the migrant camps, there were always talkers. This was very helpful to me, and I think it was helpful to them. It gave us a chance to meet on common ground—something a photographer like myself must find if he's going to do good work." But in another respect, the migrants—homeless, cut off from the stable rural communities they had once known—were hard to photograph. "Their roots were all torn out," she said. "The only background they had was a background of utter poverty. It's very hard to photograph a proud man against a background like that, because it doesn't show what he's proud about. I had to get my camera to register the things about those people that were more important than how poor they were—their pride, their strength, their spirit."

It must have taken considerable nerve to drive into these agricultural valleys and start asking questions and taking pictures, even when you represented an agency of the state. For most of these farms were not independent family operations but "factories in the fields," whose owners were bitterly hostile to intervention of any kind.

California's kind of intensive agriculture, built by heavy investment in irrigation and mechanization, demanded large acreages to be profitable. The "farmers" of such huge enterprises were usually absentee owners,

corporations which functioned through local managers. In the thirties, a tenth of California's farms produced over half the crops. The small farmers produced only 6 percent.

Such highly intensive agriculture meant peak demands for hand labor which could not be met locally. So the farms relied on migrant labor. The men, women, and children who followed the crops worked perhaps four to six months a year, and only intermittently. It was an overflowing labor pool, with three people for every one job. The average income per migrant *family* was between $350 and $450 a year—less than half the amount relief officials estimated necessary for living on a subsistence level. In 1932 the basic field rate was 15 cents an hour. A year later a new union organized thousands of migrants and led some fifty strikes, succeeding in raising the average wage for field and shed labor to about 27 cents an hour by 1934. But that year—the year of the San Francisco general strike and the hysterical election campaign that defeated Upton Sinclair—the same anti-"red" tactics were used by employers and the state to smash the fledgling union of migrant workers. Vigilantes made the life of strikers and organizers a bloody hell. Taylor, who investigated the cotton-pickers strike as a member of the governor's settlement committee, thought that while the union leadership was largely Communist, many of them recently radicalized students, the strikers were not. Most important, it was the conditions of labor which produced the strike. The Communists were taking advantage of a bad situation, he said, not creating it. But the farm owners believed that it was all a Communist plot and that their troubles would be over if they just got rid of the reds. The union leadership was convicted of treason under the criminal syndicalism law and sentenced to long terms. (Three years later the convictions were reversed by an appellate court.)

Out of that conflict came a new statewide organization, the Associated Farmers, the response of the employers to labor's feeling that unionization was necessary to protect its interests. It was another link in the familiar chain of labor history: workers organize, employers counterorganize—only this time in a new setting, California agriculture. The Associated Farmers, wrote *Fortune* magazine, "composed mainly of small or medium-scale farm operations . . . is dominated by the big growers, packers, utilities, banks and other absentee landlords who are all-important in the state's farm system . . . It claims to be 'not anti-union or anti-labor' but it takes pride in having helped enact picketing ordinances in the majority of California's fifty-eight counties . . . From labor's point of view, the Associated Farmers is a thinly camouflaged strikebreaking agency. To the big grower, it is a strong-arm defense against the menace of Communist agitation. The small grower's view is less clean-cut, but he often finds it healthier to join the Associated Farmers than not, if he wants to get crop loans from the banks." The editors went on to say that California's industrialized farming exhibits "all the customary weapons of industrial war-

fare including tear gas, finks, goon squads, propaganda, bribery, and espionage."

On one of the early field trips, while Taylor and his team were talking with and photographing fruit pickers in the Sacramento Valley, the grower came up and wanted to know what they were doing there. He was upset to see these outsiders on his land and uneasy about anyone talking to his workers. He asked Taylor to get into his car and they drove off. Taylor told him who he was and what he was doing there. It turned out that the man's niece was one of Taylor's graduate students, which eased the tension, although the grower wasn't happy to have anyone investigating field conditions. Taylor would often ask such men if they had any suggestions to make to SERA. It defused the anger of some, but others went to SERA and objected to what Taylor was doing.

When the team came in from the field each day, Dorothea would develop her photographs in her Gough Street darkroom. Sometimes Taylor would go along to see the prints coming through. Or she would bring them to him the next morning at the Fourth Street office. Taylor began making frequent brief reports to the agency, working Dorothea's photographs into them. It was the most effective means of overcoming the chief's skepticism about putting a photographer on staff. The informal reports varied in length and style. They might contain typed or handwritten text, news clippings gathered in the field, a few of Dorothea's photographs, and, facing them, quotations from the migrants. Every time the team came back to the office after a trip out, Taylor would turn in these "Notes from the Field" for the chief to read and pass on to Washington. Early on he asked Dorothea to sign one of the reports by herself. He wanted to build up her role in the minds of the bureaucracy. He wrote the brief text, as usual, but he felt this report, like the others, was as much hers as his, for they worked so closely together, both in the field and in preparing the reports. Their experiments with different forms of reporting developed into more formal presentations designed to produce new policy and the funds to support it. Taylor found the living conditions of the migrants still as bad as the earlier Leonard-French-Lubin report had stated them: ". . . filth, squalor, an entire absence of sanitation, and a crowding of human beings into toally inadequate tents or crude structures built of boards, weeds, and anything that was found at hand to give a pitiful semblance of a home at its worst. Words cannot describe some of the conditions we saw." He quickly decided to recommend government camps where the migrants could live decently in tents or mobile homes, with water supply, bedding, toilets, facilities for washing clothes.

What would be the most effective way to make his proposal? There was no money for the fancy kind of advertising agency presentation. The text would have to be given in typescript and the pictures pasted to the pages. Dorothea suggested using the new wire spiral-binding technique for mak-

ing up reports. She got strong cardboard covers and waxed them to improve their appearance. Maynard Dixon, who had gone along on a field trip with his wife and Taylor, drew a map of California tracing the principal routes traveled by the migrants and hand-lettered the captions for Dorothea's photographs. Taylor's text ran fifteen pages, and was followed by thirty-nine pages, with fifty-seven of Dorothea's photographs. They are not dramatic or sensational. They simply show people in the conditions the research team had observed, how they traveled, where they worked and slept. And alongside the photos the migrants speak in their own words: "If I could earn four dollars a week we could get along . . ." This from a Mexican fieldhand leaning against a shanty, his wife and three kids next to him. Some of the captions are in Dorothea's terse language, pointing out that this "house" you look at is made of rags, that one of weeds, and the "better-type" homes are built of material from the nearby city dump. The emphasis of course is on "the deplorably inadequate" housing and the lack of pure-water supply, which were the major grievances in the scores of strikes racking the state the past three years. Endorsing Taylor's proposals for action, H. E. Drobish, his division chief, passed the report on to Washington with an appeal for $100,000 to erect government camps for migratory laborers in California that would provide the minimum decencies necessary for healthy living under the weather conditions met in each locality during the crop season.

Without waiting for Washington to react to the proposal, Taylor and Dorothea found ways to speed results. They invited an editor of the San Francisco *News* to dinner, let him page through the report with its pictures while they talked to him about their field trips. A week later the *News* ran an editorial supporting the proposal for a camp program. Then they took the regional adviser on rural rehabilitation into the field to see conditions for himself. Lowry Nelson represented the Federal Emergency Relief Administration (FERA). They put Nelson and his wife into a station wagon and drove the length of the state down to Fort Yuma in Arizona, which was the point of entry to California for many thousands of families fleeing the drought. Wherever Nelson looked, he saw how urgently action was needed on the Taylor-Lange report. He asked them for a supplementary report, this time one that would document the accelerating tide of refugees from other states seeking rehabilitation in California. On April 17 Taylor and Lange turned it in, using much the same form as in the other report. This time the text ran only three typed pages, while thirty-nine of Dorothea's photographs took up twenty-four pages: a man wearing glasses, seated on the running board, looking up at the viewer; an East Texas farmer and his family of seven, standing on the road, back against a wall, flivver to the side; the shot of a woman's skinny legs from the knees down, torn shoes resting tentatively on the ground, as though unsure of

this earth. There was a hand-drawn map too, again probably Maynard Dixon's work.

Washington FERA had allotted $20,000 for some project in California which had just been dropped. Nelson wired headquarters recommending that California FERA be allowed to use that money to start two migrant labor camps on an emergency basis. The reply came: Yes. And small as that sum seems now, it was enough to build camps at Marysville and Arvin.

If Nelson hadn't been moved to nail down that money, Taylor said long after, "I don't know if ever we would have got our camps started. There was unease over the camp program in Washington; there was grower opposition. There were precedents for state and city public housing, but this housing for migrants turned out to be the first federal public housing in the United States."

The idea of government camps scared the growers. They feared that if the migrants were brought together in them, they would organize and strike. The big landowners were not about to provide land for this purpose. But a woman in Kern County, a small landowner friendly to labor, rented FERA forty acres for the Arvin campsite. And in Marysville the city council provided the land. Using the federal money and the products of WPA labor, the camps were quickly built. They opened with toilets, showers, stoves, platforms, and tents to sit on them, simple buildings for community use, and an office for the camp manager. The most the opposition could do was to check the expansion of the program. Washington asked Taylor to recommend other places in the country where such camps should be opened. He gave them a list of locations, but it took years before the money was put up for some twenty-five more camps all around the rim of the country.

Taylor and Lange did their best to promote them. He paced a public-relations campaign, talking to community leaders, to employers, to labor contractors, to such big-city powers as the Commonwealth Club in San Francisco, analyzing the problems and proposals to solve them, using Dorothea's before-and-after photographs as examples. Others might have been dragged down by the enormity of the migrant problem, but the response of Taylor and Lange went beyond sympathy. "We did not just go around wringing our hands," said Taylor. They wanted to *do* something. And they were in a position to use their talents to get something done.

Surprisingly enough, attacks came from the left as well as from the right. The radical press asked, "Are these camps, or cages?" and warned of penning up workers behind barbed wire. The American Civil Liberties Union feared that in a government camp the migrants would not be allowed to organize. Taylor countered with the fact that no one using the camps would lose his constitutional rights.

Photography did not stop when the camps opened. Now Dorothea's job included showing the uses to which they were put, demonstrating the difference they made to the migrant families. There are pictures of teachers working with pre-school children, of nurses caring for the sick, of people cooking and washing and cleaning, of men making music with fiddles, of people sitting around in the evening, just talking. The caption for the last reads: "What is the state of the nation: Marysville campers talk politics." Which way will people go, this report seems to ask, almost as if to warn the federal officials that if action isn't taken, the consequences might be bad. At the dedication ceremony for the Marysville camp, even the conservative Farm Bureau and Chamber of Commerce people showed up. The skeptics were curious.

Meanwhile, in Washington, the constant creation of new administrative agencies and the juggling of old ones had brought changes which would affect Dorothea Lange and Paul Taylor. The Rural Rehabilitation Division of FERA was transferred out and put under a new agency headed by Rexford G. Tugwell. While professor of economics at Columbia University, Tugwell had been one of Roosevelt's "brain trust" during FDR's first campaign for the presidency. Appointed undersecretary of the Department of Agriculture, he now had the additional task of running the new Resettlement Administration (RA) created by Roosevelt's Executive Order of April 30, 1935. Its broad mandate was to do something about indigent people in rural areas all over the country. Its assignments were numerous and herculean: to provide low-interest loans for poor farmers, to develop large soil rebuilding and conservation projects, and to create programs for resettlement. This last alone was a tall order for a variety of measures: setting up experimental communal farms for families displaced from the land, offering loans and supervision to farmers in trouble, moving unemployed families from the cities to rural villages where they could support themselves with home garden plots and part-time work, and sponsoring camps for migrant farm laborers.

The immediate effect upon Taylor and Lange was to enlarge their sphere of operations. Before this, they were confined to California. Now the Rural Rehabilitation Division was given a regional assignment, which added the four states of Nevada, Utah, New Mexico, and Arizona to their own. Dorothea would operate under the Information Division of RA. By June her job listing was changed to Field Investigator, Photographer, and her salary was $30 a week. Taylor, in this first half of 1935, was on two-thirds leave from the university.

Lawrence Hewes, the man who had risked putting Dorothea on the payroll in the guise of clerk-typist, was asked to come to Washington to be Tugwell's administrative assistant. The shift delighted him, and Taylor and Lange as well. They would now have a friend in Washington standing at Tugwell's elbow, and Tugwell's influence at the White House was said

to be great. This was a chance to do something more for the migrants. Extra copies of the Taylor-Lange reports were made, and when Hewes left the send-off party Dorothea, Maynard, and Taylor gave for him, he carried their reports to the capital. He showed them whenever he got an opening—to Tugwell, Senator Robert La Follette, Mrs. Roosevelt, Secretary of Agriculture Henry Wallace, Secretary of the Interior Harold Ickes. Hewes pressed the point that the migrant problem in the Far West was different from elsewhere. It was not simply poverty or tenancy; it was deep dislocation. He found nothing more influential in convincing people than the illustrated reports. Earlier, in California, Hewes had taken much criticism from the social workers who staffed the agency. They abided by standards of professionalism, and who was this Dorothea Lange? She had never studied social work, she had no college degree, she had no practical experience in their field. How could Hewes put her on to do the photography only a social worker should do, *could* do? When he saw the powerful effect of her photographs in Washington, he knew, he said, that "she was about the most important thing in the whole show."

Taylor's promotion of housing for migrants set up by federal funds made many people in Washington dubious. Henry Wallace was one of them. He was under pressure from the Farm Bureau, which opposed the idea. Many of the officials in his department, trained on the scientific side of agriculture, thought much about questions of land, production, machinery—and little about people. But when Wallace was escorted to the Marysville camp and took his first look, he was impressed. Tugwell, a professor of economics at Columbia and now Wallace's undersecretary, as well as RA chief, went over the reports from California. He studied Dorothea's photographs and responded to what they told him. He became very enthusiastic about the policies they pointed to.

On Tugwell's staff in Washington was the economist Roy Stryker. Born in 1893 on a Kansas farm, and raised in the populist tradition of agrarian radicalism, Stryker had grown up on a Colorado ranch and then come to New York to study economics at Columbia. With Tugwell as his mentor, Stryker became a teaching assistant at the college. One day Tugwell asked him to take over the job of selecting and editing the illustrations for his new textbook on problems of contemporary American civilization. He combed through thousands of pictures in the files of newspapers, magazines, and picture agencies, but found few illustrating social issues. The famous photographers of the twenties, like Steichen and Weston, were making beautiful images, but nothing documenting social problems. That too was the case with Stieglitz and the pictorialists. Stryker had to go outside their realm of salon and magazine photography to find the documentary work of Riis and Hine, men who used the camera as an instrument of social analysis. Out of his own experience and as an economist Stryker knew that millions of American families had no share in the boom of the

twenties. But few cameras were being pointed at their problems. Stryker ran across the photographs of Lewis Hine in *Survey Graphic,* looked him up, and from his files took scores of pictures showing the conditions of child labor, immigrants, poverty, and industrial life. For the next five years, while going on with his teaching, Stryker continued to improve and expand succeeding editions of the textbook, extending his knowledge of graphic resources and intensifying his feeling for the possibilities of the image in deepening human understanding of social questions.

Soon after Tugwell came to Washington, Stryker's reputation as a specialist in the use of illustration got him a summer job in the Information Division of the new Agricultural Adjustment Administration. When he discovered the wealth of material in the Department of Agriculture's picture files, he proposed to Tugwell that they do a picture source book on American agriculture. Back at Columbia in the fall of 1934 he continued research on the project, using student-aid funds to hire Arthur Rothstein, a pre-med senior and an amateur photographer, to photocopy pictures Stryker was digging up. No book came out of their effort; the work was interrupted in the summer of 1935, when Tugwell offered Stryker a job in the Information Division of the new RA. Giving him the vague and misleading title of Chief of the Historical Section, Tugwell told him his work was to find ways to bring the agency's programs before the public.

It was in those first weeks on his new job that Stryker saw Dorothea Lange's photographs. Paul Taylor had come to Washington briefly on official business and was told by someone to look up Stryker because he too was interested in using pictures for social purposes. Stryker was just feeling his way; he did not yet know exactly what to do or how to do it. But Taylor, he saw, was already doing something significant with pictures in California. He had Dorothea Lange on his staff, and in his hand were the reports they had produced together.

Whether it was on the same occasion or another is not clear, but Ben Shahn has said he was present when Dorothea's photographs were first seen by Stryker. "This was a revelation," Shahn said, "what this woman was doing." But to Stryker it was not the same kind of revelation. "Along came Dorothea Lange's pictures," he said. "I didn't know how good they were. I had to grow into that recognition of her pictures." When he got to know her work better and to see it in relation to other work produced by his staff, he came to feel that Dorothea "had the most sensitivity and the most rapport with people."

Another man who saw the Taylor-Lange reports with a special eye was Pare Lorentz. He too was in the RA Information Division. He had come to Washington that June to begin work on a government film about the Dust Bowl that would be dramatic enough to earn a place in the commercial movie houses. Lorentz knew about the migrants: a year earlier he had written a long piece on the Dust Bowl for *Newsweek.* When he saw the

Taylor-Lange reports, he wrote to Taylor to say he thought them "the best job both pictorially and from a literary standpoint that I have seen in any government bureau." He asked for a set of the prints to show educators and journalists, and wanted the name of the photographer.

That fall, when he was making *The Plow That Broke the Plains*, he borrowed Dorothea for a week. "Her still pictures which I saw in Washington when I was writing the scenario caused me to put a California sequence in the picture." She joined him along U.S. Highway 99, helping to line up migrant families so that his cameraman could film them. Lorentz found her to be "an old-fashioned guild workman. Simplicity is more than a technique; it is an attitude towards work and life itself . . . She hadn't been paid even her expenses, much less her salary . . . She was going bankrupt, and all she wanted to talk about was the exciting scenes she could get for me along route 99; the vast amount of work there was to be done, and the wonder that we were being allowed to do such exciting work." Later, he described her as "a little, soft-voiced, bright-eyed woman with a weather-beaten face . . . beret cocked over one ear . . . stalking the back roads of the country photographing the poor." But, he added, "she has selected them with an unerring eye. You do not find in her portrait gallery the bindle stiffs, the drifters, the tramps, the unfortunate, aimless dregs of the country. Her people stand straight and look you in the eye. They have the simple dignity of people who have leaned against the wind, and worked in the sun and owned their own land."

So powerful was the initial impression made by her photographs that Dorothea long after sometimes believed Stryker's unit was established as a result of her work. She says in her Berkeley interviews that the Taylor-Lange reports helped get Stryker's section budgeted. But the facts do not seem to bear out her impression, though there is little doubt that her early work not only gave impetus to the Tugwell-Stryker project but to the development of photojournalism. The July 1935 *Survey Graphic* carried two articles illustrated by Lange pictures which Florence Kellogg, associate editor, called "a gold mine . . . we regret we can't use them in dozens." In the longer article Paul Taylor described the "children of distress" driven West by dust, drought, and Depression, and speculated on their prospects in California. "Again the Covered Wagon" is laid out with six of Dorothea's photographs, captioned by those moving quotations. Placed right after this article is the other, called "Pea-Pickers' Child," signed with the pen name "Lucretia Penny," and illustrated with two Lange photographs.

For whatever reason Stryker favored her work—and national publication of her photographs must have helped—he wanted Dorothea on his payroll. On September 1, 1935, she was transferred to his RA unit, and attached to the Western regional office. Her salary was to be $2,300 a year, which amounted to a raise of about $15 a week. Her title now was Photog-

rapher-Investigator. (At about the same time Taylor was appointed regional labor adviser to the RA, assigned to the same office.) Dorothea was not the first photographer to join Stryker's unit. The priority goes to Rothstein. He was the youngest on staff; Dorothea, at forty, was the oldest. She and Ben Shahn, three years her junior, were considerably older than all the other photographers who would work for the section. Lewis Hine, now in his early sixties and desperate for work, tried for two years to get a job with Stryker, but, thinking him too old, Stryker never took him on, using lack of funds as an excuse.

Stryker himself had been given only a three-month appointment, but with an annual renewal possible if his project proved its worth. He was supposed to be recording anything of historical value about the RA's work. He gave Arthur Rothstein the initial task of training his camera on the dullest material—memos, remodeled office interiors, new RA buildings—while Stryker waited for other specialists to join the section. But the promised economists and sociologists never showed up. Meanwhile, other sections of RA began to use cameras to record their work, too. Soon Stryker urged Tugwell to unify the random shooting, and in consequence wound up with full responsibility for photographic representation of RA's work. Rothstein, who knew far more about photography than his boss, took on the job of acquiring a good darkroom and the staff to run it. Consolidation of photography brought Stryker new and superb talents. By the end of 1935 his staff was firmly established, with Arthur Rothstein, Carl Mydans, Walker Evans, Ben Shahn, and Dorothea Lange.

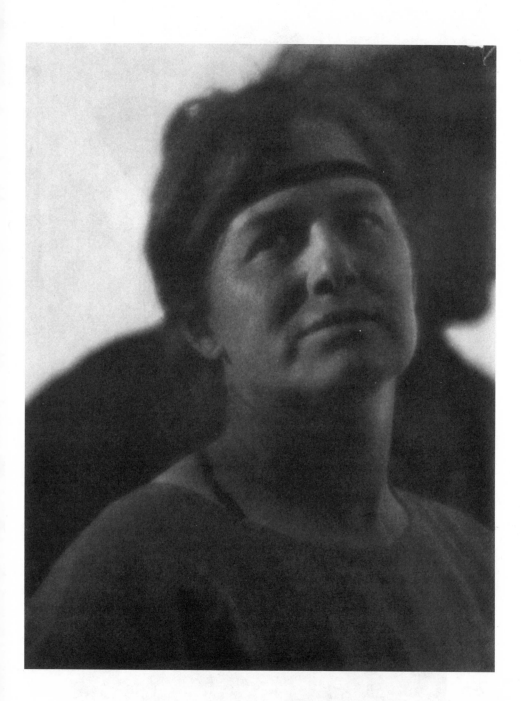

Dorothea's mother, Joan, 1922
DOROTHEA LANGE

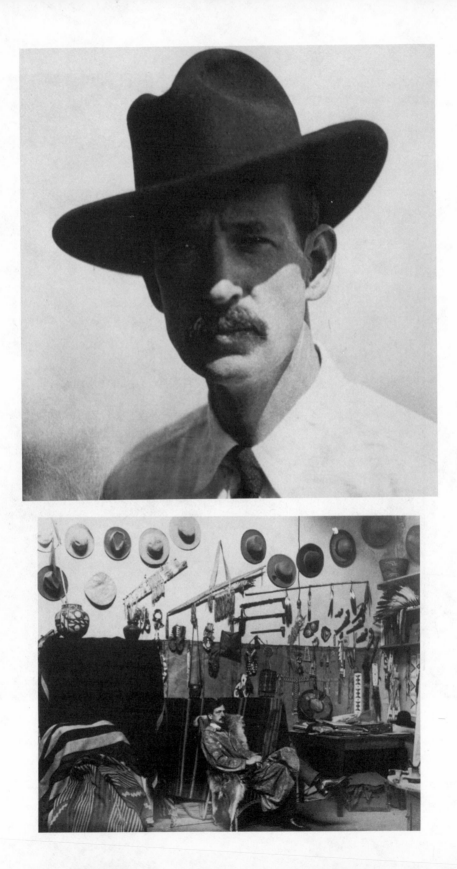

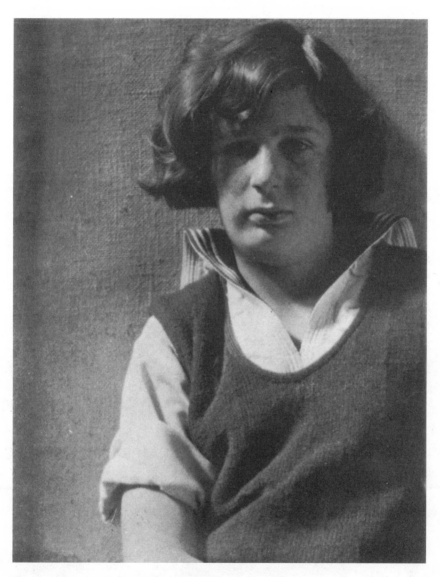

Constance Dixon, c. 1923
DOROTHEA LANGE

Maynard Dixon, c. 1921 (*opposite*)
DOROTHEA LANGE

Maynard Dixon in his studio, 728 Montgomery Street, San Francisco, c. 1920

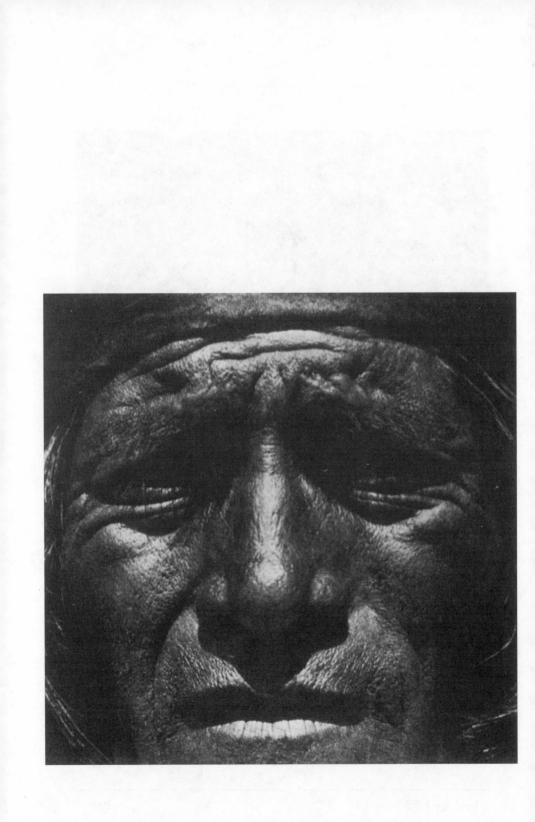

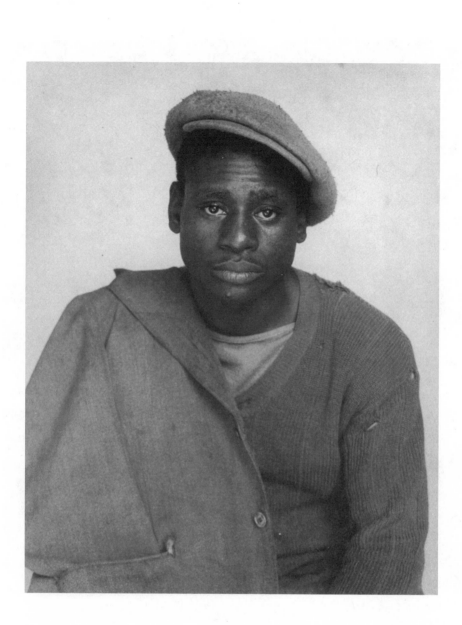

Man with Cap, c. 1924
DOROTHEA LANGE

Hopi Indian, New Mexico, c. 1923 (*opposite*)
DOROTHEA LANGE

John, San Francisco, 1931
DOROTHEA LANGE

Mexican-American, San Francisco, 1928 (*opposite*)
DOROTHEA LANGE

Ansel Adams at the Willard Van Dyke Gallery, 683 Brockhurst, Oakland,
California, c. 1933 (*above*)
WILLARD VAN DYKE

Edward Weston, c. 1933 (*opposite, top*)
WILLARD VAN DYKE

Willard Van Dyke, at Carmel, 1933 (*opposite, bottom*)
EDWARD WESTON

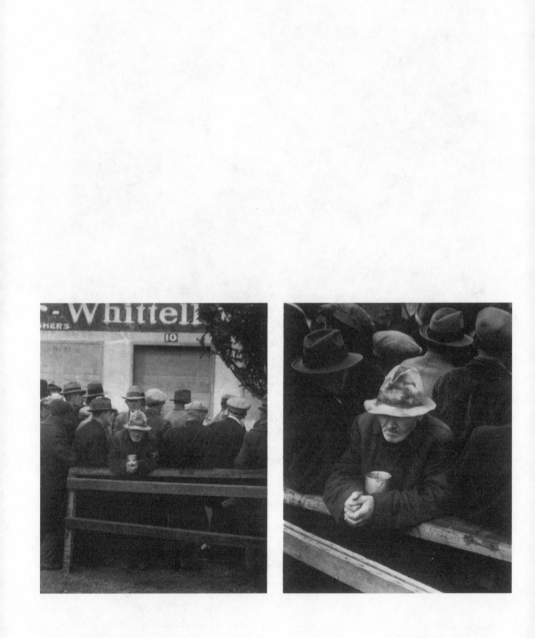

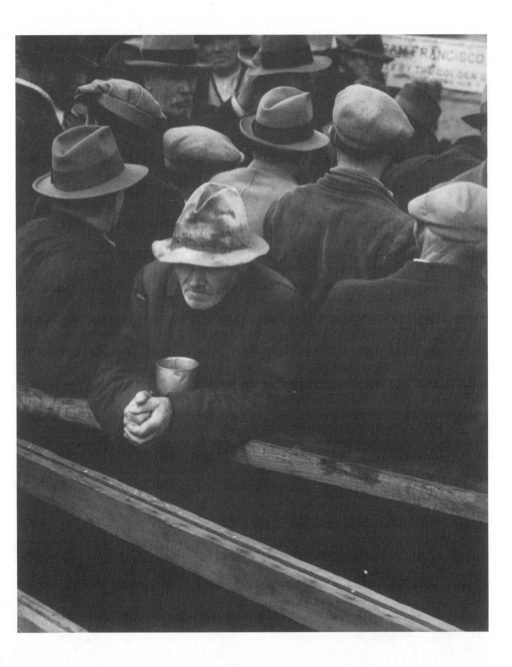

White Angel Bread Line, San Francisco, with two other views made within
moments of the classic photograph, 1933
DOROTHEA LANGE

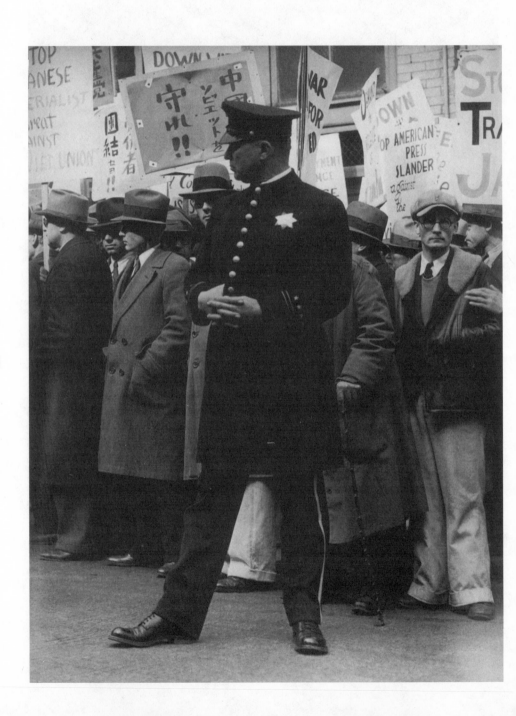

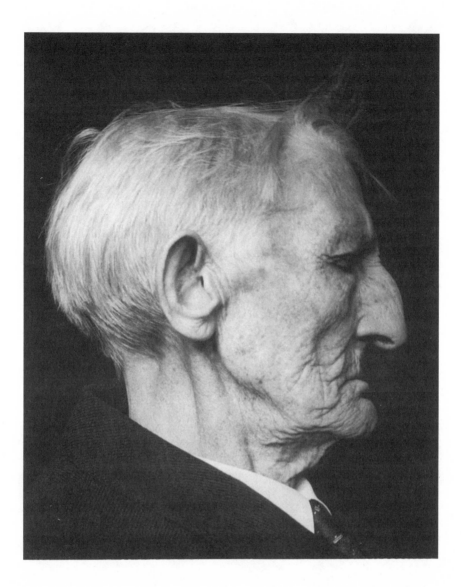

Andrew Furuseth, San Francisco, 1934
DOROTHEA LANGE

Street Demonstration, San Francisco, 1933 (*opposite*)
DOROTHEA LANGE

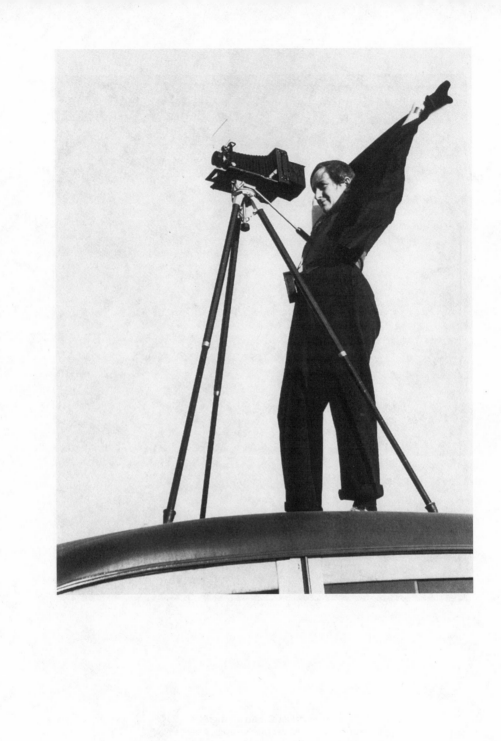

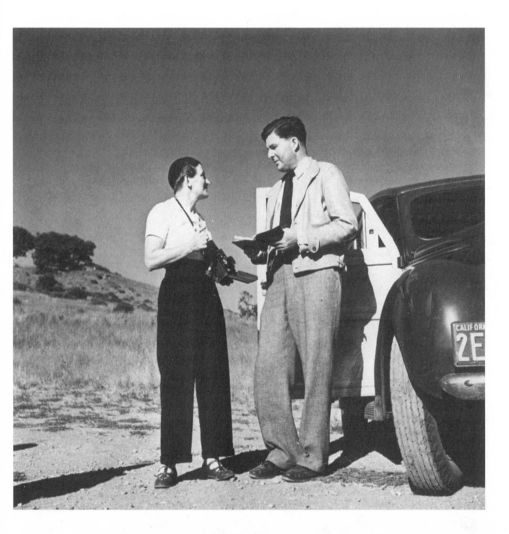

Dorothea Lange and Paul Taylor on field trip, 1935

Dorothea Lange, 1934 (*opposite*)
RONDAL PARTRIDGE

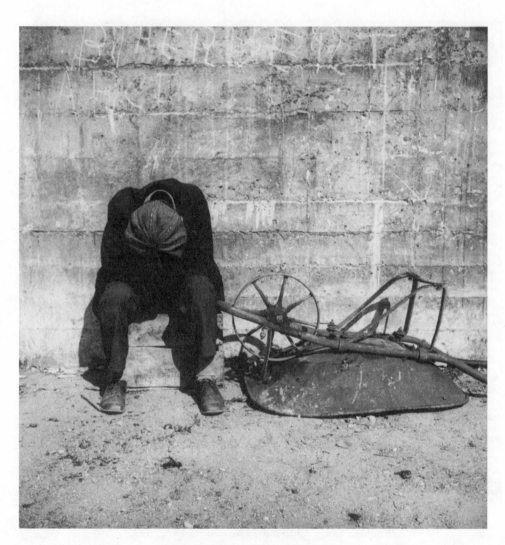

Depression, San Francisco, 1934
DOROTHEA LANGE

PART THREE

1935–1940

7 1935 WAS A CRUCIAL YEAR OF BEGINNINGS AND
endings for Dorothea. It happened to be the year of her fortieth
birthday. As she crossed that mid-life boundary line, she had al-
ready made the transition from studio portraitist to documentary photog-
rapher. Despite the commercial nature of her work from 1920 to 1934, her
honest approach to character delineation and her technical skill in captur-
ing the image had earned her a place among the West's creative photogra-
phers. The Depression cut away her studio's base of support among the
well-to-do at the same time that it forced upon her attention the unem-
ployed on the bread lines and in the Hoovervilles. The decision to take her
camera out of the studio and down into the streets was in all likelihood the
result of two pressures—one external, one internal—the crumbling eco-
nomic system and her creative frustration. For a year or so, on her own,
with no encouragement or hope of remuneration, she had photographed
the soup kitchens, the street demonstrations, the waterfront picket lines,
the hobo jungles, working alone to record the human experience of social
disaster. Here she had found her special gift as a photographer. But there
is no way of knowing whether she would have gone on with it if chance
had not brought her together with Paul Taylor. His discovery of her work
in Van Dyke's gallery, and his realization that she was the photographer
he needed for his visual approach to socioeconomic research, gave her the
patron (government) and the means (a regular paycheck) she could not do
without.

This fundamental change in her professional work is linked to the
equally important turning point she came to in her private life. She was in
the fifteenth year of a marriage that had long been in trouble. Maynard
had always had other women on the side; everyone knew it. Was it to
even the score that she turned to other men? No one thinks she was pro-
miscuous then or ever. Nor was she puritanical. "Fastidious, rather," as
one intimate puts it. After her second son was born, Dorothea had two

abortions, traveling to Seattle for them. It may have been because she felt two children were hard enough to care for under the demands of a professional commitment and with a marriage that was foundering.

When Roi Partridge told Dorothea and Maynard that he felt he and Imogen Cunningham should be divorced, they tried to persuade him not to go through with it, never confiding that their own marriage was close to that point. Soon after, Partridge married again and Maynard came to his friend's wedding, alone. But halfway through it he disappeared. When Partridge asked for an explanation, Maynard said it had so affected him to see his friend happy with a new wife that he couldn't bear to stay. Dorothea confided in Imogen. "One day she called to ask if she could bring Paul Taylor and his daughter to dinner that night. 'But it's after five,' I said, 'and all I have is a small leg of lamb.' 'That's all right,' she said, 'let Paul carve it and it will come out all right.' It did. She asked me to come down into the basement with her and there she told me she was going to marry Paul. 'But you're married to Maynard!' I said, astonished. 'Yes,' she said, 'he's a good man, and strong enough to take it; he helped me come to this decision.' "

It was on a field trip to the Imperial Valley in the spring that Dorothea realized she was in love with Paul. His marriage with Katherine Page Whiteside had been in serious trouble for some years before he met Dorothea. So on both sides they were ready for someone else. Soon after that trip, Dorothea must have determined to discuss divorce with Maynard. Her older son recalls how he learned of his parents' intentions. He came into their bedroom early one morning, and lying there in the nude, the way they usually slept, they told him they were going to be divorced. Daniel was ten then, and he remembers hearing the words and fixing his attention on the three moles on his father's head, just visible under the fine dark hair. He ran out on the street and excitedly told all the children that his folks were going to be divorced. The neighbors were largely Italian, and the Catholic children, scandalized at the bumptious way he announced the news, began jeering at him. It was painful.

And painful too for Maynard, though he did not resist it and would maintain friendships with both Dorothea and Paul. In his autobiographical notes there is this entry: "Tragic interlude: divorce." He was sixty now, badly incapacitated by emphysema, barely scraping a living, and he was losing his wife and his boys. In October he went to Nevada for a divorce and, when he returned, began a bachelor life in his studio. Taylor's wife also went to Nevada, cooperating in a divorce, as Maynard had, after fifteen years of marriage.

The Taylor-Lange match would be an extraordinary one in the view of almost everyone they knew, so different were the two in many ways. That very mixture of contradictions may have been what helped the marriage to grow and endure for the thirty years until her death. Some of their friends

think Dorothea was at first in awe of Professor Paul Taylor. Certainly photographers like herself had never enjoyed the prestige of academics. Before they met she had known no one like him. The Nutzhorns and the Langes could count no scholars in their clans, and in California the bohemian crowd she and Maynard moved among, while it boasted many artists and writers, included no intellectuals of his caliber. Here was a disciplined scholar with a superb mind, a man who could offer her intellectual challenge, and she rose to it.

She saw in him from the first what had been apparent to his adolescent classmates. Under his picture in the high-school yearbook was written "I can, and I shall." She took great pride in the courage with which Paul fought for his convictions. His unending labors to protect land and water resources from the greed of the rich and the powerful, and to see them preserved for the health of the nation, impressed her deeply at the same time that his very persistence amused her. In her papers there is frequent teasing reference to "the issue," and how Paul was ready at any moment to prepare a report in its behalf, make a speech, write a letter, teach a seminar, do a study, buttonhole an official, lobby an agency, no matter where they went, in Berkeley or Bangkok. At the age of eighty, ten years after her death, he would still be trying to get people to understand how fundamental was the question of who controls the land. His scholarship was still the foundation of a crusade for the family farm. He was still resisting the pressure of monopolists and speculators against enforcement of the 1902 Reclamation Act. He had got angry long ago over the toadying of public officials to the forces they were charged with regulating, and he stayed angry. "They took the oath of office," he said of the Reclamation Bureau officials; "why the hell don't they obey it?" It was that blazing indignation at injustice that Dorothea respected. Not long before she died she said to a friend, "To think that after all these years the issue is still alive and one man alone has kept it alive—Paul!"

The power he focused on public issues he did not exercise with Dorothea. She found in him a solid man, a quiet man. In happy contrast to Maynard, he offered the promise of emotional security. He was a one-woman man; he never strayed. And she needed that anchorage. There was the assurance of economic steadiness, too. She had met Paul after the turbulent opening years of the Depression with Maynard, and the professorship of a great university was a safe port to enter. Her new husband would bend to her will in family relationships, just as he had to his mother's will. In that sense he was more complementary to her than Maynard had ever been. Yet now and then she criticized him for his failure to fight back when they had a difference of opinion. He would simply not respond to her argument, and sometimes downright concede, "Well, my dear, you are probably right." She missed having a scrap over it. Perhaps her personality was too overwhelming for him to want to ram himself against it.

But then he was inclined to be accommodating in everything except his own special issue. For that he could be relentless. As she came to know him and his family better, she felt his mother, Rose, had long dominated him. When he ventured beyond a narrow range of established habit, he had trouble keeping a situation firmly in hand. Brave as he was in some things, he could be timid in others. Living with him would mean in part taking his mother's role.

Dorothea and Paul were married in Albuquerque on December 6, 1935. "On the afternoon of the same day she went out and photographed," Taylor said, "and our work went on from then, together." It may have been on this wedding-work trip that Paul took the photograph of Dorothea which both always liked so much. It shows her in profile, with the classic beret worn jauntily. Looking at a print of it years after Dorothea's death, one of the family said, "It has a certain softness in the face which I never felt in her."

When they married, Taylor's assistant professorship earned him a salary of $3,500 a year. Not a princely sum, but in the midst of the Depression a reassuringly livable and steady income. With Dorothea's pay of $2,300 a year, they were doing well in comparison to the average income in 1936. Perhaps feeling a bit heady, Dorothea paid $60 to have a beige gabardine suit tailor-made for her wedding—an extravagance that shocked friends.

They rented a house at 2706 Virginia Street, which she had found. It was a two-story house built of redwood, inside and out, on the side of a hill, perched over a canyon, with a superb view of part of the campus below and San Francisco Bay in the distance. The front door was reached by a long brick walk. Out back was a winding path that led through live oaks down to the next street south. On the spacious first floor were a kitchen, dining room, and living room, and above were three adjoining bedrooms and the single bathroom. In the basement, accessible only from outside, Dorothea would install her studio and darkroom. Around the side and back of the house ran a garden. She got the house ready for use the week before they left for New Mexico, and when they returned, just before Christmas, they moved in.

Meanwhile, an intensive correspondence began between Dorothea and Roy Stryker—an exchange of letters, telegrams, and memoranda which would go on for years. She was the only photographer on his staff whose base remained her home, not Washington. The idea was for her to do the photographic work for the various sections of RA in the Western region, as well as to take national assignments. In his first letter to her, Stryker spoke of the "pleasure" he had in looking over the Taylor-Lange reports. "You did a splendid job and it represents the type of thing that we are very anxious to have." He would look to Dr. Taylor for advice on what photographic work was needed out there. And he would keep her posted

on requests the field people made for photography, as well as the needs of Washington. He assured her he wanted her to make good pictures, but cautioned that costs were crucial. To go above a predetermined budget "causes severe headaches here." (Letter after letter would insist on her doing nothing but what was authorized in advance, on keeping the most meticulous hour-by-hour daily records of her activities, and on maintaining a penny-by-penny account of her expenditures.) He concluded by asking for her own ideas on how she could best handle the work.

Her first photography under Stryker was to shoot around the new federal camp at Marysville, the camp the Taylor-Lange reports had helped create. Now RA could supply a visual before-and-after comparison of migrant family life. She asked about creating a darkroom of her own, about money for equipping it, and for buying a short focal-length lens (a Goerz-Dagers), which she needed badly to do her job. Stryker replied that his funds for the next month or two permitted her only to rent the university's darkroom, implying that he hoped she could get the use of it free. Maybe they could buy her a lens and a little something else later on. All six of his photographers were clamoring for new lenses, but the higher-ups hadn't yet discovered photography cost money. He wanted her to charge off travel, per diem, and prints to whatever other RA section she did work for, so that his own budget would be kept down. He picked up Paul Taylor's suggestion that Ansel Adams might be able to do some of her printing if they could afford his charges. In the same letter Stryker asked her to get prints made from a large number of her SERA negatives to meet an author's request for photographs to illustrate his book on the *Roots of America*. Three weeks later she mailed out fifty prints.

Eager to make a field expedition and impatient at the delay in getting one authorized, she seized on her wedding trip to Albuquerque in early December and turned it into "a working holiday." For both Paul and Dorothea it was a preliminary look at a new federal agricultural project nearby. They traveled on Paul's expense account, except for the cost of her film, and got a good idea of what was going on in the Southwest. She made many negatives on the run, borrowing darkrooms whenever possible and paying for them out of her own pocket, "which I know is foolish and irregular," she wrote Stryker, "but under the existing confusions I couldn't let my work stop." She asked for full equipment and at least a month's time in which to work there come February, when the project would be ripe for shooting.

She solved her work-space problem by converting space in the basement of their new Berkeley home, with the help of Ron Partridge. She bought a projection printer, new development equipment, and new sinks out of her first paychecks, and Stryker agreed to budget $25 a month to cover her water and electric bills, a fraction of her rent, the cost of wear and tear, and the insurance on her cameras in the field. Her printing she

wanted badly to do herself, but if the work became too heavy, could she hire an assistant on per diem when needed? She hoped to avoid sending in negatives, and promised to keep Stryker well supplied if he would only "give me any sort of basis for operations—that is, a chance to get in the field, film, gross of paper when I need it and a chemical or two without having to beg, borrow, worry and steal to get it, plus a little help on running my laboratory."

But Stryker wouldn't hear of that, much as he appreciated how photographers feel about their negatives. The negatives must be sent on to Washington, except for what brief time she might need some to make prints to meet regional demands. Washington had the lab, and the men to run it, and he couldn't get funds to duplicate the setup in California. Nor could he help pay the cost of buying her darkroom equipment or hiring a person to help in her lab.

A week later he wired approval for her to start on a field trip of six weeks' duration down through California and into New Mexico and Arizona, on a budget of $600. But she had to leave before February 1 or the money would revert to the Treasury. Again the warning on travel vouchers: record your daily mileage, hours of departure and arrival, points visited, odometer readings between points, purpose for which stops are made, purchases made en route, and receipts for same. Unless this is done right, he warned, you'll wind up paying for travel out of your own pocket. Before leaving San Francisco would she take "some good slum pictures. (Of course no California city has slums, but I'll bet you can find them.) We need to vary the diet in some of our exhibits here by showing some western poverty instead of all south and east." And do the same when you reach Los Angeles, he added. Pictures of rural slums were needed, as well as urban ones. And Tugwell would like it if she could photograph various kinds of farm labor, such as lettuce workers.

But in the midst of preparations the field trip was abruptly canceled by a wire from Stryker. She went ahead with local photography and the construction of the darkroom in her home. Then early in February came another telegram approving a month on the road. Besides obtaining the slum pictures, she was to cover the pea pickers, examine all phases of the new El Monte housing project, search for examples of soil erosion and its human costs, and see what was happening to the migrants in the Los Angeles region. Dorothea had asked if she could send negatives back to be developed as she traveled. Because bad weather was typical of this season, she feared deterioration if development was postponed after exposure. Stryker agreed, promising to have prints mailed to the Berkeley regional office. He could not get a cash advance for her; she would have to pay her own costs and submit the expense sheets later. His last words to her: "Best wishes for a successful trip and I hope that the cops don't pick you up. Don't let them break your camera."

Severe storms up and down the coast delayed Dorothea's departure. She sent Stryker "four hardboiled publicity negatives" made for the Berkeley office, "subject: rural rehabilitation clients." The language suggests that in her mind there was a difference between what she chose to photograph and what the agency needed to demonstrate its good works. Into her bill for purchase of film materials she slipped a $14 item for a Graflex film magazine. She owned two film magazines, she wrote, but "there are many full working days when three is the minimum." If Stryker couldn't hustle up the money, "then as usual I will pay for it myself." But her back pay she did want—they had somehow slipped up on paying her for the months of September and October. She closed with a plaintive hint: "I wish I could come to Washington to see what others are doing, and where the work for my region would best fit in. Couldn't I come by car, photographing as I travel?"

Two days later she was on the road, traveling south alone. A short letter to Stryker scribbled one night in Bakersfield is revealing:

DEAR MR. STRYKER:—Have just finished loading and unloading the films. It's late, I'm tired. Had a good day today but I'm done up—and there are all those notes and explanations, essays on the social scene in California is what they should be—still to be done. There is still work to be done here in Bakersfield area and I am expected in Los Angeles tomorrow night.

The rains are about over. Had to get out of the San Luis area with the job unfinished before the road washed away. Will stop there again on the return trip. On some of the film which I am mailing you I took long chances—and they are probably failures. Tried to work in the pea camps in heavy rain from the back of the station wagon. I doubt that I got anything. Made other mistakes too, which will be very apparent to you. There are some tripod slips and some blanks. I make the most mistakes on subject matter that I get excited about and enthusiastic. In other words, the worse the work, the richer the material was.

A week later, reaching Los Angeles, she learned her back pay had come through. "Feel expansive and don't care how many times I stop for ice cream cones and orange juice. It's sweltering hot and muggy here. Los Angeles is a vile town and I'll be glad when I'm on the road again." She had photographed the El Monte and San Fernando homesteads and believed them to be "real achievements—especially when seen after all that misery of homeless people . . ." She was doing her best to keep track of exposures, but in a full and varied day there were lapses and sometimes she had missed out on her notes. (Across this passage is pasted a line of print marked "Proverb of China"—"The palest ink is better than the most retentive memory.")

While working in Los Angeles she had word from Stryker that he had received two batches of her negatives and would rush prints back "so you can see how bad our developing is. I am praying that everything comes out

all right because if anything slips up on this first batch of film then the laugh will be on me, I guess." He was probably especially concerned now because he had just had a short visit from Ansel Adams, "a very delightful person," he told Dorothea. His letter omits mention of what they talked about. But in Nancy Newhall's life of Adams, she says that Adams was traveling east for the Sierra Club, bearing his portfolio of photographs of the Kings River Sierra. His primary mission was to lobby for making the high country above the Kings River Canyon a national park. But Dorothea had given him a second mission: to go see Stryker and make him realize how much of "a handicap and a frustration" it was to send her negatives to Washington. Adams argued that Lange had to be able to check on her negatives quickly to see if she had succeeded or failed. Often he had helped her by developing the negatives she mailed him from the field, and returning proofs to her at once "if the subjects were crucial or were unlikely to recur." He told Dorothea that he had persuaded Stryker to let her develop her negatives in Berkeley. She was to make three prints of each and forward them and the negatives to Stryker. He would then return one print so she could keep control of the way his lab handled them.

To Dorothea's hint that a trip to Washington would be helpful, Stryker replied he agreed it would be better to talk out their problems, but since he couldn't get to California soon, the best he could do was to try to answer her letters more promptly.

Her assignments done, and the allotted time nearly up, she headed north for home. It was March, and the weather still cold and miserable. She felt worked out:

It was raining, the camera bags were packed, and I had on the seat beside me in the car the results of my long trip, the box containing all those rolls and packs of exposed film ready to mail back to Washington. It was a time of relief. Sixty-five miles an hour for seven hours would get me home to my family that night, and my eyes were glued to the wet and gleaming highway that stretched out ahead. I felt freed, for I could lift my mind off my job and think of home.

I was on my way and barely saw a crude sign with pointing arrow which flashed by at the side of the road, saying PEA-PICKERS CAMP. But out of the corner of my eye I *did* see it.

I didn't want to stop, and didn't. I didn't want to remember that I had seen it, so I drove on and ignored the summons. Then, accompanied by the rhythmic hum of the windshield wipers, arose an inner argument:

Dorothea, how about that camp back there? What is the situation back there?

Are you going back?

Nobody could ask this of you, now could they?

To turn back certainly is not necessary. Haven't you plenty of negatives already on this subject? Isn't this just one more of the same? Besides, if you take a camera out in this rain, you're just asking for trouble. Now be reasonable, etc., etc., etc.

Having well convinced myself for 20 miles that I could continue on, I did the opposite. Almost without realizing what I was doing I made a U-turn on the

empty highway. I went back those 20 miles and turned off the highway at that sign, PEA-PICKERS CAMP.

I was following instinct, not reason; I drove into that wet and soggy camp and parked my car like a homing pigeon.

I saw and approached the hungry and desperate mother, as if drawn by a magnet. I do not remember how I explained my presence or my camera to her, but I do remember she asked me no questions. I made five exposures, working closer and closer from the same direction. I did not ask her name or her history. She told me her age, that she was 32. She said that they had been living on frozen vegetables from the surrounding fields, and birds that the children killed. She had just sold the tires from her car to buy food. There she sat in that lean-to tent with her children huddled around her, and seemed to know that my pictures might help her, and so she helped me. There was a sort of equality about it.

The pea crop at Nipomo had frozen and there was no work for anybody. But I did not approach the tents and shelters of other stranded pea-pickers. It was not necessary; I knew I had recorded the essence of my assignment . . .

Dorothea could not know it then, but on this first field trip for RA she had made what is universally acknowledged to be one of the great American photographs. One of those five exposures of the pea picker's family at Nipomo, to be known as "Migrant Mother," would be reproduced innumerable times in books, magazines, newspapers, pamphlets, films, and shown worldwide in exhibitions. It would become the most famous image made by Stryker's group. Looking at a print of it nearly thirty-five years later, Stryker said to his biographer, Nancy Wood:

> When Dorothea took that picture, that was the ultimate. She never surpassed it. To me, it was *the* picture of Farm Security. The others were marvelous but that was special. Notice I never said it was the greatest. People would say to me, that migrant woman looks posed and I'd say she does *not* look posed. That picture is as uninvolved with the camera as any picture I've ever seen.

As soon as Dorothea got home she developed the Nipomo negatives and, with the hardly dry prints in her hand, went to tell the city editor of the San Francisco *News* that the pea pickers, stranded by a crop failure, were starving. The editor promptly notified United Press, and on March 10 the *News* carried a UP report that the federal government was rushing 20,000 pounds of food in to feed the hungry migrants. Alongside the headline appeared two of Dorothea's photographs of the mother and her children in the lean-to shelter. (The paper did not use the classic "Migrant Mother": by choice or because Dorothea did not submit it?)

Nowhere in the story nor as a photo credit line did her name appear. But in the first paragraph of an accompanying editorial, the *News* referred to her role: "Ragged, ill, emaciated by hunger, 2,500 men, women and children are rescued after weeks of suffering by the chance visit of a Gov-

ernment photographer to a pea-pickers' camp in San Luis Obispo County. And behind that story lies a moral for California and the Federal Government." The editorial attacked both the counties and the state for being so shortsighted and inhumane as not to offer the migrants help. It urged Governor Merriam to discourage the shortsighted opposition "by reactionary growers and land-owners" to the building of twenty more such camps the RA was prepared to finance.

The first time "Migrant Mother" found publication was in *Survey Graphic's* September issue. (The first time it would be shown in a gallery was at the first exhibit of the Museum of Modern Art's new department of photography, in 1941.) It was printed full-page, with credit to both RA and "Lange," and captioned "Draggin'-Around People." Facing it was another full-page Lange, labeled "California Field Hand." It was a portrait of a gaunt, bearded Mexican worker, taken in the Imperial Valley. Under it was what the man had said: "I have worked hard all my life and all I have now is my old body." The same issue carried a long article by Paul Taylor (with four Lange photos), reporting what the RA was doing to meet the problems of rural people in the West.

Late that summer *U.S. Camera*, planning its annual show of outstanding photographs, invited Dorothea to send "Migrant Mother" and asked Rothstein for three of his prints. It was the first such salon recognition Stryker's section had received. But when the Washington office suggested the requested prints be made in their lab to save time and money, Dorothea objected. "Please, mister," she wrote Stryker's assistant, Edwin Locke, "that idea is no good. This show is the most important photographic show we have. It tours the country. It tours Europe. I couldn't afford to show prints unsigned, which I have not even *seen*. I'll send the negatives right back." She won her point this time and returned the negatives in a few days. Jack Hurley, a close student of the Stryker operation, says that Dorothea's demand for control of her prints was unusual. He found most of the staff let the Washington lab handle print-making. That Dorothea made problems for Stryker may be one reason why she and not some more amiable photographers would be laid off when a budget crisis came. Later, she would complain that the Library of Congress, which housed the negatives after Stryker's unit was disbanded, and made prints on order, never reproduced "Migrant Mother" the same way twice. "Oh, what dreadful prints they make. I've made them guide prints of it, asking—because I don't have any control of it—that they follow the guide print. Well, they'll try, and then they lose the guide print."

This best known of her photographs, wrote the critic Margery Mann, "has been so assimilated into our culture that it has been picked up and used even outside the photographic world. Not long ago I passed the display window of an artist who would paint your portrait from your photograph, and amidst his samples, the glorified girls and the 30-year-old, sly-

smiling Bette Davis and the muscle men, sat 'Migrant Mother,' big as life, and blue and yellow and lilac." There have been other variations on "Migrant Mother." Eliminating the children, an artist during the Civil War in Spain made a closely copied lithograph of the mother, entitling it "The Spanish Mother, Terror of 1938." In 1964 the Latin American magazine *Bohemia* reproduced an artist's rendering of the photograph on its cover, turning the head of one child to show its face. And in 1973 the Black Panther newspaper ran in full-page an artist's version of the photograph which gave black features to the faces and the hair, adding the caption "Poverty is a crime, and our people are the victims." None of these credited the original source, treating the Lange photograph as folk art representing any mother's deep concern for her children. Although she never entered the pea pickers' camp at Nipomo with the intention of doing a Madonna, the image has achieved an independent existence, finding its place in the almost timeless tradition of art whose theme is Mother and Child.

The response of George P. Elliott to "Migrant Mother" is the most penetrating. In the process of comparing Walker Evans and Dorothea Lange, whom he considered to be the two foremost American documentary photographers, he wrote:

> Most of Lange's pictures are of people, and usually the center of interest is a face expressing troubled emotion. Her temptation is to sentimentalize these subjects about whom her feelings are so warm. But in her frequent successes she redeems these pictures from sentimentality by the honesty and clarity of her seeing. Her vision leads to our warm understanding . . . [Migrant Mother] centers on a manifestly decent woman whose face is ravaged by immediate worry; her right hand plucks at her cheek, pulling down the right corner of her mouth, which looks as though it wants to be humorous. She is poor, and we assume that her poverty and the uncertainty of her future cause her worry. But the viewer is less concerned with her poverty as such, and far, far less with feeling guilty about the social conditions that imposed poverty upon her, than he is with understanding the profounder, the humanly universal, results of that poverty. For the picture is a sort of anti-Madonna and Child. One sees on her lap part of a sleeping, dirty baby; but the mother, who, we feel without reservation, wants to love and cherish her children, is severed from them by her anxiety even as they lean on her . . .

A few years later, writing the introductory essay for the Lange Retrospective of 1966 at the Museum of Modern Art, Elliott made the point that

> not all the wire-pulling and slipper-licking in Babylon will, finally, do a fraction as much to get a picture known and seen as its own power. "Migrant Mother" is famous because key people, editors and so on, themselves finding it inexhaustibly rich, have urged the rest of the world to look at it. This picture, like a few others of a few other photographers, leads a life of its own. That is, it is widely accepted as a work of art with its own message rather than its maker's;

far more people know the picture than know who made it. There is a sense in which a photographer's apotheosis is to become as anonymous as his camera. For an artist like Dorothea Lange who does not primarily aim to make photographs that are ends in themselves, the making of a great, perfect, anonymous image is a trick of grace, about which she can do little beyond making herself available for that gift of grace. For what she most wants is to see this subject here and now in such a way as to say something about the world.

That the picture was exhibited and published over and over, all around the world, year after year, came to embarrass her. "I am not a 'one-picture' photographer," she would insist. "Migrant Mother" had taken hold in such a way that it no longer seemed her own. Why? "I don't understand it," she said, "I don't know why. It seems to me that I see things as good as that all the time . . . Once when I was complaining of the continual use and reuse of this photograph to the neglect of others I have produced in the course of a long career, an astute friend reproved me. 'Time is the greatest of editors,' he said, 'and the most reliable. When a photograph stands this test, recognize and celebrate it!' " It is ironic that Lange, whose relationships with her own children and stepchildren were so difficult and painful, should be known universally for "Migrant Mother."

8 DOROTHEA BEGAN HER SECOND MARRIAGE
sharing responsibility for the children of two families—hers and
Paul Taylor's. As they entered their new life together in the Vir-
ginia Street house, they had to face the problem of care for five children.
Her Daniel was now ten, and John was seven. Taylor's children were
Katharine, thirteen; Ross, ten; and Margot, six. Dorothea had full custody
of her children, and Taylor, at first, of his, for his ex-wife had gone to New
York to work on her doctorate in clinical psychology. Here were two pro-
fessionals with full-time jobs; both would be away from home as a team
for extended periods, and at other times Dorothea would be on the road
alone. What to do about their children? Dorothea would continue to do
what she had often done when married to Maynard Dixon—farm them
out—and Taylor would go along with the decision. "It was not altogether
easy," Taylor said in a classic understatement. Dorothea has said very lit-
tle about this aspect of family life, perhaps because she couldn't face the
consequences. Taylor, in his discussions of it, tends to treat it lightly.
Working together away from home, he and Dorothea were a team, and
equal, he said. But when they returned to Berkeley, one member of the
team was "harnessed to the house—not a liberated woman." The family
"competed, of course, with her work. That is, she was not free to do noth-
ing but her work in photography. Summers we were able to arrange for
the placement of the children, so that we could take the summer contin-
uously for two-and-a-half to three months. For that time we were freed;
otherwise, well, it wasn't so simple."

That first year of the marriage, Dorothea, intent on her new work with
the RA, apparently did not want to be burdened by the care of the chil-
dren. She could not leave Daniel and John with their father for he was in
poor health and had gone to Arizona to live. So the five boys and girls
were spread among three separate foster families, the homes of people

they knew. She expected to be on the road often, and probably found the prospect of handling young children, three of them not her own, dismaying, especially after the painful experience with Constance Dixon. Weekends they tried to bring all the children together at Virginia Street, took them on excursions to Oakland or San Francisco, had suppers out, went to the movies. "Gradually, as we could," said Taylor, "we knitted together the members of the family, and also kept our work going, both Dorothea's and mine . . . But no," he added, "she wasn't free as a bird."

She meant to follow her star nevertheless, though it cost her intense inner conflict. It was in the first years of her second marriage that ulcer symptoms began to show. Torn between family and career, she never felt she satisfied the demands of either. High-powered, impatient with delay or disagreement, she was quick to anger. Even when some trip or holiday was being planned to please the children, they looked forward to it with mixed joy and dread because of the pressure for perfection she would place upon them. "Dictator Dot," they sometimes called her, half affectionately, half fearfully. It was a name Dorothea's friends understood, for most of them saw her as too domineering, too authoritarian a mother. While she loved her children, she seems to have failed to respect their right to realize themselves in their own way. It was her ambitions, her tastes, her dreams they must fulfill, and if they did not measure up, she resorted to commands or threats. There are stories of how, even in front of others, she would show her pleasure in domineering over the children, in exploiting their weaknesses, in maneuvering them as she willed. Her disregard of their rights would end in the deterioration of her relationship with them. Passed from hand to hand, year after year, the unhappy merry-go-round led the boys to compose a sour ditty about it, into which they worked the names of all the people who had quartered them.

The five children could never be sure from one moment to the next what would bring her anger down upon them. Her moods were so mercurial they did not know where they stood with her. She would often pinion them with the intense glance of her gray-green eyes and the low commanding voice in which she intoned the latest litany of sins they were not aware of as transgressions. And if the target of her wrath was not her own child but Paul's, there was no seeking refuge with him, for he gave in to her discipline. This made things worse: they feared that if they angered her, they might lose him. The shift from their own mother to a stepmother was all the more distressing for the contrast between the two women. The first Mrs. Taylor was a beautiful woman—warm, rather absentminded, just beginning to get herself organized professionally, distracted by her own problems, never domineering, either over her children or her husband. Fiercely attached to her children, she was no disciplinarian. There had been a lot of laughter in that house; there was little in this.

DOROTHEA LANGE

In March, soon after the field trip which climaxed in the "Migrant Mother" photographs, Dorothea left for Utah. Scattered over the huge state were several small-scale RA projects demonstrating means of rehabilitating people and lands. She took photographs of the town called Consumers, dominated by the Blue Blaze Coal Company. The miners' families lived in miserable company shacks and bought in the company store. RA was experimenting with small loans to miners. If they could build their own homes and till garden patches around them, they would be less dependent upon the company. Northwest of Consumers, at Tooele, her camera reported what RA was doing to reclaim marginal land destroyed by overgrazing sheep and by wheat production. Her prints show the abandoned houses, the binders and harrows half buried in dust drifts, the vacant fields covered with tumbleweeds. Now the range was being refenced by relief workers, while gangs of town laborers, small farmers, and sheep herders were experimenting with methods of replanting and restoring the native grass. Grazing would be controlled and cultivation prohibited by the RA's Central Utah Dry Land Adjustment Project. Far to the south, near Bryce Canyon, she found what was a removal, rather than a resettlement, project. The town of Widtsoe lay in a high valley which had been made bleak by sheep, dry farming, and drought. The RA was placing families individually on better land elsewhere in the state. Not far from Bryce, in the Mormon hamlet of Tropic, she took pictures of relief crews working in shifts to rebuild Tropic Dam, which flood waters had swept away two years before. The hope was to restore it in time to impound waters for the next year's crops.

Dorothea, like the others on Stryker's crew, did not find assignments such as these the most rewarding for a photographer. The managers of the projects pushed for photographic coverage. Naturally they wanted to see the results of their labors recorded. The requests seemed reasonable, since the photographers were on the road anyway. But almost always the projects were still in construction, or had barely made a start toward carrying out their goal. She would photograph half-built structures with the project manager and his staff placing themselves in front, staring proudly into the camera. What seemed essential to them wasn't always vital to her. The real roots of a project, its sources in human need, in social disorder, in political turmoil, were often not visible on the site. Yet messages would reach her from Stryker, asking her to stop at this or that point on the road, and spend a day doing what the manager wanted. Building a constituency down below in a political operation was just as important as pleasing the bureaucrats on top. She would carry out the request, of course, all the while knowing that it would add nothing to the big files in Washington but more dull negatives.

The RA people in the field could be of great value, nevertheless. If she

was alone on the road, and needed guidance or help, she would go to the regional office and get someone who understood local conditions to travel with her for a few days. (They always liked a break from routine.) Or they'd assign her a staff car and driver. Sometimes, when she anticipated the need to take more notes than usual, a stenographer would go along for a few days.

Late that spring, Taylor was asked to transfer to the research division of the Social Security Board (SSB). When the agency was set up in 1935, farm labor was excluded from all its programs. Congress, however, had instructed the SSB to make studies of the excluded occupations. And Taylor was chosen as consultant for research in farm labor. Happily, his new chief, Tom Blaisdell of the SSB, was in perfect harmony with Dorothea's chief, Roy Stryker. They agreed to let Taylor and Lange continue the teamwork which had proved so valuable. On the summer field trips they took together, RA would pay the car mileage one time, SSB the next. RA would pay Dorothea's salary, and SSB Taylor's per diem of $15. Both agencies found the teamwork served their ends well, perhaps better than if the two had worked separately. And for the couple, the collaboration was of course an unexpected gift.

They were together on the road many times, but not always. Sometimes Taylor would travel for a month or so with Dorothea and then have to go back to Washington or to Berkeley. But, said Dorothea, "a good deal of the discipline that I needed in order to get hold of my assignments—some of them had a very broad base—he gave me on those trips. So I never quite did what some of the photographers on that job (some of the best ones; I say best because what came out in the end was decidedly important) did— the haphazard shooting. I learned a good deal from Paul about being a social observer."

But being too well prepared could be a handicap she thought:

> To know ahead of time what you're looking for means you're then only photographing your own preconceptions, which is very limiting, and often false . . . I certainly wouldn't criticize a photographer who works completely without plan, and photographs that to which he instinctively responds. In fact, a very good way to work is to open yourself as wide as you can, which in itself is a difficult thing to do—just to be like a piece of unexposed, sensitized material . . . You force yourself to watch and wait. You accept all the discomfort and disharmony.

Disharmony couldn't be avoided, she said, but—

> Sometimes you stick around because hostility itself is important. The people who are garrulous and wear their heart on their sleeve and tell you everything, that's one kind of person; but the fellow who's hiding behind a tree, and hoping you don't see him, is the fellow you'd better find out about. So often it's just

sticking around and being there, remaining there, not swooping in and swooping out in a cloud of dust.

Sometimes, on these trips into the field, she'd feel out of her element. The end of such a day would be a great relief. "That's behind me," she'd say. "But at the moment when you're thoroughly involved, when you're doing it, it's the greatest real satisfaction." Especially when she knew she was working fairly well. It came in stretches, the way an athlete will have a run of several great days, and then go into an inexplicable slump. She would sometimes feel she hadn't done very well, but still, it was the best she could that day. "There's nothing on the film," she'd tell herself as she went tired to her bed. "I'm sure there's nothing on it, nothing worth recording." For people who played around with photography, she once said, "It's very exhilarating and a lot of fun. If you take it seriously, it's very difficult. There's no end to the difficulties."

The first trip Dorothea made East to Stryker's headquarters came in May—nearly a year after she had transferred to his staff. She arrived in Washington, to be assigned to the Eastern region for the summer. Taylor came with her; the university semester over, he would work out of Washington on his Social Security Board research. What she found on that muggy day of early summer at national headquarters was nothing like a tight organization with a carefully detailed plan of work. "I found a little office, tucked away, where nobody especially knew exactly what he was going to do or how he was going to do it." That didn't bother her; she rapidly discovered this was "the atmosphere of a very special kind of freedom, where you found your own way, without criticism from anyone." Stryker was not a highly organized administrator but "a man with a very hospitable mind, with an instinct for what was important." This big man, with his square-cut face, glasses, and warm, sparkling eyes, was full of wonderful stories about the West—"a tough baby in a real good sense," as one of his crew said. He proved to be what Dorothea called "a colossal watchdog for his people." There was an élan about his place, a spirit shared by everyone, something that was contagious. "When you went into that little office—and later when it became a big one—you were so welcome, they were so glad to see you; did you have a good trip, was everything all right? What you were doing was important. You were important. It made you feel you had a responsibility. Not to those people in the office, but in general."

She was soon on the road again, this time to do photo coverage of the new RA project at Hightstown, New Jersey. Its aim was to resettle the families of garment workers whose jobs in New York City had vanished in the Depression. On some four hundred acres of Jersey farmland two hundred homes were being built, complete with utilities, a recreation area and lake, and a new cooperative factory. The families were to be sustained by

factory labor and the food each would raise on its own garden plot. Dorothea started by photographing the people chosen for the project, and the places they had been living and working in. She went into their homes in the Bronx and on the Lower East Side, and explored the garment district along Manhattan's Seventh Avenue. The first thirty-five families to occupy the "Jersey Homesteads" were eagerly preparing for the move. They were Jews—the ethnic group predominating in that trade in the thirties. Walking the crowded East Side, she saw the school, the library, the shops, the streets, the people she and her mother had known so intimately twenty years before. She spoke to one of the garment workers already employed on the project as a carpenter, building the first group of homes. "Will we succeed?" he said in answer to her question. "Any people who will go through what we did—any people with such patience in waiting— we will succeed." (Later two of her co-workers, Ben Shahn and Edwin Rosskam, would move into the Hightstown project and remain there. Nothing, as it turned out, developed as planned.) Not far off she got her first pictures of migrant farm labor in the East, the berry pickers of southern New Jersey, who came in seasonally from Delaware. Near Millville she photographed the local families who harvested the cherry crop.

In June she saw Aaron Siskind, a young member of the Photo League, who was working with a group on a photo essay called "Harlem Document." They met in the lobby of her hotel, where she examined the prints he brought her. Then, armed with a letter of introduction from Stryker ("any assistance you can be to Miss Lange will be greatly appreciated"), she headed south with Paul Taylor. The fact that they were husband and wife caused their friend Lawrence Hewes some anxiety. At that time a federal regulation—apparently intended to spread work in a period of mass unemployment—read that two members of a family living under the same roof could not both hold jobs with the government. Lange and Taylor came under the regulation, but the fact that she used Lange and not Taylor may have diverted the attention of federal investigators who spied on people's living arrangements. It was awkward for Hewes, who knew the facts, of course, and did not want to provide ammunition for the conservatives trying to shoot down his boss, Rex Tugwell. When he went to C. B. Baldwin, the RA administrator, with his concern, Baldwin said, "Just say no more about it. Forget it." And although it was no secret any longer, the issue was never raised again.

Their method on field trips was not to plan the route in any detail. They simply headed in the approved direction and drove along until they saw something worth looking into. Dorothea had not begun this field trip with a battery of directives from her chief. Stryker, contrary to what has often been written, did not always load down his photographers with instructions. At this point, he had been scarcely a year on his job and was still groping for the best way to operate. Three decades later he would laugh at

the legend that had grown up about his directorial skills. "This was not a preconceived, well-planned project," he said. "Like Topsy, it just grew. We were a group learning and maturing, and I had my share of learning and maturing to do . . . Never forget it was a group project."

Stryker had no idea at the beginning that the project would develop as it had, even in this first year. What could have been more fundamental than the choice of staff photographers? Yet it proved to be more or less accidental. There was no screening process, as the first man on the payroll, Arthur Rothstein, had pointed out: "It sort of just happened." Rothstein was plucked fresh from college. Carl Mydans, Ben Shahn, and Walker Evans were already working for some section or other of RA. Dorothea had been on California's RA payroll before Stryker himself had been hired. Stryker was willing, says Rothstein, "to let anybody who wanted take pictures. He would let them borrow a camera, have the lab process their films, and if they turned out good, be delighted." Edwin Rosskam, who would join the staff later, thinks it lucky that Tugwell chose this particular man, Stryker, for everything flowed from his unique personality. Nothing about the project was known, tried, tested, or even anticipated. It was not even seen, at first, that the photograph was to be the core of the project. It was Stryker who took it from history in words to history in *pictures* and words. Rosskam saw Stryker's great value in his talent as a teacher—"a teacher who could not only teach but *learn* from others." He had the ability to recognize how much a Ben Shahn knew that he didn't know, and to learn from the artist.

What Stryker did grasp was that this should not be solely a public-relations operation. Of course he knew that kind of work must be done too, but his historical sense of the period, his sympathetic grasp of the crisis of the thirties, made him seek photographs that captured what was happening in the United States now, and how that life was changing under enormous pressures. With the younger photographers, naturally, his influence was greater. Jack Delano, twenty-one when hired, felt that Stryker "knew more about America than you did, by far, gave you a feeling about the United States, a love for the detail of life and the deeper meaning of everything American. He told you what to look for, but if you didn't find or like it, and wanted to shoot something else, he'd say, 'You do what you want to.' He was trying to stimulate you enough so that you would find out what was really there."

He wanted the photographers to know all they could about whatever region or problem they were assigned to photograph. Sometimes he gave them a shooting script which listed scores of physical details or actions which to him seemed characteristic of the place or the people or the economic function he was interested in. The scripts might also ask probing questions or sound basic themes the photographer should think about or be responsive to. He wanted them to look for images that expressed such

ideas. Once he went to the noted sociologist Professor Robert Lynd, co-author of the *Middletown* study, to draw from him "suggestions for things which should be photographed as American background." Lynd's list was sent to everyone on staff. But the scripts were not meant to dictate what was to be shot. They were rather a guide for the photographer's eye. And some of the crew chose to ignore the guide. The older and more experienced—Shahn, Lange, Evans—did not need a hand on their shoulder, and might even resent it. Shahn, for one, liked to use his camera to get visual notes for the paintings and murals he planned to do. And Dorothea had already had far more experience doing exactly what RA would become famous for than anyone else on staff. Walker Evans, too, had a great sense of what he wanted his own camera to do, and rejected Stryker's criticism of his work for not being political enough, or for smacking of the ivory tower. Evans thought of himself as a free and independent artist who happened to be on a government payroll at the moment. Later when he read that Stryker had directed his photographers, he said he was "particularly infuriated . . . He wasn't directing me; I wouldn't let him."

Stryker never pretended to technical authority in photography. He knew nothing about it, and left that to Rothstein in the first days, and then to the others, too. It was ideas, concepts, themes, that he cared about; technique was merely the means to realize them better. The photograph he thought of as "that little rectangle . . . one of the damnedest educational devices that was ever made." The camera he saw as a terribly important instrument for expressing "man's ability to pick out significant things in a complex. To most of us the world is a blur." He therefore ran his section more like a sociology seminar than a photographer's workshop. He was, says Rothstein, "an irritant, a stimulus, a catalyst, a man who made you think about your work." He liked long talks with his staff, sometimes keeping them up till one or two in the morning in his enthusiasm. Or he would think of an idea and not hesitate to phone and wake them late at night to discuss it. The Stryker home became a social center for the photographers whenever they came back in from the field. Phyllis Wilson, Stryker's daughter, who was a child then, remembers feeling "they were all like family to me." With Stryker, Dorothea would have added, standing in the place of father to them all. You couldn't help being loyal to him, she said. Whatever trouble might arise, inside the agency or beyond it, "Roy took it on; we never could. We were like his children." Long after, trying to capture his essential qualities, she said of him:

> He was able to transmit a sense of freedom plus *responsibility* to his photographers. These are the two key words. He also gave a sense of support. He gave his enthusiasm to their undertakings. He could be depended upon to understand a failure. He demanded nothing, but his presence behind the desk in Washington (he rarely went out into the field) made of the work a joint venture, and an adventure.

The photographer John Collier, Jr., who worked for Stryker in the latter years of the project, thought Dorothea responded to Stryker because there was something in the man's Western upbringing which linked him to Maynard Dixon's tradition. Although an academic for years, Stryker was at heart anti-intellectual, Collier believes; "his deepest interest lay in personal relationships and their plasticity, something he shared with Dorothea. They would often clash—she headstrong, determined to have her way, and he with his sense of ownership about his people, wanting to hold them fast to himself. But the two saw eye to eye on recording life from very close up."

As Lange and Taylor moved south, the press was reporting that the severe and extended drought had caused crop losses now passing the $100 million mark. Preachers in town after town were conducting Sunday-afternoon prayer meetings for rain. The topsoil blowing off in the wind was darkening the skies of the Dust Bowl to the west. Uprooted farm families were still streaming along the highways on their exodus to California. In the fall of 1936, rural poverty would become one of the leading campaign issues as Roosevelt contended for a second term against the Kansan Alfred Landon.

Going through the Shenandoah Valley, Dorothea saw farmers harvesting oats with a cradle scythe, and tying the bundle by hand—not with twine, but with stalks. The men said they had never heard of a combine harvester ("Sure like to see that!"). Yet not a dozen miles on she passed a statue of Cyrus McCormick, inventor of the reaper more than a hundred years before. They cut through Tennessee, stopping for shots of people on the courthouse steps of Greenville on a late Saturday afternoon. In the mountains her camera caught "the distinct American frontier type, the Abe Lincoln variety." Across North Carolina, she photographed poor whites swinging their hoes, and watched an older brother out in the field teach a younger how to read. She stopped at Birmingham for pictures of the Sloss-Sheffield iron and steel mills. Leaving the industrial center, she talked with a plowhand who told her he earned 75 cents a day—when he worked. Down the road a black tenant family said they barely got by on about $150 a year. It took the labor of all seven of them to earn it—mother, father, and five children. In Georgia, glancing from the sun to the drought-parched fields, a tenant farmer said to her, "The crop is nigh to nothin' as ever I see." Peach pickers in the same state told her they earned only 75 cents a day. In the lower reaches of Georgia and Alabama, and across the line in northern Florida, she visited the turpentine camps to report how the workers and their families made out on a wage of a dollar a day. When she reached the Delta region she made many photographs of the cabins the blacks lived in, of their prayer meetings and of the families walking home from church, carrying their shoes.

Near Greenville, Mississippi, she observed the new method of check-row planting of cotton. Long used in corn, its adaptation to cotton almost eliminated the need for hand pickers at harvest. In the town of Brookhaven she found a new development, born of the Depression. The WPA had just built a textile mill and leased it to a private entrepreneur in order to bring some kind of payroll into the stricken town.

Early in July, moving through northwestern Mississippi, Dorothea discovered conditions to be so bad on an RA project called Dixie Plantation that she sent a three-page report to Washington to call attention to the plight of the tenant farmers living there. The RA had taken over a thousand-acre tract fifteen months before and settled thirty families on it. Each rented twenty-four acres. The RA had agreed to furnish their subsistence, clothing, tools, and equipment to help them make their cotton crop. Walking around the plantation to take photographs, Dorothea learned from families she interviewed that the RA agent was treating them unfairly—cheating them, it would seem, much as private planters had treated tenant farmers and sharecroppers all along. On the excuse that he was too busy, the agent, Mr. Yates, would give them no statement on their indebtedness. They had harvested their cotton crop last season, but whether they cleared or failed on their year's work he would not tell them. Their subsistence checks came irregularly, and they had gotten through the previous winter only by buying on exorbitant credit at the store the agent owned. For the few tools and equipment they did receive, they could never find out the charge. The agent had even threatened to evict one family unless it signed over to the government the cow and the mule which they claimed they'd owned before becoming RA clients. "Bad as on a plantation," one cropper said to Dorothea. "We've wrote to the government," said another, "but it makes it too hard on us. The letter gets back to Mr. Yates's office, and he makes it hard. He owns a store in Shelby. He's a planter hisself." Another told her, "We can't vote here on account we haven't got the three dollars" (for the poll tax).

A mile from the Dixie Plantation, Dorothea visited an experiment in cooperative farming established at Hill House only a few months before by the socialist minister Sherwood Eddy. She came to interview two families who had been RA clients on a group farm project in Arkansas, much like the Dixie. And in the same way they too had been abused and cheated by the RA agent, whom they accused of forging their names to government checks and keeping the money for himself. Discouraged, they had quit the farm and crossed the Mississippi to join Eddy's group. Unfortunately, there was nothing new about large Southern cotton farms finding ways to rob tenants of their small share of the cash and other benefits paid out by the New Deal's agricultural agencies. The federal legal experts tried to put teeth into the law so as to protect the interests of tenants and croppers, but

illiterate and powerless as the poor usually were, they had no defense against landlords. Long before the Depression these farm people had been savagely exploited. Without land, tools, or capital, they paid for the right to raise crops by giving 50 percent of what they grew or by paying rent. They were staked to seed, animals, tools, cabin, and food. And like workers in a company town, they almost never seemed to earn enough to get out of debt to the landlord. Dorothea's photographs of that time reveal a depth of poverty which, twenty years later, she would see matched only by conditions in the famine-stricken or war-torn lands of Asia. Her pictures show whole families working in the fields from sunup to sundown; they show the shacks which lacked water, plumbing, heating, windows. They show the sowbelly and meal on their table; they show the pellagra, malaria, and malnutrition ravaging their bodies. In the years she made this visual record, nearly nine million people—half of them black, half of them white, lived like this in the South.

Driven to desperation, tenants and croppers in Arkansas had organized in the Southern Tenant Farmers Union. Black and white had joined under socialist leadership to demand redress of their grievances. Since July 1934, when the movement began, the most active leaders had been kicked off the land; the others had been told to leave on pain of death. When the rank and file dug in stubbornly, hundreds of them were illegally evicted and night riders began hunting down organizers, flogging and lynching them, beating up men, women, and children, burning down their cabins. Everything would have remained quiet, the planters said, if "Northern agitators" hadn't come in to make trouble. Government investigators confirmed the grim reports of brutality carried in the press. But though FDR listened sympathetically, he wouldn't take action lest he offend the Southern congressmen and lead them to oppose vital New Deal measures. How many poor farmers voted and what friends did they have on Capitol Hill? It was the landlords who spoke through the powerful bloc of Southern Democrats in Congress. The RA and its successor, the Farm Security Administration, did what they could about rural poverty, but the funds they got were never enough to match the huge problems. The Southern rich got richer, the poor poorer, and the decay spread to blight the lives of generations to come.

Unable to survive any longer in Arkansas, thirty-one evicted families (nineteen of them black), most of them members of the union, had committed themselves to Eddy's cooperative. Here they raised cotton, using the Rust mechanical picker, while broadening their economic base through operation of a sawmill, a poultry farm, and a truck garden. This was the second time Dorothea photographed a cooperative. And as they had done two years before at the UXA experiment, her prints depicted attempts to run their affairs democratically, to educate both young and old,

and to build with their own hands whatever the cooperative needed. On the Fourth of July she photographed the community celebration at Hill House, jotting down what was extraordinary about it in this time and in this place . . . "whites and blacks together."

Nearby, just outside Clarksdale, Dorothea came upon a plantation store that furnished the scene for another of her best-known photographs, the one she captioned "Plantation Overseer and His Field Hands, Mississippi Delta." The heavy white man stands in the foreground, one foot planted on the bumper of his shiny car; behind, on or near the steps of the store (no doubt his own), are five blacks, "my boys." The special significance of this photograph is referred to in an article about her written by her son Daniel Dixon. In this first trip South, she told him that "she ran up against a problem she'd never encountered before. Up until then, most of her work had been done in areas where Depression had shaken apart any form of social order. But in the South, a social order remained, and it held so tenaciously to those who lived under it that in order to photograph the people she discovered that she had to photograph the order as well. 'I couldn't pry the two apart,' she says. 'Earlier, I'd gotten at people through the ways they'd been torn loose, but now I had to get at them through the ways they were bound up. This photograph of the plantation overseer with his foot on the bumper of his car is an example of what I mean, and this one too (of hands holding a primitive hoe). In the first, I tried to photograph a man as he was tied up with his fellow, and in the second, a man as he was tied up with the land.' "

As she left Mississippi, Dorothea heard from Washington that the packages of undeveloped film she had forwarded along the way were being put through the lab. She was delighted to learn that suddenly there was a great demand for pictures of migratory labor (mostly hers) and of drought conditions (Rothstein's). The press services, the newspapers, and the magazines were ransacking the RA files to illustrate their stories. "We are getting the greatest spread that we have ever had," wrote Edwin Locke, Stryker's young assistant. That same summer of 1936, in addition to the Lange-Taylor team, Walker Evans with James Agee and Margaret Bourke-White with Erskine Caldwell were also working in the South to record the conditions of rural poverty.

The route Dorothea took after leaving Mississippi is hard to trace accurately because of scattered and skimpy records. She seems to have stopped in New Orleans, then swung up along the Mississippi, crossing the river back and forth to investigate rural conditions on both sides, probing as far north and east as Indiana, Ohio, and western Pennsylvania. Then she headed west, passing through Arkansas, Oklahoma, Texas, New Mexico, and Arizona, and entering California along the Mexican border, turned north for home.

On the edge of Oklahoma City, within sight of its gleaming skyscrapers, people squatted in makeshift shelters for a rent of a dollar a month, collected by the city, which provided nothing, not even sanitation. A farmer she photographed on a country road said: "After three years, dry years, not a thing here a fellow like me can do. I'd get out and go to California like the rest of them if I could get ahold of some money and get shed of my cows. Ain't done a day's work in four months." (He had been cut off relief on April 1.)

As they drove into Texas the temperature was steadily over a hundred degrees and the drought corn lay yellowing in the fields, eaten off by grasshoppers. Dorothea photographed a family of six Oklahomans drifting down the road. The father, aged thirty-five, was not a farmer but a painter by trade. He was in an advanced stage of tuberculosis, the victim of an occupational disease and an example of how people could fall between relief agencies. Rated as totally disabled, he was ineligible for a WPA job. Under his state's relief standards, the maximum the family could get was seven dollars every two weeks. So they had lost their home and their furniture, and had taken to the road a year ago. Dead broke, without shelter or food, they stared hopelessly into her camera.

In two small towns of Texas she met ex-slaves. There were, in the 1930's, thousands of them still alive. One of them she photographed, Bob Lemmons, now about eighty-five, had come into the state during the Civil War with his owner, a cattleman seeking new range. He told her about Billy the Kid and other bad men he had known on the border. She photographed many aspects of cotton culture in South Texas, the hoeing, the picking, the weighing, the ginning, the baling, the camps of the migrants, and moved on to New Mexico, where the dry climate was a magnet for a number of Depression refugees with tuberculosis. Her photographs show them at the end of their journey; they had made it, but they were still just as sick and just as broke.

Near Blythe, the California town across the Colorado River from Arizona, she made pictures of drought refugees seeking work in the fertile valleys. She described one Oklahoma family as an example of "Self-Resettlement." This year's drought had forced them to abandon their farm, and they set out to work their way to California. Picking cotton in Arizona had earned them just enough for food and gas to enter California. But on the day Dorothea met them, their car had broken down beyond repair, and they sat by the road, wondering how far they could go on foot. It was 3 p.m. when she crossed the Arizona-California line at Blythe, and up to that hour on that day alone—August 17, 1936—the inspection service had checked through twenty-three carloads and truckloads of migrant families out of the drought counties of Arkansas and Oklahoma. The father of one refugee family from Abilene (he let her photograph the others, but not

himself) told her: "The finest people in this world live in Texas, but I can't seem to accomplish nothin' there. Two years' drought, then a crop, then two years' drought and so on. I got two brothers still tryin' it back there and this year they're sittin'." The key figure in the 1936 presidential campaign, Dorothea predicted in her notes, would be the American farmer.

9 HOME AGAIN LATE IN AUGUST, WITH SEVENTEEN thousand miles of travel behind her, Dorothea had two concerns. One was to develop the vast batch of cross-country negatives and send them with proof prints to Stryker. The other was to get back out on the road again for the good working months of autumn. First she had to have a handyman in to repair her darkroom, which had sprung leaks in her absence, and to waterproof the sinks, which had dried out. She bought new developing tanks for small film, for to print all the Rolleiflex film, each one separately by hand, would be an interminable job.

She was worried about the quality of her negatives. "It was a hard trip," she wrote Stryker, "because we went through successive record-breaking heat waves, fourteen days of it at a stretch. Am praying that the heat did not affect the exposed negatives." Two days later her lab was in working order and she sent prints and negatives illustrating drought conditions in corn country. She urged the printing crew to use extra contrast paper, for "the negatives are all flat gray, leaden and overcast. The emulsion was being affected by the extreme heat, although I developed them most carefully and nursed them along, knowing that there was going to be trouble." As she mailed out more work, she reminded Stryker the prints were only proof prints. "I am not trying to make the best prints which the negatives will yield, for that would take a lot of time." Again, late in September, she warns Stryker: "A lot of these proof-prints you will notice are gray and grainy." Not only did she think the negatives were affected by the heat on the road, but she was using medium-grade paper defective in emulsion, for to exchange it would have taken too much time. He replied with compliments for some of the work he had received from her thus far. But he couldn't understand why heat should have affected her negatives when Arthur Rothstein and Walker Evans were also out in the hottest part of the summer and "their negatives show not the least sign of deterioration. Are you sure it isn't the developing rather than the heat?"

It was the last time Stryker would bother to question Dorothea's technical proficiency. Several photographers who worked with her when they were young and she was already well established agree that she lacked a natural ability for this phase of photography. She knew what she wanted in a negative and in a print, but she often had great difficulty in achieving her goal. Rondal Partridge, who assisted in her darkroom and on field trips during the first years of her government work, said she didn't really investigate the developing process the way it is done today. She did not make any test shots in the field. She used a Weston meter rather casually, set the camera, shot the picture, and went away. She loved to look at negatives, he said, and could read them marvelously, knowing when they were not perfect. But she didn't print them well, not easily. She used the same materials year after year, paper and chemicals, and when the manufacturers took off the market without warning something she was used to, it upset her. To have to decide what new developer to try was awful. Yet she wouldn't brook another's interference with her negatives.

Homer Page, who worked with her for a time, thought she was inept, even clumsy on the technical side. She could fumble, and in spite of it come up with the answer. She liked the process of photography and to labor through it. She saw it as part of the creative nature of her work. Like several others who observed both Lange and Ansel Adams closely, he contrasted her uncertainty with Adams's superb technical skill, his ease and sureness in creating brilliant images. "She could use an old film pack or pull the wrong lever. Yet when it was all over, she had the picture she wanted. She had to go to great pains to make a good print. It took her an endless amount of time. But look at the results . . ."

Partridge remembers those long hours in the years she worked for Stryker. She would be in the darkroom from eight in the morning until eleven or later at night. He recalls her keeping him so late the trolleys had stopped running and he couldn't get home. He'd hole up in a warehouse nearby, on pads used for packing, and sleep till he was due back at her darkroom early in the morning. Where did her energy come from? Christina Gardner, another young assistant at that time, said Dorothea told her that when doing portrait work she had found it hard to stick to the darkroom for more than a few hours at a time. "But in *this* kind of work, I could go on forever," she'd say.

Almost thirty years later Ralph Gibson worked as Dorothea's assistant for some eighteen months. It was in the early 1960's, when he was in his twenties and she was going on seventy. He had come to her technically well trained, and saw quickly that she was not. Sometimes when she would send him out to a supply house for a certain kind of paper, he would know it was the wrong choice for the job at hand. It wasn't that she couldn't have mastered the technical side, he said, but that her attention was fixed far more on what she was shooting and her feelings about that.

Once, they were looking at her picture called "Damaged Child, Shacktown, Elm Grove, Oklahoma" preliminary to making another print of it. She began telling him of the time she shot it, some thirty years before (it was on her 1936 field trip), and suddenly she started to cry. He was astounded . . . so many years had passed and she could still feel the way she felt then. It illustrated the point she often made to Ron Partridge: "The print is not the object; the object is the emotion the print gives you. You look past the print to the inner meaning."

Willard Van Dyke sees the technical aspect in the same light. She didn't have great technique, he says, because she didn't care about such things. She was excited about the subject she was shooting, not the how of doing it. When he observed her in the early 1930's, during her first venture into documentary photography, it was before the days of exposure meters. Photographers learned how to shoot by trial and error. You could be very wrong sometimes and make bad pictures. She cared less than others about that, cared only about what she was trying to get on film, the idea. Group f/64 people were concerned about every aspect of the work, including the technical—the whole process; she chiefly with the subject. Back then, too, when Mary Jeanette Edwards helped in Lange's darkroom, she would complain how difficult it was sometimes to print from Dorothea's negatives.

Arthur Rothstein never went on assignment with Dorothea, but their paths sometimes crossed while in the field. What she was always after, he says, is the idea, the feeling; all the rest, including technique, was secondary. "Today, with automatic cameras and exposure systems, there are many ways to compensate for technical deficiency. Hers was a straightforward style with no tricks or gimmicks. She rarely used lighting effects or unusual lens arrangements. She sought no technical enhancement of the image. To my mind this adds to the strength and credibility of her work."

Ben Shahn too refused to fuss about printing technique. "I thought of photography as purely a documentary thing," he said, "and I would argue rather violently with photographers who were interested only in print quality. All that bored me. I felt the function of a photograph was to be seen by as many people as possible. I felt that the image was more important than the quality of the image . . . My negatives I know were very uneven, and a real trouble for the printer."

It was not that Lange did not care. The way she would work on a single negative was extraordinary. John Dominis remembers she could take all day to come up with a print she thought had possibilities. She would hang it up to dry, and then put it on the wall. Next day she would look again and decide this was all right, or, if not, go back to try more prints. If she thought she had something good enough, it might be put away for three weeks, when she would look at it once more and judge whether it was the

best she could do. "No one else I know works like that," he said. She was not superb at printing in the way of a Weston or an Adams, he said; half their art lay in the lab. But her best was far better than the average professional photographer's. Like himself, he added, many a photographer is poor in the lab and doesn't try to do it. Van Deren Coke has pointed out that "Lange was not a master printer and did not concern herself with achieving rich tonal relationships. She thought in terms of photographs to be reproduced in books, newspapers, magazines, and reports. When her work was to be exhibited, special prints were usually made by a lab technician. Her negatives have yielded good prints on these occasions."

In this connection John Szarkowski has asserted that the photographer's "*only* function . . . is to decide what his subject is." This he sees as the corollary to his conviction that "photography is a system of picture making in which subject and form are identical and indistinguishable, in which the subject and the picture are beyond argument the same thing." In the process of defining his subject, he goes on, the photographer may exercise choices ranging from the gross to the exquisitely subtle. Will he take pictures in his back yard or will he go to Egypt or to the moon? Gross choices. Once he decides where to work, "the decisions become not more important, but subtler. What subject to photograph? From what vantage point and in what light? in what relation to the picture frame? with what combination of exposure and development in order to achieve a just resolution of the conflicting claims of surface texture, space, volume, and pattern? And then the decisions bearing on the making of a print that will most closely approximate the slippery memory of that true and ephemeral subject that was defined on the site."

Applying the idea to one of Lange's FSA photographs, called "Migrant Cotton Picker, Elroy, Arizona, 1940," he writes:

> Choice, intuition and the winds of chance took Lange to Arizona. By passing a million other potential subjects, she found her way to this particular plantation. There she chose to ignore the landscape, architecture, the beautiful intricate machinery, in order to concentrate on the men who worked there. Among these she chose to photograph a group that included this man. She made several exposures of him and his fellow laborers from a distance as they loaded their cotton. She then decided that she was not yet finished; and she moved closer, homing in on this man, perhaps because he had a good face, more likely, I think, because he was in a good light. By this point, the question of what the subject is involves choices in four dimensions which must be coordinated swiftly and intuitively.

Stryker had worse problems to contend with that fall than the quality of negatives. Just as Dorothea arrived home, he wrote to say her job was in danger. The whole photographic section of RA was threatened by drastic

budget cuts. Stryker no longer had a set amount of money for the unit; his funds were now lumped with the information division's, giving him less control. While he was cautioning her to keep an eye on every dime spent, she was sending him a list of ten documentary studies she'd like to make in the field. She wished to travel in the Western region to report on resettlement projects and to record the seasonal passage of migratory labor. When approval was slow in coming, she set off on her own for a day's shooting in the lettuce fields around Salinas, where a bitter strike was going on. So explosive was that conflict between migrant labor and growers that RA had sent out a man from Washington to keep an eye on it. "Politically much hinges on it in California," Dorothea wrote Stryker as her reason for thinking "this expedition would be in line." That week *The Nation* carried an article headed "Dubious Battle in California." The writer was John Steinbeck, native son of the state, whose new novel, *In Dubious Battle*, dealing with a strike of migrant workers, had appeared in January. Steinbeck's wife, Carol, had been working for SERA, the agency which had employed both Dorothea and Paul Taylor, and Steinbeck drew upon RA sources freely. To see conditions for himself, he had gone into the field that summer and written a five-part series of articles for the San Francisco *News*. The articles sat on the editor's desk because, as Steinbeck wrote his agent, "the labor situation is so tense just now that the *News* is scared stiff to print the series. Any reference to labor except as dirty dogs is not printed by the big press out here. There are riots in Salinas and killings in the streets of that dear little town where I was born." Early in October the *News* printed his series. The fourth article dealt favorably with the RA camps at Kern and Marysville, contrasting them with the squalor and intimidation he had found at the squatters' camps. (What he was learning now would soon be put to use in his important novel, *The Grapes of Wrath*.) The articles infuriated the growers and Steinbeck received threats of violence. But he reassured his agent that "my safety lies in the fact that I am not important enough to kill and I'm too liable to get publicity to risk the usual beating."

Dorothea kept pleading with Stryker—"How about a letter to your little stepchild?"—"Can I go out in the field now?"—"When will there be money for me to go?" Then on October 9 she was dropped from the regular payroll and put on a per diem. "The economy bug has hit them so hard here," Stryker wrote, "that it looks like I will have practically no one left when they get through." Why drop Lange rather than someone else? Though he could be critical of her, her work was powerful and no one could have been more eager. But she was three thousand miles away and the administrative difficulties were sometimes too burdensome even for the energetic Stryker, who was being squeezed on all sides. The documentary work that interested him most seemed likely to be eliminated in favor

of straight news and information photos. He had argued that the publicity garnered from Lange's documentary work had given them the greatest press breaks, but he made no headway against the budget cutters. He was left with two photographers, Rothstein and Russell Lee.

She was given two weeks' notice—Stryker urged her to use it to clear up the negatives and prints she still owed him—plus the twenty-six days of leave due her. Going on a per diem basis after that meant she might, but only might, be called upon for odd jobs of photography. But so poor were funding prospects that Stryker advised her not to turn down any other work offered her. He did his best to recommend her to other agencies—the Forestry Service and Social Security. On a trip to New York he saw Henry Allen Moe, head of the Guggenheim Foundation, and urged him to consider fellowships for photographers to carry on the important work RA had only begun.

Dorothea's response to the bad news was to write she was very thankful for the "great working experience" RA had given her. Whether on the payroll or off, she could be counted on to help in any way possible. In the same letter she asked if she could photograph the RA camp at Arvin, which now, at the peak of cotton harvesting, was being used to capacity. Losing her job did not upset her to the degree it would have if her livelihood had depended upon it. Her husband's salary could support the household, and now she might have more time for her family.

Stryker tried to put off as long as possible her severance from the unit. He gave her per diem assignments and offered her confidential advice and encouragement. To protect his maneuvers, he instructed her to write him not at the office but at his home. He was perturbed to learn that, while he had been severely cut, the funds of other divisions were being enlarged. He was indignant that artists were being commissioned to go out into the field to do paintings of the people and places his staff had been photographing. Stryker was convinced there could be little argument about the superiority of the camera over the paintbrush as a recording device in the problem at hand. "I am becoming a little contemptuous of painters who are doing bad copies of good photographs." He didn't object, however, to painters (Ben Shahn was one of them) who made photographic notes for their work. When he heard Dorothea would be asked to guide a painter through the migrant camps, he urged (off the record) that she insist she was working for the Photographic Section and "not as an auxiliary to a painter . . . Your pictures," he added, "will prove more important to Resettlement in every way—publicity, documents, and records—than any twenty paintings that can be made on the ground out there."

He also had some good news: he told her the College Art Association was sending 110 RA photographs around the country in a traveling exhibit and that a publishing house was seeking permission to do a book of Lange photographs. He let her know her work was esteemed by other federal

agencies, who were borrowing her photographs for their publications but shying away from crediting her or RA. The San Francisco Museum of Art and Mills College were both planning exhibits of her photographs.

There was a ruckus late that fall when Dorothea used her initiative to try to get some things done and angered the RA information chief, M. E. Gilfond, by breaking the rules of procedure. Gilfond sent Dorothea what she called a "mighty nasty" telegram and dressed down Stryker for permitting such undisciplined behavior. She defended herself in a private letter to Stryker. She was indignant at Gilfond's "bad manners" and "sorry indeed that any action of mine caused you added difficulties at a time when I know you are already having to defend our work on every front." Sensing some suspicion that she was using agency work for selfish ends, she hotly denied the imputation. "Please know that I am flooded with requests for photographs. I do only RA work, accept no outside commissions, retain no negatives, send out nothing and use nothing of RA work to further my own purposes. Have had five requests from New York photographic agencies this week and three magazines have asked me to do special jobs."

One of the magazines was *Life*, she said. Its West Coast editor was pressing her to do a feature story on migratory labor in California. Since she had told no one but her husband that she had been dropped from RA, the *Life* man suggested she do the work on her vacation time, but she refused. Yet she wanted Stryker to know she *could* have done it as a private job by going into the field again and making new negatives. Instead, she proposed Stryker make her RA negatives available from the file, add the pictures she had just taken in the field, and offer the piece to *Life* as an RA credit. She asked Stryker what *he* wished her to do. (He told her to do as she thought best. Nothing seems to have come of it.) Then he added that the Social Security regional director in the West had asked if she could work for his agency. But "in the face of all this wave of interest in photographic social documentation I'm not at all sure that I want to tie myself to a narrow government job. Not that the work for Social Security need be of narrow scope necessarily, but if they don't see the possibilities at the outset I wonder if they could be persuaded in time or is it a hack job?" I wish, she told Stryker, that you could be placed in charge of a government department representing all the agencies that need pictures, and that "we could do photographs of historical significance, and chronological significance. For that it would not be difficult to evoke real enthusiasm and devotion. It should be done."

That November Roosevelt won a landslide victory in his campaign for reelection, taking all but two states from the Republican Alfred Landon. Not for, more than a hundred years had an American election been so one-sided. The New Deal reforms were endorsed by an overwhelming majority of the voters. Immediately after the election Henry Wallace, the

Secretary of Agriculture, made a two-thousand-mile tour of the South, accompanied by Tugwell and two of his top aides, Will Alexander and C. B. Baldwin. Wallace was appalled by what he saw in Tobacco Road country. A third of our farmers, he told *The New York Times*, are living "under conditions which are so much worse than the peasantry of Europe that the city people of the United States should be ashamed." The RA's mission seemed all the more important now, and when Tugwell resigned shortly, the agency was shifted into the Department of Agriculture. Gilfond was transferred; the new Director of Information showed a greater understanding of photography's possibilities. Budget prospects improved, and in January 1937 Dorothea was again on the payroll. What with Stryker's delaying tactics and the leave due her, she had hardly been off it before she was back on.

Although he had lost a powerful protector when Tugwell left, Stryker felt optimistic about the future. Wallace's enthusiasm promised a new lease on life for the photographic unit. Stryker hoped to sell the Secretary on doing documentary photography for the entire department, not just RA. Two chances to demonstrate his group's value soon came up. The Senate asked the Labor Department to submit a report on migrant labor, and RA was one of the agencies told to cooperate. Its files were crammed with Lange pictures of migrants—just what the report needed—and Dorothea excitedly wrote Stryker, "I think we have a chance to score heavily." In the same letter she advised Stryker that Wallace was chairing a committee preparing farm tenancy bills for the coming Congress. With that problem the central concern of RA, she urged Stryker to prepare a good photographic report "aimed at the place where it counts most, Congress."

Late in December 1936 Dorothea accompanied her husband to Washington, where he had government business. She had enjoyed no vacation for the seventeen months of her RA job. Not yet certain that she would be rehired, she had made no decisions on her future, "except to have a little fun for a few days and forget the darkroom." But while in Washington, she was apparently unable to resist work of some kind Stryker asked her to do, cutting into her days of leave. Stopping off in New York on the way back, she and her husband visited Henry Allen Moe, whom Taylor had met through his Guggenheim fellowship. Moe told them he had received an application from Edward Weston, but one whose statement of purpose was so weak and whose tone so arrogant that it couldn't be presented to the board. When they returned to California they talked to Weston about it and got him to understand that he had to look at his application from the point of view of a board inhospitable to photography. He agreed to revise it, and after more than one consultation with them, it was worked up into suitable form and resubmitted. Weston was awarded a fellowship for 1937–38, the first Guggenheim ever given a photographer. Lewis Hine ap-

plied twice in these years and was turned down. There would not be another award to a photographer until Walker Evans received one in 1940. When Dorothea talked to Moe about it long after, he told her that of all grants made to workers in the arts, none had proved as satisfying to the foundation as those for photography. It had been money well spent.

Looking back to that midpoint of the Depression Decade, one can see how the needs of the American culture, the technical state of photography, and Lange's personal development combined to produce the work she is so valued for. She was not alone in the turn her photography took in the early thirties, but at the time she thought she had "made a discovery" on the streets with her camera. "Photojournalism did not exist then," she said thirty years later. "Now I can see connections, as very often happens in any field."

Life's request that she take a documentary assignment came the week the magazine's first issue appeared. An immediate success, the photo magazine was followed two months later by *Look* and a host of imitators. Although the photo magazine was not a new idea (Europeans had begun publishing them in the twenties), its time had come in American journalism. The new kind of camera, which made it possible to record events as they occurred, was another tool for the social exploration which the time of crisis demanded. Americans wanted to know the truth about their lives and the country whose failures had crippled millions. The world of the thirties was explored and dissected with every instrument the social scientists and the arts could bring to the fascinating task. With the first shock of the Depression, writers had taken to the road to find out what was happening and why. Singly at first and then collectively through the WPA Arts Projects, men and women tried to build a comprehensive picture of how America lived and worked. The literary historian Alfred Kazin speaks of that effort to make a living record of contemporary American experience as "an extraordinary national self-scrutiny." Among the writers, he said, "it marked a release of powers of affirmation crying for expression . . . Never before did a nation seem so hungry for news of itself" nor did "America seem so magnetic a subject in itself to so many different minds." In the body of writing produced in the thirties he found "evidence of how deeply felt was the urge born of the crisis to recover *America as an idea*—and perhaps thus to build a better society in the shell of the old."

It was with a special sense of mission, then, that photographers too set out to document American life in the thirties. But that this kind of photography had much earlier origins is of course plain in the work of men like Riis and Hine, or in the even earlier documentation of the Civil War by Mathew Brady's group and of the exploration of the West done by Carvalho, O'Sullivan, Jackson. Under the broadest definition of documen-

tary—the effort to record the face of the world in an objective way—one can find accurate visual recording dating from the invention of photography. But the conscious concern with documentary photography as a means of penetrating the socially significant aspects of life is pretty much a twentieth-century phenomenon. What gave documentary an enormous thrust forward was the development of two new cameras, the Leica and the Ermanox. Marketed in 1925, the Leica established the small format camera, using 35mm film; soon after came the Ermanox, which proved the practicality of the ultra-fast lens. The small, easily portable cameras with their faster lens and larger film capacity made modern photojournalism possible. Now photographers had thirty-six chances, with ample allowance for mistakes, on one roll of film. But for some five years most professionals looked upon the small camera as only a toy fit for amateurs to play with. The exceptions were the few like Dr. Erich Salomon, Felix H. Man, Wolfgang Weber, André Kertész, Alfred Eisenstaedt. One did not need to wait for the Leica to make "Leica-type" photographs. A dozen years before that camera was marketed, the Hungarian Kertész, using earlier small cameras, was responding to "the immediacy of the fleeting moment and all its inherent emotionalism." Henri Cartier-Bresson, who did not begin using the Leica until 1932, credits Kertész with being among the first to capture the spontaneous human element. The Leica soon became the almost universal camera, although some, like Walker Evans, continued to work with the large camera. Long before 1936, the years of *Life's* birth, European picture magazines flourished—*Berliner Illustrirte Zeitung, Münchner Illustrirte Presse, Schweitzer Illustrirte,* and a dozen other such weeklies. They published the candid snapshots of statesmen Salomon made at international conferences as well as Man's picture essays of everyday street life and Weber's reportage from countries around the world. Gradually the technical advances opened up a new direction for photographing—the intimate portrayal of human situations and relationships typical of Dorothea Lange's work.

Exactly what was it she was trying to do in her work for Stryker? He himself was groping for a definition of it. In a letter to Dorothea in the fall of 1936 he said, "I wonder if you and Paul will take seriously our plans for a definition of documentary photography, or if we may even enlarge this and use the term, pictorial document." He meant to ask twenty or twenty-five people who dealt with pictorial documents in various ways to send him their definitions and three examples to illustrate them. He hoped to publish the results in some form, thinking that maybe out of it would come some conclusion all could agree to. Nothing seems to have come of that proposal. Beaumont Newhall, then head of the Department of Photography at the Museum of Modern Art, was another trying to place documentary. In an article of 1938 he pointed out that although the camera's value in making visual records was accepted from the beginning, the word

"documentary" in connection with photography did not come into use until 1905 (in France). He saw documentary as an approach rather than an end, with the end "a serious sociological purpose." The documentary photographer is "first and foremost . . . a visualizer. He puts into pictures what he knows about, and what he thinks of, the subject before his camera . . . But he will not photograph dispassionately . . . he will put into his camera studies something of the emotion which he feels toward the problem, for he realizes that this is the most effective way to teach the public he is addressing. After all, is not this the root-meaning of the word 'document' (*docere,* to teach)?" The stress on emotional impact persists: later he writes that the importance of documentary photographs "lies in their power not only to inform us but to move us . . . The aim is to persuade and to convince." This desire to rouse the viewer of the photograph to an "active interpretation of the world in which we live" is what distinguishes the best documentary work from "bald" camera records, he concludes.

Never satisfied with that word "documentary," Dorothea once appealed to Newhall to find a better word. "We rejected the word 'historical' because of its connotation with the remote past," Newhall said. " 'Factual' was too cold; it left out of account that magic power in a fine photograph that makes people look at it again and again, and find new truths with each looking. We groped, but never did find a single word which described that quest for understanding, that burning desire to help people know one another's problems, that drive for defining in pictures the truths, which is the splendid essence of her work."

Abandoning the search for the single word, Dorothea found it took her 250 words to explain what documentary photography had come to embrace by that time. While she was still working for Stryker, she was asked by Ansel Adams to prepare a statement on documentary for *A Pageant of Photography,* the book he was editing in connection with the exhibit planned for the San Francisco World's Fair of 1940. With the help of Paul Taylor she drafted this text for the book:

DOCUMENTARY PHOTOGRAPHY

Documentary photography records the social scene of our time. It mirrors the present and documents for the future. Its focus is man in his relation to mankind. It records his customs at work, at war, at play, or his round of activities through twenty-four hours of the day, the cycle of the seasons, or the span of a life. It portrays his institutions—family, church, government, political organizations, social clubs, labor unions. It shows not merely their façades, but seeks to reveal the manner in which they function, absorb the life, hold the loyalty, and influence the behavior of human beings. It is concerned with methods of work and the dependence of workmen on each other and on their employers. It is pre-eminently suited to build a record of change. Advancing technology raises standards of living, creates unemployment, changes the face of cities and of the

agricultural landscape. The evidence of these trends—the simultaneous exis-
tence of past, present, and portent of the future—is conspicuous in old and new
forms, old and new customs, on every hand. Documentary photography stands
on its own merits and has validity by itself. A single photographic print may be
"news," a "portrait," "art," or "documentary"—any of these, all of them, or
none. Among the tools of social science—graphs, statistics, maps, and text—doc-
umentation by photograph now is assuming place. Documentary photography
invites and needs participation by amateurs as well as by professionals. Only
through the interested work of amateurs who choose themes and follow them
can documentation by the camera of our age and our complex society be inti-
mate, pervasive, and adequate.

10 JANUARY 1937 IN BERKELEY WAS A GLOOMY month for Dorothea. After the excitement of the visits to Washington and New York, she returned home to sit and wait. It rained hard week after week. Each day she looked in the mail for official word of her promised reappointment, but nothing came. Worried by the long silence, and fretting to work again, she wrote "Dear Roy"— they were on a first-name basis after eighteen months of correspondence—that she had been willing to help him in Washington without pay, giving up leave time to do it, "but now I cannot see my way to continue to work and tackle fresh jobs until I have my sailing orders." In New York she had been peppered with proposals for assignments. "I was amazed," she told Stryker, "at the interest shown in sociological photography. The picture agents and agencies offer you nothing short of the Empire State Building for a good sequence . . . Worked up a lot of steam and it's disconcerting to find your hands tied upon arrival at your home base."

At last the papers came through; as of January 23 she was back on the RA payroll. She began work on the Senate report on migrants. Stryker gave her chief responsibility for selecting the photographs to illustrate what came to be known as the Lubin report. It was logical for her to do it because the bulk of the pictures in RA's migrant labor file had been made by her and no one knew the story better. From time to time Stryker forwarded to her fresh photographs of migrants being made in the field by the two other photographers presently on staff, Russell Lee and Arthur Rothstein. By late March she had the requested number of fifty photographs carefully chosen and captioned. Then John Tolles of the Senate staff committee arrived to spend two days with her checking the draft of the report against the photographs. She had hoped he would take the set to Washington, but the report's outline had shifted somewhat. As drafts of sections of the report were prepared in Washington, they were airmailed daily to Professor Taylor for his revisions, and then Dorothea, to keep

pace with the changes, was obliged to reselect a number of pictures and produce new prints and captions. Early in April she was able to mail Stryker fifty captioned and sequenced prints. She also sent those negatives which he did not already have for certain of the prints. She underscored the point that the prints were to be viewed "for subject matter *only*," because she had been forced to use what odds and ends of paper she had on hand, whether it suited the negative or not. She counted on his lab to get out a good set of prints in short order. Although the aim had been to provide the Senate with completely fresh photographs, she had found this to be impossible. Some of the most telling images had been used before: without them, she said, the migrant report would not be complete. "I've worked on this job until I'm shaking in the knees," she wrote Stryker.

The fact that her photographs were reaching the public was comforting to Dorothea while she prepared the migrant report and waited for new field assignments. *Mid-Week Pictorial,* a supplement carried by many newspapers, printed her pictures in January and so did the Des Moines *Register & Tribune,* which syndicated its photo page to other Midwest dailies. But what Dorothea seemed most eager to accomplish was placing a picture story in *Life.* She heard that the *Mid-Week Pictorial* spread unfortunately had dampened *Life's* enthusiasm. She urged Stryker to let her cover the coming pea harvest. If she got a fresh set of negatives by shooting from a different point of view, maybe it would reawaken *Life's* interest. "The idea on which I think we could resubmit photographs of migrants hinges on this—through the past years how common and often heard was this statement: 'I feel like throwing it all up and loading the family in the car and hitting the road. I can always make a living.' So many people have said it, or thought it, that it comes close to a common human experience. Well, here are photographs of people who have *done* it. This is what has happened to some of them."

A month later she and Stryker both were told *Life* was "terribly interested" in a migrant layout. Stryker asked her to rush the new photos she had just taken on a long field trip to the Imperial Valley—this while she was under great pressure to finish work on the Senate report. Feeling "desperate" with all the work confronting her, she nevertheless preferred preparing her own presentation for *Life* rather than leaving it to Washington to assemble. Stryker could make what additions or changes in the presentation he wanted to, "but I hope you will not see the necessity . . . I'm not begging to be loaded with hard work, but I really believe that I can do this for you better than anyone else on our staff, on this particular theme." She ended up with some twenty-five photographs expressing an idea voiced in the report of the President's special Committee on Farm Tenancy: "Erosion of soil has its counterpart in the erosion of our society." Her theme for *Life* was "Human Erosion."

Stryker had already given *Life* Dorothea's set of pictures for the Lubin

migrant report. The photographs could not be used until the publication of the Senate report. That was delayed so long that *Life's* interest cooled. By this time Dorothea's personal presentation on the California migrants had reached Stryker, and he hurried up to New York to try to get them to look at it as a story distinctly different from the Senate report. For whatever reason, *Life* didn't run either piece. There was nothing unusual in that decision. *Life* was notorious for nursing a picture story along, sometimes even to the point of putting it in proof, and then killing it at the last minute. But so huge was the magazine's audience, and so prestigious an appearance in the weekly, that photographers broke their necks trying to get their work into it. Although some of her photographs would appear in *Life* later on, the magazine used relatively little of her work. W. Eugene Smith, perhaps *Life's* greatest staff photographer, speaking of Lange as "an Olympian . . . a free artist who is fully disciplined and in direct engagement with the artist's responsibilities," called it "a downright crime that the largest and most influential publications of our time have made so little use of her reportorial ability, that they have realized so little from her reportorial accomplishments."

Much of Dorothea's time that winter and spring of 1937 went into planning and preparing exhibits, reports, and layouts for newspapers and magazines. Here was the payoff for the photographs she made. While she did it devotedly, she hungered for more field work.

Her first major trip was to the southeasternmost corner of the state, the Imperial Valley, where migrant conditions had taken an abrupt turn for the worst. In an urgent appeal for travel approval, she wrote Stryker that conditions in the valley had long been notoriously bad and what goes on there

is beyond belief. The Imperial Valley has a social structure all its own, and partly because of its isolation in the state those in control get away with it. But this year the freeze practically wiped out the crop and what it didn't kill is delayed. In the meanwhile, because of the warm, no-rain climate and possibilities for work the region is swamped with homeless moving families. The relief association offices are open day and night, 24 hours. The people continue to pour in and there is no way to stop them and no work when they get there. I have inquired pretty carefully and I hear the same story on every hand. Whether or not the RA should dare to enter the Valley has been argued for two years now and Garst, well knowing what he was up against, and much to his credit, has decided to go ahead . . . by putting up a camp. Those in control are bitterly opposed, and there is trouble ahead. Garst went down last week and says that he ran into a hurricane. Down there if they don't like you they shoot at you and give you the works. Beat you up and throw you into a ditch at the county line.

She wasn't exaggerating. A couple of years before, assorted preachers, journalists, and civil-liberties lawyers had visited the valley when an AFL-

organized strike of lettuce pickers and trimmers had climaxed in the killing of two strikers by armed and deputized strikebreakers. Some of the observers had been thrown into the El Centro jail, already crowded with strikers, and then deported. Sent to investigate valley conditions, General Pelham D. Glassford made a report to the Department of Labor and the Department of Agriculture which said:

> After more than two months of observation and investigation in the Imperial Valley, it is my conviction that a group of growers have exploited a "Communist" hysteria for the advancement of their own interests; that they have welcomed labor agitation which they could brand as "red" as a means of sustaining supremacy by mob rule, thereby preserving what is so essential to their profits—cheap labor; that they have succeeded in drawing into their conspiracy certain county officials who have become the principal tools of their machine.

In other words, Dorothea concluded, "It is a hot spot and for RA to go in is a dramatic situation. We shall need the pictures. They are bringing all kinds of pressure to stop it. Also I am told that flood refugees are coming in there. How many I don't know, nor where I'll find them. Shall be gone about two-three weeks." She couldn't give him an address in the valley should he need to reach her, but she would be writing a postcard home daily so the family would know her whereabouts. "I am not traveling alone," she reassured Stryker, "but am taking a young fellow, a budding photographer, who will help me drive. Down there it's too uncomfortable to be alone."

The young fellow was Ron Partridge, whom she arranged to pay a dollar a day and his keep, taking the cost out of her $4-a-day expense allowance. Before starting out she made arrangements for the children, got her equipment repaired, rounded up enough film, took out camera insurance, and secured letters of introduction to RA's field people. Just as she was leaving, the press carried the news that Roosevelt's Farm Tenancy Committee was recommending legislation "for construction and operation of decent living places for itinerant workers." RA's migratory program had won support at the top. At the bottom—that was another matter. The Brawley City Council had just gone on record officially refusing to cooperate with RA, saying there was no need for camps in the Imperial Valley. It was a miserable lie: one had only to look at Dorothea's photographs made earlier in Brawley to see what the truth was.

Still, popular support for decent living conditions for migrants was increasing rapidly. And she and Paul Taylor must have taken pride in the part they had played in influencing public opinion. RA's regional office had placed her photographs not only in newspapers but in public displays accompanying speakers before men's and women's clubs, schools, churches, chambers of commerce, town councils, trade unions. Professor

Taylor made his precise professional reports on migrant conditions before investigating bodies and community groups, in government reports and in the general press. A set of Dorothea's migrant photographs was currently being exhibited by the WPA in San Francisco. For two years now the San Francisco *News* had been running frequent editorials commending the RA and urging it to build more camps. Even the *Chronicle*, a leading Republican paper, was beginning to see the light in its editorials.

Stryker's approval arrived the day before she left; it is likely she would have gone even if it hadn't come through. With Partridge at the wheel, they drove the six hundred miles down into the Imperial Valley, which sits just above the Mexican border. "Go slow, go slow," she constantly admonished Partridge, who was a good driver but a fast one. Her eye roved the countryside. "When she saw some activity that interested her," Partridge said, "we'd stop and walk over, Dorothea carrying her 4 × 5 Graflex or her Rolleiflex. She would walk through the field and talk to people, asking simple questions—what are you picking?—and they'd answer, tossing her whatever fruit or vegetable it might be. She'd show interest in their clothing, their knives, their bins, their trucks. How long have you been here? When do you eat lunch? But never the aggressive, union-sort of questions: where do you have to go to find a toilet? how does the heat affect you? is the boss exploiting you? how much do you get? Sometimes we'd find that out in the course of talk, but never by head-on asking. I'd like to photograph you, she'd say, and by now it would be "Sure, why not," and they would pose a little, but she would sort of ignore it, walk around until they forgot us and were back at work. She always photographed them directly, never snuck up, never jumped out of the car and started in like some county agent, cop, or investigator. Her presence was the most important thing about her, and by it she would finally work up to photographing them within three or four feet. Every hour or two she'd go sit in the car and write down verbatim what people had said. She just locked it into her head and got it down in the right order."

Four dollars a day for two to live on didn't go very far. They stayed in rickety tourist cabins called autocourts in that time—usually no hot water, often no sink, cracked linoleum flooring, and a beat-up bed. Partridge had a sleeping bag and in California weather could usually bed down outside; if it rained, he slept inside on the floor. When they registered for a cabin, if the manager raised an arch eyebrow at the sight of this older woman with a youngster, Dorothea would smile and say, "Yes, this is my fancy man," and sign the register that way: "Dorothea Lange and fancy man."

The day's work often exhausted both of them. Sometimes she gave Ron a back massage; she had taught him how to give her one. Then they'd take an hour's nap, get up, eat supper, clean and pack the cameras, label the film, and go back to sleep again. Up early, and with coffee, an orange, and a sandwich, back on the road again.

Home on March 7, without stopping to unpack her suitcase, she and Ron go down into her darkroom to spend five solid days on developing the trip negatives and sorting them out. The photographs, she writes Stryker, "are loaded with ammunition. We have a grave problem in this state of California with these tens of thousands of drought people. They keep on arriving, and the fight is coming. The newspapers are playing headlines and no one has the solution. This is no longer a publicity campaign for migratory, agricultural labor camps. This is a major migration of people, and a rotten mess. The SERA has broken down under the load, the people (75% of them) refuse to go back, and I have brought back with me the original telegrams from Oklahoma, Arkansas, etc. which state that there is *nothing* for them in terms of relief or work in places from which they are coming."

Fresh from the field, where she has met with SERA's county agents and been loaded down with their facts and figures, she has learned how useful her pictures would be to them if they could only get hold of prints fast. Can I send them a few right now? she asks Stryker, and before sending the negatives to Washington, can't I also make some prints for the regional office here? "They have a fight on, the papers need photographs, and there are only those in the office now which have been used over and over again until they are stale and too familiar. There is considerable heat here on the question of photographs. They feel that Washington doesn't realize what's happening—here I have come in with what in the interest of the work they must have, the public is aroused, and I can't give it to them . . . *Please answer.*"

Such national outlets as *Life, Look, The New York Times,* and the Associated Press special features were of course Stryker's primary concern. If they used RA's photographs, it meant nationwide readership and the greatest impact for his agency's ideas. But though Dorothea too desired national attention, as the one RA photographer based in the West, she felt a strong responsibility to the regional office, whose problems were enormous. She knew that local and state publicity would be of great benefit, and she pleaded with Stryker to let her service those needs directly, without having to go through Washington. He saw the point; he too wanted to help out, and besides, if he pleased the regional people, it would increase congressional support for his national program. Then, too, he was fearful of losing control because he had learned the regional office had filed an independent request to hire the photographer Mary Jeanette Edwards on a per diem basis. (She had worked for both Dorothea and Willard Van Dyke.) Their gripe is genuine, Dorothea said, because Washington is always giving precedence to its own needs over the region's. The Edwards application was vetoed at RA headquarters and Dorothea was permitted to select freely from her Western negatives and to turn over to the regional office as many prints as she liked.

Three weeks on the road—moving every day, sleeping in different beds each night, eating bad food catch-as-catch-can, apprehensive of violence at every stop, making hundreds of photographs, gathering notes for captions—would have exhausted anyone, and certainly a little forty-two-year-old woman with a physical disability. But the score or more of letters and telegrams that passed between Dorothea and Stryker over the next two months reflect an astonishing burst of activity. As soon as she emerged from her darkroom with the pictures made on her field trip, she was asked to prepare a large exhibit of the drought refugee problem in the Imperial Valley for a California conference of social workers. Such influential national figures as John G. Winant, Paul Kellogg, and Isidor Lubin would be there, and the RA's chief, Will Alexander, wanted to make the best showing. "I am not so anxious to kill myself with work," Dorothea wrote Stryker, "but I also feel that this is a good chance for us to demonstrate our function undeniably—and I have some telling negatives. Shall I make up this show?"

Stryker was all in favor of the exhibit, but he thought it would be better if she sent the negatives to him and the lab prepared the show. He preferred to have her working out in the field. She would not have it; let me do it, she said. I have the negatives here, it would take me two-three days on the printing, then time for spotting, mounting, lettering the twenty-five 11 × 14 prints they want. It's an excellent opportunity, she urged, to show "a very high grade group of people" what sociological photography can do. Also, and not second, it's a chance "to make this same group aware of the problems presented by this migration of the homeless. And this is the group that can make things move (that is, I hope they are)."

She was already at work on the prints for the Senate migrant report and for *Life*. "I am anxious to get out of the darkroom and all this mess of prints and into the field again," she told Stryker, even as she asked to take on this chore, too. She was telling the truth, no doubt; the trouble was, she couldn't let go of any part of the work. They disputed over who was to do the job until Stryker gave in with a wire of approval. Then it turned out she meant to use for the exhibit some of the negatives intended for the Senate report and for *Life*. That would do in neither case, Stryker warned; there must be no duplicates. With the conference scheduled to open in ten days, she lamented she was left "with some negatives but not many, not a sheet of 11 × 14 paper, no stock, no tissue, no chemicals at all, nothing has come through." Nevertheless, she produced an exhibit of 8 × 10 prints made up "out of discards and duplicates and proofs and extras," borrowing the mounting paper and handling the lettering and captioning herself. "Your faithful slave," she signed her letters to Stryker in those frantic days.

Straining to make all the darkroom deadlines, Dorothea was buoyed up

by the prospect of the Northwest journey Stryker had outlined. "I want to get out into the field and tackle a fresh piece of work, maybe on a new theme," she wrote. In mid-April, when all the details had been arranged, the trip was abruptly canceled. The reason? "Tenancy is the biggest issue before RA," Stryker explained; "it is the only subject which the people around here are very much interested in our publicizing." Would she get ready quickly for a swing through the South?

With only three photographers on staff and all of them deep in other assignments, Stryker was badly off to satisfy the demand for tenancy material. He spent an evening in New York with Willard Van Dyke, finding him "a very charming person" whose camera work on the Lorentz film *The River* he liked very much. He wanted to hire Van Dyke for a few months to go back through the South for intensive still coverage of farm tenancy, but, he wrote Dorothea, "money just isn't to be had for such things."

So it would be up to her. She was to start South via Arizona and New Mexico, photographing the RA projects en route, then cover tenancy in South Texas, move up to Central Texas, and from there into Oklahoma, across Arkansas, and down into Mississippi, Alabama, and Georgia. He planned to join her somewhere in the Southwest and spend a week traveling with her to talk over plans for the tenancy photography. Toward the end of the trip he wanted her to stop in Washington to go over films and captions. There might be some extra duties on this trip, because "unofficially and off the record" Stryker's unit was now doing work for the whole Department of Agriculture, upon Secretary Wallace's request. This new turn was to be kept quiet; if it developed as he hoped, it would give the unit a broader and firmer foundation. Wallace was concerned about the cricket scourge devastating parts of Utah, Nevada, and Wyoming. Now if she stopped at the RA's Bosque farm project in Utah, wouldn't that put her within camera range of the mass formations of crickets blackening the skies?

Eager to go, she pushed through the presentation for *Life* and another one for the *Chronicle*'s rotogravure section. She managed to get the migrant exhibit up on the walls of the conference room in San Jose the midnight before the social workers settled into their seats. She sorted, classified, and captioned all her negatives still due Stryker. Then she cleaned up her workrooms, visited the dentist, made arrangements for the children for camps and vacation, bought hot-weather field clothing, and had her equipment checked out, especially her Graflex, the shutter of which was again giving her trouble. "I wish I could have a couple of days to study and rest," she wrote Stryker; "that probably won't be possible, but I wish I could. My work on migratory labor has taught me the importance of adequate background when working on a large theme. It is not enough to photograph the obviously picturesque. The same is true of tenancy. I'm glad to go and I welcome the opportunity to work on a new theme but my

first concern is to obtain sufficient background for understanding of the problems. I shall need all the education that can be injected. My first look last summer will be of great help. Your meeting me and steering me will be another." She asked for copies of Wallace speeches and department reports on tenancy, and began reading Arthur Raper's *Preface to Peasantry*, a new study of tenancy in Georgia.

There was something special to ask Stryker: "Another concern is over working alone in country which I do not know and understand. I shall be traveling into areas which are disturbed, with heavy valuable equipment, making negatives of subjects that obviously will reveal what is wrong. I shall at times be unwelcome. I am not without hope that Paul may also be working in the South. If it works out it will be much to our benefit for I shall constantly need him for what time he can be with me."

It did work out, for Tom Blaisdell of Social Security was glad to cooperate again in arrangements for a Taylor-Lange field trip. She was to travel on RA's per diem, and he on Security funds. Whenever his work required, he was to leave her and take a bus or train to his assignment, then meet her again at some designated point.

A new task was added for this trip. The poet Archibald MacLeish, then an editor of *Fortune*, was writing verse dramas for stage and radio on themes suggested by contemporary events. He was about to do a book for Harcourt Brace which Stryker described to Dorothea as dealing with "stranded people left behind after the empire-builders have found new areas for exploitation." Its form was to be a mating of photographs and poetry. As MacLeish recalled the circumstances, he had been looking at the RA photographs, perhaps for *Fortune*, and "it may well have been that collection and particularly Dorothea Lange's photographs which started the poem working in my head." As it developed, "the poem has a subject of its own but it was written out of the photographs in the sense that the photographs held the great tragic experience which the poem attempted to put in perspective." With the blessings of Henry Wallace and Will Alexander, Stryker was to supply RA photographs for MacLeish to consider. Some two hundred pictures were called for in the original plan. Stryker was assured his photographers would get full credit and he hoped for "a nice foreword on the type of thing that we are striving to do here in the RA." When you move from California into the South, he instructed Dorothea, "watch out for ghost towns left behind from lumbering and mining and oil-drilling exploitation and for the abandoned homes of people who waited for water during the irrigation booms."

Going over her equipment for the trip, Dorothea decided against using a new Mendelsohn flash gun sent her; it proved too heavy and awkward for so small a camera. Much better for her Rolleiflex was a Kalart speed gun she exchanged it for. Then she asked for the use of the one 8 × 10 camera RA owned—"I mean, if Walker Evans is not using it." She couldn't have it,

for Russell Lee had already been promised it for the land photography he would do that summer. I'll try to buy you another, Stryker wrote, but "money is so damn short around here that we don't seem to be able to buy anything but film and paper and small items . . . People are more apprehensive about a nickel than they were last summer about even a dollar." He liked an idea she proposed, stemming from observations of the previous summer's field trip: a sequence of photographs on the problems of the South, all made in the Suwannee River region, to be presented under the general title "Way down upon the Suwannee River, 1937—." He encouraged her to try a few pictures as a sample; maybe later, when the major tasks—the tenancy and the MacLeish—were finished, there would be time to carry it out.

They started out about the middle of May, taking Paul's twelve-year-old son, Ross, with them. He had been living in the East with his mother and sisters during the past year. Invited to come, he was delighted to see the country in the company of his father. They drove south through California's agricultural valleys. Along the way Dorothea made a series of photographs in the potato-growing district around Shafter.

Crossing into Arizona, she ran into three related families, seventeen people, traveling together in four cars. They came from Oklahoma, had followed cotton and potato crops in California and Arizona, and were now drifting toward New Mexico, where they heard there might be work. "Milling-about-people," Dorothea called them, dogged by bad luck. One of the families had lost two of their three babies from typhoid they blamed on the filthy roadside camps of California. One mother's arms and legs showed the effects of pellagra. "I'm not on the diet agin it," she said, "cause I have to eat what I can get."

Near the RA's project at Casa Grande she stopped to photograph the housing the cotton growers supplied their field labor. Once chiefly Mexicans, the migrants were now mixed with drought refugee families from the Dust Bowl. At Phoenix she made pictures of the three kinds of RA housing in construction with WPA labor—community apartments for laborers, a cooperative farm, and part-time farms. Driving southeast she reached Tombstone, once a thriving mining town, and photographed desolate street scenes and crumbling buildings for the MacLeish book. North again to Highway 70, where she met families traveling across the desert in search of work in the cotton fields near Roswell, New Mexico. Again and again she encountered people moving in opposite directions, this family pointed west, that one pointed east, passing each other on the road, leaving one disappointment only to find another.

Cutting through the southeast corner of New Mexico, she took route 80 into Texas. Near Stanton she talked to a farmer who had not had a crop of cotton since '32. She found him replanting after three inches of rain had washed out the first crop of the season. It was a sign of trouble ahead. She

was supposed to do work in the Panhandle to the north, work that would enlarge the scope and value of RA's migration series, but heavy rain had suddenly changed the picture. Travel along the main highways, let alone the back roads, was closed, and there was no suggestion of drought or dust, nor was there apt to be for some time. Farmers told her the unusual weather was no guarantee of good crops ahead. So instead of making Amarillo her base for a stretch of photography, as Stryker had requested, she moved on. "You never know what you're going to run up against in the field, or what combination of things."

She drove east, passing through Hall and Childress Counties. On the edge of the highway she saw flood refugees for the first time, and made photographs of a family of six—father, mother, an infant, and three older children, walking with baby buggy and homemade hand cart. They had started in eastern Arkansas, aiming for the lower Rio Grande valley in hope of "steady work" in cotton. Moving on foot with remarkable speed, they averaged twenty-five miles a day.

Early in June she wrote Stryker that she and Paul had uncovered in Hall County "a very interesting situation on tenancy—people put off farms, tenants, often of years standing and established—with tractors coming in purchased by the landowners with Soil Conservation money. Not just a few cases. It's the story of the county. The ex-tenants are homeless and landless. How far across Texas the same story holds we do not yet know. . . . This may be an important part of our California story. In part I know it is now." The next day she began as complete a camera study as possible of those abandoned tenant-homes, tractor-cultivated right up to the porch. A farm owner she talked to said, "I'd rather have renters than tractors on my place. I oppose the tractors. It puts too many off the land. I went to my limit, more than most, and kept my renters until this year. But I got $700 behind on my taxes, so I need all I can get."

One Sunday morning, driving along the road in Hardeman County looking for a house typical of those from which the drought refugees in California had come, they stopped before a shack and walked up onto the porch. Through the screen door they could barely make out that there were several men inside the dark room. No one moved to open the door. Taylor took out his ID card and, passing it through the barely open door, told them who they were and why they were there. The men studied the card and asked what they wanted to know. Taylor started to ask questions, "anything, any simple questions to get them started talking and to make them feel at ease. Only then, one after another, did they come out of that dark room, single file, onto the porch. I thought the last one never would come out, there were so many."

The seven young men were farmers, the oldest of them thirty-three. All were on WPA, supporting an average of four persons each on a wage of $22.80 a month. The cabin had been occupied by another tenant farmer's

family, fled to California, displaced by large-scale tractor farming. The other shacks on the farm had either been abandoned or were now occupied by wage laborers driving tractors for a dollar or so a day when they worked. One of the seven was living in this shack now; on WPA, he gave three days' work a month to the landlord in lieu of rent.

They talked for quite a while, and finally the men filed off the porch and stood on the ground below. When they seemed at ease, Dorothea lined them up and took their photograph, standing. A half hour later, they had enough confidence in Taylor and Lange to talk about what, if anything, they could do about the farmer's situation. It was then that these snatches of conversation were jotted down:

> The big landowners are on the WPA Committee and they want us cut off so we can work for them a few days at $1.50 a day harvesting their wheat. But if a man gets a job, he'll lose his WPA card. It'll take him a month to get back on WPA after the work is over, and another 20 days until he gets his first check. He'll lose 50 days for a few days work.

> If you take a job you're cut off, and if you don't take a job you're cut off.

> Next time they ask me to take a job like that, I'll tell them I've got a job: I'm working for FDR.

> The Chamber of Commerce and the newspapers brag on the town and brag on the country. It's ok for health, and the soil's good. But the poor people don't get none of the money for the wheat. They'll have a fair crop this year, but we won't get $10 cash out of it, and the groceryman will get that.

> I have a wife and one child, and I've been staying even on $22.80 a month by living close. I was $90 in debt when I started on WPA, and I'm still $90 in debt.

> None of us vote. It costs us $3.50 poll tax for a married man and wife to vote in Texas.

> We used to go to church when we had better clothes. These are our Sunday clothes. All of us and our families together haven't spent $40 on clothes in the past year.

> If we fight, who we gonna whup?

> We were born at the wrong time. We ought to have died when we was young.

> Give us something to do, and pay us a living wage.

> I'd be happy with a job at $1.50 a day.

A photograph of Texas farmers in work clothes, lined up in front of a shack more than forty years ago. Why should you bother to look twice at it? In his answer, George P. Elliott conveys something of what vision means:

> To be sure, if you look at the farmers twice, you will be likely to look at them more than twice, to go back to them occasionally over the years. You will get to

know them, and also something of the world which they helped make but which is no longer theirs. It is the photographer's faith that anything really seen is worth seeing, and to this faith Dorothea Lange adds her own, that anyone really known is worth knowing. But this benefit of seeing, this pleasure and knowledge, can come only if you pause a while, extricate yourself from the madding mob of quick impressions ceaselessly battering us all our lives, and look thoughtfully at a quiet image. Here are six unexceptional men who are kept from the work of their lives, partly by the drought, partly by technology and capitalism, but also by a Success game which makes them not just unfortunates but failures; yet they had no more than the vaguest understanding of the rules of that game which is wrecking them and which in any case they had not been playing. Only by meditation can you see what the photographer is showing.

From Ellis County, south of Dallas, Dorothea sent a sheet of field notes on displacement in cotton which shows the influence of Paul Taylor's analytic style. There had been much talk among the experts of the anticipated displacement of rural labor when the mechanical cotton picker would be perfected. But here in the Texas Panhandle Dorothea and Paul were seeing heavy displacement already several years in progress. And it was not the mechanical picker but the tractor and the four-row cultivator that were doing it. Everywhere they saw abandoned houses, tenants reduced to wage laborers, thrown on relief, and scattered to other parts, including California. Farms were growing bigger and fewer. It was the "deserted village" again, as rural depopulation took place. In a letter to Blaisdell, which Stryker saw too, Professor Taylor summed up what he and Dorothea were seeing:

> Landlords clash with their tenants over the crop reduction check, not openly or in organized fashion. But the landlords force tenants off the place, they use the government checks and their own livestock as payments on tractors, so more and more tenants can't get a farm. "The Farmall is ruining our country."
> We speak of the collapse of farm tenancy. Here tenancy is moving swiftly on the way out. There's drought and the well-known criticism of the crop reduction program, but the driving force is economic and powerful—mechanization. It's a force that can hardly be checked even if we would. Its effects are likely to spread rapidly, and to endure for years. And it's already expelling families who load all their household possessions and children in the car, and flee half-way across the continent. Not just "croppers," but tenants on thirds and fourths. Not blacks, but white Texans.

Yet the report of the Committee on Farm Tenancy didn't even mention mechanization. Taylor warned that any program for the relief of tenants and other low-income groups in cotton "must reckon with machine methods of production. They are here and they will spread fast."

From Texas they drove into Oklahoma, Dorothea in search of stranded oil towns for the MacLeish series. But "the oil industry doesn't work it that

way," people said to her. "A town may boom, then recede, but they do not completely peter out. And what is left is apt to be one more miserable small town in Oklahoma, with which the state is peppered. A terrible state." Ten people told her that, but she would keep on looking, she wrote Stryker, "since I have long ago learned that one is often misled in the field, and also that most people are unobservant and don't see what's under their noses. In this case, however, she failed to find what she was looking for.

In her letters to Stryker she keeps hoping he will join her on the road for a while. "You went with Rothstein, you went with Lee, you went with Mydans. And how about me? It is a damned shame that instead of being able to direct and develop the work that is before us you have to act as watchdog in the office. It's not fair to you nor to us . . . Am working hard . . . trying to develop the themes as I go along. Which is in line with your idea and Paul Strand's of a working script. You will agree that tenancy is a big subject. What I did in Hall and Childress Counties was very much to the point."

As they moved through Arkansas into Mississippi, Dorothea and Paul discovered "striking repetition" of the tenant displacement they had seen in the Panhandle. She wondered how so swift and deep a development in the Delta could not have been recognized, and again urged Stryker to come take a look for himself. "I understand much more now about our drought refugees in California. A lot of them were also tractor refugees."

It was a grinding routine to drive vast distances on poor roads day after day, and in addition to try to stay in touch with Washington and satisfy its demands. Dorothea and Paul sometimes had to change routes for bad weather or other emergencies. Stryker's letters show an occasional irritation if he failed to find her when he needed her. Then there was the problem of processing her work in the field. She mailed her negatives to Washington; he had prints made, then examined them and forwarded them, divided into three groups: "the accepted group, the doubtful group (with the corners clipped), and those which I did not feel were worth keeping at all (torn). If, however, you feel that any from the last two groups should go into the first, do not hesitate to make the change. It may have been that when you took these you had certain things in mind that would entirely change the decision."

As she moved into the Deep South, she asked Stryker if her photographs should emphasize white tenancy. He gave her a pragmatic answer: "Take both black and white but place the emphasis upon the white tenants, since we know that these will receive much wider use." He wanted her to get a few pictures of the better-looking, more prosperous type of farm. (There had been some criticism of RA for narrowing its range to bad conditions and miserable people.) But "don't go too far out of your way. If you happen to see it, shoot it." Then a suggestion that may have contri-

buted to some of her best photographs: "Later on, during cotton-picking time, would you try to get two or three good pictures, closeups of the people and work, emphasizing the hands of men and women picking cotton." He enclosed an outline for the MacLeish book, adding that because of that project and budget problems he saw no hope of getting away to join her.

Early in June she voiced the old concern about the technical side of her photography. "I need very much to be assured in regard to the quality of my negatives," she wrote Stryker. "Am relying on the meter and was perturbed when you suggested that they were underexposed. Please make sure that this holds true and let me know just as soon as you can." She had had a roll of film developed on the road as a check: the result made her feel the film was not under- but overexposed. She had told the developer she feared underexposure, so he had overdone it and ruined the film. "I need a steer as promptly as I can get it." She said she was working "on the smallest aperture I dare to. Often, when there is no wind, at x45, x32. With my view camera. If they haven't definition I can't understand it. Are any of the negatives light struck? Please check the 4 × 5 cut film particularly. Sometimes happens with packs no matter how careful you are in handling. Please make sure of 4 × 5 film. Most important. Wire . . ."

Leaving Arkansas in mid-June, she crossed the Mississippi and stopped at Greenville on the east bank, where she found upsetting news from Washington that her travel authorization would end June 30. "Very disconcerting," she wrote Stryker, "for there is so much to do and I have a full month of work ahead which I hope you are going to be able to arrange." Budget worries continued to harass Stryker and his staff without pause. He had just let two lab workers go, slowing up production of prints there was a great demand for. With Greenville as her base, Dorothea explored the agricultural counties of the Delta region on both sides of the river. She began with shots of the municipal levee and port at Greenville. The river town was now the center for displaced black sharecroppers swept off the plantations by tractor farming and the crop-reduction program. She got out of bed before dawn to photograph a huge crowd of men and women, carrying their lunches, climbing into trucks at Greenville at 5 a.m. for a day's work on the cotton plantations. She followed one group of trucks out to the fields; they did not return to Greenville until 8 p.m. and received a dollar for the day. Many of the hoers, she learned, were ex-tenant farmers.

Her Delta series includes many portraits of the people she encountered—sheriffs, plantation owners ("We in Mississippi know how to treat our niggers"), riding bosses, white tenant farmers, black day laborers, old ex-slaves ("We know our white folks and just what to say to please them"). And the new machine dominating the landscape—tractor and integrated four-row cultivator, which did the work of eight men and eight

mules. Thinking about the MacLeish outline, she wrote Stryker, "You couldn't find a better example of exploitation and its consequences in this nation than the changes in plantation life with this tidal wave of tractors."

Her camera sought out the places linked to all the other aspects of Delta life—home, church, school, grocery, café, street corner, movie house. Hearing of an abandoned lumber town in Louisiana, she made a long side trip to photograph the crumbling remains of buildings at Fullerton and the lone inhabitant, a man who had worked in the lumber mill for fifteen years and now was left stranded in the bleak, cut-over land. She went back to Hill House in Mississippi to record the changes that had taken place at the Delta cooperative farm in the year since she had visited it. She found twenty-eight families living there now. The blacks had their cabins on one side, the whites on the other. Windows and porches were screened, an uncommon feature for plantation homes. The cooperative was raising cotton, soybeans, alfalfa, small grains, and vegetables. She took pictures of the cooperative store, the sawmill, the poultry farm, and the new community house which contained a library, school, clinic, and meeting rooms.

At Hill House Dorothea met by pre-arrangement a young black named Prentice Thomas. He was an organizer for the Southern Tenant Farmers Union who had recently borrowed RA photographs for an exhibit at Howard University. "I could not believe my eyes," Thomas wrote after a few days at the Delta Cooperative. "I have witnessed black and whites eating together and sleeping and meeting together in this most hostile state." He picked out a scout to guide Dorothea through the Delta, "where there is indeed much darkness."

11 AS DOROTHEA'S SUMMER ON THE ROAD CAME to an end, the Resettlement Administration was transformed into an agency with a new name. Earlier that year it had lost its autonomous status when it was absorbed by the Department of Agriculture. Now, with the passage of the Bankhead-Jones Farm Tenancy Act—which Dorothea and Paul had helped prepare the ground for— its name was changed to the Farm Security Administration and it was charged with carrying out the functions of the tenancy bill. The FSA, like the RA, would continue to explore programs which might help reduce chronic rural poverty. It was clear Congress was not calling for an all-out war on that poverty, only for skirmishing. The object was to preserve the family farm and to reduce certain forms of farm tenancy. Some of the leaders of FSA had more far-reaching goals, democratic and egalitarian, as they sought for a viable cooperative organization of agriculture and rural life. These veterans of political struggle cautiously "cloaked their ambitious goals in traditional agrarian symbolism, and the family farm became the hallmark of the agency," wrote the FSA's historian, Sidney Baldwin. In the years that followed, "there were conflicts, defeats, disappointments, and retreats, but the extent to which they achieved their goals, improved the human condition for hundreds of thousands of destitute farm families, conceived and successfully applied unique social innovations, maintained their agency's viability, and explored the parameters of the possible, surprised their friends and alarmed their foes."

The Historical Section, led by Stryker, continued under the FSA, but funds for photography were scarcer than ever. In the spring of 1937 the country had, for the first time, pulled above the production levels of 1929. Fearful of inflation, Roosevelt decided the time had come to slash government spending. Let's see if the economy can stand by itself, said his advisers. Congress reduced funds for the major relief programs; WPA alone was cut 25 percent. In August, the economy suddenly cracked. All the

gains made since 1935 were wiped out. In the next few months two million people lost their jobs. It caught the New Dealers by surprise. The Republicans charged that there had been no real recovery all along; only pump priming had kept the machine staggering along. The Democrats retorted that capital itself had gone on strike for political reasons. Meanwhile, like a great many other government workers showered with pink slips, Dorothea found she was again to lose her job. "I had to cut my staff as far as it will go, believe me," Stryker wrote her in late September. He was left with two photographers (Rothstein and Lee), three lab men, and five office workers. Walker Evans was let go. Dorothea would be kept on only until the end of October so that she could finish work on her summer field trip negatives.

As she pinned the prints up on her wall, Dorothea wrote Stryker, "I wish that I could work the whole trip over again, go to the same places—knowing what I know now—but then I always wish that in this kind of work." She was especially concerned with grouping her prints, arranging them in sequences. If this isn't done well, she said, "I believe half the value of field work is lost." She thought she would finish it all by the first of November; if not, she would do the rest on her own time. She asked for a consulting arrangement so that the Western regional office could use her now and then, and hoped that the pay rate would be at least what had been promised her last January but never fulfilled. Even that would be "extremely low," she said, "below the prevailing rate," especially for temporary and irregular work, "but I wouldn't care if it gave me the opportunity to continue working in the fields where I am now so vitally concerned."

With the termination deadline looming ahead, she worked day and night in the darkroom, sending captions and negatives to Stryker in batches. The endless detail began to irritate her. "I am not yet through with this god-damn captioning job by any means," she wrote in October, "although I am working on it just as hard as I can. Sometimes it goes fast but sometimes I get stuck and have to go walk around the block or dig in the garden. I write 'tenant farmer' and 'Mississippi' in my sleep." She had to worry about interruptions from the regional office. A cotton strike had started and Fred Soule, the regional information chief, wanted her to go down to Shafter and Arvin to cover it with him. She knew how to handle these situations: she would follow his suggestions when they were good, and even a few when they were bad, just to keep the peace. But she'd never let him write the ticket. "These newspaper-trained men only see pictures in a very limited way and there is no sense in arguing with them."

The field trip material disposed of, she was now off the payroll but eagerly looking about for per diem work. Paul would be going to Washington in January to present a report on agricultural unemployment problems to a Senate committee. Couldn't she prepare a photographic presentation

DOROTHEA LANGE

to go with the report? she asked Stryker; "I'm convinced of the effectiveness of the method." What were her chances? "Because I am no longer on the active list does not mean that you will never write to me, and tell me what is happening, does it? You know that I am always one of your people."

Most of the month of January 1938 she gave to "getting myself squarely turned around and viewing the field as a private citizen—trying to decide what I really want most to do, what is most important to do . . . how I can do it and keep myself and my work financially afloat."

She tried to catch Stryker's eye with two news clippings she thought were cues for assignments. FDR had spoken up on the disfranchisement of Southern voters by the poll-tax device, and Henry Wallace had testified that farm mechanization was now a major cause of rural distress. Both were themes she and Paul had worked on only this past summer, and here were powerful political figures corroborating their findings. Sitting there in the Washington whirlpool you probably don't even know what they said, she teased Stryker, but wouldn't these be great assignments? "Think it over, Roy!"

Nothing seems to have come of her hints. In February, probably on regional duty, she made some pictures of the new government camps. At Arvin forty houses had been put up by the FSA for rent to the migrant workers. The simple structures were "one step up from the tent," she said. But it was tragically short of the need, as John Steinbeck was finding out for himself. He was again in the field, asked by the FSA to go and look and write. The state had been flooded by heavy rains some three weeks now, and thousands of migrant families in the interior valleys had been drowned out of their tents, "starving to death . . . not just hungry, but actually starving," he wrote a friend. "The government is trying to feed them and get medical attention to them with the fascist group of utilities and banks and huge growers sabotaging the thing all along the line and yelling for a balanced budget. The newspapers won't touch the stuff but they will under my byline. The locals are fighting the government bringing in food and medicine. I'm going to try to break the story hard enough so that food and drugs can get moving . . ."

In March, Steinbeck went back for another week in the field, finding the hunger and sickness made worse by the floods. This time *Life* had sent him, along with the photographer Horace Bristol. Steinbeck wouldn't take money for his work; it was to go for relief instead. "The suffering is too great for me to cash in on it," he wrote his literary agent, Elizabeth Otis. "I hope this doesn't sound either quixotish or martyrish to you. A short trip into the fields where the water is a foot deep in the tents and the children are up on their beds and there is no food and no fire, and the county has taken off all the nurses because 'the problem is so great that we can't do anything about it.' So they do nothing. And we found a boy in jail for a

felony because he stole two old radiators because his mother was starving to death and in stealing them he broke a little padlock on a shed . . . It is the most heartbreaking thing in the world. If *Life* does the stuff there will be lots of pictures and swell ones. It will give you an idea of the kind of people they are and the kind of faces . . . I want to put a tag of shame on the greedy bastards who are responsible for this . . ." But *Life*, for whatever reason, did not publish a Steinbeck-Bristol picture-story on the migrants' conditions until two years later. It waited until the novel Steinbeck was writing in 1938—*The Grapes of Wrath*—was published and had become a sensational best seller. Not content to sit and wait for *Life*, friends of the migrants, organized in the Simon J. Lubin Society, obtained Steinbeck's permission to reprint his 1936 articles on the migrants in a pamphlet. He added an epilogue, and Dorothea Lange provided her photographs for illustration. One of the pictures she had made in 1936, a migrant mother with a child at her breast, was chosen for the cover. Called *Their Blood Is Strong*, the 25-cent pamphlet went far and wide, was reprinted at least four times, and earned enough money to keep the society's work going.

In March, invited to Washington to testify before a Special Senate Committee on Unemployment and Relief, Professor Taylor depicted migrant labor's needs with the help of Dorothea's photographs. He drove home the point that the problem of aiding such families transcended state power and responsibility. Effective action could be expected only if there was interstate cooperation guided by federal leadership. The Senate report did not include Dorothea's photographs, but the FSA reprinted the text of Taylor's testimony separately and distributed it a month later. Taylor made the case for his position in a speech to the powerful Commonwealth Club of San Francisco.

That spring Dorothea and Paul made plans for their third summer field trip together. She asked Stryker if there was a chance the FSA could hire her for those three months. She wanted to do some work on the Southerners disfranchised by the poll tax—"dynamite in this one!"—and to build up the FSA file on cotton. But the best he could do was guarantee buying a selected group of one hundred negatives at $3 apiece. Later, if budget prospects improved, he might take another $300 worth. It was disappointing, but she agreed to do it. She had just bought herself a Zeiss Jewell View camera with convertible Protar Lens and any money Stryker could offer her was welcome. "There is very little cash left in my top bureau drawer, righthand side. Just about enough to see me in film till I get to Washington. Paul will always feed me, and if you will keep me in film, anything will be possible." Three dollars was a low price for selected negatives, taken from a traveling assignment, but she was sure it would come out all right for her and for him.

Since she would not be on the FSA payroll, the route followed would be

dictated by what Paul's research for the Social Security Board required. They would leave Berkeley on June 1 and return to California late in August for the opening of the children's schools. They would take three weeks crossing the country, spend ten days in Washington, then seven weeks working in the South and Middle West. "You will be encouraged about me," she told Stryker, "when you see what a marked technical advance I have made recently by dint of hard plugging at it. Feel that I've made real headway in that respect." But as though to guarantee technical quality, she told him in the same letter that she was having all her negatives of the trip developed by Ansel Adams. "It will cost me a lot of money but since I cannot for lack of time develop in the field I've decided to make no compromise on quality and there is no technician in the country to match him."

Stryker couldn't accept Dorothea's generous offer to do more than she could be paid for; that would be exploiting her shamelessly. He was feeling depressed about the way his unit was being squeezed. Much as he tried, he couldn't convince his superiors of the need to keep up a definite momentum in photography. It seemed to them the job was pretty well done. If there were twenty thousand negatives in the file, wasn't that enough? Their concern was with agricultural economics and politics. They didn't share his vision of the possibilities of photography in documenting national life. He wanted his photographers to take care of the special needs of the FSA, yes, but to document too "the America of how to mine a piece of coal, grow a wheat field or make an apple pie." His aim, he would say, was "to introduce Americans to America." "I never give up hope," Stryker confided to Dorothea, "but I certainly get tired as hell some days of trying to obtain the wherewithal to keep going. When I look over my list of jobs to be done, just the insistent ones, and realize how little I can accomplish with only two or three photographers, I become quite bitter about the state of the nation. All I can do is keep pounding away in hopes that either good luck will come our way, or the bosses will come across, or fire me and close up the damn file . . . Either we have got to continue our work in a sufficiently big way to make it worthwhile or close the damn thing down completely."

Dorothea was no stranger to this mood of Stryker's. She let him know how much she valued his stubbornness. "It needs to be said, and not for the first time, that I *very much* appreciate your everlasting and persistent effort to keep the thing alive and functioning." She had her own reason now to carry on photography in the field, although she was not yet ready to tell Stryker about it. The idea of doing her own book of documentary photographs had occurred to her. Such books were not a new development in publishing. As long ago as the 1870's John Thomson had published his *Street Life in London*. In Dorothea's high-school years Lewis

Hine's photographs had illustrated the six-volume *Pittsburgh Survey*, and then in 1932 Hine had done his own book, *Men at Work*. A few other picture books appeared, documenting the early New Deal years, but all drew upon the files of many photographers. Not until 1937 did a single photographer produce a book dealing with the same subject matter Dorothea focused on. This was *You Have Seen Their Faces*, with pictures by Margaret Bourke-White and text by Erskine Caldwell. Perhaps it was the impact of this book, followed in the spring of 1938 by MacLeish's *Land of the Free*, that moved Dorothea to her decision. Of the eighty-eight photographs in the MacLeish work, thirty-three were by Lange. Why shouldn't she create her own book to say what she wanted to say in the way she wanted to say it?

Bourke-White had taken her camera south at the invitation of the novelist Erskine Caldwell. He had depicted the sharecropper in fiction; now he wanted to authenticate that life with photographs. Through his agent he contracted to do a picture book with Bourke-White, the best-known photographer in the country. Then twenty-nine, she earned a large income working for *Life* and *Fortune* and for advertising agencies. In 1931 she had done her own picture book on the Soviet system, *Eyes on Russia*, and in 1934 a photo-essay for *Fortune* (with text by James Agee) on the Great Plains drought. *You Have Seen Their Faces* was the outcome of a trip through the Southern states in the summer of 1936. The book was instantly acclaimed and sold very well. It appeared upon the crest of national interest in the farm tenancy problem. Its success, said the critic William Stott years later, lay precisely in the fact that it catered to a public opinion already formed. "What a reader feels behind the photographs and captions . . . is an imagination twisting the facts to squeeze the easiest and most maudlin emotions from them; a spirit that regards its craft, its effect, rather than its subject . . . One turns the last page and finds an afterword by Bourke-White: 'Notes on Photographs.' Her first sentence reads: 'When we first discussed plans for *You Have Seen Their Faces*, the first thought was of lighting.' No doubt it was."

Walker Evans and James Agee were in the South that same summer of 1936, working on *Let Us Now Praise Famous Men*. When they saw the book by Caldwell and Bourke-White, it angered them. They felt, said Evans, that the book was a "double outrage: propaganda for one thing, and profit-making out of both propaganda and the plight of the tenant farmers. It was morally shocking to Agee and me. Particularly so since it was publicly received as the *nice* thing to do, the *right* thing to do. Whereas we thought it was an evil and immoral thing to do. Not only to cheapen them, but to profit by them, to exploit them—who had already been so exploited. Not only that but to exploit them without even *knowing* that that was what you were doing."

Another FSA photographer, Ben Shahn, was less violent in his opinion

of the book, but still critical. Shahn called the pictures "inadequate copies of our work, really. It did not have that particular dedication that ours had. It was a commercial job."

Bourke-White's pictures, wrote William Stott, "made her subjects' faces and gestures say what she wanted them to. And what she wanted to say is blatant on every page. Faces of defeat, their eyes wizened with pain—or large, puzzled, dazzled, plaintive; people at their most abject; a ragged woman photographed on her rotted mattress, a palsied child, a woman with a goiter the size of a grapefruit; twisted mouths (ten of them), eyes full of tears. These people are bare, defenseless before the camera and its stunning flash. No dignity seems left them . . . The meaning of these pictures is underscored in the captions Caldwell and Bourke-White gave them . . . The captions quote people saying what they never said. The words Caldwell and Bourke-White put in the tenants' mouths made them as abject as possible . . . The captions, like the rest of the book, reduce the lives and consciousness of the tenant farmers to force the audience to pity them . . ."

MacLeish's *Land of the Free* was altogether different in theme and structure. All of the photographs came from the Stryker files, many of them taken with the poet's basic idea in mind. Still, the book is not a poem illustrated by photographs but rather, as MacLeish has stressed, "it is a collection of photographs illustrated by a poem. The poem has a subject of its own but it was written out of the photographs in the sense that the photographs held the great, tragic experience which the poem attempted to put in perspective." Lange and the other photographers had nothing to say about which of their pictures would be used. MacLeish made the choices. He used so many of Lange's photographs, he said, because of "the human poignance of her work. Like all great artists in the visual arts her subject was mankind. And she was a great artist."

When Harcourt Brace sent a batch of free advance copies to Washington, they were swiftly distributed to influential people in government, beginning with the White House. The book had "a rather interesting reception," Stryker wrote Dorothea, whose concern was obviously great. "The pictures, I would say, came out on top in every case. There seemed to be a divided opinion about whether or not Mr. MacLeish had made a contribution to literature. It certainly has done the photographic section and the photographers who participated no harm." The reviews were good; in some cases they echoed what Stryker had reported. Pare Lorentz in the *Saturday Review of Literature* noted that Dorothea Lange's photographs dominated the book and said, "I give her chief credit for putting on celluloid what Mr. MacLeish failed to put in words: the sorrow, and the dignity, and the blood of the people."

Such publicly voiced enthusiasm for her role in the book may have crystallized Dorothea's desire to publish a group of photographs around

the theme of farm families on the move. For three years she had been photographing migrants in many parts of the country. No one had made as richly detailed a record. On this summer field trip she would have the freedom to photograph whatever would fill in gaps in the story or strengthen material already in hand. The idea for the book was her own, but inevitably she saw it as a collaboration with her husband. It was not to be a book solely of photographs. Schooled in Paul Taylor's method of collaboration between social scientist and photographer, she saw it as a picture-text representation of a social issue. In Taylor's words, the message would be: "These people are worth helping! They are down and out, but they are not the dregs of society. They've just hit bottom, that's all."

Their third summer field trip began in June with a drive into the southern tip of California, then across to Arizona and New Mexico. In the Texas Panhandle they met Dust Bowl conditions again. On the way down to Mississippi Dorothea made a series of photographs illustrating sharecropper life in the tobacco counties of South Carolina and Georgia. From the Deep South Taylor and Lange drove north and west again. Many of the photographs that would be used in *American Exodus* were taken on this homeward trip, especially in Missouri, Arkansas, and Oklahoma.

The field trip was interrupted in early July for about a week's stay in Washington. Taylor had business with the Social Security Board and Dorothea wanted to talk with Stryker. It was at this time that the only other woman photographer Stryker hired joined the staff. Marion Post Wolcott, then twenty-nine, had freelanced in New York for magazines and then had worked eighteen months as a staff photographer for the Philadelphia *Evening Bulletin*, a rare job in journalism for a woman. Wanting to explore other fields of photography, she appealed to her friend, the photographer Ralph Steiner, who sent her to see Stryker. He was impressed with her portfolio and took her on. She said Stryker wanted her "to get more photographs of the positive side of the FSA program and something different for the exhibits that could be used to contrast with the other photographs; to show something other than the 'lower third' of the country. So many photographs had been taken when I joined the program and Stryker wanted something to contrast with them and I had a different job to do." Stryker was moving toward "a brand-new territory of American life and manners as a legitimate subject for visual commentary." The question arises: why did he hire Marion Post Wolcott now when he had a month before told Dorothea a payroll job was impossible, he could only buy individual negatives from her? He may have believed Dorothea could not do the kind of photography he expected of Post Wolcott. Lange was too closely identified in his mind with documenting that "lower third."

The two women met for the first and only time soon after Post Wolcott came on the FSA staff. It was the briefest encounter, just as Dorothea was leaving Stryker's office. When he introduced them, the younger woman

felt the older was not friendly or warm or interested in talking with her, perhaps because Lange was short of time, or because she was unhappy over the session with Stryker, in which he is said to have criticized her negatives again. It is logical to think that Dorothea would have been upset to learn that a new photographer had been hired while she had been denied renewal of her job. Recalling that day, Post Wolcott said, "I doubt that her coolness toward me was in any way related to my sex or to my being a new member of a close 'family.' I was a great admirer of her work and would like very much to have known her. By the time I joined the group, things were changing. The original closely knit inner circle had broken up—those who had helped form, develop, and guide its direction. I've always felt the photographers had a very substantial, and usually overlooked, influence on Stryker's ideas and planning—more than he, or most people, realize."

Stryker's view of himself is modest and open. In an interview given long after the FSA years he said, "I'm very opinionated and very apt to be dominant and stubborn and disagreeable as hell if I don't like something." It made for trouble when such a quick-tempered man differed with so strong-willed a woman as Dorothea. "I liked Dorothea," he said. "She was a wonderful person, although she'd drive me crazy sometimes. Her negatives weren't very good, and when she wanted to borrow them, we practically had to send the sheriff to get them back for the files. A great woman, though." The FSA photographer John Vachon believed Stryker was attracted by people of brilliance and special talent, yet was afraid of them. Asked if this were true, Stryker, who had earlier spoken of himself as "not a very well-educated man, not a particularly bright guy," replied that Lange, Vachon, Delano were brilliant, but he didn't think he was afraid of them. Then, hesitantly: "Others could judge better."

12 ALMOST AS SOON AS SHE HAD SETTLED IN AT
Berkeley after the summer field trip, Dorothea began to
press for her return to FSA, at the higher rate of pay long
promised her. "Is there any reason why I should not be put on the payroll
at once at $2,600?" she wrote Stryker in mid-September. "Surely neither
you nor the Administration are suggesting that my work is below the
standards of the other photographers of your staff."

She was returned to FSA's payroll on September 29, 1938, at the old
level of $2,300, with the promise she would be promoted to $2,600 within
a few weeks. When the word reached her she was in the hospital, recov-
ering from an appendectomy. The appendicitis had attacked without
warning in the middle of the night. After only three days home from the
hospital, she was eagerly suggesting new projects to Stryker, offering to
find a replacement photographer if her recovery did not permit her to go
out in the field herself. The major job, as the administrators saw it, was to
provide thorough coverage of life in the camps and the projects FSA had
opened in California and elsewhere. A small storm blew up in Washing-
ton when John Fischer, FSA's Information Chief, told Stryker he had
doubts about the choice of Lange to do the series. "Fischer was very much
worried for fear you wouldn't work with Soule," Stryker wrote Dorothea.
"He wondered nervously if you would do 'arty' pictures. I got very mad
and told him that our photographers had never refused yet to do their
work promptly and efficiently . . . On the other hand, I informed him
none of our photographers are going to devote their full time to doing that
type of thing that can be done by a $1,200 boy with an Eastman Kodak."
Get hold of Soule, he advised Dorothea, and "let him feel he has a little
part" in the job.

On October 20 Dorothea drove south into the San Joaquin Valley,
equipped with instructions from Soule and determined to carry them out
the way he liked. She would also make some photographs of the agricul-

tural towns she passed through, as the beginning of a large series on California town and city life she hoped to work on that winter. Her mind was beginning to turn in directions other than the rural.

It wasn't hard to satisfy Soule's needs. Her pictures show the many ways FSA was serving its clients. One family near Visalia, whose farm had been failing, began to follow an operational plan devised by the Rural Rehabilitation supervisor and turned their farm into a success. Another Rehab client, a family of eight, had gone on relief hopelessly when the father lost his arm in a work accident. FSA arranged compensation for him, which paid for a 15-acre farm, and gave him a loan which stocked the farm with team, wagon, tools, cows, and hogs. In Tulare County FSA had started the Mineral King Cooperative Farm, establishing ten families on an old 500-acre ranch which was now operated as a single unit raising cotton, alfalfa, and dairy products for cash crops. The old farm buildings were being replaced by modern ones suitable for community living. In four rural counties FSA had installed pumping plants for irrigation powered by a natural gas engine which ran at half the cost of electricity, serving small farmers. At Arvin she photographed an FSA housing project adjoining the FSA migratory-labor camp. The twenty farm-labor families already moved in were paying $8.20 a month, which included electricity and water. Such homes and camps were first steps in the FSA's attempt to stabilize migrant families. On Halloween Dorothea found herself in the FSA camp at Shafter, where her camera recorded the rare occasion for a big party—refreshments, games, and dancing—shared by parents and children.

"Okies" and "Arkies," these Dust Bowl refugees were called, and promptly stereotyped like a racial minority. In Bakersfield a dump of a movie house had a sign posted outside: NEGROES AND OKIES UPSTAIRS. Stories spread everywhere about how lazy and shiftless and irresponsible the migrants were: let the FSA put a table in their shack and they'd chop it up for firewood. But what Dorothea saw belied the myth. The efforts some migrant families made were heroic. She visited an FSA family which back in 1936 had gone hungry to save $50 out of their relief money, using it as a down payment on twenty acres of raw, unimproved land. Then they got an FSA loan of $700 for stock and equipment. Now, two years later, they had a one-room home, seven cows, three sows, a homemade pumping plant, and ten acres of improved permanent pasture. Their cream check brought in about $30 a month, cash the twenty-six-year-old father added to with about ten days a month on odd jobs outside. "Piece by piece this place gets put together," said the twenty-two-year-old mother of three. "One more piece of pipe and our water tank will be finished."

Even so, it was hard to be optimistic about the future of the family farm. A small cotton farmer in Kern County, who leased his land, paying a fourth of the crop for rent, as well as his own irrigation bill, told Dorothea,

"It's come to that there's not going to be any more small farms in California. The big fellows have got us all with a ring in our nose. You take the small farmer like me—we can't come out. There's no difference hardly between me and my pickers—only I've got a place to stay out of the rain."

Three years after she had begun to photograph the conditions of the migrants, her camera was still framing families living in the brush, along highway ditches, behind billboards which served as partial windbreaks, in cheap auto-trailer camps. And where there were relief bureaus, the people lined up outside the offices early in the morning, long before the doors opened. Their needs were enormous; the FSA budget to meet them pathetic. In the FSA office at Visalia she counted 144 families filling out applications for farm-purchase loans; ten would be finally selected from this huge four-county region.

Looking at such lives from outside she found it hard to feel hope for them. Still, they themselves did not give up easily. On U.S. Highway 99, Dorothea came across three families of migrants camping behind a billboard. "Something will break loose," a man said to her. "That's my hope. People are goin' round day and night. I've had three good starts in my life. Had a place paid for, had to mortgage the first (1929) to pay for the second, so I lost both. Was where we wasn't rich, but everybody knew me and I could get what I wanted to. Now nobody knows me. I can't feed these five children of mine on 75-cent cotton so I'm pullin' out of here but I don't know where I'm goin'. The only thing I look to for a change is the election."

He was talking about the pay for picking cotton—75 cents for 100 pounds of picked cotton. A good male picker, in good cotton, and under favorable weather conditions, could pick about 200 pounds the long day, making $1.50 for his back-breaking labor. A new CIO union, the United Agricultural, Packing and Allied Workers of America, had organized the migrants in the San Joaquin Valley and they had gone on strike to raise the 75-cent rate to a dollar. By the time Dorothea arrived at the cotton fields, the work was being done only by strikebreakers protected by armed guards.

It was "the tail end of a long heart-breaking strike, unsuccessful," she wrote Stryker from Bakersfield. "FSA is feeding the strikers and therefore there is hostility—a disrupted camp program, and half-empty camps. Never worked longer hours, harder—but what the results will be, can only pray to Jesus."

She photographed a street meeting held at night by the union, the speaker an Oklahoman who had joined the union when the strike began and become the leader of the flying squadron of automobiles which attempted to picket the large fields of the corporation farms. To the Dust Bowl refugees unions were a strong phenomenon. They were hearing for the first time of the need for organization and they were uncertain what to

do. Sympathizers had formed a Steinbeck Committee to give aid to the union efforts to organize, and Dorothea photographed meetings it held in the cotton district. The FSA warehouse began to dole out emergency food and clothing to the strikebound families. When sheriffs started to arrest the pickets, she heard one striker say, "I don't care: let them throw me in jail. There's somebody will take my place." But another answered, "Brother, it's pick 75-cent cotton or starve." What she had expected to be a routine mission to satisfy Soule's needs had turned into an exciting job.

Home after ten days in the field, she disappeared into her darkroom (with Ron Partridge to help) for four days and nights to develop the negatives and rush them off to Stryker. She begged to have proof prints of her negatives returned quickly, before the field experience jotted in her notebook would submerge under other work.

Dorothea came out of the darkroom that week to vote in California's statewide elections. Her state was one of the few that fall to score a liberal victory. The progressive Democrat Culbert Olson, whom Dorothea and Paul Taylor supported, defeated the Republican governor, Frank Merriam, by a big margin. But the outcome of the 1938 elections nationwide was disastrous for the New Dealers. The Republicans picked up many seats in Congress and captured many governorships, making a decided gain over their showing in 1936. Liberal governors in Michigan, Minnesota, and Wisconsin were defeated. The issue that hurt the Democrats most was the recession that had started in 1937. Millions of unemployed still walked the streets. And now the middle class, as Harry Hopkins put it, had become "bored with the poor, the unemployed and the insecure." As FDR's second term wore on, and full recovery remained remote, people got tired of bearing the burden of what threatened to be a permanent army of the unemployed. The compassion the nation had felt for the victims of hard times in the early years of the Great Depression was wearing thin. Still, the voters kept the New Deal in power by comfortable majorities in both the House and the Senate. They did not want the Roosevelt reforms junked. The situation led the President to rely more on the conservative wing of his party; this meant making concessions he did not need to make in his first term. The result was stalemate. It was hard for progressives to get any fresh programs launched; it was just as hard for conservatives to get any old programs killed.

Happy over Olson's victory, Dorothea wrote Stryker: "You know that we have just elected a liberal Democratic Governor, after a bitter fight. You know too that the La Follette Committee is working on the subject of the violations of civil liberties and the activities of the Associated Farmers. Happening simultaneously this is causing lively times, and a chance to work on interesting and important themes, with effect, I hope. Our work on migratory labor has certainly been fruitful, and you who have stood behind it and made a lot of it possible should feel some satisfaction."

The FSA exhibit, which had aroused great interest in New York that spring, had not yet reached the West Coast, and she kept prodding Stryker to send it out. There are many places that want it, she said, and "it might help me in my work for you to have it shown here for a while." The FSA had shared in an International Photographic Exhibit arranged by Willard Morgan at the Grand Central Palace. Rothstein and Lee had chosen about seventy of the best prints from the files and enlarged them considerably for the New York show. To Stryker's delight the FSA panels drew the most excited response. What he had conceived as social documentation was being applauded at the same time as art. One of the leading art critics, Elizabeth McCausland, calling the FSA work the best in the exhibit, wrote that "after the usual diet of the art world—cream puffs, eclairs, and such— the hard, bitter reality of these photographs is the tonic the soul needs. They are like a sharp wind sweeping away the weariness, the fever and the fret of life. For so grim is the truth they represent that the vapors of pseudo-intellectual culture are immediately dispelled. In them we see the faces of the American people . . . We might also see (if we were completely honest and fearless intellectually) the faces of ourselves."

The Museum of Modern Art had taken the FSA section from the show and was touring it around the country. Stryker had no control over it, he told Dorothea. But he did have some good news: *U.S. Camera* was out with its 1938 annual, containing a 32-page section of FSA photographs (including Lange's) chosen by Edward Steichen, who had thought the Grand Central show superb. Stryker spread copies of the issue among the top officials and wrote Dorothea, "I am astounded at the number of people who have been impressed . . . much more effect than the MacLeish book." Pleased to hear such news, Dorothea did not forget to ask time and again about her delayed raise. Nor did her technical problems disappear from view, especially in regard to development of negatives:

> Do you [Stryker] and the staff photographers favor the use of fine grain developers (Edward, Harveys, Champlin) for *all* negatives regardless of whether they are strictly miniature or not, in light of the fact that we are being called upon to make so many huge prints for so many different purposes? These developers are expensive of course, but there is *no comparison* with D.K. 76, for instance, as regards brilliance and range and grain. I tried out the Harvey formula and got a good roll. I used a tankful of Champlin on a second roll, same subject, and got a very fine set of negatives. I like it better, *thusfar*. The question is, shall I develop my large negatives in this developer, so that they can be projected into large sizes, and shall I order my developer accordingly?

There is no record of Stryker's reply to this query, but often he wrote her long letters about technical or administrative matters which make one wonder how FSA managed to achieve what it did. To get permission to stick an airmail stamp on an urgent letter was so difficult Stryker always

paid the postage out of his own pocket. The everyday routine of running a photographic unit was cumbered with a thousand restrictions. Stryker's group was only one tiny unit within the large FSA, which itself was part of a huge Cabinet department in turn subordinate to federal government regulations. "When you get one thing straightened out," Stryker wrote Dorothea mournfully, "two more seem to pop up." That was in Washington, but it affected everyone in the field, perhaps Dorothea more than all the others. Remote from headquarters, she had to rely on fragile communications with Stryker for everything. And she too suffered her local if minor disasters. That December, when the Bay weather turned bad, and rain and mud and poor visibility made impossible a field trip she had planned, she turned to her darkroom only to find its roof suddenly collapsing under the downpour, with water leaking all over her enlarger, warping the easel, and making a general mess. It meant loss of valuable time until workmen could put on a new roof.

It was at the end of the year that she reminded Stryker of what she must have told him in Washington about plans for her book: "You know that my book is coming out one day. I got it all assembled up to a certain place and then got sick of it and put it clear away. Yesterday I pulled it all out again and laid the prints all over the floor for another look. Maybe it is better than I thought. At any rate I should like to take a day off now and then, maybe a week at a stretch—I don't know how it will go—to work on it. I cannot do this without your knowledge and can arrange it whatever way you prefer. This is however not primarily a personal venture—it has been done from the first from the point of view of revealing and communicating a national problem. So that in working on it I don't or won't feel that I'm chiseling. It's all the same job and when it comes out it will further your purposes, I hope."

Stryker's reply was encouraging: "I see no reason why you couldn't take out a little time now and then. You will have to use discretion, since there are folks around who are not at all sure that a photographer should not be in the field all the time. I know differently—and after all, I am the boss! The book is important, and will benefit us all. I know that you can handle the thing quite satisfactorily."

The most intense work on the book—to be named *An American Exodus*—began late in 1938 and went on into the spring of 1939: finding the right form, making the selection of pictures, deciding what text could best fit with them. Paul and Dorothea needed undisturbed space and privacy; for $15 a month they rented an attic about half a mile from home. Here they made trial lineups of proof prints by laying them out on the floor as in facing pages, section by section. Each part would represent an agricultural region of the country, moving from Southeast to Far West (Old South, Plantation under the Machine, Midcontinent, Plains, Dust Bowl, Last West). They worked closely together, sorting out the pictures until they

had them the way they wanted them. "Dorothea took the initiative here," Taylor said. "There was no friction in our collaboration." Their foreword to the book stresses the point: "In this work of collaboration it is not easy nor perhaps important to weigh the separate contributions of each author. Those distinctions which are clearest arise from the fact that this rural scene was viewed together by a photographer and a social scientist. All photographs, with the few exceptions indicated, were taken by Dorothea Lange. Responsibility for the text rests with Paul Taylor. Beyond that, our work is a product of cooperation in every aspect from the form of the whole to the least detail of arrangement or phrase."

The function each photograph would serve within the book was the prime consideration for Dorothea, Taylor insisted. Just as, he said, when out in the field, documenting what she saw, "she did not, as some photographers might, have foremost in her mind, 'How am I going to make a beautiful photograph that will be shown on a museum wall?' She thought of the immediate, specific purpose, and served that purpose." He pointed out that when another photographer's picture made the point better, it was used. (There are nine such photographs in the book.) More of the images she would become best known for (including "Migrant Mother") appear in MacLeish's *Land of the Free* than in her own book, bearing out what Taylor said of her basic motive.

"We were trying to spread information of a current condition, and the need to do something about it now. We wanted documentation saying, 'these are the actual conditions.' We wanted a national program." And to that end, he went on, Dorothea "was entirely willing that we should use any photographs. If the subject dictated that a certain photograph should be there, one that wouldn't meet the same artistic standard as some of the others that were there, that didn't bother her at all. The criterion for selection was: what were we trying to say and do in that book?"

The book's theme was the contemporary exodus from the land, the mass migration which in the past four years had brought 300,000 refugees, nine-tenths of them native white Americans, into California. With camera and typewriter Lange and Taylor had covered all the regions from which "thousands of families had been swept toward the Far West, like so much top soil, by the ravages of nature, the encroachment of technology, and the desire of owners to substitute day laborers for tenants . . ."

What the collaboration produced to express the theme was, they wrote, "neither a book of photographs nor an illustrated book in the traditional sense. Its particular form is the result of our use of techniques in proportions and relations designed to convey understanding easily, clearly, and vividly. We use the camera as a tool of research. Upon a tripod of photographs, captions, and text we rest themes evolved out of long observations in the field."

Captions and text are used flexibly in the book. The words spoken by people in the pictures were truly their own. They rejected what Caldwell and Bourke-White had done in their book. "We adhere to the standards of documentary photography as we have conceived them," says the Lange-Taylor foreword. "Quotations which accompany photographs report what the persons photographed said, not what we think might have been their unspoken thoughts." When they used photographs which contain no people (cabins, the land, highways), if the captions are quotations, they come from persons they met in the field. Quotations are found with about half the photographs (and they are reproduced on the endpapers of the book). The other half are captioned with the authors' own words, or with quotations from other sources—newspapers, letters, government documents, books on agricultural problems, folk songs, advertisements. Besides the foreword there are some twenty pages of text, brief essays on the human and economic dilemmas in each region of the great migration.

The book became what Beaumont Newhall called "a bold experiment, pointing the way to a new medium, where words and pictures do not merely explain and illustrate: they reinforce one another to produce . . . the 'third effect.' "

In a closing section called "Directions," they faced honestly and unsentimentally the implications of their findings. What the government had done was to take measures only to relieve some acute distress, but little beyond that. As they were finishing the book, needy migrants were still entering California at a rate of six thousand a month. And no one had yet counted the large numbers going elsewhere. What these people who had long made a living from the soil wanted was not relief but a chance for self-support. At what? With advances in agricultural technology the country needed fewer, not more, farmers. The small subsistence farm was no longer an answer for people displaced from either agriculture or industry. "The real opportunity for large-scale absorption of the displaced must lie in the direction of industrial expansion, not in crowding them back onto the land where already they are surplus. Industrial expansion alone offers hope of permanently raising agricultural income to high levels and of employing at good standards the populations produced but unneeded on the farms."

At the end, the book raises the question Paul Taylor would always be concerned with—the inroads history had made on a very old American ideal, the ideal crystallized in the Homestead Act of 1862, "that our land shall be farmed by working owners." The sweep of mechanization was turning our best lands over to factory agriculture, the modern latifundium with its absentee owners, its managers, day laborers, landless migrants, and recurrent strife. No observer could feel confident that the family-size farm would endure in any significant number. Then where could those

who till the soil find security and a full share of their labor's benefits? The alternatives Lange and Taylor pointed to were "associations of tenants and small farmers for joint purchase of machinery; large-scale corporate farms under competent management with the working farmers for stockholders; and cooperative farms."

13 AS 1939 APPROACHED, THE PROSPECTS FOR
his photographers looked good to Stryker. C. B. Baldwin
had assured him that his unit stood high in the Department
of Agriculture, now that they had been doing so much work for other sec-
tions. He must see to it, however, that this tail of outside work did not wag
the dog: "Remember that FSA is the dog." Reporting the conversation to
Dorothea in a long, gossipy letter, Stryker outlined his program for the
next few months. She was to concentrate on California, with side trips to
other states of the Western region. His other photographers—Rothstein,
Lee, and Post Wolcott—would be dispersed to the South and Midwest. He
expected to have a new air-conditioned lab soon, and another darkroom
assistant. "Really, Dorothea, things are certainly coming along for us
now!"

It was not such a good time for the unemployed. There were still eight
million of them, nearly a decade after the Depression had begun. Indiffer-
ent to human suffering and eager to dismantle Roosevelt's social pro-
grams, the conservatives in Congress had just slashed relief funds. That
January the Workers Alliance, the union of the people on WPA, organized
simultaneous mass demonstrations in the nation's larger cities. Dorothea
went out on the streets of San Francisco to photograph the parade up
Market Street and the rally held to protest the relief cuts.

In that same week, Governor Olson took office. After forty-four years
of Republican administration, California now had a Democratic regime. It
would encounter the same opposition to change as had the national New
Deal. Olson's staff talked of setting up a state visual-education unit so that
they could take their progressive program to the people. Stryker was eager
to help, but nothing seems to have come of the idea. Meanwhile, Dorothea
pressed him to give more and faster service to her state. She saw it as a
chance to make the new state officials aware of the purpose and power of

documentary photography. The regional FSA officials kept pressing for more photography of their local projects. Sensitive to their needs, Dorothea in turn pushed Stryker hard. He meant to do his best, but he never had enough photographers, technicians, or laboratory time to satisfy the demands of all twelve regions.

She went into the field again in February, putting aside work on the book, and staying out ten days. She traveled over much of the state, reporting on the spreading pattern of industrialized agriculture. She covered the newer services the FSA camps were trying to provide, and photographed the migrants bringing in the cotton, lettuce, carrot, and pea harvests. Everywhere she encountered a heavy oversupply of labor and intense competition for jobs. The field trips she made in the summer of 1939—alone, without Paul Taylor—were considerably shorter than in previous years. In July she spent a couple of weeks in North Carolina, photographing the black and white sharecroppers raising tobacco in the Piedmont region. Some of the sharecroppers were FSA clients, which is probably why she was sent there. Although she was present on the Fourth of July, there was no celebration of Independence Day. The next day, however, turned out to be Annual Cleaning-Up Day at the Baptist Church near Gordonton, and she took her camera over. At day's end she wrote the following report, documenting what she saw and did. It is an example of FSA reporting to explain the photographs. But it also, as Beaumont Newhall has remarked, tells us much about her own qualities: "the depth of her observation, her sympathetic attitude to her subjects, her respect for their privacy in not photographing inside the church, her success in getting permission to do this later, and especially the sharpness of her ear."

North Carolina
DATE: July 5, 1939
LOCATION: 1 and 1/10 miles S.E. of Gordonton, Person County.
MAP CODE: Person 21
SUBJECTS: Annual cleaning-up day at Wheeley's Church.
GENERAL NOTES: Accidentally learned at Gordonton that "everybody in the community was gathering at the church, going to take their dinner." Was not able to get back in time to see the dinner in progress and most of the cleaning done. Farm women of all ages, men and children; one six-month-old baby and one woman on two crutches were still there finishing up the cleaning at about 2:30. There were fifteen cars; "a good many people" left before dinner. Had to talk to a succession of people: had to ask some of the others: had to ask the older members: had to talk to the head deacon to get permission to photograph. They very much want to have a print showing the church and the grounds. Very proud of their church, spacious well-shaded churchyard, well kept (though very simple) cemetery, and very proud of the fact that they keep everything so tidy. They had done a thorough job of sweeping the yard close to the door and raking the rest, about five acres. The church is primitive Baptist—"don't know whether you

ever heard of that kind or not," and is "over a hundred years old" but no one seemed to know exactly. It has 70 members and "lots of friends around who help out." Preaching once a month and the church is crowded. Will probably hold 500. Cleaning the church consisted of sweeping, dusting, washing the windows; "we think we ought to keep it as nice as we do our homes." The church is sealed, painted white inside, is heated by a small coal circular with a pipe suspended from the ceiling nearly two-thirds of its length; "that keeps the back of the church warm." A table in the space before the pulpit had a large cover of coarse crocheting and a tight little nose-gay of flowers. No picture taken inside the church because of hesitation of church members. The people were substantial, well-fed looking, the women in clean prints mostly ready-made, the men in clean shirts and trousers, some overalls. Good-looking children. Many addressed each other as cousin or aunt, etc. Very gay and folksy—evidently having a good time together. Cars new or relatively so and not all Fords. A group of solid country people who live generously and well. Much interested in the photographing, much joking about posing.

Group on church steps: note rakes, yard brooms made of dogwood, home-made buckets with dippers. Note woman wearing bonnet, front and side view. Note homemade gloves. This woman was named "Queen."

July 9 is "preachin' Sunday" and got permission from deacon to return to make pictures of the congregation.

The work she sent in to Washington on these field trips pleased Stryker. "Excellent material," he would say again and again. But he also complained that she and Marion Post Wolcott took too many pictures of essentially the same thing. It would simplify his problems and speed the work if she would do what Rothstein did—edit her negatives before sending them in. "Remember labor is the big cost in any photographic lab." He asked her to place all her weeded-out negatives in one package labeled REJECTS when she sent them in with the others.

Stryker had the habit of punching holes in negatives he rejected, making them forever useless. While Dorothea understood his stress on economy, and was willing to put aside negatives that didn't seem worth printing, she nevertheless believed in preserving them all. Years later she would find such a negative had within it exactly what she wanted for a particular purpose. "So on what basis can you discard permanently?" she would ask. Only those that had some chemical imperfection, perhaps.

She did not seem to mind criticism for overshooting. What mattered more was a running quarrel with Stryker over retouching negatives. The big fuss occurred over her 1936 photograph "Migrant Mother." In the original there is a ghostly thumb barely visible near the lower right corner. At the moment she had taken the picture, someone's hand must have reached out to pull back the tent flap. The picture was one of a number to be added to the Museum of Modern Art collection, and unhappy over that thumb, she had it taken out. When Stryker saw the change in this and

other negatives, he complained angrily. To him it was a breach of his principle that to alter a photograph was to violate the truth. To this Dorothea replied in a cold, formal tone:

> The negatives were retouched in my presence by the best retoucher on the Pacific Coast. One of the negatives (the Oklahoman) was in very bad condition, which we rectified. Unfortunately the exposure had been made on Agfa film which is very difficult, almost impossible, to work upon, due to the hardness of the emulsion. The retoucher did a very skillful job. You might contrast the head in relation to the background as it appears in *Land of the Free* with a good print from the negative now. I also call your attention to the fact that a glaring defect in the other negative (mother and children) had been entirely eliminated, You say: "Whoever retouched the negatives was a little careless in his work." This is not the fact, for the negatives were handled with the utmost care.

She had taken the photograph and believed final control of the image should be hers. Stryker, as photo editor for FSA, thought final control should be in his hands. The difference of opinion upset her badly, especially when Stryker spoke of what she had done as "dirtying the negative." Seeking to smooth things over, Paul Taylor wrote Will Alexander, his old friend at the agency. Alexander replied tactfully pointing out this was only a human difference of the kind we all must put up with. Stryker tried to bolster his case by writing to Jonathan Garst, the Western regional director. Garst replied, "I think I am going to be able to calm down the Taylors and I may say there are some people, especially in the Information Division, that are sort of on your side. I assure you, however, that I never saw any person more excited than Paul Taylor, whom I always judged as being a rather phlegmatic individual . . . Dealing with fighting cocks, race horses, and lady artists, you will have to make arrangements that they win once in a while."

Ron Partridge, who was often Dorothea's helper in those years, said, "I don't see Stryker as so precious. I think he just wanted an excuse to get rid of Dorothea because she was hard to handle—though not as much as some other people, Walker Evans, for instance."

That general issue—to retouch or not to retouch, to crop, to enlarge—has been debated among photographers for generations. There was a time when the people around Stieglitz thought you should never do these things. One of them, Paul Strand, had the reputation of being a purist. But near the end of his life he said, "It wasn't true even then." He described how he enlarged or cropped or retouched some of his most famous early photographs, "and had no great feeling of guilt" over it. "I've done all sorts of retouching when there's been a functional reason for doing it, and I crop negatives in the enlarger all the time. It's not a great issue. The only great issue is the necessity for the artist to find his way in the world, and to begin to understand what the world is about."

Dorothea said she knew some photographers didn't allow cropping. "They consider it an admission of failure. There is a purist group that insists that one conceive of the thing in its entirety at the moment and nothing less than that is permissible." But she liked to take a negative and find different ways to use elements within it. "Why not do that, when the medium permits it? I think it should be explored to the limit, though I don't know what the limit of that method is." Then, too, she cropped for the usual reason. Often in taking a photograph, she said, you know while doing it that "you're going to have to crop because there'd be confusions in it, awkward portions, or a lamp post would be sticking out though you can't at the moment of photographing change point of view. You know you're going to have to crop. Most cropping is for the purpose of simplification, isolation from environmental factors that contribute nothing to it. Sometimes it very much changes the picture."

One sorry consequence of cropping is pointed out by George P. Elliott in his monograph on Lange. It was not, however, a case of cropping by her hand, but by an unknown other's. Her 1936 Mississippi photograph called "Plantation Overseer and His Field Hands," which strikingly portrayed the ruler and the ruled, is so cropped in MacLeish's *Land of the Free* that the blacks are left out and the white man now looks like an ordinary farmer. Working apparently from this heavily cropped photo, MacLeish wrote poetry facing it which, as Elliott says, "transforms this Southern man of power into an American man of freedom." The image was made to have a meaning "profoundly opposed (and inferior) to that of the whole, complex picture."

An example of her own judgment in cropping can be seen in her 1938 photograph called "Six Tenant Farmers without Farms," made in Hardeman County, Texas. The photo is printed uncropped on page 32 of the Museum of Modern Art monograph for her retrospective exhibit. But as reproduced many years earlier on page 77 of the Lange-Taylor book, *An American Exodus*, the sixth man standing at the right is missing. Dorothea cropped him out, probably because he didn't seem an organic part of the group. Is it his darker clothes? his arms behind his back, withdrawing him somehow from the others? or the space between him and the next man, which is slightly greater than between all the others? The same photograph, this time called "Jobless," can be seen in the catalogue of "The Bitter Years" exhibit arranged by Steichen, and here too the end man is cropped out.

One of the most striking instances of the effect of cropping is in her California photograph made in 1935, called "Ditched, Stalled and Stranded," as reproduced (page 26) in the monograph for her retrospective show. For comparison there is an uncropped print used on page 46 of the book *Years of Bitterness and Pride*. It shows the front seat of the car, the man at the wheel, and the woman huddled in her coat beside him. In the uncropped

print much more of the car's tattered roof is seen, more of the windshield, and more of the near side of the seat. As cropped, the woman is dropped out, except for a small piece of her coat. The viewer is pulled up close to the man at the wheel. The edges of the picture now frame him from just above the top of his cap down to the lower rim of his steering wheel. The effect is infinitely more intense. The staring eyes, the lined face, the mouth partly open, grip the attention. He seems to be saying, Where to? What next? Is this all?

What the FSA photographers had worked on for years—the focusing of public attention on the needs of the migrant workers—was accomplished almost overnight in the spring of 1939, and by a single novel. John Steinbeck's *The Grapes of Wrath* was published in April; it became an instant best seller. Though it was fiction, many readers took as fact its portrait of the trials of the Joad family in their journey from Oklahoma to California.

When Steinbeck turned in to Viking Press the manuscript he had been working on for three years, he had no expectation of such an enormous success. "I am sure it will not be a popular book," he wrote his editor. "I feel very sure of that. I think to the large number of readers it will be an outrageous book." Outrageous, yes, in the sense that Steinbeck's indictment of the land barons for their treatment of the migrants infuriated readers and won their sympathy for the victims. Except for *Gone With the Wind*, the novel became the greatest seller of its time. It roused some of its readers to hysterical denunciation. They called the book "obscene sensationalism," accused Steinbeck of "propaganda in vilest form," charged the book with being "100 percent false to Christianity," and denounced "the Communistic base of the story." Steinbeck said that "the Associated Farmers have tried to make me retract things by very sly methods . . . The vilification of me out here by the large landowners and bankers is pretty bad." Frank J. Taylor, a publicist for California's large growers, wrote a "factual" rebuttal to the book for *Forum* magazine, which was replied to in the next issue by Carey McWilliams, chief of Governor Olson's Division of Immigration and Housing.

Pare Lorentz, who produced *The Plow That Broke the Plains* (1936) and *The River* (1937) for FSA, wrote: "While Dorothea Lange was the first to photograph the migratory workers, and while John Steinbeck was the first novelist of importance to write about the migratory workers, and while I was the first movie man to make a picture about the drought, there was no correspondence or even conversation among any of the three of us in those first years of work." In those first years, true enough. But while Steinbeck and Dorothea did not meet until after the novel appeared, a personal encounter was not necessary for her influence to have been felt. She had made her first migrant photos in 1935, and they had been printed in many places. When Steinbeck began work on the novel, he studied

DOROTHEA LANGE

FSA's photo file and got to know well the work of Lange and the others. *Land of the Free*, which appeared early in 1938 with so many Lange pictures, "obviously" left an impression upon Steinbeck, in MacLeish's opinion. Parallels between FSA photos, and especially the Lange pictures in the MacLeish book, and descriptive passages in *Grapes* have been ingeniously traced by D. G. Kehl. He makes a convincing case when he displays the Lange picture of the migrant, "Ditched, Stalled and Stranded," and places beside it the Steinbeck description of Tom Joad, or when he compares her photograph of the evicted Arkansas sharecropper (made at Hill House, Mississippi, in 1936) with Steinbeck's verbal picture of Preacher Casy.

Seeking to help Steinbeck in every way possible, the FSA's Western office put him in the hands of Tom Collins, manager of its camp at Arvin. Collins was a Virginian who had drifted West, gone to work in California's pea fields, shown leadership ability, and been made manager of one of FSA's first camps. (Dorothea had made several photographs of him in 1936.) Collins's intimate knowledge of migrant life helped ground the novelist in the realistic detail which proved so convincing to readers. Collins appears in the novel as the camp manager, Jim Rawley, and Steinbeck dedicated *Grapes* to his wife, Carol, "who willed this book," and to Tom Collins, "who lived it."

Within two months of the novel's publication, Twentieth Century Fox had bought the film rights, assigned John Ford to direct it, and rushed it into production. In preparing for his film, Ford "sought and found primary source material in Dorothea Lange's photographs," the photography curator Grace Mayer has written. It is not hard to see the connections in the film, for shot after shot reproduces images found in Lange's FSA file. The director hired FSA staff in California, including Tom Collins, who is given screen credit as consultant. They were granted leaves of absence, which ran out before work was completed, and Steinbeck appealed to the FSA to have the leaves extended. Unfortunately, says Lawrence Hewes, who was the regional director at the time, "most of those people got film-struck and weren't worth a damn when they got back to work."

Paying tribute to both Steinbeck and Lange, Pare Lorentz said in *U.S. Camera 1941* that "if there are transient camps, and better working conditions, and a permanent agency seeking to help migratory workers, Lange, with her still pictures that have been reproduced in thousands of newspapers, and in magazines and Sunday supplements, and Steinbeck, with two novels, a play, and a motion picture, have done more for these tragic nomads than all the politicians of the country."

Late that July, on her way back from North Carolina, Dorothea joined Paul Taylor in making the rounds of New York publishers with a dummy of their book. Still without a title for it, they showed their work to their friend Paul Kellogg at *Survey Graphic*. He quickly came up with the title: *An American Exodus*. It proved hard, however, to get a book contract. Tom

Maloney, the publisher of *U.S. Camera*, couldn't do it, nor could Covici-Friede or Random House. The editors liked what they were shown, but said their budgets for the next season had been allocated. Lange and Taylor, anxious to get the book out quickly, kept moving from publisher to publisher. At one point Dorothea appealed to Steinbeck for help. In a letter to Pascal Covici, his editor at Viking, the novelist said, "Someone told her I could *force* you to print her book and she practically told me to *make* you do it . . . Hers is a good book but I'm not telling you to publish it. Then a couple of days ago she telephoned me. Reynal and Hitchcock said they would print her book if I would write the preface." He declined; it was a policy he generally followed her fear of being flooded with such requests. Reynal and Hitchcock took the book anyhow, agreeing to issue it around the end of the year.

While in New York, Dorothea visited the Photo League, an organization of photographers started in the mid-thirties. Their chief interest was in documentary photography. They offered classes, lectures, and symposia, and issued the publication *Photo Notes*, which carried news of their field and occasional articles and reviews. On this night she heard Eliot Elisofon lecture and then joined in looking over the work of younger members. She was especially enthusiastic about the prints coming out of the collective project "Harlem Document," headed by Aaron Siskind. She told the group of her difficulties in finding a publisher for her book, and voiced the hope that universities and foundations would some day help young photographers publish their work. She had joined the league earlier, as did many of the FSA photographers. Not long before she came, the league had presented an FSA exhibit of rural photographs, including her own. Stryker too had given his support to the league, speaking at one of its meetings about how to find work in government and the problems staff photographers encountered. Later that year Dorothea donated a scholarship to the league for a student in the documentary class; it was awarded to Louis C. Stoumen.

It was shortly after her return to Berkeley that the catastrophe everyone dreaded occurred. Hitler invaded Poland and began World War II. "We don't know what to expect in regard to our book, with this war upon us," she wrote Stryker. Publication of the book of one of Professor Taylor's colleagues had been canceled, she said. "We have no such word, no word at all for two weeks. Anything may happen." Their book, the outcome of eighteen months of labor, seemed of small consequence next to a world war; yet their fear that their work would never see print is understandable. Two days later, however, Reynal and Hitchcock decided to put the book through on schedule.

Although Stryker had some trouble accepting the idea of Dorothea publishing a book which included many pictures he considered to be government property, he was so accommodating as to agree to withhold from

newspapers and magazines the pictures Dorothea had chosen. And again at her request, he purchased special paper for the FSA lab to use in printing her photographs. He wrote Hitchcock to offer aid in promoting the book and tried to arrange an FSA show at Rockefeller Center keyed to publication date. Just as Dorothea returned from a long and arduous field trip in the Northwest, he passed on the worrisome news that Hitchcock was uncertain what effect the war would have on sales. "No one can forecast these days what the war is going to do to our own life and activities in the United States," Stryker wrote, adding that the price of imported lenses had already jumped one-third. He sent her back to the Northwest, and spun out plans for trips to Wyoming, Utah, and Nevada.

Then suddenly in October, while she was working in Oregon, Stryker phoned to warn her she would probably be laid off on January 1. He had been advised months before that the next budget might require cutting off one photographer. He had said nothing to his staff, feeling certain he could find a way out. Now, just as he had been told there was little chance of that, Pare Lorentz had requested that Dorothea be assigned to work on a new film for the Department of Agriculture, directed by Robert Flaherty. Shooting of the film, to be called *The Land*, had begun late in August in Iowa with Arthur Rothstein assigned to do still photography and scout locations. The film crew expected to move down to Oklahoma, Texas, and New Mexico, where Lorentz thought Dorothea's experience would be most valuable. "He has been interested in your work for a long time," Stryker wrote Dorothea, "likes it very much and hopes that the thing can lengthen out into other work."

Not wanting to be falsely optimistic, Stryker added that the future of the U.S. Film Service was uncertain and he could not be sure they would have enough work for a still photographer. But since it was anything but certain he could keep her on his budget, she ought to think seriously about Lorentz's proposal. She should consider whether she could work well with the film people, and "whether the work that you would do could be utilized in the way which you would most like to have it." Meanwhile, in a last-ditch effort, he would try to dig up enough department assignments so that he could convince the budget office of the need to maintain all four photographers.

Nothing came of the Lorentz request—it is not clear why—and at the end of October Stryker told Dorothea that his efforts to save her job had failed. She would have to be dropped on January 1. The Regional Office in San Francisco had been instructed to provide Dorothea with office space and secretarial help so that she could complete captioning the large quantity of her recent field work and turn over all government property in the right order before her leave was to begin. Her behavior in the office upset the staff: she has been "somewhat temperamental" here, one of the regional officials wrote Washington, and is creating difficulties for us.

There is no direct evidence of how Dorothea felt upon being dismissed. Paul Taylor, after eleven years as associate professor, had just been advanced to full professor, at a salary of $4,200, not very much for a large family. Still, all she asks is will the government pay to have her cameras cleaned and repaired? The answer was no: regulations. But that she—and Paul Taylor—were "very much hurt" is made plain in a sensitive and confidential letter to Stryker written by Jonathan Garst in behalf of himself and another regional official, Walter Packard. Because of its evaluation of Lange and Taylor by two men who knew them so well, it is worth giving in full. Dated November 21, 1939, it reads:

DEAR STRYKER:

Packard is in my office and we have been discussing the situation of Dorothea Lange Taylor. I know that this is probably to some extent like waving a red flag in front of you, but for the moment forget your artistic temperament and let's see what we can do about this. I have no hesitancy in writing to you because, as you know from my insulting remarks, I have great respect and real affection for you. Likewise I have the greatest admiration for Paul Taylor and the highest regard for the ability of Dorothea Lange. The situation is about as follows:

Paul Taylor is in reality the father of our migratory camp program in California. I think no one who has known the history of these camps can deny this. Moreover, he has continued his study of the problems of agricultural labor to his own great detriment in a Republican controlled University of California, and his students have been, and are, the backbone of those who are progressive in tackling the problem. Dorothea Lange has been whole-souled in this enterprise. She has that sort of a nature wherein she can only go pell-mell into something and I certainly think, and you without question will agree, that she has made great contributions through her photography.

I hear by the roundabout that after I interceded with you and arranged for you to bring her back to Washington, that difficulties arose so that there was not a completely amiable settlement of this arrangement with Dorothea. I don't know what these amount to, and I can readily believe that Dorothea with her pell-mell enthusiasm may be at times difficult to work with. I hear that since her return from a trip to the Northwest she has been advised that her appointment with the Farm Security Administration is being terminated. The sad part about this is that both Dorothea and Paul Taylor feel very much hurt.

I doubt whether the income is of paramount importance, because it is my own belief that Dorothea can probably profitably employ her time in taking pictures for the many photographic publications now being published. If the financial remuneration is of importance, I would like to say that I know the Taylors are hard up, with a large family and, as I have said before, a low income from the University—largely because Paul Taylor's energies have been devoted almost exclusively to the problem of agricultural labor, which is *not* popular with the Republican Board of Regents and their Head of the Economics Department of the University of California.

Moreover, Paul Taylor is apparently still violently in love with Dorothea Lange and takes her problems very much to heart. As a matter of fact, I think

anything that would hurt her feelings would have very much more effect on Paul's feelings than anything that was done to him directly.

Packard and I are writing this letter to you personally. We are not getting in touch with anybody else about it. The Taylors do not know we are writing it. My first inclination was to tell Dorothea Lange to skip it if she called but after talking it over with Packard we both want to plead with you to see if arrangements cannot be made so that at least there won't be more bitterness and hurt involved than is absolutely necessary. Packard's suggestion, and I think it is a very good suggestion, is that you might retain her on a W.A.E. basis. This will give her an official relationship and occasionally you can use her to great advantage. If you have found it difficult to deal with her from Washington, I think it might be possible to let her continue her relationship through Fred Soule and Bill Staats, the Information Representatives in Region 9 and 11, respectively. Fischer can tell you about this.

I am sorry that I will not be back in Washington soon so I can talk this whole thing over with you but the Stamp Plan is going so fast that I hate to spend the time on a trip East. Therefore, I hope you will take this letter with the sincerity in which it is written, and reply personally to us so we will know how things stand.

SINCERELY YOURS,
JONATHAN GARST

Stryker replied that he appreciated the spirit in which Garst and Packard had written to him, "but I don't believe there is much that can be done . . . I faced the disagreeable task of making a decision as to which photographer I would have to drop from the staff . . . I selected the person who would give me the least cooperation in the job that is laid before me. I can assure you that this was no easy job. I think I appreciate as fully as anyone, perhaps more so, the contribution which Dorothea has made to the photographic file of the FSA, and certainly to the presentation of the migrant problem to the people of this country. I know that judgments of art are highly subjective. And yet subjective or not, I had a decision to make. I made it to the best of my ability . . ."

It is a curious explanation. First, he says he chose to fire the least cooperative photographer on his staff. Then he makes a vague reference to the subjectivity of artistic judgment, as though there were some question of just how good her photographs were. Yet he goes on to praise her work as he had done both publicly and privately many times before, and would continue to do long after. More likely the essential reason was her difficult personality. In the many letters Stryker wrote her during her RA and FSA years, there is a repeated note of irritation. She asks too much, she takes too many exceptions, she wants special treatment too often, she costs him too much time and trouble. Their relationship started out on a quite formal basis. She came to him not as an apprentice but as an experienced photographer who had already set the standard for precisely what he hoped to achieve. She was not a youngster, like all the others but Ben

Shahn. "She could not be treated as one of the boys," says an FSA staff member in a position to observe their relationship. "He was always teaching most of the others, telling them about cotton or corn or cattle . . . But all Dorothea needed from him was logistical help. She was the wife of a specialist in agricultural economics who knew more about these things than most anybody else. They didn't use the term in those days but I'd say Roy was something of a male chauvinist when it came to women working. He had a kind of Western macho style, a pride in maleness—not that he put down women in any obvious way." It took quite some time for Stryker and Lange to drop the formal tone of their letters. And even after they had met in Washington and reached a more personal footing, Stryker never managed to join her in the field, as he did with many of his other photographers, although she begged him to. Because of her great distance from headquarters, their connection was much more by mail than by direct conversation. It is easy for misunderstandings to spring up in correspondence, and for the grievances which develop out of them to turn into estrangement.

It was differences of temperament which made Stryker's relationship with Walker Evans not a happy one, either. Evans joined the section in the fall of 1935 and was fired in the spring of 1937; here, too, shortage of funds was given as the reason. But Stryker had grown impatient and angry with Evans for the relatively small number of photographs he made, for his indifference to filling in the file, and for his reluctance to submit to bureaucracy. As Evans saw his chief, "Stryker did not understand that a photograph might be something more than just an item to file away. He missed the point of the eye . . . Stryker did not have any idea what an artist was and it was unfortunate that he had one like me around. I was excessively independent by temperament and had a hard time with him because of this. Stryker was shrewd enough to make use of the talent I had, but we were born to clash."

By the end of November Dorothea gave up all hope of remaining with FSA. She wired the Guggenheim Foundation: SUDDENLY FIND GOVERNMENT JOB TERMINATES JANUARY IS IT TOO LATE TO APPLY FOR FELLOWSHIP TO ENABLE ME TO CONTINUE MY WORK. It was too late by more than a month. Stryker continued his effort to promote her book. He visited the publisher in New York and was shown an advance copy. He was pleased to find the quality of picture reproduction so high on a book priced at only $2.75. He got Curtis Hitchcock to agree to make display posters for bookstore windows, using big blowups of Dorothea's prints which the FSA would supply, and he gave him a list of people and organizations that might help publicize the book. Hitchcock went down to Washington to hand copies of *An American Exodus* to Secretary Henry Wallace, Mrs. Roosevelt, and top officials of the FSA. Stryker assured Dorothea her book would attract much attention because of the La Follette committee hearings and the

Steinbeck novel and film. When the book came out in January, Dorothea and Paul Taylor invited friends, including Senator La Follette, to a dinner party to celebrate publication day. Dorothea asked Stryker to pass on to her any criticism of the book he might hear. "I believe that the method which we developed is on the way to true documentary technique and I should certainly welcome all the critical comments and observations which can be gathered. It would be a misfortune not to hear them." She donated a copy to the Photo League's library and asked for the criticism of the students in the documentary class.

An American Exodus was published in January and given prompt attention by the reviewers. *The Nation* thought the book "one of the best devoted to the dispossessed farm worker. Both the text and the photographs are excellent; together they provide a vivid story in brief space of the nature and extent of the disaster, and of the measures, so far very inadequate, with which it has been met . . . The authors do not provide a blueprint. They do make the human and the economic dilemma clear." In *The New Republic* Carey McWilliams wrote at length of "the tragic exodus so graphically documented" by the co-authors, concluding that "the combination of talents that has produced *An American Exodus* could scarcely have been improved upon. Paul Taylor, who for years has been the outstanding authority on agricultural labor in California, has supplied a running commentary that is wholly characteristic of the man: quiet, scholarly, dispassionate, unassailably accurate. The photographs by Dorothea Lange are beyond praise; indeed they are so good that the text is really not essential."

A rare kind of review appeared in the scholarly journal *Social Forces;* it showed an understanding of what Paul Taylor had been trying to achieve by the use of photography as a tool of social investigation. The writer Margaret Jarman Hagood, of the University of North Carolina, pointed out that documentary photography as a recent technique was

> still exploratory yet rich in promise. Miss Lange, a pioneer in this new mode of social research, has brought a high degree of professional skill to the task. The results are a record which will make the reconstructing of the current exodus to the West much easier for the social historian a century or so hence.
>
> The term "social historian" is used deliberately, for it appears that documentary photography serves the descriptive rather than the generalizing function of social studies. The poignant picturization of dispossessed sharecroppers adds a quality to their portrayal which verbal description has lacked. It shows the essence of agricultural problems distilled into its visible effects on a limited number of individuals. The particularization inherent in the use of selected cases is at the same time the greatest contribution and the chief limitation of *An American Exodus.* The emotional appeal of excellently reproduced photographs of the disinherited serves well the layman or the scientist in sensing the meaning of phases of the American economy in terms of the people affected. Research

workers trying to answer "why?" and social planners trying to answer "how to improve?" may thereby reach an emotional identification with these victims of transition, although such a state must be lived through and transcended before there can be an objective approach to the solution of the problems.

The text of *An American Exodus* is subservient to the pictures. Perhaps this is necessary; it may be that a "picture book" must be limited to the descriptive function alone. But perhaps the synthesis of documentary photography and dynamic scientific analysis suggested here can be more fully achieved. Certainly this best example to date of the use of photography as a tool of social research will challenge the more adventurous of social scientists to strive further for ways of utilizing this new resource.

The New Yorker thought the book "a superb documentary analysis of human erosion." *Time* said, "Some of the photographs are exceedingly good; some are merely 'magnificent'—overfiltered, overdramatized. Even so, the whole selection considerably excels that in the Caldwell–Bourke-White collaboration . . . or in the MacLeish poem with photographs . . . The text has dignity and is compactly informative. Many of the captions are direct quotations . . ."

From Paul Strand—the photographer Dorothea admired perhaps more than any other of her contemporaries—the book received a mixed review. Strand wrote it for *Photo Notes*, the mimeographed publication of the Photo League, to which they both belonged. Strand's first picture-text book, *Time in New England*, would not appear for another ten years, but his experience with documentary film gave him a unique vantage point for judging *An American Exodus*.

The form they [Lange and Taylor] chose is a complex one. They have tried to weld photographs, an expositional text dealing with the causes and effects of this vast social upheaval with an additional element: words they heard spoken by some of the people who are the victims of this catastrophe.

The very statement of the complex nature of this interesting form emphasizes its difficulties. For the balance to be established between these different elements in order to achieve a basic unity of statement whose sum would be "a record of human erosion" is a most difficult problem. Different from, but no less urgent than the solution demanded in documentary film of the relations between commentary, dialogue and the photographic images.

I do not think Miss Lange and Mr. Taylor have solved this problem in their first attack upon it. There are some very fine photographs in the book; some remarkable records of human feelings spoken as only these people could have phrased them; Mr. Taylor's account is straightforward and interesting but yet the total impression does not have the impact upon the eye and the mind which the subject surely contains and which the authors clearly were deeply moved to give us.

To Strand it seemed clear that "in such a book as this the photographs must be the foundation material, provide the basic structure just as in a

documentary film, and that the function of the text must be to heighten and extend their individual and total meaning. It would not seem that the authors made that decision, were clear about it. As a result many of the photographs do little more than illustrate the text. Or vice versa, the text at times simply parallels the information given explicitly by the photographs. Thus there is a tendency towards negation rather than active interaction between image and word."

The decision not to make the photographs the foundation of the book's structure had led to "a very uneven" choice of pictures, Strand thought. Lange is "a very talented photographer who has done some of the finest work in the FSA," he went on, pointing to several photographs in the book for "that concentration of expressiveness which makes the difference between a good record and a much deeper penetration of reality." Where the level of the book fell off was in the use of some photographs "as mere record making." He insisted that in such a book all the pictures "must contain in themselves (and in their juxtaposition to each other) that unity and intensity of expression which give all works of art their impact." Despite his reservations, Strand "warmly welcomed" the book as "a valuable document and a work of integrity and honest feeling."

Thirty years later, and after Dorothea's death, *An American Exodus* was reissued in drastically remodeled form by the Oakland Museum and the Yale University Press. Discussing the 1970 edition in *The New York Times Book Review*, John Szarkowski, director of the Museum of Modern Art's photography department, regretted the decision not to reprint the book in its original form. For that, he said, "remains one of the best and truest documents we have of the breakdown of America's earlier agrarian ideal." He valued Lange as "a photographer of great talent and a woman of acute native intelligence . . . It would be an injustice to Dorothea Lange and to this remarkable book if one approached it as a collection of her best photographs. It is on the contrary a true book, defined by the pressures of one coherent idea. Taylor was an intellectual and Lange an artist. Remarkably, both understood that in the book to be done neither could take precedence over the other. The words and the photographs must supplement, not repeat, each other, for one medium was dumb where the other was eloquent. From this basic perception Lange and Taylor demonstrated a new concept of the photographic book, in which the pictures were no longer illustrations, and the text no longer captions, but each maintained its own integrity."

Szarkowski, like Strand, had some reservations. "Like most original works," he said, "this one was obviously flawed. It is unlikely, I suppose, that the finished work was completely satisfactory to either of the authors. Lange surely was aware that it included weak pictures and badly constructed spreads. Nevertheless the total work was a powerful social statement and a creative act. Its force remains enormously impressive today."

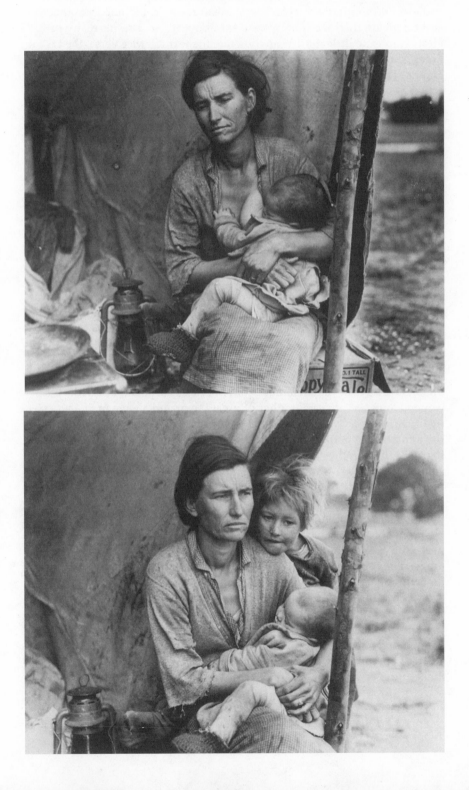

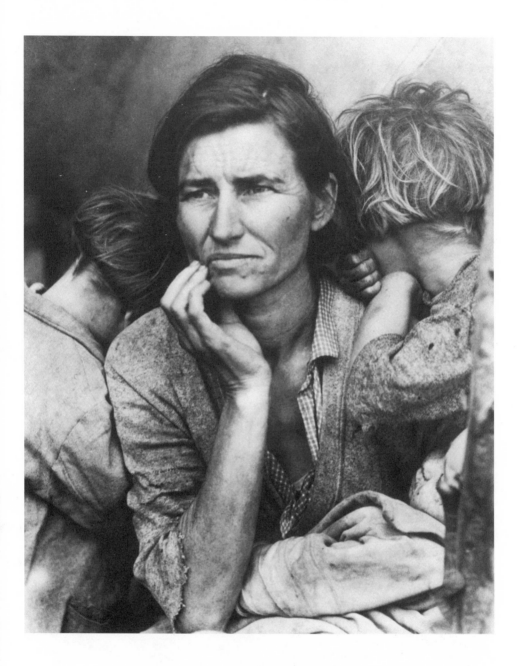

Migrant Mother, Nipomo, California, 1936. The other two photographs were
made in the same ten minutes on that March day
DOROTHEA LANGE

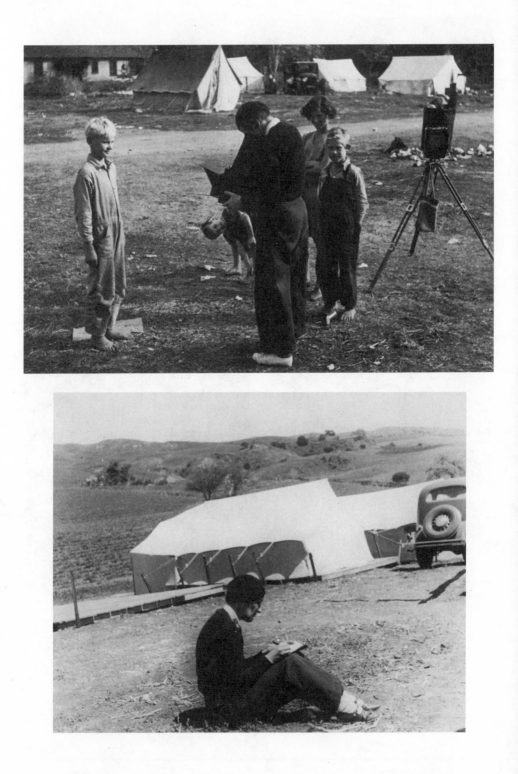

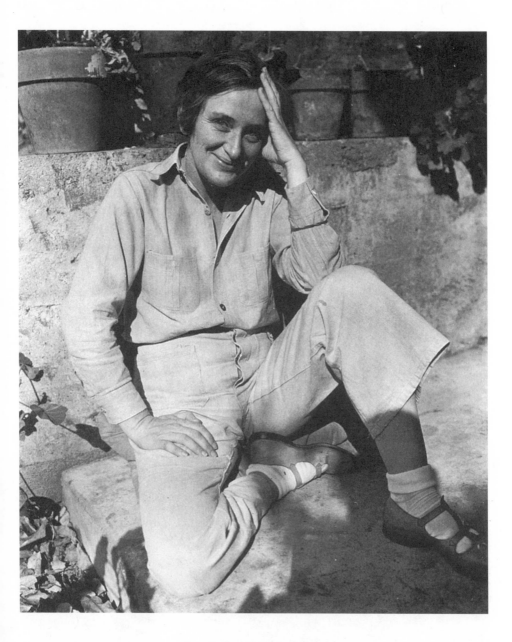

Dorothea in Berkeley, 1936
RONDAL PARTRIDGE

Dorothea photographing migrant children in tent camp, California, 1937
(*opposite*)
RONDAL PARTRIDGE

Making notes after photographing pea pickers, 1937
RONDAL PARTRIDGE

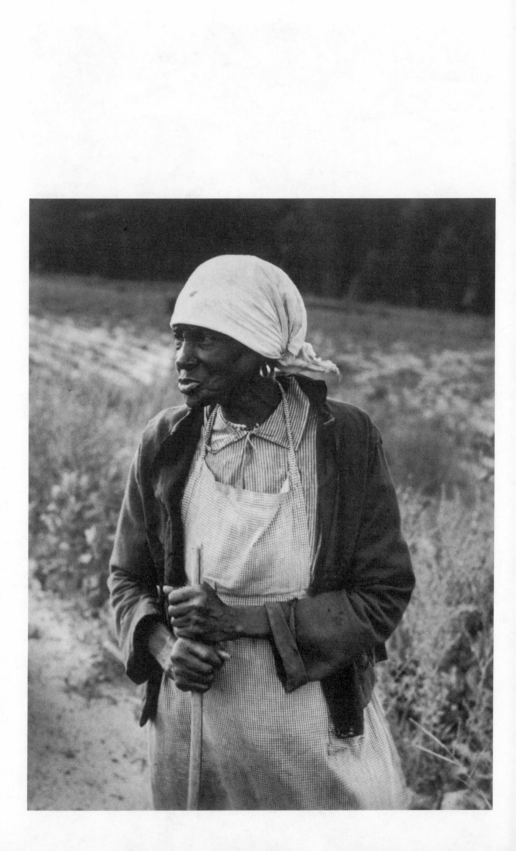

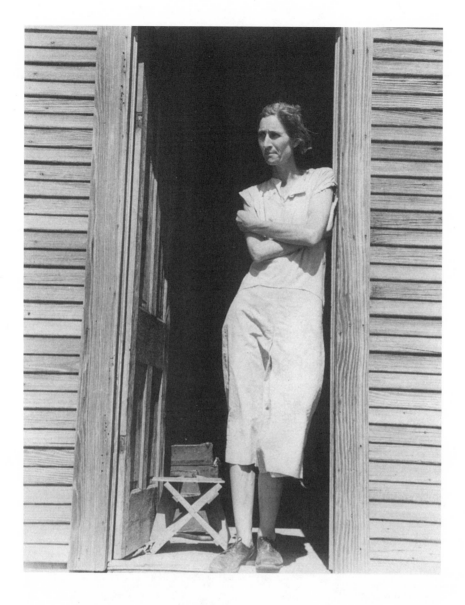

Woman of the Plains, 1938
DOROTHEA LANGE

Ex-Slave, Alabama, 1937 (*opposite*)
DOROTHEA LANGE

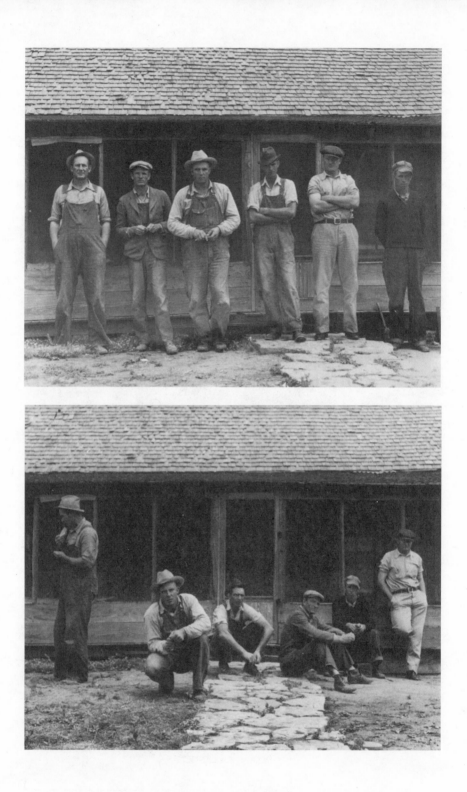

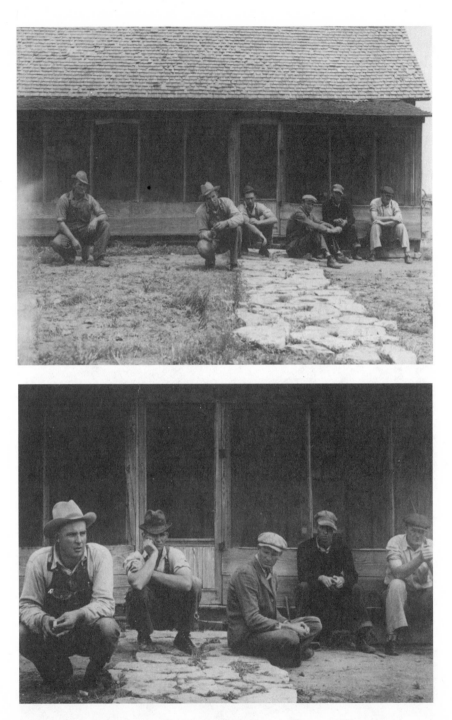

Six Tenant Farmers without Farms, Texas, 1938
DOROTHEA LANGE

Ditched, Stalled, and Stranded, San Joaquin Valley, California, 1935
As cropped (*opposite*)
DOROTHEA LANGE

Plantation Owner and His Field Hands, Mississippi Delta, 1936. As cropped
(*opposite*) for Archibald MacLeish's *Land of the Free*
DOROTHEA LANGE

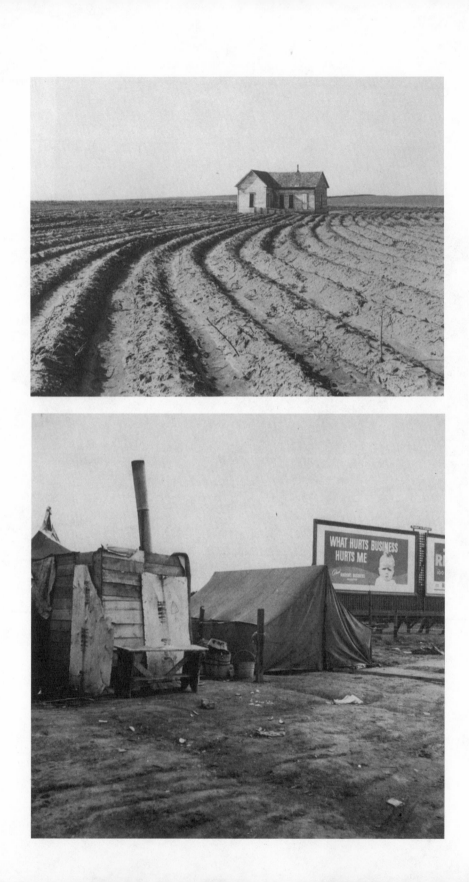

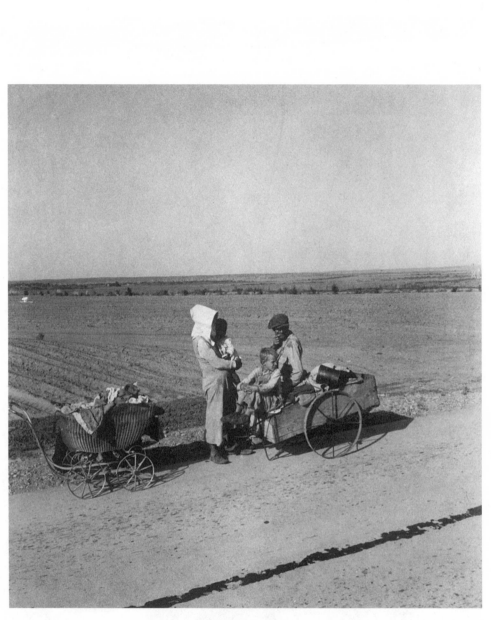

Homeless, 1937
DOROTHEA LANGE

Tractored Out, Childress County, Texas, 1938 (*opposite, top*)
DOROTHEA LANGE

Migrant Homes, 1938 (*opposite, bottom*)
DOROTHEA LANGE

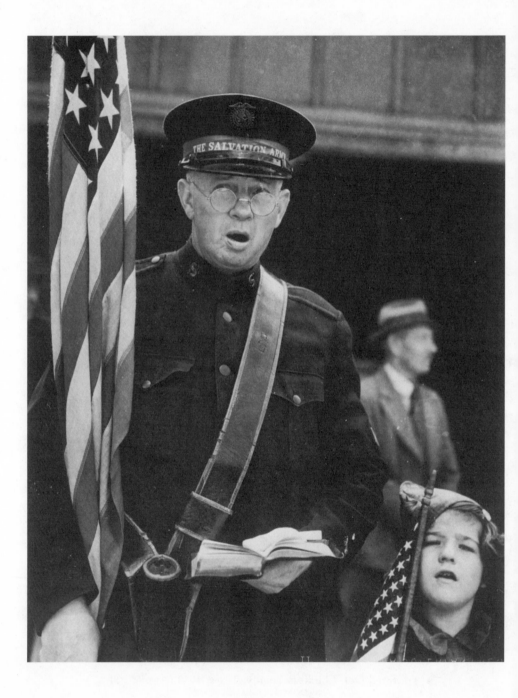

San Francisco, 1939
DOROTHEA LANGE

PART FOUR

1940-1945

14 THE BOOK WAS WELL LAUNCHED, BUT INTO a world rapidly losing interest in the Depression and the problems of the migrants. Very soon Hitler would conquer the Low Countries and France. By midsummer of 1940, Congress was appropriating staggering billions of dollars for a defense program. The nation rushed into production of guns, tanks, planes, ships, ammunition, and began raising and training the necessary manpower for both war industry and the fighting forces.

From Dorothea's doorstep she could see the Depression fade into defense. As the Kaiser shipyards at Richmond boomed, migrants deserted the fields and orchards for steady jobs on the assembly line. The market for *An American Exodus* disappeared. The book never had a chance to reach the people for whom it was intended. Paul Taylor remembers finding it remaindered in Berkeley stores at a dollar a copy, and toting home a dozen in a sack.

The years of service Dorothea had put in with Stryker were over now. The volume of work she had turned out was enormous, its usefulness unquestioned, its quality so superb at times as to earn her rank among the masters of photography. What those years added up to for her, she said, was "the greatest education I could ever have been given by anything or anybody."

Perhaps no one has assessed her work for the FSA better than Van Deren Coke, the photographer and art curator. Discussing her photographs several years after her death, he wrote:

> Through her photographs the symptoms of the Depression are clearly set forth and through them we can better understand the tragic events of those times. She made intimate contact with the victims . . . Her pictures were effective for they were believed. Nothing about them was contrived or artificial; her warmth was so contagious that her subjects were virtually unaffected by the presence of the camera . . .

In addition to the revealing and informative quality in her work, there is another ingredient of utmost importance. This is the unforced interplay of the formal elements she incorporates in her pictures: the foil of black by white passages, the use of a low or high camera position to simplify her compositions or to give emphasis to an element of importance in the meaning of a photograph . . . She developed an eye for strong compositions. She consistently found ways to isolate the things she wanted us to see at first glance. She also gave thought to the placement of elements of secondary importance that would cause a viewer to return for a second and more searching look . . .

Where does Dorothea Lange's work stand in relation to that of other documentary photographers? She stands with the best—Lewis Hine and Robert Frank. Her pictures are as disturbing as those of Lewis Hine's and show as much insight as Robert Frank's. Lange's pictures made during the depression were meant as an indictment of society just as were Hine's made in the early years of the century and Frank's made a decade and a half ago . . .

Lange's pictures of the Thirties have endured as important referential documents . . . They are also readily accessible metaphors that speak of man's suffering and man's perseverance when faced by a society that no longer has a respected place for a segment of that society. The somber moods Dorothea Lange caught so graphically on film confirm that photography is a medium of great power not only for the making of vivid documents, but at the same time, is a medium for creating works of enduring esthetic value.

Surely someone else would find use for that talent and experience. On February 1, 1940, a month after she was dropped from FSA, she was appointed Head Photographer by another section of the U.S. Department of Agriculture—the Bureau of Agricultural Economics (BAE). It was not a payroll job; she would be given occasional assignments at a rate of $7.22 per day. It was an easy bridge from one agency to the other. The two had developed a close relationship through their common interest in rural rehabilitation programs and their liking for field studies. The BAE wanted to document farm community life in all its aspects as part of its continuous study of rural America. Going beyond the traditional limits of farm policy, the staff thought in larger terms of geography and economics. Some suggested that doing away with county or state boundaries in favor of more natural regional integration would benefit farming. It was an unpopular advocacy among the power holders, for it stepped on too many political toes.

For the next year Dorothea made brief field trips for the BAE in California and Arizona. Her prints, captions, and field notes show the nature of the work was not much different from what she had done for FSA. She and Stryker wrote each other occasionally. Once, after a brief visit from Arthur Rothstein in her home, she told Stryker, "I miss FSA, although I have much work to do. Once an FSA guy, always an FSA guy. You don't easily get over it." Rothstein was planning to leave FSA soon for a job with Look magazine. But instead of trying to rehire Dorothea to fill the opening,

Stryker offered the job to the young Jack Delano, who had taken up photography only the year before. If this upset her, she said nothing about it. Her FSA photographs continued to win attention. Sherwood Anderson's picture book, *Home Town*, appeared that year, with nine of her photographs included. *U.S. Camera* published an article about her work, and in her nationally syndicated column, *My Day*, Eleanor Roosevelt praised *An American Exodus*. A new critical journal, *Film*, discussing *Grapes of Wrath*, linked it to Lange's photography. Lange pictures were of course included in the photography exhibit arranged by Ansel Adams for the San Francisco World's Fair.

The establishment of a new home took as much of her attention as photography that year. Giving up the rented place on Virginia Street, the family bought a house not far off at 1163 Euclid Avenue. It would be Dorothea's home from January, 1940 until her death twenty-five years later. The house had been designed in 1910 by John White, the partner of Bernard Maybeck, whose style of regional architecture had been a great influence in the Bay region. Maybeck stressed the use of natural materials, especially the local redwood. House was tied to setting, indoors connected to outdoors, with natural light pouring in through large expanses of glass in window and door. The Euclid house was set back from the street on a hillside abundant with trees. The interior look that friends came to love was all Dorothea's making. One woman who knew the house through every passage of Dorothea's life there describes it:

> She liked comfort, but the house was stripped for action, with great elegance through its basic simplicity. It always had surprises. I've walked into it hundreds, possibly thousands of times, and I cannot remember its looking exactly the same. Furniture would move from place to place, the dining table appeared and reappeared always differently, a chest would disappear and reappear. The rooms would change with the seasons . . . Sometimes there would be containers of fragrant dried things, and grasses and huge limbs . . . brought in every spring. The house always had cleanliness and Shaker-like orderliness. In all the times that the furniture moved from room to room I can never tell you who did the moving. I assume Paul did. But you never caught her moving the stuff. It had the same mysterious quality of the wall sconces which puffed into flame spontaneously and magically in Beauty and the Beast. Dorothea had the same qualities. Magical is the only word.

Her kitchen in particular was a joyful place to explore. A large marble-top table was the room's focal point. What made it extraordinary were the useful remembrances she had collected on her field trips for the FSA and later on the journeys she made around the world. There was a turquoise bowl from a hand pottery in Carolina; a big wooden "slavery bowl" from a Mississippi plantation which a black woman had given in return for a Lange photograph of herself; a jar from Teheran; a woman's broad-

brimmed straw hat from Vietnam hanging on the wall near the garden door; copper trays of many sizes on a chest; aprons from Osaka dangling from a peg; a pueblo bowl from the Cochiti of New Mexico; a Balinese basket with a lid; pitchers from Appalachia, made in an Elizabethan pattern by the earliest English settlers there; bowls from Luxor and Kabul; huge Korean jars atop a cabinet.

Clearly kitchen chores were not something to be put up with simply because one had to eat. In the preparation of meals, one of her stepdaughters has said, "she demanded the same excellence from herself and from her helpers that she did behind the camera or in the darkroom." She insisted on starting with good materials, taking no shortcuts, arranging supplies and utensils for quick access, and cleaning up as you went along. At mealtime the dining-room table was always carefully set with a lovely bowl, flowers, and sometimes candles. While she rearranged the table from time to time (she hated to keep furniture or any other objects in the same place for long), the feeling of a household shrine was preserved because of the kind of care she gave it. The children and later the grandchildren who served as her handmaidens learned about cooking, but also, as one said, "I learned about the aesthetics of everyday life from my time in her kitchen."

The study, a rather narrow rectangle with French doors at the far end, overlooked trees and garden. A worktable ran the length of the right side, with special drawers built in to suit a photographer's needs. Above it the wall was of cork, for the prints she pinned up. A fireplace, rug, and easy chairs made it a comfortable living room, too.

To the left of the entry hall a stairway, with bookcases on the landings, led to the upper floor. At the top turn a window opened out on the garden. At the far end of the corridor was Dorothea and Paul's bedroom, facing out on the garden. Glass doors opened onto a deck she had built on after they moved in. The great live oak she often photographed lifted its head over the deck rail. ("She felt very much a part of that tree," said the photographer Ralph Gibson, who worked for her during the early 1960's. "She and the tree were the same age, she used to say; she saw much of herself in it. She thought the tree understood her.") The small bedroom was painted off-white, as was the wooden bed. On the wall was a clock picked up by Dorothea on a visit to Vermont at the age of thirteen (the collecting habit started early) and Dorothea's early photograph of her mother. A simple walnut chest, made for them in Amana, Iowa, was the only other piece of furniture. Another and larger bedroom, across the corridor, was used by the children or guests.

From the kitchen door a walk about a yard wide wound through the sloping garden which grew around the house. The walk was brick here, earth there, and slabs of wood somewhere else. For coffee time or picnics there was a leveled grassy area about five yards from the door which held

wooden benches and a table. Trees of many kinds grew in casual disorder—tulip, pear, flowering cherry, lemon. Large and small pieces of driftwood were scattered all about, with foliage and flowers growing out of their hollows. Rocks of many sizes, colors, and shapes, gathered like the driftwood on the Pacific beach, were placed here and there. Something bloomed in the garden all the year round. She planted with the idea of constant change in mind, just as she always rearranged the interior look of the house.

Off to the right rear of the house Dorothea began building a separate studio with a darkroom about a year after she moved in. The new darkroom was badly needed. The space converted to that purpose in the Virginia Street house had not been satisfactory. Sometimes she had had to borrow the darkroom of the architects who were designing the camps and housing projects for the FSA. Free to satisfy her own needs, she sketched plans for a studio about 14 X 22 feet. On one of the long sides, facing north, there were seven panels of frosted glass about six feet high which sloped in from the roofline to counter height above the floor. Opposite, standard windows were set the whole length of the wall. In the rear she placed her darkroom.

Describing the studio as it looked in the early days of its use, her son Daniel Dixon wrote: "In a way, [it] is an eloquent expression of the purity of her passion for photography. Though comfortable enough, everything not essential to its operation has been austerely sacrificed to broad expanses of uncluttered working space. Nothing in it—a narrow couch, a couple of worktables, a pair of canvas-backed chairs—could divert the attention or confuse the purpose. 'That's the way I want it,' she says. 'This is where I work, not play.' Between the house and the studio is a distance of about twenty-five yards. It was her hope that the stretch of open ground would discourage the domestic interruptions which so often conspire to heckle professional ladies clean out of their professions, and in her case it seems to have worked."

Busy as she was with construction of her new studio and her BAE assignments, Dorothea did not drop her interest in a Guggenheim fellowship. There was some reason now to think an award was possible, since both Edward Weston and Walker Evans had succeeded in getting grants during the last few years. She filed her application in October, and saw her project as a direct continuation of her work of the past five years. Her specific intention was "to photograph people in selected rural American communities. The theme of the project is the relation of man to the earth and man to man, and the forces of stability and change in communities of contrasting types."

Having already observed astonishingly varied social patterns in rural America, her desire, she said, was "to document some of these patterns, photographing people in their relations to their institutions, to their fel-

lowmen, and to the land." She could do stronger work now, she said, if she could photograph "as a wholly free individual" responsible only to a fellowship. She meant to work in but a few places, selecting them carefully and penetrating them deeply. Making no references to photography as art, she said she believed that "the camera is a valuable tool for social research which has not been developed to its capacity."

She was realistic about the use to which her work might be put. She could not promise a book would come out of it, or even any exhibits. She hoped only "to produce a collection of photographs, integrated and closely documented, with brief collateral text." If she succeeded in revealing "some contemporary farm types, cultures and institutions—some stable, some dissolving, some rising—" then she was confident that useful outlets for such photographs would be found. The list of references she gave bore out her sociologic intent. Of the six people, only two—Edward Weston and Pare Lorentz—were linked to photography. The others were social scientists.

Late in March 1941 she was granted a fellowship. Her son Daniel, then sixteen, recalls it even now as one of her great days. Not a drinker, she celebrated by getting "tiddly," he said. Others were not so happy at the announcement. The newsletter of the Associated Farmers attacked the foundation for selecting the wife of "Liberal Dr. Paul Taylor," with whom she had collaborated on "a grapes of wrathy" book. Dorothea sent the clipping to Henry Allen Moe, and added, "Can still not believe it—that I am to have this year."

She was the first woman to receive a photography grant. There would not be another one for eighteen years, when Helen Levitt won a fellowship. Several others soon followed.

June 1 was the date her Guggenheim work was to begin. She did not start for the field, however, until late in July, when she and Paul began driving east. They had placed all five children for the summer with Paul's first wife, who was living in Seattle. Dorothea's intention was to photograph three contrasting cooperative religious communities: the Hutterites in South Dakota, the Amana society in Iowa, and the Mormons in Utah.

They were gone for two months, spending most of the time in the Midwest corn belt. On the way out she took pictures in Utah and Wyoming before doing a series on the Hutterites in South Dakota. Then to Iowa, for two weeks with the Amana society. On the way back, she did some work in Nebraska and Nevada. Apparently out of touch with Mr. Moe at the Guggenheim, she wrote him promptly upon her return home in September. She did not try to improve upon the facts to make herself look better. Mr. Moe, she said once, conducted his foundation "on the basis of simple faith and talented people. No questions asked." He wrote not to ask what you were doing but only to encourage you. "Our big successes," she quoted him, "have been where we placed our bets on uncertain qualities.

He's given me courage," she said, "to operate my life on that basis." In her letter to Moe she said she had developed most of the negatives from the trip. "Looked them over last night one by one, with my most critical eye, and wish I could do it all over again, of course. But on the whole am encouraged, feel that I am on my way, ideas fortified. Having a great time working."

It did not look so good to her in retrospect. Years later, examining prints of that trip, she penciled a note on a scrap of brown paper: "This is the record of a poor period. I was tired out to begin with, truly exhausted from many duties . . . with a sense of depletion, pushed by Paul and his energies. It was the beginning of the Guggenheim, which I cherished, but the circumstances were not right for me. We went to Amana. It was very hot, dense, and there had been no rain. Skies thick, as they are in the East . . . I didn't work well." Then this, added in red, still later: "Spring 1957— As I read the above (working from bed) it seems as though I must have been *born* tired."

Thinking back on that field trip, she remembered the Hutterites as very prosperous, but rigid . . . "stark, bleak, and demanding of their people. They really kept them in bondage." The Amana society had built prosperous communities in seven villages. They made good furniture, but they permitted someone to redesign it for the market. It was still fine craftsmanship applied to fine wood, but what it had been originally was now obliterated.

She intended to do photography among the Mormon farm communities of Utah that fall. Before she could start, an unforeseen event changed all her plans. In mid-October she sent Mr. Moe a message asking whether it was possible to grant her a two months' leave of absence from her fellowship. "I must ask this because a serious catastrophe has occurred to a member of my family."

It was her brother, Martin Lange, who had got into trouble. He and three other men had been arrested and charged with defrauding California's state-unemployment-insurance fund. Their scheme, based on collection of unemployment insurance for nonexistent employees of fictitious firms, had operated for a year in a dozen counties. The "master mind" of the swindle, said Attorney General Earl Warren, was a high-school principal named Raymond Killian, whom Martin had met years before in Nevada. Making a confession to Warren, Martin said that while working for the state-unemployment-insurance department he had seen the possibilities of such a scheme, and had broached it to Killian. It was Killian who then worked out the details. Both pleaded guilty, with Killian getting the stiffer sentence. Martin was placed on seven years' probation, with the first six months to be spent in jail. The other two men involved were the dean of a junior college and Killian's young nephew.

Dorothea found it too painful an experience to share with anyone out-

side the immediate family. She had made herself her brother's keeper, or rather, mother, trying to take care of him all her life. A big handsome man, always attractive to women, Martin "bubbled over with love of life," said one of his younger friends. "He did certain things to excess, yes. He never learned to drive well and was always smashing up cars. If he got a gallon of wine, it was to drink all the way down. Dorothea called him a drunk, but he wasn't. When I met him he was a laborer on the Boulder Dam project. He had the Wobblies' feeling about labor and their great respect for the working stiff. But he was no spouter of ideologies. When he got that job with the state agency, he rose swiftly because he understood the people it was serving. The establishment was the enemy to him. He had a thousand ways to rip it off. I think he enjoyed discovering how easy it would be to swindle the state because the fools had left such big holes in procedures. He told Killian about it, and that guy set to work to bring it off."

"Uncle Muckie"—a childhood nickname—was an idol to his young nephews, a warm strong man, a colorful hell-raiser, always getting into exciting scrapes. John and Dan Dixon noticed how their mother tried to keep a check rein on him, which made for trouble. "She'd say, I know better than you! and then there'd be a fight." When the novelist and teacher George P. Elliott moved near Martin in Berkeley, almost the first thing Martin told him after they met was that he had just served a term in prison for embezzlement. Dorothea, however, never mentioned it to Elliott. He observed that when around her, Martin always acted the younger brother. In the simplest matters she showed her authority over him. Whether it was to go on a picnic here or there, or to take a walk now or later, it was her decision that counted. She was overprotective with Martin, it seems. She loved him but she didn't respect him, and he knew it; he bitterly resented her because she was always bailing him out of trouble.

Upon Martin's arrest Dorothea did everything she could to help, with lawyers, funds, advice. The blow was heavy. She had suffered from her father's departure and the breakup of her own family; she was going through agonizing difficulties with her adolescent son Daniel—and now this. She tried to deal with it by saying that at least Martin didn't take from individuals, from defenseless people, from anyone who would be hurt by it. Looking at it that way made it possible to keep Martin in the bosom of the family. He had done wrong, yes, but he was not a mean man, not a bad man.

More than twenty years after Martin's imprisonment Dorothea still held the same view of him. "All my life we have never really been separated," she said. "He is my very good friend. We are utterly different people, and I have only in the last few years been able not to be his big sister, and have always been a little worried about him . . . He really is a

superb fellow, just an extraordinary guy . . . I am, in comparison with him, very conservative, very methodical. I know just what I am doing."

It was January before Henry Allen Moe heard from her again: "For three months I did not have the camera in my hand, and my studio was deserted. Now I am back at work. Some day, given the opportunity, I want to tell you the story of what happened. I simply cannot write about that now—more than to say it has been grave trouble, and I had no choice. It's over, and I am back, but I find that I have come up in a different place. I am also faced with the necessity of revising my work plans due to war conditions."

The Japanese had bombed Pearl Harbor on December 7. The tremendous shock of the sudden attack united the country for the war effort almost overnight. That she would be drawn into it was certain in Dorothea's mind, but in what way was not yet clear. Meanwhile, she again took up the negatives brought home from the summer field trip, studying and editing them in preparation for resuming her fellowship on February 1. She had hardly started when, again, events in the world outside altered her plans.

15 ON FEBRUARY 19, 1942, PRESIDENT ROOSE-
velt signed Executive Order 9066, allowing military com-
manders to set up military zones wherever they thought nec-
essary, with the authority to remove anyone they wanted to from these
areas, regardless of race, nationality, or age. On March 1, Lieutenant Gen-
eral John L. DeWitt, head of the Western Defense Command, announced
that all persons of Japanese ancestry would have to leave the Pacific Coast
military area. No individual charge was placed against any of them: the
110,000 men, women, and children, two-thirds of them native-born
Americans with full citizenship rights, were collectively ordered to report
for internment in camps outside the military zones. The United States was
also at war with Germany and Italy, but Americans of German and Italian
ancestry were not being penned up in concentration camps. This largest
single forced migration in American history seemed to be based solely on
race.

The government began hasty construction of large internment camps in
isolated inland areas. The U.S. Army was in charge of rounding up the
Japanese-Americans and holding them in assembly centers until the
camps would be ready. A special civilian agency—the War Relocation Au-
thority (WRA)—was set up to run the camps. On WRA's staff was an in-
formation officer who had shifted over from the Social Security Board
Paul Taylor had worked for. When WRA decided it wanted to document
its work in photographs, the information man, who knew Dorothea's
work, had her appointed to his staff.

One asks why the government—committing a gross violation of justice
(as almost everyone today sees it)—would want to record its actions on
film. Back then, though some considered it a scandal or a tragedy, most
people did not. The liberal President Roosevelt signed the order, his lib-
eral Attorney General, Francis Biddle, went along with it, and California's
Governor Olson and Attorney General Earl Warren supported it. A small

number of whites protested on the ground that it was racist and destructive of constitutional liberties. But most Americans paid little attention to it. When some Japanese-Americans challenged the evacuation order, the Supreme Court declared it legal.

No one seems to have thought through the reasons for hiring a photographer to document the evacuation and internment. To have a photographer in a government agency was by now almost the thing to do. Probably some WRA officials wanted to show they were handling the situation decently. Possibly there were others who thought it outrageous and hoped the photographic record would bear them out. At any rate, Dorothea began to work for the WRA in April, arranging to have her Guggenheim checks suspended for the three months she expected to be on this job. Thinking she might need financial aid, Moe offered to keep her checks coming, but she declined, preferring to have the fellowship time and stipend intact.

The evacuation order stunned the Japanese-Americans, although they had never been immune to prejudice and discrimination in this country. The Japanese had begun emigrating to Northern California in the late nineteenth century. Most were peasants who sought better opportunities abroad, and they began life here as migrant laborers. They were hard-working and frugal, and by pooling savings, many were soon able to rent and later to own farmland and small businesses. The San Francisco trade unions agitated for the exclusion of this new competition just as they had earlier fenced out the Chinese. Many Japanese then turned south toward Los Angeles, only to encounter the same discrimination. By 1924, California's nativists were able to get Congress to bar Japanese as well as Chinese from immigrating. But natural increase could not be stopped, and at the war's outbreak there were some 110,000 Japanese-Americans on the West Coast. They were established in farming, gardening, and fishing, in business and the professions, and their children were doing well in school and college.

Such achievement against the odds, in the American tradition of "making it," was of little help to them after Pearl Harbor. Hundreds of prominent Issei (the Japan-born immigrants who were barred from naturalization) were swiftly arrested by the FBI, their business licenses taken away, their bank accounts sequestered, their companies closed. Hunting for spies, the FBI entered homes and seized guns, cameras, radios. Fearful families burned their Japanese books and pictures, smashed their Japanese records, gave away their costume dolls. Landlords evicted them from homes, offices, stores. Desperate to prove their loyalty, many Japanese-Americans bought war bonds, donated blood, made bandages, tried to join the armed forces (and were turned away). When the army said the West Coast might be bombed or even invaded by Japan, people feared the Japanese-Americans would give aid to the enemy.

Rumors spread of espionage and sabotage. Although the Department of Justice and the FBI said investigations disproved the rumors, the hysteria mounted on a wave of vicious press stories. "Herd 'em up, pack 'em off and give them the inside room of the badlands," wrote a San Francisco *Examiner* columnist. "Let 'em be pinched, hurt, hungry, and dead up against it." And from Congressman John Rankin: "I'm for catching every Japanese in America, Alaska, and Hawaii now and putting them in concentration camps . . . Damn them! Let's get rid of them!" There were racist-minded people who saw the war as an opportunity to get rid of all the Japanese-Americans, and others envious of Japanese-American prosperity who welcomed this chance to grab their property. General DeWitt, who believed he could weed out the disloyal from the loyal, did not want, at first, to remove the Japanese-Americans from their homes. But he caved in under public pressure and soon was declaring, "The Japanese race is an enemy race, and while many second and third generation Japanese born on American soil, possessed of American citizenship, have become 'Americanized,' the racial strains are undiluted." They're organized and ready for concerted action, he said. He gave the order to evacuate them all—the aged Issei, their American-born children, the Nisei, and the Sansei, the babies of the Nisei.

Assembly centers were set up almost anywhere there was temporary space—on race tracks, in fairgrounds, in exhibition halls, at a migrant labor camp. The army could not move over a hundred thousand people at once, so areas were picked out and the victims given a week's notice or less to report on a given day for transportation to an assembly center. All over the West Coast panicky and confused Japanese-Americans were trying to sell or store their household goods and find people who would run their farms or operate their businesses. Whatever anyone would offer, the victims were obliged to accept.

As soon as the decision to evacuate was announced, Paul Taylor joined the newly formed Committee on American Principles and Fair Play. He had a personal as well as humane motive, for he had learned from Dorothea that former students of his were among those being evacuated. The group's purpose was to conduct a publicity campaign to counteract the wave of hostility to the Japanese-Americans. We wanted, Taylor said, "to remind people that the evacuees were not convicted, were not found guilty of anything, that they were entitled to every consideration under American principle and fair play." When violent letters appeared in the press, the committee responded with letters to offset them. The committee would continue to function until late in the war, when the government decided to release the people from the detention camps.

Early in April Dorothea began photography for the WRA. Her assignment was Northern California; other photographers covered the evacuation in the south. "What I photographed," she said, "was the procedure,

the process of processing." Starting with the Japanese-Americans of San Francisco, who were moved early, she stayed with "the baffled, bewildered people" as they ran from place to place, seeking information and help—the Y's, the churches, the Nisei organization headquarters, community leaders' shops and offices. "Everything they could possibly do for themselves, they did, asking the minimum, making practically no demands." Refusing shots from army medics, they turned to their own doctors for inoculations. She took her camera into one of the assembly centers in San Francisco, a big automobile salesroom on Van Ness Avenue, empty of cars in wartime. The families came in with their luggage, dressed in their best clothing as though this were departure for a holiday. The older people were dignified and quiet, the teenagers rowdy in concealment of their fright. The heads of families lined up at a sea of desks to answer questions from the social workers the army had brought in for this stage of processing. Out on the streets and along country roads Dorothea photographed the big white placards nailed up on telephone poles, announcing the dates for district evacuations and telling people where to assemble.

Although it entered few people's heads at the time, what was going on was startlingly like what the Nazis had been doing for years with the Jews of occupied Europe. This roundup on the Pacific Coast of an innocent people was a repetition of Hitler's collective internment, a method forbidden by our Fifth Amendment. And the crime of the victims? "To look at the world through an epicanthic eye," as Nelson Algren put it. When Dorothea watched the lineup in the assembly centers, she noticed some among them whom she would not have known were Japanese. Like the Jews under Hitler's Nuremberg Laws, if you had one-sixty-fourth part of Japanese blood, you were racially tainted and guilty.

She was surprised to see how quickly the temporary life in the chain of ten assembly centers settled into a routine as self-organization took over. But soon the evacuees were moved again to one of the four relocation camps the WRA was in charge of. These had capacities ranging from a few thousand to fifteen or twenty thousand people. From April into July Dorothea photographed the Japanese-Americans, going with them on buses and trains as they were shifted about. She made pictures in about a dozen different locations. She photographed only one of the interior camps, Manzanar in Owens Valley, visiting it three times. Going through the WRA photo files long after, Richard and Maisie Conrat estimated that of the 25,000 pictures still in existence, Dorothea had made 760.

"It was very difficult," she said, recalling the experience. "I had a lot of trouble with the army. I had a man following me all the time." This, though she was a government photographer on official business. She may have been tailed because her opposition to Executive Order 9066 was common knowledge, or because the WRA, her employer, was at loggerheads with the army over some policy issues. Lawrence Hewes, who was

working at the time on some agricultural aspects of relocation, remembers the army treating Dorothea so roughly it frightened her. She was shocked, he says, by the ruthlessness of the military. A few times she had a run-in with a Major Beasley. The first occurred when a Quaker working with conscientious objectors published a pamphlet on the evacuation with a photograph of it Dorothea had given him permission to use. The major called Dorothea in to answer for it, but before he could do her any harm, it turned out the same photograph had been reproduced in a congressional report. The next encounter took place in the WRA office when Major Beasley handed her an apparently empty negative envelope and demanded to know where the negative was. She took the envelope, put her fingers into it, and, bringing out the negative, said, "Here it is!" It was an embarrassing moment for the mistaken major. He thought he had caught her red-handed. His last complaint arose when he came across a photograph she had made of nurserymen in a relocation camp, working in the latticed sheds used to break the force of the sunlight. He didn't like the picture because the streaks of sunlight and shadow made it look as though the evacuees were behind bars or dressed in stripes.

The Japanese-Americans did not resent her photographing them. They felt that in her they had a friend, and upon their release from the camps, many came to visit her. As in the case of the migrants, wrote the critic A. D. Coleman, "she was precisely the right photographer for the job . . . She functioned in effect as our national eye of conscience in the internment camps. Her constant concerns—the survival of human dignity under impossible conditions, the confrontation of the system by the individual, and the helpless innocence of children—were perfectly suited to the subject." Some of her "most poignant and angry images" were made for the WRA, he believes.

Dorothea remembered her WRA work as one of her most intense experiences as a photographer. "On the surface," she said, "it looked like a narrow job. There was a sharp beginning to it, a sharp end; everything about it was highly concentrated. Actually, though, it wasn't narrow at all. The deeper I got into it, the bigger it became."

It was on the WRA assignment that a close friend first noticed how ill Dorothea often was. Christina Gardner helped her by driving the car when she went out shooting in the Bay area. "She complained of terrible bellyaches. Sometimes she was hardly able to function." These pains must have been forerunners of the ulcer she would later come down with. It was a time of terrible tension. No one knew how long the war would devastate the world, nor what its final outcome would be. Dorothea's own private life was in turmoil, her brother serving his prison term and she plunged into documentary photography of a shameful period in American history. Twenty-odd years later she took comfort in the fact that "the American people generally are willing to concede that we made a hell of a mistake."

She observed that the internment of the Japanese-Americans was often cited "as an example of what happens to us if we lose our heads. I think it's rather encouraging, as a sign of our mental health, that we admit a mistake. What was of course horrifying was to do this thing completely on the basis of what blood may be coursing through a person's veins, nothing else."

Her feeling was echoed by Tom C. Clark, civilian coordinator for General DeWitt at the time of the evacuation and later Associate Justice of the U.S. Supreme Court. Dorothea's images were to him "a powerful reminder of a nightmare that was acted out here in our land of the free, all as the result of racism and wartime hysteria Racial hatred coupled with economic and political opportunism kept hearts closed and fear predominant; it was a sad day in our constitutional history. The truth is—as this deplorable experience proves—that constitutions and laws are not sufficient of themselves. They must be given life through implementation and strict enforcement."

Thirty years after she finished her work for the WRA and years after her death, her WRA photographs were made the core of an exhibit and book called *Executive Order 9066*, which reminded the country of the fragility of American justice. In 1972 the traveling exhibit was presented at the Whitney in New York, the Corcoran in Washington, the De Young Memorial Museum in San Francisco, and a Tokyo department store. The idea for the exhibit originated with Dorothea. In 1964 she had gone to Washington to look through the work she had done for government agencies in preparation for her retrospective show at the Museum of Modern Art. She returned home with hundreds of negatives which Richard Conrat, her assistant, proofed, among them some of the evacuation and internment photographs. "Apparently," said Conrat, "she had acquired such a bad taste in her mouth as regards the evacuation and internment that she had come to feel she had done a very poor job as a photographer. But after reviewing the files, she told me: 'You know, I didn't do a bad job at all. Not at all.' "

She talked to Ansel Adams about the pictures (he too had photographed the internment) and their possible use in an exhibit. Soon after, when Adams was on a Western trip with Stewart Udall, Secretary of the Interior, the department which had administered the camps, Adams suggested that Interior might wish to sponsor a commemorative exhibit. Adams asked Dorothea who might assemble the exhibit from the National Archives file, and she recommended Conrat. The Interior Department postponed action and eventually dropped out. The exhibit advanced slowly in the hands of Richard and Maisie Conrat, and when it finally opened in January 1972, it was under the joint sponsorship of the National Archives, the California Historical Society, and the Japanese American Citizens League.

As the Conrats began to work on the exhibit, they met opposition from several sides. Some in the Japanese-American community felt those dark pages of history were over and should be forgotten. For many of the older generation, said one Japanese-American editor, "silence was a virtue." The younger people, however, were now outspoken about social issues. Some of them argued that if the exhibit was to be done at all, it should be placed in their hands, not controlled by whites. But to the Conrats this was as much white America's history as Japanese-American history. "The aggressor," they said, "is as much a part of the crime as the victim."

The exhibit contained sixty-three images made by a dozen photographers, but Dorothea's twenty-seven photographs, the largest group, commanded the greatest attention in the critics' comments. A. D. Coleman pointed out the significant use of "the photograph as evidence, not as graphic design or art object. They happen to be superbly made pieces of evidence, documents of such a high order that they convey the feelings of the victims as well as the facts of the crime. But there is no way of abstracting oneself from them, ranged along the muted orange walls of the Whitney, no way to step back into an appreciation of their composition or tonal range. Such evasion is best left to the other graphic arts, where it has long been mastered and used as a shield. Every photograph, no matter what its virtues or failings, is a slice of reality; the best are moments of truth, and confrontations."

To Hilton Kramer, art critic of *The New York Times*, the exhibit was "harrowing in its vivid glimpses of Americans suddenly made refugees and prisoners in their own country. It . . . reminds one of how powerful the photographic medium has been in recording the political horrors of the modern age . . . Miss Lange's work dominated the exhibition. Her pictures of the Japanese internment are, in a sense, a further extension of her work in the thirties in which the victims of a catastrophic social fate are so graphically particularized that we can only with difficulty ever again regard them as belonging to an abstract historical event." He saw "nothing either sentimental or ideological in the pictures . . . only an extraordinary truth. The documentary function is not the only interest that the art of photography can claim, but it is certainly one of its great functions, and Miss Lange was clearly one of the great practitioners of the documentary medium. In her photographs that have been brought together in *Executive Order 9066* she and her colleagues have left us a moving and permanent record of a human and political catastrophe—something that no other medium could have done in quite this way, with quite this effect."

By the time Dorothea finished her WRA assignment, her old friends at FSA were involved in war photography of one kind or another. Stryker's Historical Section was doing work for the new Office of War Information (OWI), most of it routine photography intended to promote the war effort. Arthur Rothstein had taken his camera into the Signal Corps, and

Russell Lee was doing reconnaissance photography for the Air Force. Stryker's unit was soon transferred bodily into the domestic branch of the OWI, and discontent with furnishing propaganda pictures out of his old files, he quit to build a documentary photography service for Standard Oil of New Jersey.

Dorothea sat on the sidelines for months, until Jess Gorkin, an executive of OWI's New York office, visited her in Berkeley and asked her to work for his group. Their job was to produce materials for distribution in Europe and North Africa. They published a number of magazines which commissioned photo stories to illustrate aspects of American life that would contrast with the totalitarian regimes of the enemy. She accepted the offer and, under the misleading title of Feature Picture Editor, took on photographic assignments at a rate of $16.53 a day. Her chief work was to develop picture sequences about minority groups on the West Coast— Americans of Italian, Yugoslav, Hispanic, and other origin. Their lives, like those of the Okies and Arkies, were being transformed by the war. Workers came from all over the United States in response to the "Help Wanted!" appeals and the promise of steady work at high wages.

The social and economic life of the Bay Area was violently disrupted under the immense pressure of military necessity. That priority made it impossible for local government to catch up with the newcomers' needs. The only housing was often dreary trailer camps or jerry-built tract homes, which began to fall apart as the tenants moved in. Rationing of food, gas, and tires produced a raging black market. The utility and telephone companies fell way behind demand. Sewers ruptured, schools went on double session, bribes got around rent control. It was a war against fascism, but domestic prejudice took little account of that. Like the Japanese-Americans, black Americans and Mexican-Americans were the victims of discrimination and oppression, if on a lesser scale. Women, though they found jobs because their labor was so badly needed, got no warm welcome from the men in the plants and shipyards. Despite the demand for labor, neither the armed forces nor the trade unions broke with generations of prejudice, and the tensions built up by the chaotic and fevered life of wartime easily erupted in violence.

Again, Dorothea had to work under strict controls, which made it difficult for her. The Bay Area was one of the major military zones and she had to get clearances from the army for almost anything she wanted to do. The OWI in New York could be of no help. She was obliged to clear each move with the Presidio. "When I was working on Italian-Americans," she recalled, "I couldn't photograph the locale from the top of Telegraph Hill. I couldn't describe it geographically without having a soldier with me and bringing the negatives and proofs back to the Presidio for them to check on. I couldn't photograph from the roof of a building or out a window because of all the extra war restrictions. It was laborious."

She was engaged in propaganda photography, yes, but she reasoned there was nothing wrong with it in this case. She knew conscientious people had to draw a fine line when it came to propaganda: "Everything is propaganda for what you believe in, isn't it? I don't see that it could be otherwise. The harder and the more deeply you believe in anything, the more in a sense you're a propagandist . . . But at any rate, that's what the OWI work was."

The OWI usually permitted her to develop the negatives and make pilot prints. She sent the negatives to the New York office with captions and explanatory notes. She did all the paper work herself, for there was no budget for assistance except when she needed someone to carry cameras over a long haul. Although she always had release forms with her, she never used them unless the person photographed wanted the reassurance or someone demanded to know what right she had to take these pictures. In all the years of her photography she shied away from getting clearances signed. "It's like working under suspicion; you have to have the confidence of the people you're working among. If it depends upon authentication and clearances it doesn't work. I don't know why, but it's so."

A few of the pictures she made were released for United States publication. *Survey Graphic* in its October 1943 issue ran a cover and a spread of three other Lange photographs inside showing five hundred Mexican workers arriving by train in Sacramento, their job "to produce more food for victory" on California farms. It was a strange twist for the photographer who had documented for years the exploitation of migrant labor.

Overseas Dorothea's pictures appeared in such OWI magazines as *Victory* and *Photo Review*. Copies were scattered by airplane to the local populations of occupied countries, just in advance of the Allied forces; and when such territory was secured, the magazines could soon be found on the newsstands. Beaumont Newhall, serving in the Air Force as a photo-interpreter, tells of coming across a copy of *Victory* (published in Italian) in the small Italian town of San Severo, and finding in it a photo-essay Dorothea and Ansel Adams had collaborated on:

I was struck by the force of four photographs symbolizing the Four Freedoms. There was no credit to the photographer. I sent the magazine to my wife, Nancy, and wrote her: "The handling of the Four Freedoms theme is the best which I have seen, and it may interest you if I give a free translation of the captions . . .

"Freedom of Speech. [Photo shows a group of eight men talking on a street corner.] The custom of Americans of Italian origin in San Francisco. Sunday, after Mass, the men stay behind to talk of politics and the war, while their wives go home to prepare Sunday dinner. The photograph shows a group of them deep in discussion near the Church of Sts. Peter and Paul, center of the Italian quarter of the city.

"Freedom of Religion. [Photo shows churchgoers coming through a door on

the lintel of which appear the Italian words 'Per l'Universo.'] The crowd of Ital-
ian-American faithful are going out of the church of Sts. Peter and Paul, after
the 10 o'clock Mass. Almost a thousand youths of the parish are serving in the
American Armed Forces, and every Wednesday a Mass is said for them. Like
very many Italian-Americans, the inhabitants of the Italian quarter of San Fran-
cisco are deeply religious.

"Freedom of Want. [A farmer in overalls standing before grapevines: in the
background, rolling hills.] California is one of the richest agricultural regions of
America, and the Italian-Americans have greatly contributed to make it so. The
farmer in the photograph, born in Italy and now an American citizen, has in
contract 26 hectares of grapes from the Italian Swiss Colony, a vine-growing
society established and administered by Italian-Americans.

"Freedom from Fear. [Eight kids, hand in hand, are being escorted across a
street by a smiling, burly policeman. The background shows a typical U.S.
street, with ads for 7-Up in store window, a marquee with 'Club Lido' in big
letters, a billboard, some autos.] The Italian-American kids know that police-
men are friends and protectors of the public. Here a group of them around a
cop of Irish origin who takes them to school in the morning and guides them
across the street. They call him familiarly, 'Jackie,' and he knows them all by
name."

I wonder who made these four photos? I wouldn't be surprised if we found
that they were taken by someone we know.

His wife, Nancy, wrote back that the photos were taken by Dorothea
Lange on an assignment she and Ansel Adams were doing for OWI, with-
out credits. Visiting Berkeley, Nancy had met Dorothea for the first time
and had talked with her about the possibility someday of a Lange retro-
spective at the Museum of Modern Art. The photographs Beaumont had
seen were part of an OWI picture story on the Italian-American colony of
San Francisco, which Dorothea had asked Adams to share with her. They
spent a week together, photographing, reporting, and printing. Adams
thought her "a wonderful person with a marvelous gift for people and
sharp seeing." He found it stimulating to work with her, for they comple-
mented each other well—he doing the landscapes and handling the diffi-
cult problems of groups and lighting, and she getting at people,
recognizing the significant moments, capturing their feelings in their own
words.

It seems to have been their first collaboration in photography; earlier
Adams had helped her with printing. Now they would work together on
shooting assignments several more times. One of their joint assignments
came from Fortune in 1944. They were to do a twenty-four-hour sequence
in the life of shipyard workers at Richmond, the industrial town on a
headland jutting into San Francisco Bay. On the eve of the war its popula-
tion was 20,000; now over 100,000 workers were building freighters at a
dizzying pace on the new Kaiser shipways, financed largely with federal
funds. To Ansel Adams it was an exposure "to a cross-section of brutal

life that exceeded anything in my experience." Dorothea had a better idea of what to expect, for her brother, Martin, out of jail, had found work in the Richmond yards and had become a foreman. Dorothea's son Dan was there too, and Martin was his boss. "Martin gave the yard its money's worth," Dan said. "Workers disliked being in his crew, he pushed them so hard. They called him 'Walkin' Marty Lange' because he was in constant motion. And he drove me twice as hard as the others."

A few of Dorothea's friends, too, became involved with that assignment, especially Homer Page and his wife, Christina (whose parents had been among Dorothea's first portrait customers). Page at the time was a shipfitter in the Richmond yards. He had been taking pictures of the workers on his own time and, knowing the setup and the problems, offered to guide Lange and Adams. "What an impossible team!" he said of them years later. "They were so unlike one another." He remembered Adams trying to get pictures of the workers coming out of the movies at four in the morning (they worked round-the-clock shifts and entertainment was geared to those hours). He rolled up to the theater in his big station wagon with the platform on top, his big cameras and lights, and so astonished the crowd that nothing useful came out of his shots. "But Dorothea hobbled around quietly, made herself part of the crowd, and got what they needed. Ansel did best with the grandiose aspects of a great shipyard, she with the intimate aspects of workers' lives. She was interested in the flow of things. I remember her picture of the man and woman glaring at each other. They were husband and wife, uprooted from Oklahoma, wandering a thousand miles from home to enter a radically different kind of life, and driven apart by the pressures of long and conflicting hours. Their inner relationship is revealed at once in that single shot. It's the space between them that counts."

Christina accompanied Lange and Adams to Richmond several times, serving them as caption taker. The contrast in their working methods was a revelation to her. It began with the equipment they took along for this assignment. Before starting out early one morning in Adams's station wagon, he checked what he had brought in from another assignment, completed only the night before. There were two cartons of flashbulbs, two reflectors, two tripods (one of them massive, as if to withstand a hurricane), several boxes of 35mm film, miscellaneous cords and light holders, two Jewels, a Contax, a Super Ikonta, a carton of sheet and roll films, a droplight, bottles of chemicals, and unnumbered odds and ends. All Dorothea had was her usual Rolleiflex, an extra film bag, and a notebook. If they had been in her own car she would have taken her short stepladder, which she sometimes needed to see above the heads of crowds, particularly when she was using the Rolleiflex, which operated at waist level.

As they got rolling, with Adams at the wheel, Dorothea kept peering out

the front window, urging him now and then to slow down so she wouldn't miss something. "When she was photographing alone," said Christina, "she usually had me drive about ten miles per hour so she wouldn't miss anything. Sometimes we would go round and round the same block, or stop on the street so she could really look over a place or a situation. Ansel on the contrary sees, feels, and responds mostly to the sweeping view. His vistas of the natural scene have conditioned him to see largely; it is enough for him to sweep by his subjects and in fact it enhances his seeing originally to see it fast. He thinks that way, something like quicksilver."

As they drove, Dorothea pushed in the lighter on the dash once or twice, but nothing happened. Adams took over and in a second out it popped, red-hot. That was typical, Christina thought, of his easy way with the inanimate. "Machines responded to him, shutters worked, flash guns flashed when they were supposed to." But Dorothea had to be careful with things or they wouldn't perform properly. "She had basic fears that her camera would jam or the film would get light-struck in some way."

When they reached the center of Richmond, Adams parked the car and began to unload the equipment he thought he might need. Dorothea got out and started wandering up a street with her small camera. Her habit, said Christina, was to disappear into the crowd. "She had a peculiar facility for just melting away and for not seeming to be photographing at the same time that she was sticking a camera in somebody's face. People ignored the camera's presence for her. It was something about her attitude. People didn't demand to know what she was doing, if they were the subjects."

After she absorbed the frantic rush, Dorothea made some pictures, including one of a young black woman, probably a burner on the graveyard shift, who was parading down the street in vivid dress, enjoying her night out, which in this upside-down life was in the middle of the afternoon. Then they went over to see what Adams was doing at the far end of a big crowd of people. He was trying to shoot from the dark arcade of a store out into the light of the street, waiting for the right person to come along. But with his big camera and big tripod, his fierce dark beard, and his ten-gallon hat, he was not someone who faded into the background. People didn't act like normal passers-by. Instead, they stopped to join the crowd gaping at the photographer. Frustrated, he quit and they all went home, feeling not too much had been accomplished that day. But they returned again and again, working from early morning until late at night, and finally got what they decided was the true story—the wild boom-town atmosphere of wartime Richmond.

The symptoms of the illness which had begun to bother Dorothea early in the war years continued. She suffered from intermittent epigastric distress, often accompanied by nausea and vomiting. Despite a fat-free diet and various anti-ulcer regimes doctors prescribed, the symptoms per-

sisted. Tests probing for deeper causes proved negative. Her poor health undoubtedly contributed to a sense of disappointment registered in her work notes of the time: "Never did get anything very good, and tried surely eight times to show it." And again, "feeble tryout . . ." and "very poor . . ."

She must have been troubled, too, by the scrapes her son Daniel was getting into in the army. He was drafted in November 1944, at the age of nineteen. He felt the family was glad to see him go, on the theory that military life might make a man of him (a theory proved wrong once before when his father had sent him to a military school). But in his one year of domestic duty he went AWOL so often he spent more time in the stockade than out. The experience only seemed to confirm what everyone, including the psychiatrists, had said—that he was "a hopeless mess" and would never even be able to earn his own living.

It was while Dan was in the last months of the service that Dorothea collapsed and was taken to a hospital. The minorities project she had been assigned to by the OWI was transferred to the State Department early in 1945, and when the founding conference of the United Nations was scheduled for San Francisco that April, she was asked to photograph it. Knowing that this would be a hectic two-month assignment, her doctor warned her that she would have to take it easy. "Take it easy?" she said. "How can a photographer take it easy? I had no business to do it. I knew it, but I did it anyway." Once more government restrictions made her task difficult. "After asking her to photograph it," recalls Paul Taylor, "the State Department shut her away from what she could do best. They confined her movements to the gallery; all she could see from there were tiny figures on a remote stage. She was never allowed close enough to do the job right. It was an unhappy time for her." Her proofs and caption notes show that, impatient with a gallery view, she went outdoors looking for UN delegates and photographed them wherever she could find them. Among the proofs there are shots taken the day Roosevelt died, showing people on the streets reacting to the big black headlines.

By the time the UN work was ended, she was in bad shape, her colicky pain so severe she required morphine for relief. She entered the University of California Hospital for treatment on August 27, was mistakenly diagnosed with gall-bladder disease, and was operated on for it. She was discharged on September 14 and remained in bed at home for nine days, never feeling well. After repeated severe bouts of pain, nausea and vomiting would recur. A sanitarium was tried to assure constant care, but a few days later she began hemorrhaging and was rushed to the University of California Hospital. Martin Lange rallied family and friends to contribute blood for transfusions. Now it was thought her trouble might be a bleeding duodenal ulcer. She felt a bit better in a few days, then massive hemorrhaging set in. She seemed completely irrational, was pale, cold, and

clammy; then seemed to be burning up with fever. "It was a terrible time," said Paul Taylor. "We thought we had lost her." But then she took a turn for the better, and the hospital was able to do a GI series, which suggested a duodenal ulcer. She was put on an anti-ulcer regime and, when healing apparently began, was discharged on November 11—the day her son Dan got out of the army. She re-entered her home to the music of a Bach chorale triumphant on the record player.

On January 9, back in the hospital, on the eighteenth out again; on February 25, back in again. The recurring abdominal pain had not been relieved by the strict medical regime. She was getting worse and worse, the pain unbearable. An attending physician noted that "she becomes nauseated if she talks too much." She consulted a psychiatrist. (One wonders what she was telling him—or concealing from him.) One house physician speculated that the gross distaste she showed for all food was "close to nervosa anorexia, with all its psychological implications." Another noted that "all concerned feel that a quite patent psychogenic factor or factors are at work here . . . but all cannot be sure and because of this feel that she should receive full benefit of the doubt—a complete check . . ."

Her history, the X-ray findings, and the episodes of repeated bleeding made the duodenal ulcer diagnosis firm. Her condition was built up to the point where surgery was possible, and on March 16 a gastric resection was done. It is a standard procedure for this kind of ulcer: most of the stomach, the acid-bearing portion, is removed. Her response to surgery was good, her recovery rapid, and two weeks later she was discharged from the hospital. Coming in the door of her home, she was given a royal family welcome, with musical accompaniment by Ross Taylor on the French horn and John Dixon on the clarinet. Then someone put on the recording of E. Power Biggs on the organ, playing "Jesu, Joy of Man's Desiring," the Bach chorale which was "practically my theme song."

The pleasure of survival was not lasting. She began to fear she would never be able to take up her camera again. To fill the empty hours, she turned to domestic tasks. She got a sewing machine and made clothing or did mending, working in the room next to Paul's study. She knew that he liked to hear the whir of the treadle while he was at his work. She found that her garden, too, helped pass the time; like sewing and cooking, it was another way to deal with her pain and despair. Moods of depression seized her often after the long siege in the hospital. In despair over her illness, she once came near feeling it wasn't worth going on. Then she happened upon a story of William Saroyan's—"The Warm Quiet Valley of Home"—which, she said, helped revive her desire to live. Despondent as she was at times, she was never a whiner. She would refer to her troubles only by making jokes about how dreadful it was to have to eat the Jell-O-like stuff she was limited to. But she placed no greater burden than that on family or friends. To one of them she interpreted her illness as retribution

for her bad behavior with her sons. Homer Page, borrowing her darkroom nights when she was so sick she had to stay in bed for a time, heard excruciating sounds through the walls (her bedroom was next door) as he was working quietly into the early hours of morning. Listening, he realized it was muffled groans caused by the pain she suffered in her stomach. It happened three or four nights in a row. He finished his work and left for a few days. When he returned, she was downstairs and busy again, saying nothing about having been so sick, only looking somewhat more gaunt than usual.

She had described herself as a chain smoker before the ulcer, but friends observed that she rarely inhaled, only liked to hold a lit cigarette in her hand. When she left the hospital, the surgeon told her not to smoke again. She had no problem with alcohol, for she had never been more than a moderate drinker. She had not been a heavy eater at any time, nor was she ever a vegetarian or a food faddist. On the medical diet, she was obliged to eat tiny amounts of sippy food, and often. Friends remarked that she seemed now to do everything with a slow, considered savoring. She would take a tiny Scotch-and-soda and, when she sat down to table, eat with great deliberation the tiny dabs of food permitted her.

Paul Taylor, who in the last two war years had served as president of the Berkeley Democratic Club, gave up the post when Dorothea fell sick. After her hospitalization he began serving her breakfast in bed, a custom that endured. Across the fence, in the next house to the west, was a neighbor who proved most faithful when illness struck Dorothea. She was Lyde Wall, and Dorothea's photograph of her, made in 1944, can be seen in *The American Country Woman*. She is coming smiling through the door, bearing a big apple pie on a tray. Opposite her photograph Dorothea wrote, "Friend and neighbor, who makes the world's best apple pie, and knows everything going on for miles around." Mrs. Wall was originally from the California foothills. The two women had become friendly meeting across the fence. When Dorothea went into the hospital time and again, Mrs. Wall would come over to cook and take care of everyone. "She kept the family going," said Paul.

Confined to home and shut off from her work, Dorothea had more time for books. She was not a literary person, however. Her son Daniel recalls that she did read, but neither voraciously nor widely. She liked Dickens, whom she read in an old set with small print she had acquired when young. She did not read aloud to her children. It was her husband Maynard Dixon who did, bringing home copies of the tales illustrated by N. C. Wyeth and Howard Pyle. Dorothea's own taste ran to Carl Sandburg, Archibald MacLeish, and William Saroyan, and what she liked them for, George Elliott observed, was their sentimental side. She would talk of "the people" with overtones of "The People, Yes," but that simplified attitude rarely entered her photographs.

Her reading was often directed to her professional interests. She followed the important new books and the journals dealing with photography. And in preparing for special assignments to parts of the world she was unfamiliar with, she would study scholarly books on the subject. In the arts she liked especially the works of Lewis Mumford and André Malraux.

1946 passed—"a total loss," she said. "I didn't know whether I was going to live or die." These words she said long after. But to those who knew her in the bad postwar years she tried to present a cheerful face. Toward the end of that year Maynard Dixon died in Arizona at the age of seventy-one. His obituary in *The New York Times* spoke of him as a muralist and painter of the West, especially distinguished for his depiction of the American Indian. It mentioned that he left a widow, the artist Edith Hamlin, but made no reference to Dorothea Lange or to their two sons.

As 1947 came on Dorothea wrote to Henry Allen Moe of the Guggenheim: "Please keep my balance for me. At last I am beginning to be able to make some plans for time ahead. Not yet entirely clear of my long illness, but hope that the months ahead will see the end of that. Then I'll be able to give details."

But it would be another five years before she would write to him again.

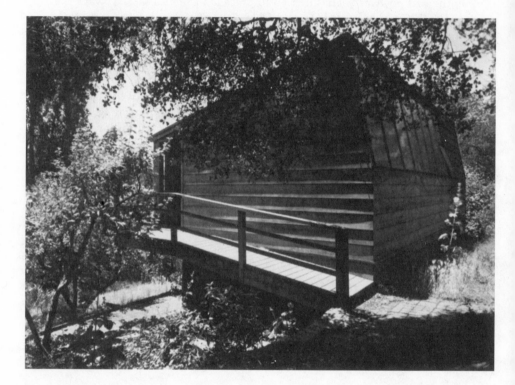

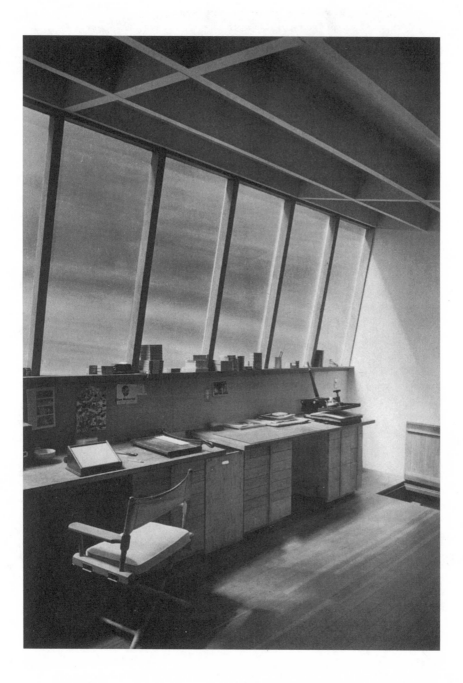

Dorothea's studio, Berkeley

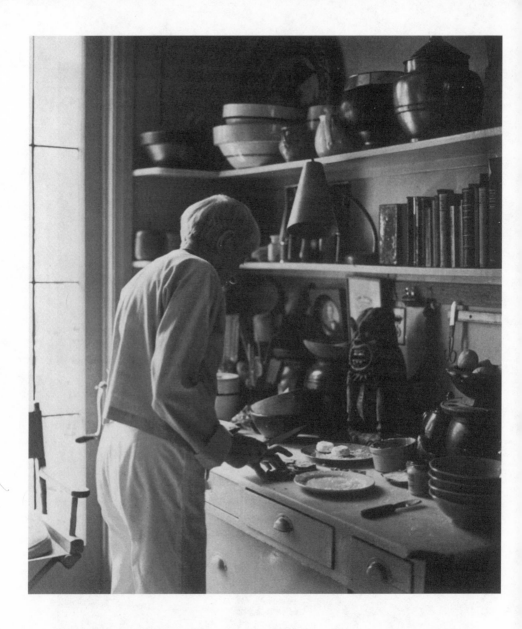

The dining-room table
RONDAL PARTRIDGE

In her kitchen (*opposite*)
RONDAL PARTRIDGE

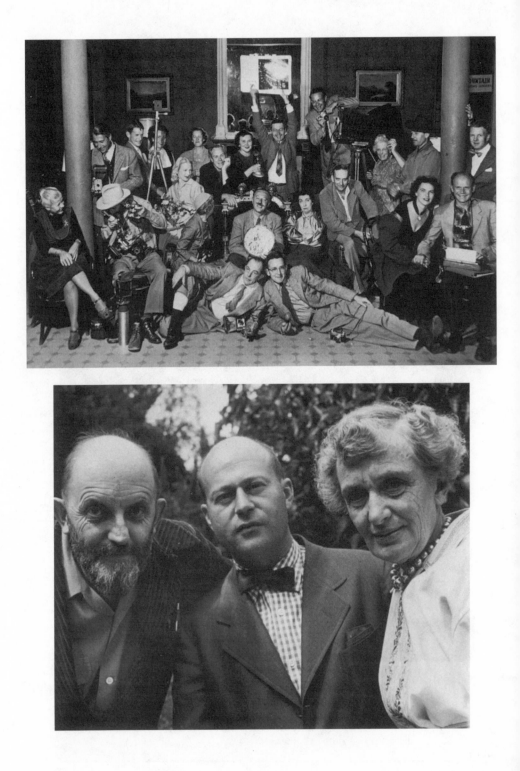

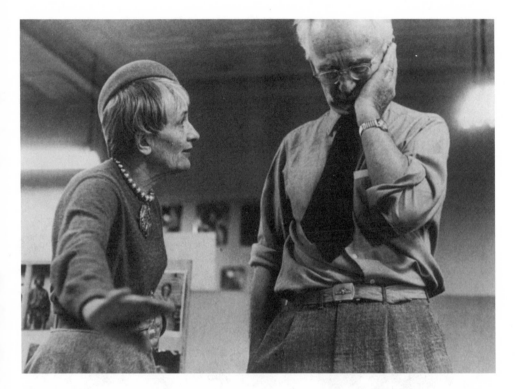

Dorothea discussing preparation of "Family of Man" exhibit with
Edward Steichen

At the photographic seminar, Aspen, Colorado, 1951. Left to right, back row:
Herbert Bayer, Eliot Porter, Joella Bayer, Mrs. Paul Vanderbilt, Connie Steele,
John Morris, Ferenc Berko, Laura Gilpin, Fritz Kaeser, Paul Vanderbilt; center:
Mrs. Eliot Porter and Minor White; foreground: Millie Kaeser, Ansel Adams,
Dorothea Lange, Walter Paepcke, Berenice Abbott, Frederick Sommer, Nancy
and Beaumont Newhall; on floor: Will Connell and Wayne Miller (*opposite*)
ROBERT C. BISHOP

Visiting at Berkeley in 1952: Ansel Adams, Arthur Rothstein, Dorothea Lange

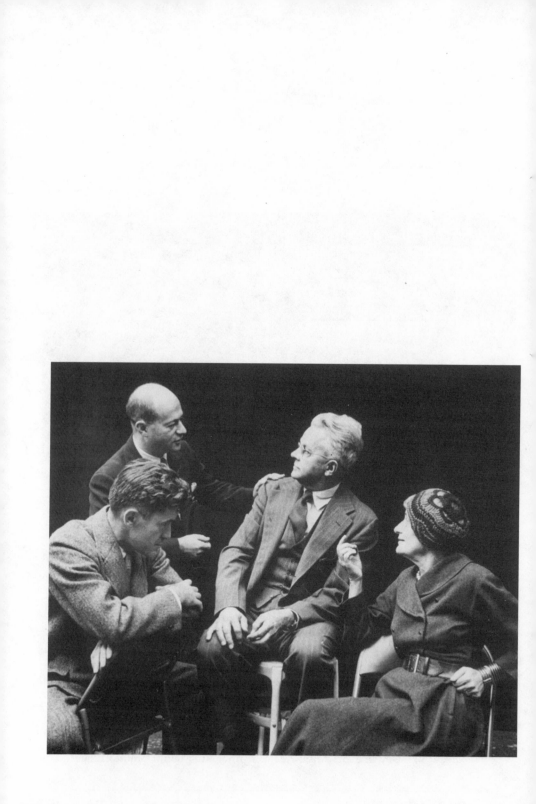

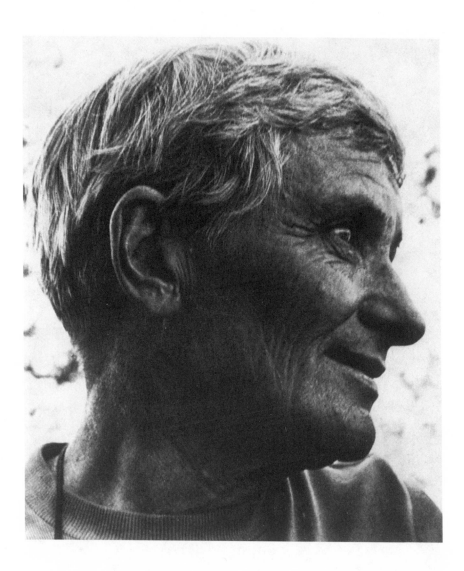

Dorothea, 1953
PAUL TAYLOR

Veterans of the Farm Security Administration's photography group, 1962
From left: John Vachon, Arthur Rothstein, Roy Stryker, Dorothea Lange (*opposite*)

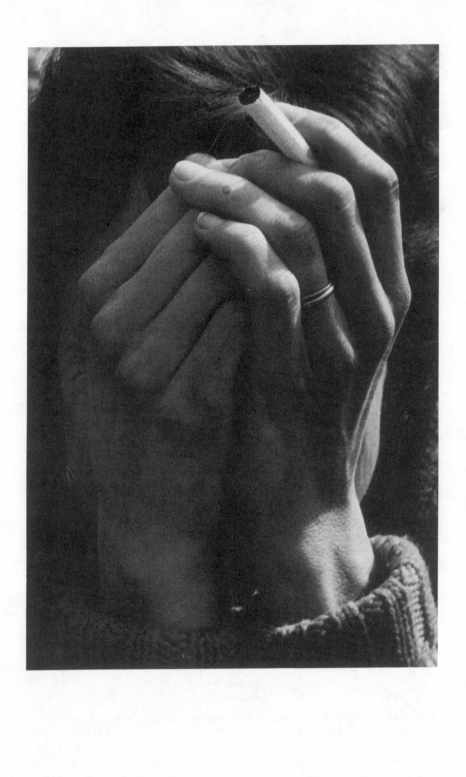

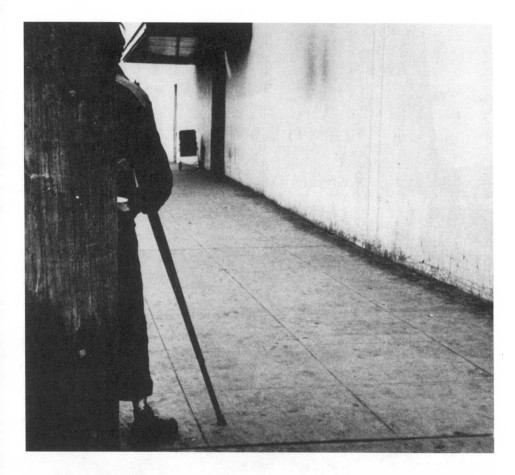

Walking Wounded, Oakland, 1954
DOROTHEA LANGE

Bad Trouble over the Weekend, 1964 (*opposite*)
DOROTHEA LANGE

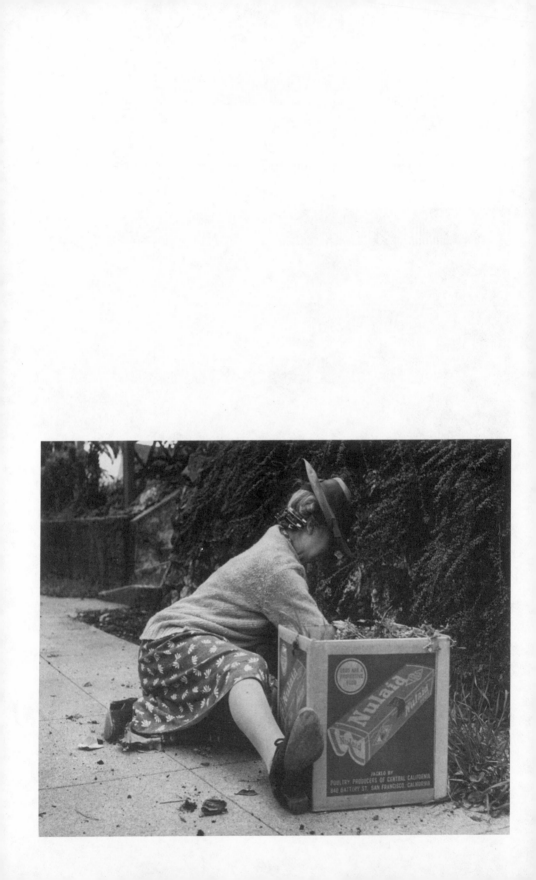

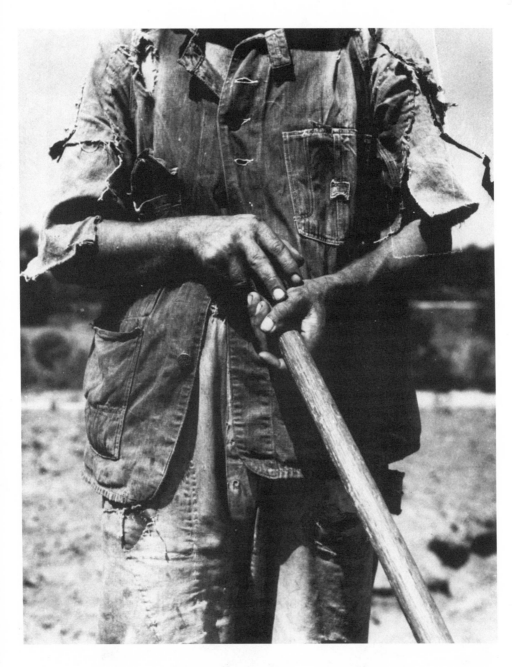

Hoe Culture, Alabama, 1937
DOROTHEA LANGE

Spring in Berkeley, 1951 (*opposite*)
DOROTHEA LANGE

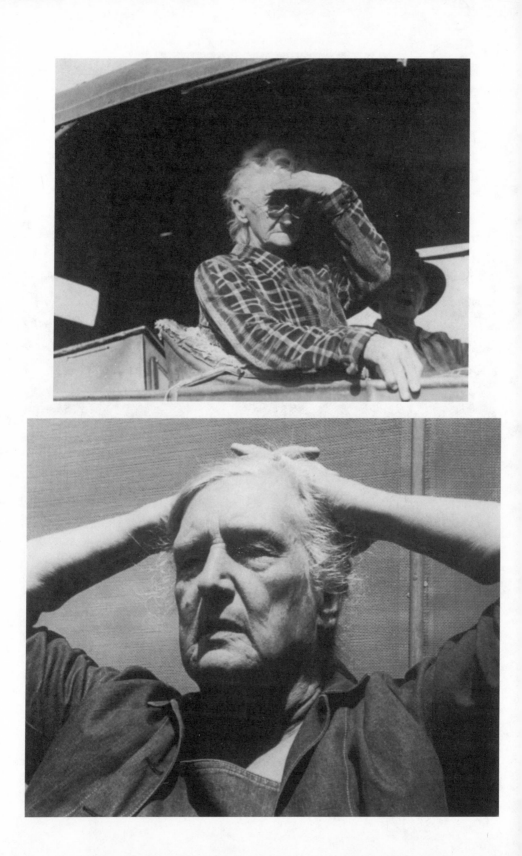

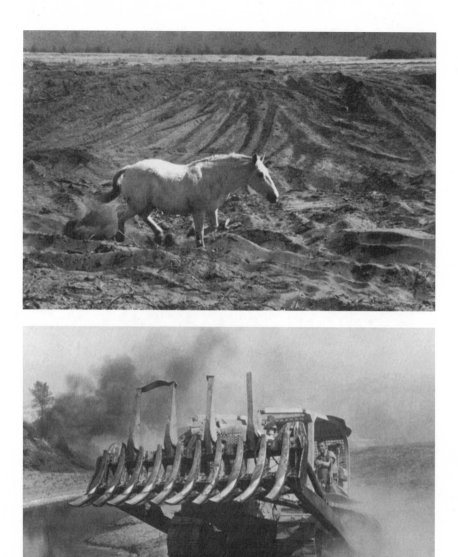

Terrified Horse, Berryessa Valley, 1956
DOROTHEA LANGE

The Big Cat, Berryessa Valley, 1956
DOROTHEA LANGE

Migrants entering California, 1936 (*opposite, top*)
DOROTHEA LANGE

Rebecca Chambers, Sausalito, California, 1954 (*opposite, bottom*)
DOROTHEA LANGE

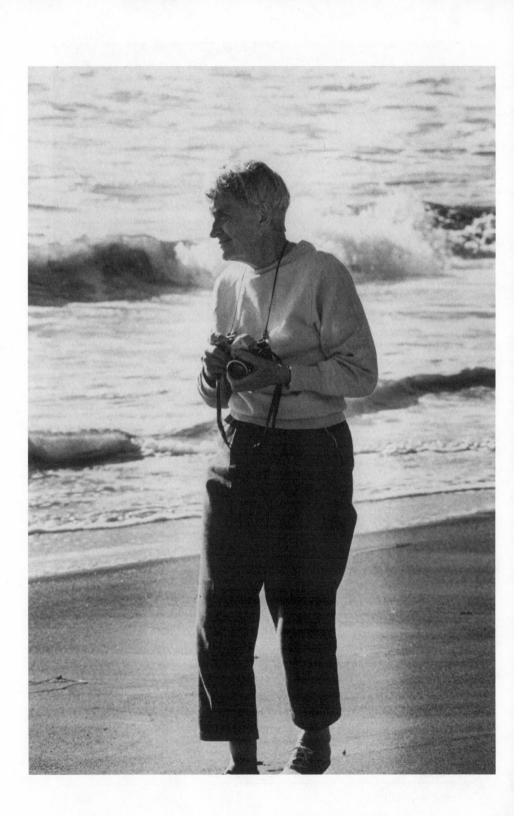

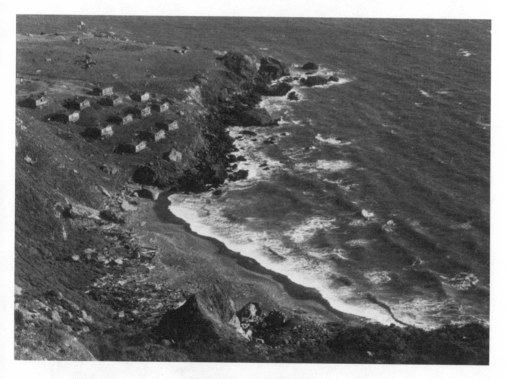

Steep Ravine, California
DOROTHEA LANGE

On the beach at Steep Ravine (*opposite*)
RONDAL PARTRIDGE

Dorothea and Richard Conrat laying out prints for her Museum of
Modern Art exhibit
RONDAL PARTRIDGE

Dorothea confers with John Szarkowski on her retrospective exhibit (*opposite*)

Family Portrait, June 1965
PIRKLE JONES

In the doorway of home, August 1964 (*opposite*)
RICHARD CONRAT

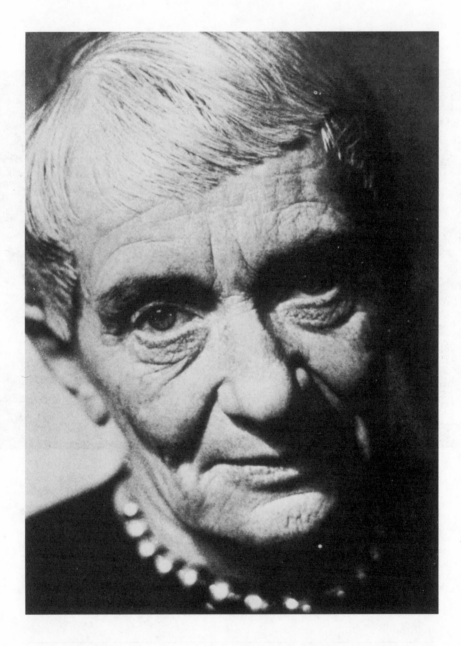

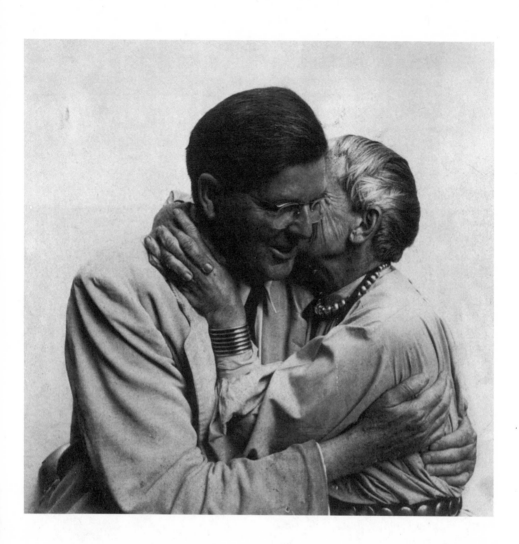

Dorothea and Paul

Dorothea (*opposite*)
ARTHUR ROTHSTEIN

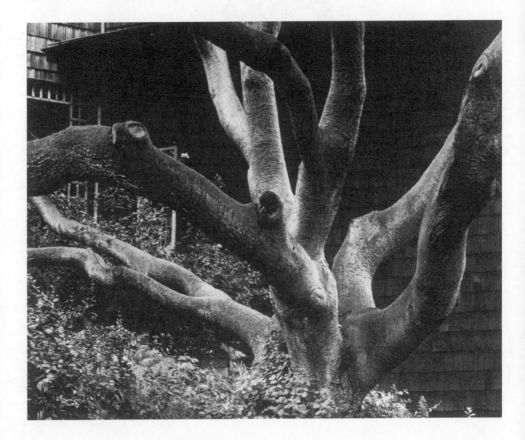

The oak outside Dorothea's window, 1957
DOROTHEA LANGE

PART FIVE

1946-1965

16 THREE YEARS PASSED BEFORE DOROTHEA TOOK up a camera again. She made some pictures of her son John and his girl, Helen Nesbit, on an excursion to Monterey. With Helen she went into San Francisco one day to make photographs of a few people on the street who caught her eye. Evidently it did not go well or she felt it too much of a strain to continue. That spring of 1948 Nancy Newhall asked her to contribute prints to the American section of a Paris show to be put on by the Women's International Democratic Federation. The theme was the struggle of women in all countries for peace and democracy. "I cannot imagine any show of American photographers, or of great photographers irrespective of sex, nationality and so forth, which would be valid without you," Nancy Newhall wrote, urging Dorothea to send ten to twenty prints representing what she would like to say.

"I'd like to contribute," Dorothea replied, "but my affairs (photographic) are in a sort of upheaval right now. I'm doing, or beginning to do a little work, but nothing for any eyes but my own. I've torn my studio apart. I've thrown away mountains of photographic trash. I've cut off from some of my old moorings (ideas)—I'm reclassifying my negatives, and if I have anything which would contribute to a women's cry for peace I don't know what it is, or where anything of mine is which would be of use or value to you." But rather than say no outright, she promised to go over her prints with this goal in mind.

Newhall wrote again to encourage her, saying that Berenice Abbott, Barbara Morgan, and Helen Levitt would be among those contributing, all of them "involved in some aspect of fighting for a hell of a lot better world than we've got at present, and we want that feeling to come through. I think Europe knows all about the rottenness infecting us and our hypocrisy . . . I want to tell them there's more to America than Truman and the Thomas Committee [The House Committee on Un-American Activi-

ties] and the rest of that ridiculous and dangerous walpurgis dance . . .
Don't tell me YOU have nothing for this show!"

Before Dorothea could get very far, her doctor ordered her to quit everything and go back into the hospital for a week of intravenous feeding and some more probing of her innards. She wrote Newhall: "I tried assembling a group of faces of American women, all kinds, from all walks of life, but couldn't make it hang together. Realize, too, that I have years of work in four different government repositories (at least, I hope so) which makes it harder. The American women idea was then abandoned, and I was in the well-known stage of hauling out everything I have and lining it along the walls of the studio (pitifully little, weak stuff, mostly junk and this is *true* for you overrate me) . . ." It was then that illness forced her to stop.

Determined to have Dorothea included, Newhall began to scour the Museum of Modern Art's collection for Lange prints and to borrow some from Roy Stryker and from *An American Exodus*. But when the committee was unable to raise the funds required in so short a time, the show had to be canceled.

Dorothea made another abortive try at photography in 1949. The *Ladies' Home Journal* was running a popular series of picture stories about the lives of selected families, called "How America Lives." It was edited by John G. Morris, who knew Dorothea's work and hoped to commission her. To make some test shots for the series she used her own family. She went up to Tracy, a town north of home, where her son John, now married to Helen Nesbit, was working for the Federal Bureau of Reclamation as a field engineer's aide. Again, she was not well enough to see it through. That fall Steichen presented at the Museum of Modern Art a show called "Sixty Prints by Six Women Photographers." Eight of Dorothea's photographs, all of them of migrant workers, were included, together with prints by Bourke-White, Helen Levitt, Tanya Hoban, Hazel Larsen, and Esther Bubley.

She worked with the camera a few more times in 1950, taking pictures of the graduation exercises at Berkeley (with Paul Taylor visible in the academic procession) and of James Roosevelt's campaign for the governorship.

John's was the third marriage to take place among her children and stepchildren. Paul's son, Ross, married Onnie Wegman in 1947 and his daughter Katharine married John Loesch a year later. The first of the nine grandchildren and stepgrandchildren she and Paul would share was born in 1951. That grandchild, Gregor Dixon, she photographed in the arms of his father, John. It was the beginning of a rich catalogue of family pictures she would continue making almost until her death.

These ventures were what Paul Taylor called "getting out on a short tether." When illness cut down her range of action, she began to work

from her files, re-examining what had already been done, seeing new relationships, new connections. If themes seemed only partially worked through, she tried to fill them out. With a friend or someone in the family along to help, she would go down into Oakland or San Francisco, but only for a few hours at most, gathering the strength she needed to pick up her work again.

Gradually, changes began to take place in the kind of photographs she made. She gave such names as these to her tentative themes—"Consumers," "Life on This Place," "Every Hour on the Hour," "A Circle of Friends," "Ballet," "Useful Women," "Relationships." "The Walking Wounded" was her name for photographs of "the spiritually maimed," those who walk the streets of any town every day. Her "Ballet" series tried to capture the beauty of motion in those actions of everyday life we are scarcely conscious of—the lifting of a baby, the combing of hair. In her files for 1951 is a series of photographs headed "Relationships": a family on the street, a father carrying his child, a couple holding hands, people eating in a restaurant booth, a woman pushing a baby carriage. About "Relationships" she said, "In the past, events have always played a major role in the work I've done. First there was the depression, then the dustbowl, then the war. All of these were big harsh, powerful things, and it was in relation to them that, as a rule, I tried to photograph people. Now, however, I'm trying to get at something else. Instead of photographing men in relation to events, as I have, today I'm trying to photograph men in relation to men, to probe the exchanges and communications between people, to discover what they mean to each other and to themselves. Usually, too, I'm trying to do this in the most ordinary, familiar, usual kind of way. By this I mean the relationship of a gardener to the planting season, or a young father to his first-born son. Sometimes, as they were here, these relationships can be comic, sometimes moving. But almost all of them are very subdued and subtle, things you have to look very hard to see, because they have been taken for granted not only by our eyes but, often, by our hearts as well."

Would the shift in the focus of her work have taken place if she had not fallen sick? She could no longer go where the events were happening. Unable to give up photography, she turned to the intimacy of human relationships. She might have come to it because of age—she was now in her mid-fifties—even if illness had not handicapped her. At any rate, thematic clusters of prints appear in the files of those first few years of her return to the camera. She went into many shopping districts, drawn by people's craze to consume, and shot in all directions to capture the signs and symbols of buying and selling. When a wave of strikes swept the Bay area, she photographed telegraph operators, bus drivers, carpenters, steel workers on the picket lines and in the union halls. Under the heading of "San Francisco Is" she began to sketch in her vision of the city's singularities.

Little of this work reached the public. The market for photojournalism was still a good one; for personal photography the opportunities for exhibition were few, and for sales even fewer. No photographer could live on earnings from the sale of prints. Those few photographers whose artistic standing was exploited by commercial publications might receive good pay for their efforts, but they could draw small satisfaction from the outcome. *Fortune,* occasionally commissioning people like Ansel Adams to undertake "big" assignments, would send a photographer driving one or two thousand miles, have him shoot hundreds of pictures and make a great many meticulous prints, and then publish only a handful, scattered among the industrial advertisements. To get decent prices for prints sold to a private collector, a museum, or a publication, the photographer had to conduct a running battle—a battle seldom won. Photographers learned to band together to press for fair reproduction fees and for one-time-only use. If a photographer was lucky enough to be asked to prepare a show, he often found that when the show was taken down and his prints (most of them unsold) returned, glass was cracked, frames battered, prints scuffed, mats soiled.

Still, there were important signs of recognition in those years. The Museum of Modern Art, which had shown one hundred of Walker Evans's photographs in 1938, in 1945 gave Paul Strand a major retrospective. The Strand was the first exhibit on such a scale that any museum in the United States, and perhaps anywhere in the world, had devoted to a photographer. Dorothea must have been encouraged by that. Five years before she had bought a portfolio of Strand's hand gravures, twenty photographs made in Mexico, and written to tell Strand "how proud I am to have the portfolio."

There was talk after the war of doing more such portfolios, but on a bigger scale, with institutional support and distribution. Ansel Adams sketched a plan for portfolios of fine prints by each of a dozen of the country's best photographers (Dorothea included). If the portfolios could be guaranteed in advance a national sale of a hundred dollars each, then the photographer's share could be perhaps five hundred dollars. The Museum of Modern Art, key to its success, warmed to the idea, then dropped it. Adams was a major figure, too, in planning the photography department of the California School of Fine Arts, a San Francisco institution founded immediately after the war; Dorothea would teach there in the 1950's. He wanted it to be the best school of photography anywhere. That project made headway when a foundation gave it a starting grant. Shortly after, Edward Weston followed Paul Strand with a major retrospective at the Museum of Modern Art. The next year, 1947, saw the organization of Magnum, a photographers' international cooperative, by Robert Capa, Henri Cartier-Bresson, and other outstanding men. It was a joint enterprise whose staff executive functioned as an agent to obtain work and to

bargain for the best rates. By the end of the 1940's, a dozen photographers had been honored by Guggenheim fellowships.

The photography department of the Museum of Modern Art, already the pacesetter, was no longer headed by Beaumont Newhall. He had resigned in 1946 and soon, on a Guggenheim, undertook to write his important *History of Photography.* Replacing him in the director's position was Edward Steichen, who had spent the war years as a navy captain supervising photography. The museum announced that under Steichen there would be "exhibitions where photography is not the theme but the medium through which great achievements and great moments are graphically presented." The big theme would dominate Steichen's thinking. He soon produced two such exhibits—"Road to Victory" and "Power in the Pacific"—out of his conviction that photography was "a great and forceful medium of mass communication" to which the museum gallery could add another dimension. A series of related photographs could collectively communicate a significant human experience, achieving an effect no unrelated collection of even the finest pictures could accomplish. While making grand plans for dramatizing elaborate themes, Steichen drew his first show, a small one, from what seemed to him "the most promising and most vital area of photography, the field of documentary photojournalism." Among the young photographers he selected were Homer Page and Wayne Miller, men who were, or would be, close to Dorothea.

The Photo League, training ground before the war for photographers concerned especially with social issues, was providing a forum for the exchange of ideas. Many of the leading practitioners, critics, and curators—Strand, Weston, Adams, Lange, Barbara Morgan, Todd Webb, Lisette Model, Berenice Abbott, W. Eugene Smith, the Newhalls, Philippe Halsman, Fritz Henle—were now among its members. They lectured to its classes, spoke at its meetings, exhibited in its gallery, wrote for its publication. Some, like Ansel Adams, considered *Photo Notes*—cheap paper, blurred mimeographing, and all—to be "the only real photography journal in the United States," because it expressed true concern for serious professional photography. That concern was often heatedly voiced, as when Adams gave a critical talk at the league which made distinctions between reportage and creative work. His iconoclastic views provoked his listeners to carry the debate from the floor into the press.

But almost immediately another issue smothered the healthy discussion. The organization received a stunning blow from the U.S. government, a blow which ultimately shattered it. Toward the end of 1947 the Photo League's name appeared on the Attorney General's long list of subversive organizations. It was one of the first gaseous bubbles to explode on the surface of the political swamp soon to be identified with Senator Joseph McCarthy. The charge of subversion led to suspicion, suspicion to division, and division to dissolution. By 1951 the league was dead.

That year marked Dorothea's return to active photography. Late in August she wrote to Henry Allen Moe at the Guggenheim: "I never did finish out my Fellowship. You know why. Now for the past two months, after a newly developed X-ray treatment, my health and my hopes are at the best in six years. I believe I can do work again, and the remainder of the Fellowship would help me do it. Can you put me back on the rolls?" Moe responded immediately, sending her a check and following up with the rest of the money due her from the grant which had been interrupted in 1941.

Her letter to Moe spared him the details of her medical condition. She had developed esophagitis, the aftermath of the gastric surgery of 1946. Her gullet had constricted, making it difficult for her to swallow food. It was a physical handicap that would continue to plague her periodically. In 1950 and again in 1951 she was hospitalized for radiation treatment. The hope, a desperate one, was that by treating the intractable ulcer with irradiation, the reflux of acid from the stomach into the esophagus might be reduced. In her case it worked quite well for periods of eighteen to twenty-four months. She would also, from now on, require bougie treatment from time to time. The bougie is a flexible instrument which, with gentle pressure, is put down the esophagus to dilate the constricted walls and make it easier for food to pass down.

Better than any medical treatment was the psychological restorative Dorothea found in the Aspen Conference on Photography she took part in that fall of 1951. For ten days she was one of a score of the leading figures in photography exchanging ideas and experiences in the Colorado mountain town, under the auspices of the Aspen Institute for Humanistic Studies. "Nothing as intense or as inspiring has ever happened to a group of persons in and around photography," wrote Beaumont Newhall in a report of the conference. The speakers included the photographers Berenice Abbott, Ansel Adams, Ference Berko, Will Connell, Laura Gilpin, Fritz Kaeser II, Dorothea Lange, Wayne Miller, Eliot Porter, Frederick Sommer, Minor White; John Morris, photo editor of the *Ladies' Home Journal;* Paul Vanderbilt, iconographer at the Library of Congress; and Beaumont Newhall of the George Eastman House.

About 150 amateur and professional photographers joined the core group. In that atmosphere and environment so conducive to human exchange, nothing but photography was discussed from breakfast till past midnight. But no technical matters: shop talk was ruled out by common consent. What concerned them all was the place of their art and themselves in the world they lived in. And what emerged from the talk was the central desire to make photographs meaningful.

Dorothea was a panelist in two of the discussion groups, one on "Objectives for Photography" and the other on "Photography and Civilization." No text survives, nor were the sessions recorded. But Beaumont Newhall reported that she pointed out the inadequacy of the word "docu-

mentary" and asked for a better term—which no one could supply. She defined documentary photography as closely related to time and change and, to show what she meant, sketched a shooting script for a hypothetical assignment to tell the story of the Aspen photo conference in a series of ten pictures. Her unusual approach, said Newhall, showed that the documentary photographer does not merely record but uses the camera to seek "the most characteristic and informative subject matter." Speaking to amateurs, she urged them to record their own life by a regular use of the simple box camera. With Adams, who shared a panel with her, she had hot differences on some issues, a debate never acrimonious, he recalls, and always rewarding: "We learned a lot from each other."

It was Adams who voiced the need for a professional society, with a dignified publication of its own, to establish standards of quality. Although no such society was formed (there was not even a second photo conference at Aspen), *Aperture* soon appeared, a publication Newhall said was "perhaps the most tangible outcome" of the conference. "Similar photographic journals had been in many minds for years," he added; this time one materialized out of a pitifully few contributed dollars and has sustained itself now for more than a quarter of a century. With Ansel Adams, the Newhalls, and others, Dorothea was one of its co-founders and served briefly as an advisory editor. Minor White became its editor.

Dorothea was ready now, at the age of fifty-seven, to put down on paper her own ideas about photography. Two articles appeared in 1952, both the joint efforts of herself and her son Daniel Dixon. The second issue of *Aperture* carried "Photographing the Familiar," and was signed by mother and son. It was her idea to attempt the piece, partly to express her own views, but just as much to help her son get something published under his own by-line. The writing was almost entirely his, and the fee, $50, went to him; she took nothing. The other piece, "Dorothea Lange," was really autobiographical, as told to Daniel, and his name alone was signed to it in the December issue of *Modern Photography.*

It was Dan's idea to write an article about Dorothea. Trained for nothing, unable to finish anything, he thought perhaps writing was the way to make a living. When Dorothea agreed to cooperate, he sent the idea off to the editor of *Modern Photography.* She offered him $500 for an article and some Lange photographs to illustrate it. He sat down with Dorothea in her studio and in two or three sessions drew out the facts and her opinions. Then he secluded himself in her house and in ten days had an article. It was a new field for him; he had done no thinking about photography before this. She had not tried to interest her sons in the craft, and had never even put a camera in their hands. Neither Dorothea nor the magazine requested any revisions. When he mailed off the piece he moved out of her home. Later, when a check came, she had to hunt him down. It was his first significant earning.

The article, illustrated with nine Lange photographs, provides many insights into her work, some of which have been discussed. Out of Daniel's difficult and painful experience with his mother he made this observation:

> Dorothea Lange, the person, is as complicated as is a definition of her work. Even her closest friends cannot take hold of the fact that the woman they know is not the only Dorothea Lange. Deceived by her simplicity of manner and intimacy of spirit, they fail to see that she is a many-sided person who, in giving herself as wholly as she can to whatever she's doing, whoever she's with, wherever she is, makes each of her many sides appear a complete person in itself. This is the kind of complexity, of course, over which friends are entitled to squabble a little; but it is also the kind of sympathy which, even behind a camera, can convert suspicion to trust and hostility to warmth—particularly when its rush of impulse is so unstudied as hers. She is almost mysteriously intuitive, and senses change in her surroundings before she is aware of change in herself. Like lightning, in flashes, she responds to atmosphere, and because her responses are expressed as passionately as they are, the atmosphere responds to her.
>
> It is not true of her as it's true of others that in her pictures the photographer behind the camera is as clearly exposed as the subject in front. In no way are her photographs interpretations, or statements, or impressions of herself, though they are a form of self-expression. But before she seeks self-expression—or maybe as she seeks it—she seeks also to let her subjects express themselves. They, not she, are the focus of her attention.

What, then, was the nature of her documentary work? There is no single method, she said, for method changes with subject, and subjects are as limitless as the universe:

> For me documentary photography is less a matter of *subject* and more a matter of *approach*. The important thing is not *what's* photographed but *how* . . . My own approach is based upon three considerations. First—hands off! Whatever I photograph, I do not molest or tamper with or arrange. Second—a sense of place. Whatever I photograph, I try to picture as part of its surroundings, as having roots. Third—a sense of time. Whatever I photograph, I try to show as having its position in the past or in the present. But beyond these three things, the only thing I keep in mind is that—well there it is, that quotation pinned up on my darkroom door.

It was the passage from Francis Bacon: "The contemplation of things as they are, without error or confusion, without substitution or imposture, is in itself a nobler thing than a whole harvest of invention."

But do "things as they are" include only the grim and the terrible— bread lines and Dust Bowl, hunger and despair? Why didn't she photograph something else? She did, said Daniel, but because she was so well known for the other kind of picture, few were aware of it. And in the final analysis, he pointed out, ugliness and horror are not really the subjects of

her photographs but "the people to whom ugliness and horror have happened. Her attention is not given to misery but to the miserable. Her concern is not with affliction but with the afflicted."

In the *Aperture* article Dorothea urged her colleagues to "photograph the familiar." This was one aspect of "things as they are" which she believed photography was neglecting. Absorbed for too long in the mastery and exploitation of the young technique's mechanics, the photographer had avoided the harshest demand of his medium—to serve it as artist. "He seeks to escape along the frontiers of shock. Thus the spectacular is cherished above the meaningful, the frenzied above the quiet, the unique above the potent. The familiar is made strange, the unfamiliar grotesque. The amateur forces his Sundays into a series of unnatural poses; the world is forced by the professional into unnatural shapes."

By the fall of 1952 Dorothea felt well enough to make her first long trip in many years. Alone, she flew to New York in September to work with Steichen on her contribution to a group show he called "Diogenes with a Camera." It was the first of a series of such shows he would organize to draw the public's and the profession's attention to the many ways in which modern photographers searched for truth. When Dorothea arrived at the Museum of Modern Art she found Steichen so engrossed with his plans for what would become the "Family of Man" exhibition that he forgot what she had come for. The "Diogenes" show opened in November for a three-month run; it included thirty-six of her photographs, chosen without benefit of consultation.

While Dorothea was in the East, her mother, Joan, died, in New Jersey, at the age of seventy-nine. No one seems to know when her father, Henry Nutzhorn, died. The last time his name appears in a public record is 1940, when he was seventy-two. (Dorothea's stepfather, George Hollins Bowly, had died in 1943.) A few days after Joan's death, to her friend Laura Banfield, Dorothea said, "It's a strange thing. My mother has died, and for the first time I feel like an adult!" Mother and daughter had seen one another only infrequently for a great many years, nor did they write each other much. Joan left a surprising amount of money, in the form of stocks, four-tenths of it to Dorothea, the same proportion to Martin Lange, and the rest to George Bowly's children. Perhaps moved to it by her revived memories of childhood years on the Lower East Side with her mother, Dorothea went downtown and photographed some street scenes.

Before returning home she was interviewed by Jacob Deschin, the photography editor of *The New York Times*, who asked what her answer would be to that perennial question of the amateur: What shall I photograph? Don't take pictures haphazardly, she said; you soon run out of material. Pick a theme and work it to exhaustion. But not from a shooting script. Let yourself loose on it. Choose themes you care strongly about, something

you truly love or hate. The more personal the venture, the greater the satisfaction. Such themes are never really finished. Some days you may think you have nothing more to say about it, but on other days everything you see will fall into place. "The secret is attention—observation and receptivity." It helps, too, to have some use for your pictures in mind. "I believe that if you follow a subject far enough there will be a place for it somewhere." Then, echoing a point made in her *Aperture* article, she criticized the current hunt for what was merely "different." If photographers are "always looking for the new angle," she said, "they miss the world."

17 WHAT DOROTHEA LOOKED FOR WAS THE ES-
sential human gesture. "She was marvelous with gesture,"
wrote John Szarkowski. "Not just the gesture of a hand, but
the way that people planted their feet, and cocked their hips, and held
their heads." In the 1950's, when her health permitted, she worked on sev-
eral picture essays which demonstrated that quality, a quality already visi-
ble in her early documentary photography. Her first major effort after her
drawn-out illness was a collaboration with Ansel Adams. Long used to
working together, they met now to discuss subjects that would suit a com-
bination of their special talents. Adams is not certain whether he or Paul
Taylor proposed the Mormons. At any rate, both Lange and Adams had
worked in Utah before, and the idea of portraying three Utah towns which
together might suggest the diversity and depth of Mormon life seemed
promising. Dorothea saw the Mormons as people of a heroic mold, living
against a demonic landscape. She needed Adams to do that landscape.
The original plan was to work toward an exhibition, and to seek a maga-
zine commission to cover the cost of making the photographs. *Life* agreed
to go ahead, but permission was needed from the Mormon Church. Paul
Taylor offered to take care of that. In Salt Lake City he saw one of the
apostles, Reuben Clark, whom he had known in Mexico City. Clark lis-
tened and seemed to be agreeable to the project.

Both Paul Taylor and Dan Dixon accompanied the photographers,
Dorothea asking her son along to help, without specifying what he might
do. Fresh from his experience working with her on the two magazine arti-
cles, he thought he could develop a structure for the story and hoped he
could write the text. They drove into southern Utah in two cars and spent
three weeks working in the villages of St. George, Gunlock, and Toquer-
ville, where the grandchildren of Mormon pioneers lived. But in two or
three of the places they wished to photograph, they learned Salt Lake City
had telephoned a warning that "the party coming down to make pictures

is unauthorized." It took hours-long efforts to convince local church authorities they meant no harm. Still, some of the people questioned their motives and refused to be photographed. Usually Adams and Dorothea went out shooting together. "We shared the work in a rather obvious way," Adams recalls. "She concentrated on the people, and I concentrated on the environment, although in some instances we overlapped or worked together on a single subject." Dorothea photographed some landscapes too, but *Life* gave no individual credits in its layout and it is hard to be sure any of her landscapes were used. Photographs undoubtedly hers are those which offer only a detail, the symbol, the part standing for the whole. There is a closeup of a weathered hand on the crown of an old hat; the bare legs of four children astride one horse, taken from the left side, with only the legs, the belly of the animal, and a patch of ground visible beneath; a woman in calico seen from neck to waist, her arms embracing four big jars of preserved food; a man's legs from waist to knees, his big left hand resting gently on the head of a little girl, whose right hand holds tight to his leg.

In Utah Dorothea was able to see her friends the Banfields, who were living in Gunlock. It was an isolated hamlet with scarcely two dozen families trying to make a living on less than 250 irrigated acres. They sat outdoors one day as people strolled past. One woman came up to be introduced and stayed a while to talk with Dorothea. When the woman left, Dorothea asked Mrs. Banfield how old that woman was. "Fifty-seven." "Why, I'm the same age," said Dorothea, "and when I looked at her, I thought of someone else's grandmother." She seemed to realize for the first time how old she must look to others now. On another visit Dorothea borrowed a loose robe so she could take off her clothes and be cool in the summer heat. Sitting on the edge of a bed, she glanced into a mirror on the wall opposite and suddenly flinging the robe open said, "God, look at that, what I've been wasted to!" Laura Banfield saw how emaciated her body was, with a brownish stain spreading on the stomach where she had received radiation treatment. It was the only time she referred to her illness in Laura's presence.

The shooting over, Dorothea and Adams made their prints, then met to go over what they had and to decide what to send to *Life*. Adams showed up with Nancy Newhall, whom he had asked to help shape the story. But Dorothea showed such dislike for that intrusion that Adams backed off and left it to her to handle alone. Unable to complete the story, she carted the prints to New York that fall and sat down with *Life* editors to work it out. They wished they had more pictures to choose from. They were used to photographers who shot far more than these two, for fear of missing something they couldn't anticipate. That was not the way Dorothea or Adams worked. They had provided what Adams called "very handsome" material, but "as so often occurred with such projects," he said, "it suf-

fered from over-editing and loss of emotional drive. It was intellectually pared down." Nothing *Life*'s editors might have done would have satisfied her. Once she told George Leonard, West Coast editorial manager of *Look*, that picture-magazine layouts should consist only of one photograph per page with a large border around it, the photograph published full frame as the camera took it. His rejoinder was that if you did that, the magazine would simply be a surrogate for the walls of a museum, with the reader sitting back to admire the work of art.

Nevertheless, when *Life* ran the story in its issue of September 6, 1954, it covered ten pages and used thirty-four pictures, as well as part of the text Dan Dixon had provided. Upon publication a woman whose photograph was used in the story demanded a thousand dollars, charging misrepresentation. Paul Taylor assembled evidence against her case and she couldn't make her claim stick. Adams felt the trouble arose because it hadn't been made clear that not only was a photo exhibit planned but a picture story in *Life*. Feeling guilty about it, on a later trip to Utah he called on some of the people photographed to explain what had happened. He found them understanding but still resentful that the full facts had not been told them.

Out of the trip came eight of the twenty-eight photographs that would appear years later in her exhibit and book *Dorothea Lange Looks at the American Country Woman*. One of them is the gravestone of Mary Ann Savage, plural wife and pioneer, born in 1849, died in 1936. Dorothea photographed it in 1953 because she had made a portrait of Mary Ann Savage twenty-two years earlier, while traveling in Utah with Maynard Dixon. As a child Mary Ann had gone West with her family, pushed across plains and desert in a handcart by her mother. The portrait of the eighty-two-year-old woman who had helped build Toquerville in the wilderness is paired with the photograph of her gravestone.

Did Dorothea like working for *Life?* She must have, for within a year of the Mormon trip she was on her way to Ireland on another *Life* assignment. Bernard Quint, who as art director of *Life* knew her well, said, "She was not untouched by the desire most photographers have for recognition and exposure." Her professional career was a mixture of independent, personal photography and photography done within another's framework— the expectations of people paying for their portraits, the demands made by government agencies, the style set by publications giving out commissions. If you took assignments from a *Life* or a *Fortune*, you had to be prepared to subordinate yourself to their requirements in selection of what to photograph, and to their editors in choice of what pictures to use, and how to print, crop, size, and arrange them. Certainly Dorothea recognized the practical ends an editor wished her to serve. But as Quint observed her at work, he felt she managed nevertheless to live her own kind of life, "always at her pitch of emotion, busy with what concerned her, not modi-

fying her feelings to meet the demands of the commission." He did not think she saw *Life* as an ogre threatening her integrity. She knew how many millions looked at life through *Life*. If her pictures could reach them through its pages, that was good. Then too, unlike many freelancers, she apparently did not feel she had to please every editor because her earnings were essential to her survival. Asked once by Wayne Miller if she supported herself by her work, she laughed and said, "No, I'm a kept woman."

The Irish piece started with her enthusiasm for a book, *Irish Countryman* (1937), by the anthropologist Conrad N. Arensberg. His was a study of modern Ireland, particularly County Clare, and was absorbing for the data it provided on the meaning of custom and belief in the lives of the Irish who still followed the old ways. Dorothea was moved to try to capture Arensberg's insights and observations with her camera. *Life* liked the idea and agreed to have Dan Dixon go along, paying his expenses, too. They arrived in County Clare in September 1954, putting up at the Grand Hotel in Ennis for a month. They took side trips to Leinster and Cork, but Dorothea made most of her pictures in County Clare. In a country strange to her she was not focusing on Irish people for their individual characteristics; how could she know them so quickly? She was more concerned, she said, "with only a portrait of the country itself, its population, its customs, its mores, its atmosphere, the texture of its life. In these things you don't approach individuals as individuals. You're thinking at a different level." Her mood was buoyant; she liked the country and its people. Occasionally she would be testy with Daniel because he spent more time than she liked having a jug with the boys in the pub. But then, he said, she was always nervous about alcohol; she had a broad puritanical streak about most indulgences other than sex.

Out in the streets or in the pubs Dan worked as he had done in Utah, taking no notes, just observing. But when they got back to New York it turned out *Life* wanted facts of him, not ideas, and demanded names, dates, places, clearances, none of which he had. The editors sent a team of two researchers over to Ireland to traipse all over the county with a set of prints, trying to identify the people in them. ("*Life* does very fantastic things," Dorothea said.) She had come back with "a big harvest," and her own idea of how she would like to have the story done. But it didn't happen that way. "Those pictures," she said, "are dumped on a desk in the office and then the makeup man and the art layout man and the editor and the picture editor hash out what they like."

The piece was laid out for more than a dozen pages, but when the issue was about to go to press a big news story broke, the magazine was ripped apart, and "Irish Country People" was reduced to nine pages, with twenty-one of Dorothea's photographs. Text had all but disappeared,

leaving room only for captions. Dan Dixon's name was not mentioned in the credits. He was living in New York now. He had come to New York with Dorothea in the late summer of 1954, on their way to Ireland. They had checked into the Grosvenor Hotel on lower Fifth Avenue late at night and gone out on the Village streets, alive with people even at 2 a.m. They ran into the photographer Gjon Mili, who threw his arms around Dorothea and kissed her. Dan felt, God, how great it would be to live here! So Dorothea talked to John Morris, now executive editor at Magnum, the international cooperative picture agency founded in 1947. He took Dan on, convinced he could help Magnum in a bad time. Two of its stars, Robert Capa and Werner Bischof, had recently been killed while working. Dan's job was to create ideas for stories, hustle assignments for the photographers, and help edit pictures. It was his first chance at a real job. The day he started at Magnum, *Life* appeared with the Mormon piece and Daniel Dixon's name in the credits. It was a great turning point for him. He sent for his wife, Mia, who was working in San Francisco and nearing the end of her pregnancy. They moved into a small place on the West Side just before their daughter Leslie was born. Dan worked hard at Magnum, but business was poor and they were forced to let him go in six months. He turned to freelance writing for magazines.

A project of Steichen's—"The Family of Man" exhibition—consumed as much of Dorothea's energy in those years as her own work. She became intensely concerned with contributing to its success almost from the moment the idea was broached. Steichen seems to have come up with the idea as early as 1950, when he talked of it to a few West Coast photographers while visiting California. The public response to the three grim war exhibits he had organized at the Museum of Modern Art made him realize that a negative approach did nothing to move people into action for peace. "What was needed," he said, "was a positive statement on what a wonderful thing life was, how marvelous people were, and above all, how alike people were in all parts of the world." When his brother-in-law Carl Sandburg called his attention to a phrase of Lincoln's, "the family of man," he knew he had his theme.

At first he thought making public appeals to photographers would produce the pictures for a show. His 1952 survey trip to Europe, when he visited twenty-nine cities in eleven countries, giving persuasive speeches to photographers, evoked enthusiasm but not photographs. Twice more Steichen came out to California, and Dorothea collected under one roof all the photographers whom she knew or had heard of, so that he could tell them what he was looking for. Once she went down to Los Angeles to speak to members of the American Society of Magazine Photographers, whom Shirley Burden had assembled. Many of them had confined themselves so long to commercial work they no longer ventured into personal

photography and Burden thought Dorothea might reawaken them. "Those hard-bitten bastards, every single one of them came to the meeting," Burden said. "Rather sheepishly, but with batches of prints, big portfolios of their work. She talked to them about the show and what Steichen was looking for, answered questions, and then said anyone who liked could come up and show her his work. So many did that it was two-thirty in the morning before the meeting broke up. She took every portfolio, studied the prints, and never made an unkind remark, though plenty of it was hack work. She had them all eating out of her hand."

But not much good material came out of it for Steichen. Finding the pictures became "a dredging process," Dorothea said. "It was digging in to get photographs, not making a big public call for them. They had to be *found*." Many of the pictures that would be used in the show she had a hand in collecting. Not so much by traveling as by writing to people, talking to people, tearing pictures out of newspapers and magazines, searching through her own old clipping files, recalling pictures she had seen here or there, and sending all the leads to Steichen.

"Still," she said, "there was a time when it looked as though there wasn't going to be any show. It looked as though he was going to have to hire people to go out and make pictures." One day, when she was in New York, he said to her, "I know now that I can proceed. I have enough up on the wall so that I'm confident." He gave her the key to a little room on the museum's top floor so that she could see for herself. "I looked and my heart fell, because I didn't see it. And I was sure that he was whistling in the dark."

But as word of the exhibit fanned out, photographs did begin to come in, from all over the world. The museum hired Wayne Miller to assist Steichen. He combed through more than two million photographs in the files of major magazines. A preliminary selection of about ten thousand prints was made, and the task began of shaping the material. Cutting the number in half was not too hard, but refining it from that point was increasingly difficult. For the last year of work Homer Page was taken on to supervise print production. Like Wayne Miller he was one of Dorothea's close friends. "If anyone asks if Dorothea had an influence on that show," said one photographer whose work was in it, "the answer is, inevitably. Miller and Page were Steichen's chief aides, and she certainly influenced *them*." Kathleen Haven, who worked for Steichen during the active years of preparation, 1953–55, observed that the two people whose opinions he wanted most were Wayne Miller's and Dorothea Lange's. He thought Dorothea a powerful photographer, and one whose ideas about photography were worth listening to. He believed her sympathetic to his point of view, his emotional response to life and photography's place in it. (There were many, including some on the museum's staff, who were not.) Imogen Cunningham, whose work was turned down for the show, spoke of Stei-

chen as "a great commercial man . . . very large in the head," who "really loved himself tremendously."

When the mountain of incoming photographs had piled too high, Steichen moved the work out of the museum and into a loft above a Fifty-second Street nightclub. There they could pin the prints on big Homosote boards to get an idea of how they meshed together, in tentative categories—women, children at play, men at work . . . With so many nursing mothers and children in the show, the staff had its own name for it—"Tits and Tots." Pictures went up and down on the boards, shuffled and reshuffled to find the best for the purpose. The staff began with no fixed notion of how large the show would be, only that it would be "enormous." The number of pictures would depend upon what design and enlargements did to the allotted exhibit space, the museum's entire second floor. Steichen had already made his mark on exhibit design by using photographs blown up to mural size. He believed in the grand scale for impact. The staff worked long hours, often until one in the morning, Steichen sometimes curling up for a nap in a little room adjacent to the loft. They knew they were on to something extraordinary, and a mood of exhilaration carried them over the frustrating moments when things went wrong and Steichen's temper would explode. Sometimes a picture was lacking to make a section come out right. They never commissioned a photographer to fill the need. Instead, relying on Steichen's fantastic memory for pictures he had once seen, they would call up a photographer to ask him to go into his files for the shot Steichen thought he must have.

Steichen kept complete control over the prints that would go up on the exhibit panels. None was supplied by the photographers themselves. All had to be made by COMPO, under Steichen's direction, to the size he specified. This didn't go down well with some of the photographers, who wanted control over their own prints. But they all gave in, even the purists. Some supplied prints they approved of; then Steichen had copy negatives made from them, and finally positives to the size he desired. From the beginning the staff knew that certain of Dorothea Lange's classic photographs—"Migrant Mother" and "Bread Line" among them—would be in the show, and some of them became the key pictures in their section. (Wayne Miller had the greatest number of prints in the show, but Dorothea's nine were among the highest number chosen from any one photographer.)

When the exhibit was in the later working phases, Steichen liked to take choice guests on a tour of the loft. He was showing Dorothea around on one of her visits in 1954, explaining what he was doing and why. He valued her advice in editing the show. She was quiet until they came to one part whose conception and treatment she disagreed with. Stopping in front of the pictures she asked, "What did you want to do this for?" Steichen replied, "Why, these are the greatest pictures for this theme!"

"Doesn't hold up with the rest!" she said, and they were into a donny-brook. He enjoyed a fight with her. She was one of the few who didn't fear to assert her own opinions. It was one reason he loved her greatly.

It was while on this same visit to New York that Dorothea fell so sick she had to stay in her hotel room, canceling a talk she was to give before the American Society of Magazine Photographers. When Steichen phoned her room a nurse answered, saying Dorothea was having a bout of fever and couldn't speak to him. Something about the brief exchange made him fearful. With Wayne Miller he rushed downtown to see her, found her terribly sick, lifted her out of bed, and rushed to a hospital in a cab. Miller sat up front and Steichen in the back, cradling Dorothea in his arms. At the hospital, emergency blood transfusions were necessary. The physician treating her said if she had not been brought in right then, she would have died. Later, when she recovered, she said to Wayne Miller, "Steichen has the most marvelous protective hands."

Back in New York shortly before the opening of "Family of Man" in January 1955, Dorothea found Steichen pressing hard in his usual way: "He works up to a terrific climax where everybody doesn't sleep for three or four days and they work day and night and they live on black coffee and he gets it done. On the afternoon of the day the show was to open they were still making prints, and many of the prints were wretched. But Steichen took it in his stride and that's the way it came out. He's no fellow to dither around with things. I might have kept on working. He has the great quality of accepting imperfection as being part of a thing."

The final selection consisted of 503 photographs representing 68 countries. The work of 257 photographers, 163 of them American, was included. "If you put your hand on a print that opening night," Dorothea recalled, "the paste would squeeze out." It didn't matter then or later. The show broke all the museum's records for attendance at its exhibitions of contemporary arts. Six traveling editions were made up by COMPO, which had prepared the original exhibit, and within a few years, more than nine million people had seen them in some seventy countries. Published in book form, *The Family of Man* became the most successful photography title in history. Still in print, it has sold over five million copies.

"No one," said Steichen, "had suspected anything like the reception accorded to 'The Family of Man' across the world. [It] appealed to all kinds of audiences, the illiterate as well as the intelligentsia, who, in some areas, gave it unqualified endorsement." The popular response was truly overwhelming. Steichen concluded that "the deep interest in this show was based on a kind of audience participation. The people in the audience looked at the pictures, and the people in the pictures looked back at them. They recognized each other."

Steichen had to qualify the response of the intellectual, for some of them ridiculed the show. Writing in *Aperture*, Minor White placed it "in

the tradition of Max Reinhardt or Cecil B. DeMille." A critic in *The Atlantic* accused it of the same sentimentality which the jukebox and television catered to. Nearly twenty years later Susan Sontag would echo this charge, stating that people of good will welcomed "The Family of Man" in the 1950's because they "wished . . . to be consoled and distracted by a sentimental humanism." But such voices were the exception. Aline Saarinen, the art critic of *The New York Times*, felt the show's "terrific emotional wallop" raised the question of whether photography had replaced painting as the great visual art of our time. "Granting that all art is an expression of a response to life and a communication of emotion, is it not true that photography makes itself immediately intelligible and that its statement is undeniably universal? Conversely, has painting not become so introverted, so personal, so intellectualized that it has lost both its emotion and its power of communication?"

Dorothy Norman, who assisted Steichen by preparing the texts for the show, wrote that in working with him she came to realize that he was not simply putting on an exhibition. "He was attempting to project his own vision of life by working through and with others." He functioned, she said, "as a conductor of an orchestra using other people's art as an instrument through which to forge a composite statement that may be made available as widely as possible . . ." Like many others, she observed that "it is not 'photography' at all of which people think, as they walk before the pictures, but of what is being communicated (by way, of course, of the sensibility of the photographer, plus the manner of presentation). What is communicated, it so happens, shakes people to such an extent that, almost paradoxically, it makes them feel as though they were being confronted by some *new* aspect of photography, even if, in truth, this is not at all the point of what is happening to them."

Examining books of photographs in the mid-1970's, the critic Colin Westerbeck, Jr., saw "The Family of Man" as a show which had "established our mythic expectations of photography and photography books. Posing as an anthropological study of all mankind, it in fact proposed the myth of the global village that Marshall McLuhan was to promote ten years later . . . Even in the way it was composed—as the epic work of many hands, of literally scores of photographers—*The Family of Man* is a myth form, like an oral tradition of a cycle . . . Steichen did not invent this sort of mythic appeal, but I think that with *The Family of Man* he permanently installed it in our expectations of photography."

Just before the Steichen exhibit opened, Dorothea and Paul Taylor applied jointly to the Guggenheim for a "refresher" fellowship. They hoped to study the foundations of rural society in Europe and Asia. She saw this as a great opportunity to extend the work she had begun in 1935. She wanted to photograph people in their relationships to each other and to their environment in a changing society. Shunning the photography of

picturesque people in strange places, her aim was "to experiment with, and demonstrate if possible, unfamiliar and effective ways of using sequences of photographs on a theme."

They would be free to start work in the spring of 1956, when Professor Taylor expected sabbatical leave. But the foundation did not award them the fellowship, apparently because she was unable to submit prints for the consideration of the jury. It seems a strange reason, since she had explained that most of her earlier work was lodged with government agencies who would not release the negatives, and her more recent negatives were in the hands of *Life*, which would not release them, either. But surely her work was visible enough in many magazines, books, and exhibits, including the current "Family of Man" and a show of FSA photographs at the Brooklyn Museum.

The disappointing decision from Guggenheim would not come for more than a year; she did not sit around waiting for it. In the spring of 1955 she began work on a photographic essay that would become known as "Public Defender." It arose out of Martin Lange's troubles with the law. Her brother had been able to draw upon the family's resources for his costly legal aid. But what happens to a penniless person accused of crime? Where can he find the money to hire counsel for his defense? The sacrifices made by her family in Martin's behalf started her thinking about it. She learned that the country's first public-defender system had begun in California back in 1914. On the theory that truth and justice are the government's aim in criminal cases, it seemed logical that the indigent poor should be provided a public defender paid out of tax funds, just as the state pays the expenses of the public prosecutor. By now more than eighty cities, counties, and states—including her own Alameda County—were using the fast-spreading system. She proposed a story about it to *Life*, which told her to go ahead. They planned to use it in May 1956 to mark Law Day.

She found a perfect focus for her story in Martin Pulich, a handsome young Yugoslav-American lawyer on the staff of the Alameda County defender's office. Even after twelve years' service he had not grown hard and cynical; he was still concerned about protecting each prisoner's rights. When she came to see him the first time, she told him about her work for the FSA and showed him some of her prints. As they talked he found her social and political ideas matched his own interests and outlook. He felt she was a gentle and sensitive woman who could be trusted. She wanted, he said, to find one prisoner whose story would best express what it meant to be a defendant under these circumstances. But it proved impossible to build the essay around a single case. Day after day she met him early in the morning and stayed by his side, watching and photographing what he did in the office, in the courtroom, in the jail cells, joining him at coffee breaks and often going out to lunch with him so they could talk about

what she was observing. She wanted at one point to make pictures of Pulich with his family, but he declined, feeling it best to stick to the professional side of his work. He was astonished at her persistence. She worked on the story off and on for over a year, until the spring of 1956. He noticed that certain facial expressions or body postures, the way a shadow fell, or how a jail key looked, had a symbolic significance for her and would get her most intense concentration. Once she told him she'd like to do a story using only a box Brownie, to show that a good photographer could get fine pictures without depending on the most highly developed equipment. Another time she said that in her experience the fifties were the best age: you've gone through the storms of youth, have mastered your profession, and are beginning to see the fruits of your life in your work and in your children and grandchildren.

Photographing people deprived of their freedom while they awaited trial, she showed the same respect for their dignity that accounted for her success in photographing the dispossessed of the thirties. On one of her shooting days she asked a friend, Pirkle Jones, to come along and help carry her cameras. He watched her walk into a cell with fourteen men in it. She explained quietly what she wanted to do, and why, and said those unwilling to be photographed could sit in a corner of the cell, out of camera range. Only a few chose to do that. She would not take advantage of them in any way, by stealing shots or failing to tell them her true intentions.

Although her prints were submitted to *Life*, the Law Day issue did not include any of them. Instead, the editors featured the Legal Aid Society of New York and used drawings of its work made by an artist. Why *Life* rejected her work this time is not clear. It may have been because her approach was not journalistic. Her images represented all public defenders, not a particular defender in a particular case. She didn't provide answers to the questions a magazine like *Life* wanted asked: What was *this* defendant accused of? What did *this* witness testify? How did *this* public defender handle the case? Her pictures were illustrations for a general situation. She was never really a photojournalist, not when she worked for RA and FSA and the other agencies, and not when she obtained assignments from *Life*. She did not think within the terms of reference of a journalist. The immediate impressed her, but not for its momentary meaning. She saw beyond that to its large human significance. Perhaps that is why Magnum—which around this time began to represent her not as a full member but as one of the independent photographers who used Magnum as agent—was never able to get her assignments. Both Magnum and the editors it did business with respected and admired her work, but felt she was not right for the demands of the journalism market.

Dorothea's "Public Defender" photographs did find other outlets, however. A feature syndicate distributed to newspapers a four-page story with twelve of her pictures and text and captions built around Martin Pulich's

work. The United States Information Agency sent her photo-essay overseas, where it appeared in a number of newspapers. The national Legal Aid Society made a brochure of the essay to interest communities in developing public-defender services. Six of her photographs helped to illustrate a National Lawyers' Guild publication called *Minimizing Racism in Jury Trials.*

Several times in these years she made proposals for photo-essays to *Look,* but George Leonard, who greatly respected her work, had such differences with her over the mode of shooting a story meant to reflect contemporary issues that he rarely could endorse her ideas. A few he did forward to New York were rejected. One, however, was not—at first. Dorothea had learned in the spring of 1956 that an artist friend, Emmy Lou Packard, was working with children of the Hillcrest Elementary School in San Francisco to create a mosaic mural for the library. To begin the work, about thirty of the children were bused to Pescadero Beach, where they would hunt for colored pebbles and shells to be worked into the mosaic. Dorothea went along, photographing the children talking about their plans on the bus, prowling the beach, and then working on the mural in the school. The prints pleased her and she approached *Life* with the story. It offered a three-page spread, but she thought it worth more, and showed the material to *Look,* which promised five pages. All this took nearly a year. Shortly before the piece was to appear, in the summer of 1957, the House Committee on Un-American Activities came to San Francisco with some fifty subpoenas for lawyers, scientists, actors, and artists to testify on "Communist infiltration" of their fields. Almost all the witnesses were dramatically hostile to the committee, and among them was Emmy Lou Packard, naturally a central figure in Dorothea's story. The story never appeared in *Look.* Dorothea attributed this to the committee, although *Look's* editors were known to detest McCarthyism.

Photography in prison cell, courthouse, and school, close and confined, gave way to photography on the open land. Again Dorothea turned her attention to a social issue, this time one linked to the deeply familiar theme of human migration and its costs. More than twenty years before, in 1935, she had begun to photograph the first wave of refugees from dust and drought and Depression. She had explored with her camera the process of inching painfully up from ditch bank to grower's shack to government tent to patch of ground and home of one's own. And then the big change that came with the war—the jobs, the paychecks, the unions, the security—which symbolized the urbanization of those same refugees of the thirties. After the war had come another wave of people, many of them the young who had passed through California on their way to Pacific battlegrounds and who had decided upon their return that California was where they wanted to live. Unlike the earlier migrants, these had come by choice, but still it was too many, too fast.

What the consequences were to the land and to man's way of living on it had always been Paul Taylor's concern and had long ago become Dorothea's. Not far off, only forty-five miles north of San Francisco, was a place where the forces of change were pitting one group of people against another in a conflict whose implications she wanted to photograph. The place was the Berryessa Valley. Lying between the Cava Mountains and the Cedar Roughs, the valley was eleven miles long, and two and a half miles wide. Warm, sunny and quiet, it was a place of settled homes and deep loam soil where people raised cattle and horses, pears and grapes, alfalfa and grain. It had never known a crop failure. It contained the town of Monticello, a center with only one store, two gas pumps, and a small hotel. From two sources, her husband, Paul, who was a consultant for the Federal Bureau of Reclamation, and her son John Dixon, who worked for the same agency, she learned that the Berryessa Valley was to be replaced with a reservoir to supply the constantly rising needs for water of the people flooding into the towns and cities.

Dorothea drove up, and with her son John, who lived nearby, looked around the valley. What she saw made her determine to photograph the process of change already taking place. *Life* gave her a thousand-dollar retainer to explore the story and agreed to pay additional page rates if they published it. Dorothea asked Ansel Adams if he would work on it with her, in spite of the fact that their collaboration on the Mormon piece had been so troubling. It should have been no surprise to her when Adams declined. She then asked Pirkle Jones if he would join her, taking half the retainer fee. Jones had been an assistant to Ansel Adams for several years. He and his wife, Ruth-Marion Baruch, had met Dorothea in the late forties, through Homer Page, who had taught them photography at the California School of Fine Arts. They began working together without any preconceived plan, or even any detailed discussion of how to approach it. The inclination of both was to shun fixed shooting scripts and time schedules. "Sometimes we might hear of some event," said Jones, "such as an auction to be held in the valley, and go up to see it. But with an open mind about it, observing closely, and photographing what we responded to."

They usually went up to the valley together, though sometimes she traveled with Paul Taylor. It was exhausting work, spread out over 1956 and 1957, and at the time Dorothea was in one of her poorer periods, scarcely able to eat anything, and looking so tiny and weak Jones wondered how she could go on with the job. She pushed herself beyond endurance. At Berryessa it could be 102 degrees in the shade and she might be running a high fever, but still she'd insist on going ahead. Only when she was at the point of collapse could she be forced to stop. They would drive to John and Helen Dixon's place in Winters, where she would rest for several hours. It was hard for her to sleep; Jones noticed she had to place herself in a half-sitting-up position.

Jones remembers that sometimes they photographed the same scene or subject, intending to use whatever shots would be best, regardless of who made them. They came in time to capture the last seasons of the last generation to enjoy the valley—the homes, the barns, the fields and vineyards, the gathering of the last crops, the rounding up of the cattle to be shipped out of the valley. And the slow-moving visible changes: packing, selling, auctioning off farm machinery, buildings, implements, gear, and the families melting away, leaving in attics the relics of an abandoned life, scattered portraits, school books, curtain rods. Now the demolition contractors were in the valley bringing about its orderly destruction. The site of the reservoir was cleared of trees and stumps, brush and fences, the wooden houses removed completely and all the adobe and concrete buildings leveled to the ground. Gravediggers came in to disinter bodies from their family plots and carry them, gravestones and all, up to new plots prepared on ground above the valley. Fires burned out the debris, and dust and smoke filled the air. Power lines came down, leaving the valley black at night.

She listened to the voices, too. The construction worker overheard in a roadside hamburger stand: "Damnit, it's getting so a person can't stand still in one of these here fields without you get mowed down, raked up, or painted." And watching a huge tractor at its devastating work: "It's kind of sickening what one of those big cats can do." And then, when it was all over, someone saying: "Everyone said they'd never flood it. Even when they talked about it, we never believed they'd flood it." And one voice, trying to see the change from every side: "The valley and this land was good to us, but the water over it will be good for the *majority* of the people. We *have* to think that way . . ."

Nothing was left of the Berryessa Valley when they took their last photograph. It was desolate. *Life* was to see the results of Dorothea and Pirkle's work at this point. They made proof prints of a great number of shots and sent them thoroughly captioned to New York. The editors prepared layouts on their story and were ready to print when a flood occurred in Texas and swept their piece out of the issue. *Life* sent back the material and gave up all rights to it. They put the prints away for a few years. In 1959 they decided to prepare an exhibit, "Death of a Valley," for the San Francisco Museum of Art. They chose about thirty prints from the great number of images they had made, designed the show, and even hung it themselves. At the same time Minor White, the editor of *Aperture*, gave an entire issue to "Death of a Valley." It contained no individual photo credits because they had pooled their work and wanted it to appear as a joint effort.

Minor White's editorial introducing the 40-page photo-essay described it as a "simple, straightforward understatement—purposely an understatement. Under the swelling pressure of a skyrocketing birth rate, places for

people to live and water for crops and factories has become critical. Perhaps understatement is the better way to show that bulldozers are only slightly slower than atomic bombs; or that the nature of destruction is not altered by calling it the price of progress. To witness population inflation of such proportions that ways of life are uprooted, fruiting trees sawed down, productive land inundated, and bodies already buried forced out of the ground is to realize that as life teems so does death. And that man is the active agent of both."

Dorothea and Pirkle Jones anticipated by many years the public concern with ecology. Their essay on the death of the valley was one of the earliest attempts to photograph the cost of "progress." Dorothea's sensitivity to historic change and her will to act upon it by recording and interpreting the transformation of Berryessa set an early standard in a new field for the concerned photographer.

18 AS A PHOTOGRAPHER WHO HAD DEVELOPED A considerable degree of self-consciousness about her work, Dorothea Lange began in the 1950's to teach what she had learned. Like any art, photography needs informed criticism. Yet at the time she ventured into teaching, the trained eye had paid little attention to photographs. Although she never set herself up as a critic, Dorothea's responses to images made by others were highly valued by curators and art historians, as well as by the most accomplished photographers. Even in this last decade of her life, when the suffering from her illness grew worse, "she chose," said her friend the photographer John Collier, Jr., "to meditate not upon death but upon photography. What she shared with others was not her pain but thoughts about their work and her own. She would look at her pictures, some of them made twenty years before, and provide an analysis of them that introduced a new way of working with images. Here was the ultimate reading you can give an image. She showed how out of your own personality you can read your images and arrive at an authentic understanding of what you have done, where you are, and what you can do with yourself. I think she offered something unique among the great photographers. It is not found in Ansel Adams. There was something of it in Edward Weston. But never on the psychological level Dorothea reached."

Although her teaching experience was brief—she was too sick to go on long with it—her students remember how she taught them to work with their own images, harder and harder, to command honesty in photographic vision and voice. She conducted two seminars at the California School of Fine Arts (now the San Francisco Art Institute), one in the spring of 1957 and the other a year later. In both she described the seminar's purpose as "to evoke from each student a completely personal (symbolical or realistic) interpretation of the theme 'Where Do I Live?' " By this is meant an attempt by the student to photograph "the most meaningful and

personal place of his total environment." The assignment each week would be the same: to produce a photograph of one's personal environment that would have no person in it. Toward the end of the sessions each student was to present a folder showing a sequence the images made to answer that question, "Where Do I Live?" It seemed a very strange assignment to many. She explained that photographers usually direct the camera away from themselves. She hoped they would learn to use the camera to express the inward self. She suggested peopleless images that might hold special meaning: an unmade bed, dishes in the sink, a flight of stairs, a doorway looking in, or one looking out. Photographs all too often show what things look like but not what those things mean to the observer.

The example of the unmade bed had a curious outcome. One of the students complained to Imogen Cunningham that Dorothea's only assignment was to make a meaningful photograph of your environment without people, and mentioned the unmade bed. Remembering it one morning as she looked at her rumpled sheets, Cunningham arranged some hairpins on them and made a photograph, sending a contact print to Dorothea. Made as a joke, the image became one of Cunningham's most popular photographs.

There were perhaps a handful of American schools at that time that taught photography not oriented solely to the technical aspects. To Dorothea what came first was the image, not the means of taking or printing it. That would come later. Jerry Burchard, a student in the first seminar, said, "She was uncanny at looking at a photo of yours and telling you all about yourself from it. Even to what happened to you the day you made it. She gave no prepared lecture. She would stand before us, a little woman usually dressed in white, wearing a piece of distinctive jewelry. Her manner was quiet. She'd think for a minute, head down, then look up and start in. She paused often, aware of what a pause can mean. Every statement seemed a commitment. 'The good photograph,' she kept repeating, 'is not the object. The consequences of that photograph are the object. And I'm not speaking of social consequences. I mean the kind of thing where people will not say to you, how did you do it, or where did you get this, but *that such things could be!'* "

The first few weeks students kept telling one another they could never do what she asked. "At the end," said Burchard, "we found we could, much to our amazement." Still, she was never satisfied. No one ever raised his image high enough to please her. 'You need to get *more* into it,' she would say. 'I know perfectly well we can all do much more than we think we can. We don't go to our own limits.' " She was constantly suggesting ways to stretch the mind, to shake up preconceptions, to widen the grasp. In the notes kept by one of her students, Nancy Watkins Katz, there are snatches of what Dorothea said: "In these pictures without people, only the heart should be present, and yet invisible—a presence felt, not seen.

We ought to know beyond a doubt that the things we look at in these pictures are the most important things in the world, that to the photographer this desk, this garden, is home. And by the time we have looked at all these pictures, we ought to feel that our own homes, our own hearts—by the view we have been given of the hearts of others—are not what they were when we began to look."

She read them a sentence from William Faulkner's Nobel Prize address: "An artist in any medium is one who has tried to carve, no matter how crudely, on the wall of final oblivion, in the tongue of the human spirit, the message, 'Kilroy was here.' " And from Francis Bacon, the lines she had put up on her own door: "The contemplation of things as they are, without substitution or imposture, without error or confusion, is in itself a nobler thing than a whole harvest of invention." And finally, from Robert Henri: "When the artist is alive in any person, whatever his kind of work may be, he becomes an inventive, searching, daring, self-expressing creature. He becomes interesting to other people. He disturbs, upsets, enlightens, and he opens ways for a better understanding. Where those who are not artists are trying to close the book, he opens it, shows that there are still more pages possible. The world would stagnate without him, and the world is beautiful with him."

The interaction between life and art was her most constant theme. To explore, record, reveal—those were functions she asked her students to think about. But also to persuade, for she saw that as one of the photographer's roles. "Bring the viewer to your side," she said, "include him in your thought. He is not a bystander. You have the power to increase his perceptions and conceptions."

She ended one seminar on this note: "I hope I have said only enough to indicate that this profession of ours is a dreadfully serious one. It is a profession in which, thank God, we cannot escape reality." The last meeting of the 1957 seminar took place at her home, where the students showed the prints they had made and Dorothea put up some of her own photographs. One of them was of her right foot, held in the air, naked, damaged, unattractive. "I hate that foot!" she said. Startled, one photographer asked why. "Because I got polio as a child," she replied, "and that's the result of it." "But how can you say you hate it? It's part of your own body." "I hate it," she said.

In or out of class, with students or with others, she prodded people to do more and better. She chided one friend, a freelance photographer, for going places without his camera. "There is so much to see, to record, to capture, which might never be there again. How can you walk around without taking pictures? What kind of photographer are you?" Yes, said the friend, he knew many photographers always had their cameras with them, waiting for a certain kind of light. "Not that," she said—"What if you see a *face!*" He remembers too how she frowned on commercial suc-

cess. "If you earned a significant amount of money then de facto you were not as wonderful as someone struggling outside the pale of commerce. She had a gift for making people feel uneasy when they did not toe her line."

Her relationship with young photographers was felt by some of them as mother to her children. "What she had to give us," said one of her protégés, "was glued to you with that motherly concern. The result was an upsetting ambivalence. You could both love and hate her at the same time." Those who came to know her in these later years found her ready to help them, but in her own special way. She was generous with encouragement. She did not think of newcomers as rivals to be pushed out of her path. Ruth-Marion Baruch, whose photographs Dorothea admired, was a sporadic photographer who had difficulty in working persistently. There were long gaps when nothing happened. Determined to get her back to work again, Dorothea introduced her to a new development in cameras, got her excited about its possibilities, and led her back to work again. When Baruch had built an essay on the theme of "Illusions of Shoppers," taking it as far as she could, she brought the proofs to Dorothea, who looked through them, put them down, and said, "I consider that subject photographed!" It gave her a good feeling about her work, Baruch said. But there were other times when Dorothea could be cruel, too. While Baruch's husband, Pirkle Jones, was working with Dorothea on the text for "Death of a Valley," Baruch made some suggestions, and was told bluntly by Dorothea not to mix into something she knew nothing about, implying she had no business trying to be a writer. It hurt, but the friendship endured. Jones once took his prints to Dorothea when he had trouble resolving a problem in a photo-essay. She flipped through the prints rapidly and then, without telling him what to think, asked just the right questions to help him figure out what was wrong and how to remedy it.

Not long after Shirley Burden met Dorothea, he did a personal essay on Ellis Island, the receiving station for immigrants in New York harbor, long abandoned. Preparing the work for exhibition at the Museum of the City of New York, Burden showed his prints and captions to Dorothea. She liked it, but thought it needed people; there had been no one on the island except for two caretakers. She suggested something to indicate loneliness and abandonment, and brought down her photograph of a woman leaning on the rail of a boat, looking out into space. He took a print from her to use in the show. She cropped it for the purpose, taking out figures in the background, leaving the woman all alone, to emphasize the isolation.

There is a reverse side to this instance of a photograph of hers appearing in someone else's show. Dan Dixon, working in San Francisco as a freelance writer, took an assignment from *Pageant* magazine to do a picture-text story with his mother on the city's cable cars. When the piece appeared in the March 1957 issue, it ran ten pages and contained thirteen photographs. But though they were all attributed to Dorothea Lange, one

was not hers but Dan Dixon's. She had never taught her sons photography, but at one moment, for whatever reason, she set her camera for the right exposure and handed it to Dan. Standing at the back of a cable car, he pointed the camera at a passenger getting off. The car itself, except for a step and a hand grip, was out of the frame, and what the picture shows is the back of a man, from the shoulders down, stepping to the street, one foot on the step, the other in mid-air. It appeared in the magazine without a caption, and is plainly what it is. But later, detached from that story and mistakenly titled "Man Stepping off Curb," it was used in Dorothea's retrospective show at the Museum of Modern Art. Her son was much amused by this accident which turned out to be art.

Just as she began her second seminar early in 1958, she heard from the Newhalls that they were at work on a book to be called *Masters of Photography*. The idea had occurred to them back in 1942; now, with a contract from Braziller, they were pressing a select list of photographers to provide prints, and statements interpreting their work, within one month. It was encouraging to hear of their plans, Dorothea replied, and to be given a place in the book, but "to produce out of the body of my photographs a group which will represent my photographic beliefs, to document and caption them decently, in order to explain my photographic existence, is a formidable order. I am so slow in these things. So slow, and there are many demands (or requirements) on my daily life . . . You know that writing is almost impossible for me . . . writing of any kind, even a letter. This has caused me no end of difficulties, my life long." If only Nancy were with her, or some other friend to talk it over with, and draw the words out of her. But she promised to do her best.

When the Newhalls thought they would include the work of the best younger photographers and asked for nominations, Dorothea offered several—Pirkle Jones, Ruth-Marion Baruch, Philip Greene, Homer Page, John Collier, Jr., William Maund, Cornell Capa. Among the younger people, she said, "I constantly meet talent and cleverness, occasionally originality, and rarely that extra dimension that has to do with *depth* of seeing. Photographs seem to have a life-span. By this I mean that only a few survive, and go on functioning as images, in their own right, and on their own." The Newhalls quickly decided to omit the younger photographers; it was better to do those whose life work is "incontrovertible"—those dead or over fifty—and to do them "magnificently."

As for choices of her own work, Dorothea suggested they look at the list of twenty-six photographs she had sent Beaumont in May 1957, in response to a request, for possible purchase by the George Eastman House. "This is a list of photographs of mine which have been time-tested and in which I have confidence. You will notice that most of these photographs are in pairs (13 groups of two each). I believe that these pairs amplify and extend the meanings of the photographs."

Twenty Lange photographs were tentatively scheduled, among them "White Angel Bread Line" and "Migrant Mother," which the Newhalls considered "two of the greatest and most moving photographs yet made." But when the book was published, the number had been reduced to nine, and Dorothea's painfully prepared statement did not appear in the book. Instead, each photographer was given a biographical page which sometimes included a few quotations. The work of nineteen photographers was represented, eleven of them classical figures of the past. Dorothea was the only woman chosen to be among the eight contemporaries, who included Steichen, Strand, Weston, Salomon, Evans, Cartier-Bresson, and Adams. She had wanted to document each picture "as fully as my ability and my memory will stretch . . . I greatly believe in this reinforcement of photographs and will try to make my contribution to your book demonstrate this." But the information supplied was omitted. Seven of the photographs selected by the Newhalls from Dorothea's list were made in the 1930's. The two others, dated 1955 and made in Oakland, were "The Defendant," which came from the public-defender essay, and "Last Ditch."

In her early sixties now, and working as much as her health permitted, Dorothea seemed to find more time for her and Paul's children and grandchildren. There were five grandchildren already, and in the next years there would be six more. With the youngest of Paul's children, Margot Taylor, who married a Slavic scholar, Donald Fanger, in 1955, she maintained a fairly steady correspondence as their family moved wherever his professorships took him. Postcards, notes, and letters flowed out to them from Berkeley, always voicing affection and bridging the distance with family news: the birth of another grandchild, the celebration of anniversaries and holidays, the title of a book or movie just enjoyed, treasured lines from a Lorca poem, recipes, reports of nursery-school adventures, changes made in the garden's design, bouts of illness, a request for copies of the Ben Shahn lectures at Harvard, gloomy accounts of winter rains. She got brass hooks to hang her cameras on "in places quick and easy to reach and right out in plain sight, one in the kitchen and one in the living room." She joked about Paul's devotion to his cause: "No crisis, no new troubles, all the old ones, however, in full blast. By that I mean 160 acres and the academic mind."

Her first teaching seminar in photography may have taken much out of her, for at the end of the summer of 1957 she apologized for writing Margot no letters lately. "It is because I have been in one of my dumb periods and in temporary retreat. I don't know what I have done this summer besides watering the garden."

The weekends, beginning in 1955, when Dorothea and Paul acquired a cabin on the Pacific coast, and lasting ten years until her death, became the core of family life. The cabin was one of about twenty put up at Stinson

Beach by the man who gave Muir Woods to the state. He rented them out, and when the state took over the land, it continued the policy. At first Paul and Dorothea shared it with another family on alternate weekends. Then they kept it for themselves. It was a simple wooden structure, board and batten, with slanted roof, divided into two small rooms, one the living room with kitchen, the other the bedroom. The children slept in the bedroom, on cots or in sleeping bags, and Dorothea and Paul on a bed in a nook of the living room. Mornings they often took the grandchildren into bed with them. They used it weekends all the year round. "It became our special place to be together," said Dorothea, "and be with the children, and then we found that another element was creeping into it which we caught in the children—that is, they thought of it as a place where they were free." The three generations shared it and loved it, but Dorothea perhaps most of all, because she believed it was knitting together a family which had known great troubles. Spending a day at the Steep Ravine cabin, a friend watched Dorothea gathering driftwood on the beach with one of her grandchildren. "I thought how she was giving this child the time and attention her own boys did not get from her. When she was starting out as a photographer, she was so intense about her work she could not give the children what they needed. If she had been a man, no one would have thought twice about it. It's taken for granted that a man has to go off and do his work. Dorothea knew that, of course. Still, I think she felt guilty about what she had done—or not done—and was atoning for it with the next generation."

The custom was to go off on a weekend, taking two of the grandchildren along, usually pairing them by closeness of age. They would leave town Friday afternoon in the tan Volkswagen bug, bound for the rustic cabin, which had no electricity, no phone, no hot water. Under kerosene lamps they started the wood-burning stove and built a fire in the corner fireplace, while Dorothea began the two-hour preparation of the meal. Paul took over the outside chores, with the children helping to gather the firewood and assisting Dorothea in the kitchen. They went to the cabin more often in the winter months, though the sky was often overcast and the air cold and blustery. Even in summer it was hard to swim at the beach because of the water's coldness and the treacherous undertow and tides. Only Paul would do it. The others sometimes went to another part of the shore where there was better swimming from a patch of land Paul owned. Indoors, they played games, Parcheesi especially, or Dorothea read to them, often from a geometry book. Though they were all too young to be studying mathematics at school, they remember enjoying her explanations of mathematical ideas. Or Paul would read stories to them, some of them taken from Maynard Dixon's illustrated book of American Indian tales. There was music, too. Dee Taylor played her flute and Greg Dixon his clarinet.

It was on these excursions to the beach that Dorothea taught them how to see in a way they hadn't learned to before. What she chose to look at and what she said about it affected them all. When a child would return from the shore with pebbles, she would look at them, wait for a certain light, then take a photograph of the hand with the pebbles. It made the children interested in how different hands look and how they move and how the changing light affects that look.

Dorothea always had her camera along. She never talked about photography with the children or showed them how to use a camera. It seemed a natural part of her. To the grandchildren it was as integral to her personality as her limp. They never knew her to be without either. Sometimes, when they and Dorothea went for long walks or climbed hills, she would need to rest that leg. But she did not make anything of the handicap. She would simply say, "Just let me catch my breath."

Nor did she conceal from the children her sickness. They knew she couldn't take many foods because of some trouble with her esophagus. She did not pretend nothing was wrong. At night in the cabin they could sometimes hear her labored breathing, or her voice saying quietly, "Oh dear! Oh dear!" and they knew the pain was strong. To the children it did not seem morbid or depressing because she took her illness so matter-of-factly.

As children—the oldest was only fourteen when she died—there was never any question in their minds that Grandma was no one to argue with. Her requests were usually reasonable, but there was an intense insistence in her tone. Much as she tried—and often succeeded—to win their love, she managed at the same time to instill fear. One grandchild remembers a nightmare at the age of about seven in which he is going to Dorothea's house and on the path to the door he is terrified by her sudden apparition in the dark. The same child's father, a musician, experienced his nightmare of Dorothea, too. One night he dreamed he was playing in an orchestra, feeling an anguish that was unaccountable until he realized the conductor was Dorothea.

Over the years Dorothea took a great many photographs at Steep Ravine. One Christmas she made a selection from the negatives and printed up eighty pictures, which she positioned in albums as gifts for each part of the family. Earlier she had shown the prints to the grandchildren and asked them what they thought or felt about them. Their comments, keyed to the photographs, were placed in front. In the Christmas message accompanying the albums she wrote:

"These are pictures about our cabin," says Paulie, and that is exactly right. They are to a cabin, and a life surrounding a cabin—a life independent of "things." There are shells, pebbles, Keds, lost socks and wet pants. Sands, tides, fire and smoke, sun and stars there.* Also fog and wind and weather. I hope to

really photograph this but in the meantime the snapshots are a beginning, and will show you that to watch the natural growth of the children there, and to see them so happy and so free there—is the joy of
Grandma Dorrie
* Grandpa Paul's comment—"You left the moon out."

Still trying for a story in *Look*, she brought two albums of the cabin photographs to George Leonard. He had been a guest at Steep Ravine, and liked how the pictures caught the weekend life there. He sent them on to New York, hoping they would be used. But they were not. Six months after her death, *Look* published a three-page tribute to "Dorothea Lange: Friend of Vision." It included six of her photographs, one of them taken on the beach below the cabin.

Like their mothers, the granddaughters believe they learned much from Dorothea. It was not that she tried consciously to shape them. She had a strong effect simply by being there. One said it was something sensuous she imparted—through the way she dressed and the scent of sandalwood which clung to her clothes, the way she gardened, the way she designed her rooms, the way she cooked and presented her meals, the things she chose to look at, to pay attention to.

The Euclid house they loved—the wood and glass, the high-ceilinged openness, the occasional shoot of ivy pushing through a crack in the cedar wall, the secret room to play hide-and-seek in, the great creaky flights of stairs, the piles of Pakistani caps to try on, an intricate set of electric trains (masterminded by Ron Partridge), and always, Parcheesi, which Dorothea played with a legendary pugnacity that did not stop at cheating to win. Afternoons the younger grandchildren napped in her bedroom. The sun would slant through the deck doors across the bed and honeysuckle floated in on the breeze. Down below in the garden they would enjoy lunch or tea, munching on freshly picked artichokes and pretending horror at the green flicker of a garter snake. Sometimes they put up and played in a Bedouin tent she and Paul had brought home from Egypt.

She encouraged friendships between her grandchildren, so that they all grew up feeling close to one another, like surrogate brothers and sisters. Once she told a five-year-old grandson that a granddaughter he especially favored wouldn't be able to come to his birthday party—and then presented the little girl to him in a large gift-wrapped box. Was the time and care she gave them an attempt to make up for the bad years with her children and Paul's? If she had not fallen sick in 1945—a half dozen years before the first of the many grandchildren was born—and been forced to stay close to home, would she have been different?

"But," said one grandchild, "you could always count on some things being a certain way with her. Holiday celebrations most of all. They were full of magic for me." The holidays are remembered by everyone who

shared in Dorothea's celebrations. She would stop her own work before Thanksgiving and not take it up again until after the Christmas season. It was always a period set aside for family ritual. In a letter to Margot on December 15, 1957, she wrote: "Every year, starting about mid-December, I used to write a daily line to my mother, so that she would feel with us and by us. And so, if you suddenly get a deluge of postcards about nothing at all, it will be because, at this time of year, I like to feel with you and tie 1163 Euclid and 21 Ellery into a Christmas knot. Yesterday Helen and John, Andrew, Gregor and I went Christmas shopping in S.F. Wow!"

Great care went into planning and carrying out every detail, so that the tradition she cherished would endure. The immediate family was always there, of course; then the circle widened to include close friends, visitors from abroad whom she wanted to introduce to this custom, and finally friends of friends stranded in town with no place to celebrate the holidays. Sometimes as many as thirty-five sat down to table. She gave thought to a special present for each guest, wrapping each one differently. And not forgetting the distant ones. It upset her badly this Christmas of 1957 that the one thing she had in mind for Don Fanger—"for *you* especially, not as an adjunct to Margot"—did not get into the mail on time. "This saddens me," she wrote him, "but it will come later." Then disaster: "Paul has *wrecked, wrecked,* all my Christmas plans because he went on an *independent* shopping tour, and took care of *everyone,* in no time at all, feeling then very virtuous but everything is a little bit wrong. I am desperate."

Still, even with Paul's error, she was this Christmas as always "the Napoleon of the holidays," as Dan Dixon put it. Again she was in full command, and the meal was once more superb. At its end, the room lit only by candles burning on tree, she served the festive coffee bowl with brandy and orange peel, and looked calm and very beautiful to all the guests. For many years Paul played Santa in costume, jingling his bells outside the house, the children going wild with excitement, then coming in with a great bag full of gifts. Soon after this New Year's Day, Dorothea wrote Margot and Don a note that signifies what the celebration meant to her: "Just as you told us to do with the two red candles we did, and just what you knew they would carry with them and bring forth, they did. The record, and the playing of the record, was for me, the first half-hour of Christmas, 1957. Mid-afternoon, Helen lying on the floor, Paul on the couch, children asleep, John and I listening to every sound and syllable. By that time all the big doings were over. The house was back to order, nearly. Our big party had quiet reverberations. It was big and noisy and beautiful and we celebrated life and meant it. Everyone, and this year it was true. But for the record and the half-hour I send you extra love and thanks . . ."

Guests at the celebration felt it was a storybook Christmas, the mood of the holiday caught and held. A close friend of the family thought

Dorothea felt so strongly about tradition because her father had left his family and this was her way of ensuring that family ties would not be broken. To Dan Dixon, his mother seemed to pursue the holiday ritual—burning candles, the ancient cracked record of Schumann-Heink in "Stille Nacht"—with the same ruthless passion with which she pursued her work. It was not normal, he thought. But as each year passed, her health going and death nearing, she became even more tenacious of traditions that bind family.

19 EARLY IN 1958 THE CHANCE TO TRAVEL AND work in Asia was offered Dorothea by Paul Taylor. For some years now he had been a consulting economist for government agencies and private foundations providing technical aid to developing nations. Without Dorothea he had gone to Haiti briefly in 1952 and to Asia for three months in 1955. His interest lay in community development, which to him meant the involvement of the people themselves in the solution of the problems of health, sanitation, overpopulation, land tenure, and government. From his long study of rural life at home, where efficiency of crop production had not assured a stable, balanced society, he had developed a deep interest in how to make more equitable and enjoyable the life of rural peoples anywhere. Wherever he went, he saw land and technology in the hands of a few and society polarized. Unlike many agricultural specialists, he was less concerned with techniques of effective production than with fair distribution of the benefits from it. It was not that he questioned the need to spread abroad knowledge of better agricultural production; rather that he thought it a grave mistake to let production technology loom so much larger than the way to teach people to help themselves, which required an effort to understand their culture and their needs.

This time, on a schedule that would keep him traveling in Asia for at least six months, he wanted Dorothea to go along with him. The prospect did not excite her, although she had been outside the United States only once. (It was forty years since the robbery in San Francisco had cut short the plan to work her way around the world with a camera.) To leave home now meant giving up what she had grown strongly attached to. Another grandchild—John's and Helen's—was expected in the spring. John had decided to quit his federal job in Winters and look for something altogether different. With Helen carrying their third child, they would need a place to stay while John tried to sell their house and find work. Dorothea and

Paul offered them the use of the studio for the time of transition. They had windows cut into the darkroom and a kitchen made out of it. John's family came in February, and in a few months he succeeded in selling the Winters house and finding work with a contractor who built homes and remodeled kitchens. Though they had looked upon Dorothea's studio as only a temporary haven, it was so beautiful and convenient, with a bus stop across the street and a park close by, that John decided to stay on and remodel the place into a home.

It turned out to be a mistake—in view of all the past difficulties with his mother—to place himself next door again. She could not prevent herself from exerting her old dominance. She seemed to know what everyone around her was doing or thinking, and to find ways to influence their decisions, even with her sons in their thirties now. Naturally they resisted her. Although her powerful will made her magnificent, it could make her destructive, too. Her insistence upon shaping people to her pattern was attributed by some to her polio: it was her way of compensating for a physical handicap. Dorothea herself, however, often told stories of how "Teutonic," how demanding her grandmother was. It did not seem to occur to her that this was one of her own characteristics. It began with her need to categorize people immediately upon meeting them. She took their measure at a glance, decided what their capacities and possibilities were, and then treated them that way rigidly. It was hard to escape from her stereotypes. Women felt she treated them as inferior to men. And the more attractive the woman, the more likely Dorothea was to put her down.

Throughout that winter and spring, absorbed in the immediate necessities, she put off consideration of the trip to Asia. Her second photography seminar at the School of Fine Arts began in February, Steichen paid her a visit, and Ross and Onnie Taylor announced they too were expecting a baby (their third) and would be looking for a new place to live. Paul and Dorothea helped them finance a new home, paying at the same time to remodel the studio for John and Helen and to put a new lab for Dorothea into the house. Though it was a burden, she felt good about it, "because we have the pleasure of helping." Bad weather dampened her spirits: "It rains, rains, rains, the garden is a mud puddle, and while I work all day, every day that I can, I seem to spend my life doing very necessary errands. Yours, in wrath, D." Then, in a sudden change of mood, the frustrated photographer switches to delighted grandmother: "Gregor will be 6 years old on Monday! No teeth in front. Dee in the 1st grade. Leslie can tell wonderful fairy stories, with all shades of expression over the telephone even—Andrew can *sing* and Paulie just smiles and smiles."

Her notes, often on postcards, flew out to Margot almost weekly, binding the family together. She kept a close eye on weather and its effect upon her garden, the garden everyone has had a share in nurturing. In the

midst of wild storms and high winds, with the creek a roaring torrent, she observes that the fruit trees are blooming but that "Miss Nettie O'Melveny [a favorite variety of jonquil whose delicacy on first appearance made both Dorothea and Margot ecstatic] is late. She is retiring until it is all over." A card crammed with family gossip is headed "Goings-on, Goings-on, Goings-on." When John's family arrives from Winters, Dan Dixon and Martin Lange are recruited to move them into the studio. "They worked with a will," Dorothea reports, "but each one groans to me in private about the other's vagaries. I tried to keep them agreeable by noodle soup." Paul, on this occasion, is "in full retreat—to the University."

With John's family settled in, she could think of Asia again, though still with no delight. When Paul announced the trip would start on June 1, she remarked that "a quiet summer at home would suit me too—poking around in familiar places, watching the garden and the children grow." She was tired—tired not in the usual passing way but with a sense of deep depletion which had afflicted her for a great many years. As far back as 1941, when she had started photography on the Guggenheim, she had remarked that she was not working well because "I am truly exhausted." Once, when Nancy Newhall told her how relieved she was that a large task had finally been completed, Dorothea wrote her: "That you should now have real rest is part of what you have done. Women need this, especially, I feel, after great effort." In April she writes on a file card: "My limitations are obvious. I am about to go to Asia (with Paul) and the complaint is identical except that I do not so easily deceive myself." She worked as much as she could, "doing the thing that I can best do—for long stretches and (for me) long hours. I don't have much to actually *show* for what I have been doing, but I do know that there is progress in directions which make me satisfied and sometimes feel very *good.*"

She couldn't believe they were really going, because Paul did nothing about shots, plans, routes, bookings, putting their house up for rent, getting background material on Asia. It soon became clear Paul would be expected to do a mountain of work in Asia. "So if we go," she wrote, "the harness goes with us. That is, using what we already know rather than learning about what we don't. In short, where is our Free Time?" Meanwhile, she was making many prints, some for the Newhalls' book and eighteen more requested by the Museum of Modern Art for its permanent collection ("This makes me feel very, very good"). The work went slowly in spite of many hours put into it; she feared she would be "hoisted on a plane on June 1 without having had my camera loaded, and not knowing where I'm going (or why) with a copy of The New Yorker under my arm, and tears at leaving home. While Paul writes a memo, at the last minute, on 160 acres." His devotion to his issue could amuse or irritate her, depending upon the circumstances. One thinks of the British abolitionist Buxton's wife, who came to wish all blacks were at the bottom of the sea,

or of Carlyle's wife, Jane, who after suffering through years of his constant work on a biography of Cromwell wished that the Lord Protector had never been born. As departure neared, forced to take over many of the details of arrangements, she complained that "my Liege is entirely absorbed in water and power, and it would happen that the issue *now* becomes lively again. NOW. This is Dorothea speaking, in one of her swivets, well-known, even to herself." Paul was preparing testimony which he gave that spring in Washington before the Senate Subcommittee on Immigration and Reclamation. When June 1 came and went without visas or passports, Dorothea speculated they might be victims of security regulations. For weeks, every time the phone rang, she jumped to it, thinking that this might be the call which would end the uncertainty.

Taking the difficulties of travel in Asia into account, she asked her doctor if she should go. "What's the difference," he said, "whether you die here or there?" So when the signal finally came from Washington late in June, she went. They had barely started when the trip almost ended for her. Flying from Honolulu to Wake Island, she became so sick, lying in her berth, that she feared the end was coming; she could not go on. But the next day, as they flew from Wake to Tokyo, she managed somehow to pull herself together. Paul did not learn till much later how sick she had been. It must have taken a tremendous effort of will to keep going for the next seven months. Afterward she would say to him, "You dragged me around the world." But then again, she would announce proudly to anyone in sight: "I am a woman who has been around the world." It may well be that the excitement generated by this trip and others to come were what helped keep her going. She tried to protect her husband from her illness. Her physical distress, prolonged over so many years, was not thrust upon him. Whatever she was going through inside, he said, "she did not allow to dampen her spirits. It was a treat to see her, to be with her always."

As both saw it, their interests dovetailed beautifully on the trip. She wrote in her notebook: "Paul and I are very happy together. My struggles with innards continue and there are some bad moments. Or rather half-hours. But Paul and I survive it, and we are happy in the same room together, in Saigon, in Berkeley, même chose." He thought neither ever wished to be doing something else, although sometimes she was irked by the long hours he gave to writing reports; she wanted more free time to roam around. On the other hand, she put in so much time shopping she began to register disgust with herself in her notebook: "To this you sacrifice your photography, Dorothea? Is your photography just something you like to talk about? . . ."

Further down the page she writes, as though it were free verse:

tired, dirty, fed up with Asia
fed up with its scrounging millions

fed up with its dirt and stink
fed up with its crowds and sweat
fed up with not knowing where you are
fed up with its dirty food and bad water and spitting and those pitiful little
 backs and wiry legs and black eyes and general soil glad to retreat, to this
 hotel

She sees her response as a fault in herself:

I am seriously handicapped by my revulsions to lack of sanitary standards. In
this I am weak. I cannot take it, and my bad digestive system does not help.
Paul, and others, have more stamina—(or maybe they don't see so much . . .)
How could they eat in that filthy hole last night? How will I forget that kitchen
thru which we passed on our way to the stairs which went up. That floor had
never been cleaned. And cats, and babies, and those stairs. The smell of the
grease for the shrimp . . .

Perhaps accounting for this outburst, she later notes that her stomach
pains are relieved at last, after five days of travel cramped in a jeep
pounding the roads. And that very night, as if in answer to an earnest
prayer, they are invited to dinner with the head of the American mission.
She is plunged into a different world, a world that at home she has always
tried to create around herself:

A beautiful dinner party, with *real style*, harmonious and perfect. The Am-
bassador was the lowest brow. The women were gentle and beautiful. The men
were interesting and in fine mood. Food, service, superb. 3 wines, seating plan,
swift and attentive servants. The Ambassador took the wrong napkin and
spilled his wine. Champagne in the tropics with doors open, like a pavilion.
Things on walls to look at, no junk anywhere near. Paul in his blue suit. Lan-
guage French. (Paul with his horrible accent, not minding a bit.) What a contrast
to the night before—and the restaurant, that hotel, that company. And yet, not
to have been there, would be to have missed the truth, the truths. Remember
how the phrases of the Chinese music, coming in the window, from the street,
so pure and reedy, helped to lift the spirit, in that dirty, cat-infested restaurant?

They stayed in Korea for nearly eight weeks. Despite the American
money being poured into the war-ravaged country, Dorothea was not op-
timistic about its future. The Koreans she found "sociable, merry and
rough," but Seoul's "filth" was a shock to her. There was a shortage of
everything, "but not of poor people. We live in what here is splendor, aus-
pices of U.S. government. I am having such an avalanche of experiences
and bombardments of impressions that I am quite lost." A little later:
"There are many things that Koreans (in their own country) are not *allowed*
to do, which is a situation I do not enjoy. We are very much the upper
class. We roll around their streets with our fine cars and drivers. We have
the best which Korea can afford, supplemented by the best that the U.S.

Army can import. The Korean way of life is very different." She had not felt much interest in Korea before the trip; she came ignorant and expected a dismal land. But after several weeks she was writing home that Korea was "peculiarly beautiful, and the Koreans unlike any other people. We have had a great experience."

She had made no plan for photography in Asia. She went along with Paul, always taking her cameras, shooting catch-as-catch-can. When his schedule confined him to meetings, as it did on their first stop, in Japan, she was reduced to photographing the people around the table. When they moved on to Korea, she went out into the city streets to see what she could find. On weekends Paul had a car and driver at his disposal and they rode into the country, stopping to explore the villages. In the city markets she learned what people made and what they had to live with. Change came much faster there. The rural people exemplified how life had been lived for a long, long time. She photographed everywhere she went in Asia, but without any theme in mind. When she had worked for the government agencies at home it had always been to a set task; abroad she shot whatever caught her eye.

Not without handicap, however. In Seoul: "I cannot go out into the streets unaccompanied. I am surrounded, my clothes examined, my hair stroked. I am a novelty, and the camera just tops it off. So am marooned." Often when she started to use her camera, crowds would gather round instantly and in such numbers she couldn't get a clear shot of anything. The people were friendly; no one wanted to prevent her photographing, but the effect was just as frustrating. Still, here and elsewhere she succeeded in getting many pictures she valued. Near Panmunjom she photographed a family of three generations planting onions. In Saigon, in the rain, a young man walking on his hands down the middle of the empty street, the people sheltering under veranda roofs paying him no attention; he was not displaying his skill for an audience, but simply doing what he wanted to do.

They spent nearly a month in Indonesia, most of it with Paul working on an economics project. But they managed to get five days in Bali, where, as Paul said, they glimpsed other worlds, living and dead. They lived in a prince's court, sleeping in a carved bed, the doorway to their bedroom in red and gold, and the interior doorway to their bath of beautifully carved stone. They saw dances, cockfights, temple festivals, the work of farmer-painters and woodcarvers. In contrast to the Koreans, the Balinese acted as though these strangers were invisible. Whether or not Dorothea was using her camera, the Balinese went about their business, ignoring her. If she stood in the middle of a crowd, the people simply flowed around her: she didn't seem to exist for them. (It was different only in places that served the tourist trade.) This made it easier for her to photograph. The picture of

a dancer's hand which would be used in the poster for her retrospective exhibit at the Museum of Modern Art in 1966 was taken on a Sunday morning when Dorothea and Paul were watching dancers rehearse. It was one of a large number of pictures she made, concentrating on legs, feet, hands. She did that so often that their twelve-year-old guide, who spoke English, asked if she had a special camera for photographing legs. It was without plan, only upon impulse, that she chose such details.

In Dokjakarta they saw great stone Hindu and Buddhist monuments, watched a dance at the sultan's palace, and attended the ceremonies of a family paying homage to its sultan ancestors, with incense and braziers and chanting and flowers; Dorothea, wearing a sarong, borne by men in a sedan chair up the mountainside to the tombs.

Even when the opportunity for a photo came, it was often snatched away from her. Driving with Paul and a government man through mountain country, she lamented not having a really adequate chance to photograph. "It's only grab-shooting. The distances are too great. Travel is fast. No chance to discover for yourself what you are in the midst of, and work it through. So there are moments when I chafe, and am unhappy. Twice, yesterday, I saw what could have been a great recording. *Twice,* and for different reasons, we couldn't stop. No one knows how I sit in that car, cameras on my lap, and seethe. One reason that I can't push it is that it is only by special dispensation that I am allowed to come, anyway. And so I must accept the terms."

But two months later her mood is different. She finds the vast subcontinent of India "truly marvelous. Enormous contrasts. Immense problems. Everything on great scale. The people become their land and the land becomes the people. I am one who has seen the Ganges River, the plains of central India, camel trains and countless smoky villages at suppertime and coming night. Swarming with people. Dusty and dry and wonderful color in the clothing, even in the rags that serve as clothing. Have seen the Taj Mahal by night, full moonlight." The rhapsody continues as she promises to tell the family of Chandigarh and the Red Fort and all the other wonders she has seen under the golden light and blue, blue sky. And never forgetting the family, she closes the circle by sending on to Margot in Cambridge a leaf Helen has just sent to her from the garden in Berkeley.

In Calcutta, where they stayed at a hotel in the newer city, Dorothea asked to see the slums. When she had gone to school on the Lower East Side of New York its people were jammed more densely into tenements than anywhere else in the world, including India and China. But here, by a temple where they were slaughtering lambs, she saw cripples crawling in the streets and around their car, and unable to stand the massed human misery more than a few moments, she fled without taking a picture. She questions herself constantly: "The tropics, and it may be Asia, cannot be

photographed on black-white film. I am confronted with doubts as to what I can grasp and record on this journey. The pageant is vast, the pageant is vast, and I clutch at tiny details, inadequate."

While in Asia they were cabled the news that a boy, Seth, had been born to Onnie and Ross Taylor. Delighted to hear of the start of a new life, Dorothea reflected how important family seemed to be to Asians. "Is this something we could learn from them? Would this strengthen and deepen American life?" And a few days later, told there was a letter from her son Dan, she noted that this makes it "a *good* day, for I find that I am still anxious, *very anxious*, that all should go well with this family. I think of it. Too often? Do I hold my breath that all should be well with Dan, Mia and Leslie? I love Dan, Mia and Leslie with all in me and should I not fear? What do I fear? My mother was a woman of much fear. Remember?" This confided to herself. But sometimes, in the many letters directed to each member of the family, down to the youngest grandchild, telling what she and Paul were seeing and doing, she let slip her anxiety whether this one could handle all he had to meet or that one were not being overburdened with her duties. "Thinking back to home and those we love, while living in an alien culture, one seems to see *clearer*. Less clutter of immediacy."

This Christmas, for the first time, would be celebrated far away from home. But well in advance she began to prepare for the customary shower of gifts, packing and shipping off baskets, lanterns, gongs, masks, jewelry, dresses, belts, hats, bowls, plates, jars, sarongs, embroidery, paintings, posters, books, brooms, blankets, seashells, drums, statues—"a *thousand* things for everyone . . . our loot" from the bazaars of Asia. November and most of December they traveled in India and West Pakistan. Almost out of Asia now, after five months of travel, she suffered a last twinge of conscience: "I wish I were a photographer. All day closed my eyes, and even so, saw things, especially the prostrate boy, lying in the street, feet up in the sun, way up, as he slept. Beautiful, sensitive, dirty feet. Asia. And the dark people, in the gleaming light, move about in the world, at a different pace and rhythm, and the photographer is too busy to observe and record. Why come? Why come?"

On Christmas Day they were in the air, flying to Kabul and from there to Tashkent and to Moscow. "We move on and move on, too often, too fast." But "no complaint intended. The trip has been tremendous for us both." On their short stay in Moscow they braved the terrible cold to make the rounds of theater and ballet and to inspect the university and the libraries. Down with a fever, Dorothea spent two days in bed. Lying quiet and warm, staring at the white lace curtains, memories flooded in of Bloomfield Street in Hoboken, of the Vottelers and Aunt Caroline, of Grossmutter and her stove and her mirror. "The thoughts of family, the deeper ties, deep like the realities of the Russian winter."

They flew to East Berlin, where Dorothea lost her notebook at the air-

port but had it returned the next day in West Berlin. On Sunday they went to hear a Bach cantata and Handel's *Te Deum*. As they left the city Dorothea wrote: "They were *good* Germans who sang the cantatas last night in the concert hall, and they sang and played beautifully, music which they loved. Was it 6,000,000 Jews they exterminated? I'm glad to leave Berlin . . ." They were going down to Stuttgart, to pick up at the auto plant a new Volkswagen they had arranged in Berkeley to buy. It was Dorothea's first sight of the town her grandparents had come from. Still not over her Moscow fever, she lay in bed, writing down what this place summoned up in her, addressing herself in the third person, mixing in snatches of German:

> Gruss Gott . . . Fux du hast die ganz geshaften . . . The past, partly because she is old and enfeebled, partly because she is visiting the home of her ancestors, partly because she is ill with cold and fever, and lies under a whole feather bed in this old European town—the past fills to overflowing the mind of the pale world-traveller. The people, so nearly forgotten (who else thinks of them?) now come forward in character and colors. The world-traveller will try to pass it on to her grandchildren, if she can find a way, and if they will listen. If we could all only listen better, what might we not hear. Wir sind Komish—wir leiben Sehr die alten Sachen . . . There was uncle Fritz (the irascible), Wilhelm with his quiet kindness, Otto the magnificent (until the end), Grossmama (the sound of her sewing machine), her white neck ribbons, a touch of style, her black "salchel," her black silk cape, and bonnet. Tante Adelbert (the big open plain face, with big nose, and how), Great Grandmother Ottelia (who was stern and narrow), Tante Tillie, Tante Eda, von-den-Heide, Willie Votteler, gentle Albert (who gave the glasses) and Aunt Caroline whom we should never forget, who left Stuttgart with her family, face tied behind a veil, so it must have been winter, and landed at Castle Garden—that's as far as they got—Hoboken. But on these streets they worked 100 years ago!

She picked up the phone book and found ten Vottelers listed, one of them a Wilhelm, like her uncle. She remembered the visits Aunt Adelbert paid to Grossmutter, the only visitor she had. And it suddenly dawned on her that Grossmutter and her son John had much in common—"Wit, talent, and a strong urge to seek defeat. Gott Hielfe uns." The next morning she woke under the feather covers to find the fever gone. She took a bath and washed her hair, and looking in the mirror saw "the poor old wasted face, wrinkled, thin and aged . . . I can never recover from and accept this statement of the facts of life (mine)." She felt now she could write a book, a small one, full of tiny details, about each one of those people who figured in her childhood. But she knew she never would. Such books "we all have locked within us, bolted against our own egos, for in this mass of detail, unassorted and disorganized, lies sleeping the truth of these lives—and our own. I wonder if I could ever write of my father. So *hard* that would be."

Piling baggage into their VW bug, they drove a hundred miles through the snow and bitter cold into the French countryside. Dorothea found the winter landscape beautiful: "No one ever loved bare trees more than I do." It was hard to find a town not damaged by the last war. Strasbourg was a relief, and Dorothea asked herself, "Why do people make war on each other? What can be substituted to release these insane compulsions?" And what, she continued in a mood of self-analysis, "can be done close to home? Very close to home? You, yourself, are one prone to wage war on those around you. You attack and when you do not have your own way, when you must give way to another's route, you imagine yourself persecuted. Your attack is a rain of petty criticism, spoken and unspoken. You are not a man of blessed peace. You punish Paul, because we cannot go easily to Paris. You set yourself up as a Paris-sort-of-person. You make him feel like one too dull to be a Paris-sort-of-person. This is not true, but it is *revenge*."

Bundled in their curious clothes, they were stared at and laughed at wherever they went in France. They wore fur caps, camel vests, Karachi slacks, Kabul gloves, and carried a Dacca bag, full to bursting, with the handle broken. Her camera cases too were broken now. They headed for the Belleau Wood battlefield, where Paul had been gassed by the Germans in 1918. A return visit to his youth of forty years ago, a journey Dorothea resisted, but in vain. It looked much the same to him, except that the houses had been repaired. He saw exactly where the gas attack had come, in a little wood across a creek. They stopped in the barnyard of a small farm whose wine cellar, half underground, had been the first-aid station Paul had been taken to. The farmer shoveling manure paid no attention to them; he was used to veterans coming back.

In London they visited four days with Margot and Don, who were sweating out a long-delayed visa for the U.S.S.R., where Don was to pursue research in his field. Then they flew west again, spending a night in Chicago with Kathy and John before reaching San Francisco, where family and friends gave them a great welcome at the airport. How fine it was to be home, she felt, to see everyone in the family in good condition, each child a wonder in his own way, the garden doing things on its own, the trees bigger, the sun warm, and the loot from Asia strewn all over the place.

20 PAUL WENT BACK TO WORK AT 9 A.M. THE VERY next day, returning home at 5:50 p.m. as regular and steady as ever. But Dorothea's darkroom stayed closed. She still felt the wheels of Asia turning under her, and every day surrounded by family was a holiday. It was a month before she tried to get started again. She went over her negatives, a familiar means of working her way back into photography. "But it is, as always, a struggle," she wrote. "I am easily derailed." She took photographs now and then; most of them were of family or friends. She could not direct her attention to any theme. In the early spring, recurrence of ulcer pain put her in Kaiser Foundation Hospital for a few days. Out of bed, she needed constantly to be reminded to take her medicine regularly and to eat little, often. She did fairly well for a while, feeling good enough to write Margot that, in spite of illness, "Paul and I have never had a finer life and appreciated our world more than since our return home."

That summer, on the invitation of the new Castro government planning land reform, Paul went to Cuba for a month, as a consultant on community development. He wanted Dorothea to go along, but this time she refused. She watched him depart, Spanish dictionary in one hand and a briefcase stuffed with reports and statistics in the other, "very pleased to be in the thick of a really good fight, where we will, as always, be on the losing side. Or what always *seems* to be the losing side, but maybe it isn't."

The summer of 1958 passed with little to show for it. "Speaking as DL, photographer, I am producing nothing at all. It isn't exactly stagnation, though I may be deceiving myself. As photographer I do not seem to be willing to work. I say to myself, next week, next week, and next week." She watched the seasons change on her Berkeley acre, the first leaves falling onto the bricks, the first figs plopping down on the dry and brown earth. Going up the walk for the mail, she could smell the ripening apples. Her head was full of memories of her own sons' earliest years, memories

matched with the signs of her grandchildren's growth. Only last Sunday, while walking on the beach with four-year-old Leslie Dixon, examining pebbles and shells, pulling at seaweed, the two of them had looked up to see a daytime moon, three-quarters full, riding in the clear sky. "I watched the child pick up and turn over a piece of a large clamshell, just a piece, and her question to me was, in her flute-like voice, 'Do you think, Grandma Dorrie, that this *could* be the other part of the moon?' "

She took her satisfaction in such moments as this, if not in work. When she got her camera out, it was to record an event in the life of friends. Near the end of the year, when the Walter Packards were celebrating their fiftieth wedding anniversary, she came to the party to photograph her old friends. In the darkroom she discovered something had been wrong with the camera; most of the pictures were hopelessly overexposed. But of the few that were not, one—a straight portrait of the old couple standing on the sunny porch of the hotel—was superb.

She found some comfort in the news that the *New York Times* photography editor, Jacob Deschin, had chosen her "White Angel Bread Line" as "the most desirable" of the fifty-six prints by fifty-two photographers on exhibit in the new photography gallery of the Museum of Modern Art. Upon request she supplied the museum with sale prints of some of her photographs in its permanent collection. By now they numbered thirty-six, the earliest dated 1932 and the latest 1955.

Her periods of depression must have become more marked, for Paul, who rarely made observations to others on her emotional state, wrote a daughter that Dorothea was having her "downs and ups." Inability to work is likely to produce that swing of mood in any artist. As the time for the birth of Margot Fanger's first baby drew near, then passed, she sent her notes almost daily, labeling them "Stomach Pats" and filling them with homey advice on infant care. She mailed Margot a batch of Physician's and Surgeon's soap—"no other soap permissible" for the babies of this family ever since Dan was bathed with it thirty-five years ago—and a nice soft old linen rag as the best washcloth. When Steffen, the new baby, was born at last in February, she regretted being too far from Cambridge to do the back rubbing and the hand holding and the babysitting during the first weeks of sleepless nights when new parents yearn for relief. Her own relief came soon after, for she was back at work by spring, at it every day, "and when that goes on all else is neglected. Paul comes home expecting a good 6 o'clock supper (Sioux City style) and finds me blank on the subject. Twice last week he ate pancakes (—and said they were *good)* without a salad, even."

One weekend she accompanied Paul on a field trip with his students down the length of the Central Valley, by bus, seeing many of the places she had photographed on their field trips of the thirties. That was twenty

years ago, she thought, and she would be sixty-five in another month. She enjoyed the field trip, and when a much more taxing one came up, she was ready for it. The United Nations Social Welfare Division asked Paul to go to Ecuador and Venezuela to look into community development programs. He would be gone for two months of the summer, and wanted Dorothea to come with him. In mid-July they flew down to Guayaquil, the chief port of Ecuador. "The city of the deprived," Dorothea called it in her travel notebook, "the city of money and export, as ugly and terrible a city as one can experience, with no sense of the good life for its inhabitants that I can see, beyond a huge sports arena." By pouring more and more money into the South American countries, the United States was only pretending to solve grave questions. "A crude deal," she thought, "of which we are ashamed as we walk the streets. It will never reach into the lives of the Sierra Indians, upon whom the culture of Ecuador depends. We are just playing the old game, which the politicians of these republics so well understand."

Again, as in Asia, they traveled much in the countryside, getting away from cities and offices and regulations so that Paul could see for himself what had been done with community development and land reform. For Dorothea it was dispiriting. She bumped along the Andes in the back of a jeep, eating dust, and itching with scabies, her legs covered with what looked like flea bites.

Her mood changed when they rode through the coastal haciendas, seeing sugar and coffee, bananas and pineapples, cacao, mango, papaya. The dusty roads were sweltering, but "there was a relationship of man to environment that felt good, and deep. Even though life is hard and clothes are rags and ignorance is black. Then back on the main road of traffic, back to the loaded banana buses, the vile little towns lying there, stinking in the heat, with radios blaring out and skeleton dogs and Indians loafing (who have just cut off their braids, for status). A quarter of their earnings of 125 sucres per week (about $6) goes for beer. I wish I could come back here in 10 years and see for myself whether *this* is the foundation for anything decent. I look on all these people with pity." The Indians in the Amazon Basin, she was told, were killers. "But we Americans, with our money civilization, are in another sense savages, and we spread our ways and influence and poison."

She watched children of the barrios playing in puddles of green slime. Garbage floated in the water-flooded streets in the rainy season. The Ecuadorean government didn't want to bother with antimalarial spray. If the Estados Unidos wanted to do it, okay. She was told this was a government "corrupt in the extreme." One day, when Paul went off on a hard trip to a resettlement project high in the tropical country, she decided to stay in the hotel. "My health is precarious, truly," she wrote down, as

though to excuse herself. "I enjoy the quiet day. Paul's work life is full and energetic and devoted. I go along with him. My head contracts, immersed in all his purposes and disciplines. I am of another kind."

As for her photography: "I have come to a dead stop. Is it altitude? I have been yanking at the hang-nails, always a bad sign with me. Goes with reading last December's *Reader's Digest* on the bed in the middle of the afternoon." And three days later: "Paul works with officials and pamphlets and papers. I am isolated and go out to buy things. I buy things for home. I wish I were at home. I see that I have become old now, and spoiled, for I do not make the effort."

She tried to analyze what was going on inside her:

> I believe that I can *see*, that I have the ability to read from what I see. I believe that I can see straight and true, and fast. I do not see second-hand, and operate in preconceptions. It is not easy for me to work on Paul's expeditions. I learn much, but I am not free. Rather I do not *feel* free. The gentleman whom I love so much does his very best, his very best, consciously and conscientiously, to make everything for me as right as he can. But there is dust on the cameras, because I do not want to make snapshots as we tear about, from one province to another. Early and late, seeing all the special and meaningful total moments, first on the corner of my eye as they flash into the center of awareness. I see them and salute in a sort of loneliness. Even when I am asking questions and listening to answers, "interested as can be." I had thought to live the strange existence, *the visual life*, here in Ecuador, on this trip—my drive, my spirit, have deserted me—Paul is healthy, purposeful, and relentless. There is no give. If he relaxes he will sleep—or shop. There is dust on the cameras, and I permit it to happen. My energies, of course, are short and limited because of my physical sickness. Paul calls on everything I have, and often more. It is hard for him to learn new or changed ways. He *relies* on his fixed habits and approaches. He is slower to adjust and protects himself by his *methods*. And I am so much weaker, and quicker, and flexible. I *have* no habits, in the habit of growing up in the quiet of my own soul.

Some years later, probably early in 1965, she looked again at these notes, and wrote alongside in red ink: "This is one of my characteristic bleats. Over and over. A small talent is easily defeated. I take it out, my malaise, on others . . ."

In mid-August they were in Venezuela. From the fourth-floor window of their Caracas hotel she studied the narrow little street below, reverberating with traffic and street sounds. Sometimes at night she rose from the bed, Paul sleeping "like a good child," and stood naked at the dark window, looking down at the street, hearing the chimes ring every quarter hour from the church behind them. She saw Caracas as a hodgepodge, an ambitious city, everything on the make, with the old Spanish building they were in representing the life that was completely finished and done with. A hint of what a decent future might be they saw on their trips into

the country. The Indian and mestizo people worked small allotments of two or three acres, with aid from the community development program. One day they drove into a frontier oil town. It was a dry and dusty place, with no water for the public. The gentry from Mobil and Phillips had a private supply, and even a swimming pool. But outside their gates there was little of anything, including jobs. That night she and Paul went to a meeting called by the community development director they were traveling with. When they came up to the dimly lit building on the plaza there were hundreds of dark, patient figures crowding the Campesino Union hall and the street outside. They were there to elect officers and organize for community action—to lay the government-donated pipes for water, to develop a sanitation system, to build roads and a community center. "So earnest, so serious, so poor and sweated, so willing to raise their work-worn hands and arms for the communidad," Dorothea wrote. "Little islands of planned progress," Paul termed such places. For the moment, under the new liberal President Betancourt, who had replaced the dictator Pérez Jiménez, one could feel hope. But everywhere Dorothea went on these journeys she feared that nothing good would last, that the ideas people like Paul stood for were almost bound to lose in a brutish world.

They were back in Berkeley in September. She went out with a camera almost at once, but as soon as she got into her darkroom, she discovered, to her horror, that her Pentax was out of order. "It was, then, out of order in South America! How hard to be a photographer . . ." Whatever the trouble, it happened again. "Camera out of order, alas!" she notes in November. She was working, too, on her Asian photographs. Under the title "Remembrance of Asia" she planned to develop five or six sequences that would have nothing in common with a country-by-country travelogue. Thinking back on the Asia she had experienced nearly two years ago, some things came to mind which her photographs could reveal. She planned to use captions too, not the poetic kind, not words that tell a person what to look for, not words to explain the picture. She wanted words that would give background, that would fortify the photograph without directing the mind. One Asian sequence was based upon a letter she had written home while making a day-long train trip. The eight photographs she chose to go with it were not taken from the train, for the windows had been impossibly dirty. But what the letter evoked—not what Asia looked like, but what it felt like—she had found pictures for. Another sequence was of the eyes of Asian children, nothing else, and it needed no words. She was also doing a sequence on the village as a characteristic of Asian life, and to be understood by Americans it needed some words. She found as she went along that she was repeating some of the same photographs, or parts of the same one, in various sequences, but using them in different ways. Different applications of the same negative, a method that she wished to explore to the limit. Just as she sometimes came across photo-

graphs she didn't know she had made, unable to recall the circumstances, so now she had been unaware of shifting point of view in the sequences she was building. One Asian passage turned out to be absolutely direct, nothing at all oblique, while another had not a single direct thing in it. She didn't know that was what she was doing until it was finished and she saw what she had done.

It was a process full of discovery, but she met frustration, too. She put in ten straight days on what she hoped would be the fourth episode, bringing in a printer to help, and then she destroyed it all because she felt she had failed. "What I wanted to do," she said at the time, "I know I'm not going to be able to do. That's a disappointment to me. If I had been able to put it together out of materials I had, I would have done something quite unlike anything I've done before." She thought one of her cameras might have been responsible for the failure. "It could be me," she said, "but it could be that the camera will not do the thing that I was looking for in those negatives. There's a sharpness of edge that isn't in them. They're too mushy."

Her chief camera on these trips was a 4 × 5 long bellows extension Graflex, "as heavy and bulky and awkward a camera as can be," she remarked, "a camera that curtails your freedom and which needs strength and heft to manage." She could have taken along a 35mm too, a camera at the other extreme, but she believed that "if you are going to use it, you should never use anything else. I think you have to say to yourself, 'I am a 35mm person and there I stay,' because it doesn't seem to work to use it otherwise. It is then never your base camera and it becomes your fill-in. You begin to fill in and the structural line of the job is weakened. What the 35mm can deliver is almost always within a certain stylistic frame. You accept that and there's plenty you can do within it, adding the full range of accessories." She had tried using both cameras, but it didn't sit right with her. She found she was adapting her style to too many different kinds of things. "It jumbles you, it rocks you—which means you're always looking for the perfect camera."

The next few years—chiefly for reasons of health—saw little productive work done by Dorothea. By happy accident, however, she was given the chance to think back over her whole life and record her memories and observations. The Regional Oral History Office at the University of California in Berkeley asked permission to tape-record interviews with her because of the place she had earned in the history of art. Paul pressed her to do it, but she herself was reluctant, doubting how good a subject for interviewing she would be, while admitting that "people who maintain they don't like to have their picture taken really do like it." She was taped eleven times between October 1960 and August 1961, each session lasting about ninety minutes. Given the transcript for correction and approval a few months later, she had great difficulty in accepting the record of what she had said. She did not like this self-portrait—not that it was so false, she

said, it was just not true enough. She told her interviewer that it was like the trouble people had in choosing among photographic portrait proofs for the most honest likeness. At one point she came close to burning the manuscript. What with the sieges of illness, a long trip to Egypt, and her grave doubts, it was not until the fall of 1964, nearly three years later, that she returned the transcript. She made only a few changes, and those minor. She had silently accepted the fact that there were great holes in the story she told of herself, as well as a number of distortions—as there un-doubtedly are in most autobiographies. Few can see themselves as others see them. Or know who and what they truly are—in all their contradictory complexity—and why.

In the early 1960's Dorothea turned to landscape, going out into the country alone or with a friend, and started on a series called "Trees in All Seasons." Her contact files show spurts of photography, the subjects ranging from a chamber-music group playing in the park to a street riot, labeled "Test Shots for Something or Other." In this time, however, she did see the fruit of earlier work come to wider public attention. "Death of a Valley" appeared in *Aperture* in 1960 and was then presented as an exhi-bition at the San Francisco Museum of Art and, early in 1963, at the Art Institute of Chicago. A selection of her photographs of American country women was shown in France that year, and the next year "La Donna Rurale Americana" was exhibited in the Biblioteca Comunale of Milan.

That spring the Carl Siembab Gallery in Boston exhibited about forty of her photographs, mostly of the farm women series. The Boston art critics were simply not interested in photography then, and they ignored all such shows. In New York, the Urban League included her work in an exhibit called "America's Many Faces." Early in 1962 her work was included in "USA FSA: Farm Security Photography of the Depression Era" at the Allen R. Hite Art Institute, the University of Louisville. In the summer her work was shown in "Man, Woman, and Child: 14 Perspectives," pre-sented by the San Francisco Museum of Art. And that fall, another and by far the largest and most significant show of FSA photography was pre-sented at the Museum of Modern Art. Called "The Bitter Years," it was Steichen's choice for his farewell exhibit after fifteen years as Director of Photography.

As close as she was to both Steichen and the FSA experience, it might be expected that she would provide considerable help in planning "The Bitter Years." But her poor health made that impossible. Indeed, for much of 1961 and almost all of 1962 her condition hampered any attempts to work, and even endangered her life. As early as March 1961 she said her health was "pretty bad—not all the time, but enough of the time. I am troubled by it." The drastic remedy of another round of surgery was hinted at, but with the outcome uncertain, postponed. In November she reported working "constantly, and hard, in spite of internal trouble and

being plagued by same." Two months later: "Trouble with my innards has pushed me out of everything, to lie still." X rays showed she was worse than the symptoms had led anyone to believe. Her prospects were continued deterioration if she did not have surgery; improved condition if the surgery was successful, or if it was unsuccessful, deterioration plus the shock of surgery. A month later an internist and a surgeon agreed she had no choice; they wanted no delay in an operation, and when her doctor and friend William Lister Rogers concurred, she went into French Hospital in February 1962, staying some six weeks. Surgery was performed to take care of the symptoms of gastric obstruction that had developed.

Her first week at home was a struggle; then she began to pick up, and by early April was glad the hospital ordeal was over and done with. "There is time ahead," she wrote Margot, "and I am full of hope." But not for long. The operation turned out to be only a partial success. In June she was back in the hospital for a few days. Hating to be a constant emotional drain on the family near or far, she tried not to talk or write about it. Impossible, when everyone wanted to know the facts and to help. "I am left with a situation which no one up to today is anxious to cope with or prescribe for. I live in the land of 'Let's wait a while and see' and suffer a good deal of pain, not all the time, but it takes over."

At the end of the academic year, completing forty years of teaching at Berkeley, Paul Taylor retired. With a large part of the family, he and Dorothea went up to Echo Lake to enjoy a two-week vacation. It became too much for Dorothea and she returned home in a week. Despite her condition, she felt a surge of optimism. She spoke of going with Paul to Egypt, where he had been invited for a year's visiting professorship at the University of Alexandria. In mid-summer Steichen came out to talk with her about plans for "The Bitter Years." He wants my undivided attention, she said, "so I must pull myself together." That conference over, she had to enter a hospital again, this time Kaiser Permanente. "My luck is incredibly bad," she said, "hard to believe." Her ulcer was again active and now the doctors wanted to treat it medically for two to four weeks. They did control the pain, and she thought her prospects were better. But she would not be allowed to go to Egypt just now. Radiation treatment was begun and time was needed to see if it helped. "I try to live from day to day," she wrote in September, "with my oak trees and the autumn days, and try for the best." The cobalt treatment seemed to work, and a month later she felt "miraculously improved. Happened overnight that the pain disappeared, and I am back into the world again." She was weary, and not yet strong enough to do all she wanted to do, "but very happy. Everything seems wonderful and possible again."

In November Paul left for Egypt, expecting Dorothea to join him in about a month. Her doctors thought her condition fairly stable now; they did not object to her going. But she was making the long journey only be-

cause Paul's work took him there. "For my own work," she confided to Nancy Newhall, "I would choose to stay in my own country." Paul knew she didn't really wish to go to Egypt. "She was getting back into shape and wanted to photograph in this country. She wanted to go back over our old trails. But I had committed myself to go to Egypt and of course I wanted her to come with me. So she came . . . When she got there, she reminded me again that Egypt was not her choice, but mine. She did it in the nicest way; there was such frankness between us. She meant what she said: left to her, photographing in the United States was what she wanted to do. But of course I had agreed that *this* was what *I* was going to do, and I guess I had the main leverage and she had to come in tow."

She followed Paul by stages, reaching New York the day before "The Bitter Years" was to close at the Museum of Modern Art. John Szarkowski, the new director taking over from Steichen—he had had no connection with this exhibit—took her through the gallery. Opening the show were two of FSA's best-known pictures—Lange's head-and-shoulders portrait of a grim-faced, weatherbeaten farmer against the sky and Rothstein's shot of the Dust Bowl family running through the windstorm toward their shack. Then, said Szarkowski, he and Dorothea came to another photograph of hers mounted in a key position. "Steichen had wanted a country woman in big sunbonnet to make a certain effect. He was the kind of curator who used everyone's work to create his own piece of art, not bothered by whether what he did with their photographs might upset them. In this case Dorothea's picture had what he wanted, but it also had two rednecks in it, so he had had the men airbrushed out and the photo recopied without them. I knew this and was scared to pass by it with Dorothea. I watched her reaction as we came up to it. Her mouth opened wide, she hesitated a moment, then she laughed as though to say that ballsy old bastard! I had wondered which way she would react, and it was touch-and-go for a second. From the moment she laughed, I loved her."

She was not furious, because this was Steichen, a man she had great respect and affection for. "Steichen is not hampered and hemmed in by all kinds of fears, meeting everyone's standards," she said. "If the negative is weak, let it be weak, so long as it speaks." She herself would not have dared to make such giant blowups from some of her small negatives—"sometimes the world's worst," she admitted—"but if Steichen wants to make something big, he makes it big." After all this time, she delighted in seeing right in the middle of Manhattan such a great number of her 1930's images and hearing again in her mind the many passages on the walls from what the people in the photographs had said to her.

With Steichen's declared objectives for the exhibit she was in full agreement. He thought the time "ripe for a reminder of those 'bitter years' and for bringing them into the consciousness of a new generation that had problems of its own but was largely unaware of the endurance and forti-

tude that had made the emergence from the Great Depression one of America's victorious hours . . . The image of stamina presented by our people during the 'bitter years' of another critical period might perform a revitalizing function." Out of the 270,000 FSA photographs on file in Washington, his staff had made a preliminary selection, often picking without looking on the back to see whose pictures they were. When Steichen made the final choice of some two-hundred, it turned out that eighty-five, or nearly half, were by Lange. It is forgivable that in a letter she proudly referred to the exhibit as "so largely my own."

Writing in *Infinity* about the impact of the exhibit, Nat Herz pointed out that in addition to giving the public a chance to see many of the FSA's best pictures, the show was reminding us of three things: that the terrible conditions of the Depression were still to be found in the countryside and in the hearts of our great cities; that in the American people are qualities which exist at depths beyond phoniness; and that (perhaps as a criticism of current trends in photography) "photography by means of light can show us the real, the material, more directly and acutely, perhaps, than the other arts." The value of the FSA work as a documentary record was hardly the least important contribution of the photographers. But some of the images would be remembered long after because the artist, whatever the subject matter, had created "something of permanent value that would teach us a little more about man's meaning in this puzzling, often ugly, but deeply beautiful world in which he finds himself." This, he concluded, is to be seen in the best work of each, "and it is very consistently visible in the work of Dorothea Lange." He called her "not a photographer of the Depression, but an artist for all time."

In a review of the show in *Contemporary Photographer*, Lee Lockwood noted that Lange had so large a part in it that it gave her in effect a show-within-a-show.

After a couple of weeks spent enjoying New York, interrupted by a trip to Providence to visit with the Fangers, Dorothea flew to Rome in mid-December, and from there to Cairo, where Paul was waiting for her. A day or two later they started driving toward Alexandria. She was immediately caught up in this new world, watching the Nile Delta unroll outside the car window. But photographing Egypt was a difficult experience, and it became harder as time went on. She began work in Alexandria, where Paul was visiting professor at the university on a project financed by the Ford Foundation, the Institute of Land Settlement. It was headed by an Egyptian soil scientist who had spent a year at Berkeley on a fellowship from the Institute of International Studies which Paul had directed. Paul's job was to lecture on community development and land reform to students mostly employed in government positions involving the resettlement of people on reclaimed land. His hope was to give the government some grounding for studying the relationship of farm work with soil and seed to

the varieties of people they were uprooting or creating. He wanted them to understand how community development could be done "with" the people as well as "for" them.

The Taylors were given an apartment on the eighth and top floor of a house, with windows and balconies offering glorious views of the Mediterranean and the city, a city transfigured by the quality of its light—but from a distance. Up-close Alexandria she found "a dirty, crowded, noisy place with the splendor gone. The narrow streets and alleys are filled with people buying selling pushing hauling arguing squatting eating sewing hammering hawking their wares and drinking their delicious sweet black coffee out of dirty glasses. The women in thin black from head to heel, the men wearing long robes and classical turbans." Overall, a sense of decay and neglect. She had been dreading the beggars after Asia, but though she saw many bitterly poor people in rags, she did not see hungry people. Food seemed to be cheap and plentiful. They walked in the city as though it were a vast museum. "I enjoy looking quietly and intently at living human beings going about their work and duties and occupations and activities as though they were spread before us for our pleasure and interest. A huge opera. A huge arena. And also to be only dimly self-aware, a figure who is part of it all, though only watching and watching. This is an exercise in vision, and no finger exercise, either. For a photographer it may be closer to the final performance."

The institute provided them with a house servant, Hussein; a Ford Falcon; and a driver, Aly, a forty-nine-year-old Egyptian with eight children, "a big ugly face, a rich crusty voice, and a merry eye," who loved to careen around corners and whip through narrow alleys hand on horn. On the days when Paul was teaching, Aly was instructed to take Dorothea wherever she wanted to go. But driving around in a car was fatal to observation; she couldn't see while riding, and when the car stopped and she got out to photograph, she was spotted at once and surrounded by a crowd. If she walked alone with a camera in hand, a parade sprang up behind her. Beggars followed her everywhere, beggars and pesky children. She quickly ran into resistance. To protest the taking of a picture was considered "a patriotic act, an act of nationalism," she said. At one place the women and children she was photographing started snarling at her, and then struck at her camera to knock it out of her hands. Another day, as she was seated in the car, aiming her camera at a façade of buildings in Alexandria, a man came up to her and, pointing to the Mediterranean coast, said angrily, "Why don't you photograph something beautiful?" As he walked away, children nearby picked up pebbles and hurled them at her. Her driver seemed scared of the police, and would not summon them to her aid. The atmosphere was anti-foreign; she feared there could be a riot. She despaired at the difficulty of working in a country where the materials were so rich.

When Dorothea and Paul spoke of these incidents to Paul's chief at the institute, he explained that in the eyes of the people on the street she was an agent of the Israelis. Paul's colleagues to an extent justified the resistance she encountered, claiming that Israeli propaganda showed photos of Egyptian poverty and compared them with photos taken in Israel, implying that Israel stood for progress while the United Arab Republic did not.

Her driver soon became less and less cooperative. Often when she would ask Aly to stop, he would drive on another hundred yards or so, and then stop, trying to prevent her from photographing what she wanted. One day Paul saw him writing what he was certain was a report to the authorities on what Dorothea did. As the harassment and hostility increased, sometimes she broke down in tears of frustration.

Paul thought the "anti-Israel sentiment served as a rallying point for people in political power. It enabled them to cast themselves in the role of defender of the people. So from my point of view, they magnified the dangers." Agitation against Israel was strongest in the Nile Delta. But when they left Alexandria for the upper Nile Valley south of Cairo, Dorothea had few difficulties. Where there had been little or no propaganda, there was no problem for a photographer.

Still, there were times when all went well. One was a long trip by jeep to the desert oasis of Siwa near the Libyan border. It was like a test to see how much heat, sand, fatigue, and bad food she could endure, but a glorious trip over unmarked, trackless desert that brought her to the gateway of an ancient world of massed date palms and two-story villages made of mud. "It was a silent place," Dorothea wrote home, "the rumble of a cart, white-robed figures, two children playing with a donkey, the flash of bright orange-colored silk as a black child ran across the wide place which was the center of the village. A few stall-like shops, no women to be seen at all, anywhere. They stay behind walls, and their faces and bodies are always covered. Even little girls will instinctively pull their head cloths over their face if you come upon them unexpectedly. These are Bedouin, Berber and Sudanese people who have lived here forever, speak Siwa language, and raise the famous Siwa dates." They made a side trip to the Sudan, flying a thousand miles south to Khartoum to examine the Gezira Scheme, an 800,000-acre irrigation project the British had developed to turn grazing country into cotton farms, transforming semi-nomads into farmers. It provided rich material for Dorothea's camera.

At Easter time Dorothea was down with dysentery and she had to have a doctor's help in spite of the urgent recommendation of their cook that she cure herself with "the soup of the rabbit." How she could keep going with all her physical infirmities and limitations she herself didn't know. "I am thin as a rail," she wrote. "I have to hold up my clothes with safety pins because of the dysentery, but am able to sleep well, my days are completely free of pain, my disposition is good, and my endurance

matches that of others who are more normal in their physiology." If anyone should ask why she had undertaken such a strenuous trip, her answer was, "Better missing than rusty."

Her morale needed no booster, but she got one when the American Society of Magazine Photographers notified her she had been elected to its Honor Roll in recognition of her "great and lasting contributions" to photography. From Egypt she cabled Steichen to accept the scroll for her. Speaking in her place, he told the audience "what kind of guy Dorothea Lange is," underscoring the point that he didn't want to talk about her as a woman photographer, just as a photographer. Not that he need apologize for taking up the cudgels for women photographers. He believed the medium of photography was particularly suited to women, "because women have that curious thing which is intuition, stronger than men have. Intuition is simply keen perception and evaluation. They know how to value their perception, which is something a man is very poor at, as a rule." He went on to praise her as a prodigious worker without whose pictures he could not have made "The Bitter Years" exhibit. "If the proper study of mankind is man, then she has lived up to it, for she has always studied people, people, people."

In June they left Egypt, arranging before departure to get Dorothea's negatives out of the country, for fear they would be confiscated. (Despite all the obstacles to photography, she managed to produce about two thousand negatives in Egypt—not a small amount of shooting.) The American consul-general, using diplomatic immunity, had them taken to New York unexamined. So it was with a sense of relief that they moved on, spending a few days in Beirut and Baghdad on their way to Paul's next assignment in Iran. From Teheran they flew to Tabriz in east Azerbaijan. There Paul found the community development program shrinking as a result of budget decisions in Washington.

The first night in Tabriz, Paul woke to hear Dorothea babbling unintelligibly. He took her temperature: it was 103. Luckily, with help, he was able to get her quickly into the Presbyterian Missionary Hospital. This was her second episode with fever, for at Luxor in Egypt she had run so high a temperature they had been forced to return to Alexandria. Antibiotics had reduced the fever, as they did again in Tabriz. A week later Paul got her back to Teheran, where the temperature went way up again. Another rough week in the hospital, with more antibiotics and intravenous feeding. She insisted Paul go about his work, meanwhile. She had been able to see little of Iran when they flew out in July. They landed in Stuttgart, her second visit to the ancestral home, and again they picked up a new Volkswagen. They drove into Switzerland, to St. Moritz, where the fever rose again. The hotel doctor brought it under control in two days with antibiotics. Then they started over the mountains. In a few hours Dorothea's temperature was climbing up and up, hitting 103 again. Des-

perate, Paul finally got her to a hospital in Interlaken. The doctors refused to give her antibiotics; that would only diminish the fever and mask the true cause of her illness. They got her fever down by other means, and lab tests revealed she had malaria, contracted in Egypt. The standard therapy was applied. They were much relieved to know the fever's cause and that it could be treated. In three weeks she was able to leave the hospital. Early in September they reached Holland, where Dorothea made short sallies into the streets and museums, taking quinine when a low fever recurred and resting in bed till noon each day. They stopped on the East Coast on the way home, visiting in Boston, Providence, New York, and Washington.

As soon as they reached Berkeley, Dorothea disappeared into her dark-room "to discover whether anything was recorded in Egypt." Paul was almost at once off again, to Chile and then back to Iran. It left her free to work all day, every day, feeling wonderful that she was physically up to it.

21 HOW LITTLE TIME SHE HAD LEFT DOROTHEA had no way of knowing. And how much she accomplished in the two years it is hard to believe. Only the most powerful will could have forced so ruined a body to go on until the work was finished. She would prepare her retrospective show for the Museum of Modern Art and her photographic essay on "The American Country Woman," collaborate on two television films about herself, develop and promote a proposal for a national project on documentary photography, all the while making prints to meet requests and attending as best she could to the needs of her family.

The immediate task was to proof up the work she had done in Egypt. Wanting a darkroom assistant, she called Morley Baer, a friend who taught photography at the San Francisco Art Institute, to ask for a recommendation. He sent over Richard Conrat, a twenty-three-year-old part-time student of his, who could not imagine a better job for someone in his circumstances. She remembered meeting him a year before when he had come by to show her his photographs and to ask her advice. They agreed he would come twice a week, working the full day for $2 an hour. (Later he worked four days a week for $3 an hour.) He stayed on as her assistant until the end, and after her death worked with his wife for years to produce the exhibit and the book, *Executive Order 9066*, which were based largely upon her WRA photography.

She gave attention to each of her commitments in turn. Her habit was to work from nine to five. She tried to get as much as possible done in the morning, because she knew she would wear out in the afternoon. Evenings she saved to spend with Paul when he returned from work. The body which had failed her so often in the past twenty years kept failing her now too, but each time she managed through an act of will to pull it through its immediate affliction and keep it running. Working with her,

Conrat found it easy to be deceived, to become convinced that she was not really dying, that she would rise up one more time.

As they assessed the Egyptian material, Conrat saw that her custom was to make an 8 × 10 print of every negative that interested her. (They made more than five hundred work prints from the Egyptian negatives.) These went into a file kept for reference. If somebody like Steichen asked for prints, these she would make herself. But requests from less important sources she would hand on to her assistant. Much of the work Conrat helped her with was for collectors and exhibitors. Limited by her facilities—small darkroom and small sink—no print could exceed twenty inches. She did not send work out to commercial labs, but did it herself or with the aid of assistants. (Before Conrat there had been a long string of them, younger people like Rondal Partridge, Pirkle Jones, Ralph Gibson, Philip Greene.) When a batch was printed up, she and Conrat would sit down to spot them, and then she would put her name to them. If a print met her standards and she signed it, then it was her print. In those two years Conrat observed her in many situations with different people, and "she was always the one in control."

There was a curious tension between the young photographer in his early twenties and the old one in her late sixties. Although he thought her "brilliant, a genius, in fact," he did not stand in awe of her. He came to his job with an intense concern for a photography that confronted social issues and tried to better man's condition by exposure of the truth. Such was the nature of Dorothea's work for the FSA. But he thought the Egyptian photographs, like her work in Asia, showed more concern for pure aesthetics than for the social implications of that culture. He risked taking her to task for not applying the values of her most characteristic and memorable work to the photography of these later years. She was receiving praise in many quarters for her photography abroad, and to have it criticized by this youngster upset her. She did not discuss their differences openly, but rather let her feelings come out in occasional grouchiness or petulance. Still, the two of them shared fundamental beliefs, and Conrat felt they grew closer because of these clashes, not in spite of them. What he learned most from her was not so much photography as how to fuse one's life with one's work.

The prospect of a one-man show at the Museum of Modern Art had been in her mind some time before she received a formal invitation. What photographer could have resisted the thought? Probably her old friend Steichen had suggested it during the 1950's, but if there was such talk, it had never been made official. Her photographs had been a significant part of several of the museum's shows. Up to now, however, the museum had presented only five major one-man exhibits: Walker Evans, Paul Strand, Edward Weston, Henri Cartier-Bresson, and most recently, in 1961, Stei-

chen himself. While Dorothea may have desired to take her place on that distinguished list, she knew the risk of publicly baring one's soul. Retrospective shows, as Minor White once put it, offer a rare aerial view of an artist's life. They reveal whether the artist has developed or has come to rest on safely taken ground, afraid to venture into strange territory. She had declined many an invitation for a one-man show, convinced that she wasn't good enough yet. She would not show until she was satisfied with her work; she had not yet done her best. Now, however, nearing seventy, with her health worsening rapidly, she must have realized this would be her last chance. The director of the photography division, John Szarkowski, pressed her hard. In February 1964, to prevent her putting him off with the excuse of other projects that came first, he proposed a Lange show to the museum's exhibition committee, telling them he considered Dorothea a major artist worthy of a definitive retrospective that would do full justice to her unique and important contribution. He got a commitment for generous space on the ground floor of the new East Wing. "Without a by-your-leave, and whether you like it or not," he wrote her, "you are down on the schedule for a one-man show two years from now."

Two years is not as long a time to prepare a major show as it may seem. A lifetime of work had to be reviewed carefully, themes developed, selections made, prints produced, captions written, space designed, pictures mounted, catalogue material gathered and printed. Szarkowski offered to come out in the fall to assist her in getting started. "You surely know how to handle me," she replied, "nailing me down to a commitment. For this I do seriously thank you. I will give it all I have. I will make it as fine as I can."

If only she would not let herself be deflected. In the multi-purpose existence I lead, she said once, one interest is always interfering with another. She feared Paul might drag her abroad on another assignment, and then there was her project for photographing the United States. For many years it had been in the back of her mind that the unique achievement of the FSA in the short history of photography should be followed by a second collective effort, this time to record national life with the focus on the cities. As early as 1952, in an interview with Jacob Deschin of *The New York Times*, she had said, "The time is now ripe for another file along FSA lines." In 1955 she brought it up again, in *U.S. Camera*, and in 1958 sent a memo to Magnum suggesting they try to enlist the financial support of Henry Luce and Gardner Cowles in establishing the equivalent of Nieman fellowships in photography. Two years later, observing renewed attempts to organize migratory farm labor in California, she regretted there was no provision to record it in photographs. Today's young photographers, she said, "don't have the training and the education and the experience that we in FSA had. And they should have the same chance that we did. But

nobody is financing a project to do it. Foundations are shovelling out money for all kinds of things that are on the edges. But this is right in the middle!" Every city she went into was becoming a horror, she thought. "The new megalopolis is not just an American phenomenon, it's international, and we are creating this environment, teeming with unfamiliar ways of living, almost without scrutiny." When she saw the powerful public response to "The Bitter Years" exhibit, she knew she was right. FSA's assignment had been to bring back the truth about rural America in the thirties. And now, thirty years later, the photographs still served those who looked at them. It helped them understand what those years were like. She felt FSA veterans like herself should take on the challenge to get a new generation of photographers started on Project One, "not for the sake of the photographers, but to advance the medium itself and its possibilities." She didn't want the young photographer who might record the modern city to make the kind of picture that would illustrate popular preconceived notions. Of course to avoid this would be a tall order, she said, especially for so many of today's artist-photographers "whose alliance with the world is very slight. Their alliance is to themselves, and their effort is to translate the outer world in terms of their needs." She looked for "a new photographer, a different breed, who expresses his responsibilities to the outside world. His alliance with it is very great. But if he does this job well, as a byproduct he creates a work of art."

On her way to Egypt in the fall of 1962 she had stopped in New York to talk with Henry Allen Moe of the possibility of Guggenheim Foundation help in setting up Project One. She doubted the Guggenheim was geared for it, but Moe might open other doors for her.

Encouraged, she clung to the idea while in Egypt, and in April of 1964 drafted a one-page memorandum to be used in promoting Project One. Its aim was to create a national cultural resource in the form of a file of photographs to be made by a director and a crew of six to ten photographers free to travel and work all over the country, but concentrating on urban and suburban life. She did not want photography of the extraordinary, the dramatic, the bizarre, but of the vast variety of everyday life in all its complexity. Nor did she want the camera to be an outlet for passionate personal protest. Rather it should reveal "the values and purposes and dangers of our intricate society, along with its outward appearance."

She thought $250,000 annually, over a period of five years, would suffice to accomplish the goal. And she looked to universities, to foundations, to corporations, or to government as sources of funding. She hoped arrangements could be made to begin work by the spring of 1967, with the Library of Congress charged with housing and managing the photographic file. There it could be drawn upon for use and publication by the many kinds of people who would see its value as an important national resource. Here she listed historians, sociologists, students of environmental design

and the humanities, teachers, writers, artists, legislators, judges, administrators, planners. What Project One will establish, she said, is a benchmark to measure change, progress, and decay.

Meanwhile, she kept thinking of the retrospective show, sending Szarkowski brief notes of her ideas, always referring to it as "our" exhibit, "because that is the way in which I think of it and that is the way in which I can accomplish it and that is what you promised me." This time she did not let work give way to family concerns. Early in the spring, as the Fangers waited for their third child to be born, Dorothea wrote Margot that though she wished she could send her daily postcards as a sort of hand-on-the-shoulder, "there are times when I just can't write. I think of you much and often. We are a strangely knit and composed family, but family we are, and the proof lies in the years that we hang on to each other and understand each other and love each other . . ." She sent Margot the same shawl used when Gregor (her first-born grandchild) and the other infants had been carried home from the hospital.

She hoped to drive down to Carmel to enlist Ansel Adams's support for Project One, but when she couldn't find the time to squeeze it in, wrote him about it instead. "No nation that I know of has ever attempted this kind of close, hard scrutiny of themselves," she said. Then: "The last months have been productive months for me and with this unexpected dividend of a few more years of working life, I am expanding and using it." The implication is that she had not expected to be well enough to keep working, but had discovered somewhere within herself the reserves to go on.

Dashing downtown "to have my hair cut so that I will look less like a coconut," she was off to New York for three weeks late that spring. She attended the opening of the museum's new Photography Center, named in honor of Edward Steichen, and saw a show Szarkowski had prepared for the occasion, in which she had one or two prints. But most of her energy went into promoting her photography project. She had Szarkowski bring together a few young photographers so she could test their response to her idea. They were enthusiastic, delighted at the prospect of being part of something like the old FSA. But as the talk went on she was troubled by their identification of the project with conditions of poverty. "We know by now how to photograph poor people," she said. "What we don't know is how to photograph affluence—whose other face is poverty." Project One would not be a repeat of the FSA. To photograph the America of the sixties would be harder, much harder. For there is poverty within us, the affluent, she said, a poverty of the spirit which allows conditions that degrade and humiliate people to continue. She approached the Ford Foundation, talking to officers of both the Humanities and Arts and the Public Affairs divisions. They listened, but made no promises. To rally support for her campaign, she visited Ben Shahn in New Jersey, where she

spoke to a group of photographers he had invited to his home, and went up to Connecticut to see Steichen.

In New York, photographer-friends dropped in at her room in the Westbury Hotel. Homer Page remembers people coming and going until very late one evening, Dorothea pumping enthusiasm into them for Project One. She made time too for family reunions. She visited the widow and children of her uncle, John Lange, down on East Eighteenth Street. She had stayed in touch by occasional letters or visits. They discussed family history and she told them how everyone in Stuttgart had looked like a Lange to her. There had been so many Langes in the phone directory she dropped the idea of calling them. They got out the von Karajan–Leontyne Price recording of "A Christmas Offering," listened to the music, and then, though this was June, began singing Christmas carols in German. She got Uncle John's widow, Minette, alone, and questioned her at length about her belief in an afterlife. She seemed to want to be convinced, but couldn't accept it. Cousin Minelda took her down to put her in a cab. Dorothea was wearing a small gray caracul hat. They said goodbye on the curb, the cab started to pull away, then suddenly backed up, and leaning out the window, Dorothea pulled off her hat and tossed it to Minelda. It was the last time they met.

For Paul Taylor that spring was a time for intensive lobbying. The land-reclamation policy was threatened with disaster in California and he marshaled all his forces to save it, shuttling between Berkeley and Washington, speaking before influential groups anywhere he could, testifying at congressional hearings, fighting with Secretary Udall, trying to get President Johnson to intervene. "We are not enjoying a leisurely old age at the present," Dorothea wrote, quite without regret. But rushing around the East cost her something. She had traveled to Washington, too, in order to go over all her government work she could find on microfilm. It was a staggering task: "Out of all these years of close association with the little black box, I now have to make the selection of prints which will describe it." She had meant to go up to Rochester to discuss her photography proposal with the Newhalls, but failed to make it. "I had become finished with being with people and speaking with people and giving all my energies to all my interests," she wrote Nancy from Berkeley. "I had a great time, but there was nothing left."

By mid-July she was feeling quite weak. She began having new and recurrent symptoms while swallowing food. "I am working but I don't know if I am working well," she wrote Margot. "Insides giving some trouble. Not too awful, but enough to slow me down." And enough to send her to the hospital. X-ray films revealed the possibility of a malignancy in the mid-upper portion of the esophagus, and a biopsy confirmed it. This was a new site of trouble: this portion of the gullet had not bothered her before. The esophagus is not an unusual site for cancer. In this case it had not devel-

oped out of her ulcer or from the old difficulties experienced in her esophagus. It was a coincidence that the cancer occurred in the esophagus, in the hitherto untouched upper portion. Unfortunately, there is as yet no satisfactory treatment for cancer of the esophagus, and it is not amenable to surgical intervention. About 95 percent of such patients die within a year, no matter what the treatment. Cancer of the esophagus is terribly difficult because of the pain it causes; only constant medication gives relief.

In August, when the diagnosis was certain, Dr. William Lister Rogers told Dorothea the facts. She took it well, he thought, asking how much time she had, how long she might hope to survive. He could give her only the range—from a few months to eighteen months.

She and Paul considered what to do. For a brief time they thought of going back to Switzerland, to wait for the end in that idyllic hospital at Interlaken, near the Jungfrau, where less than a year before she had been so beautifully cared for. Paul even wrote to the Swiss doctor who had treated her malaria. "Yes, you may come," he replied, "but I recommend that you find a solution where you are."

He was right, of course. To have gone to Switzerland to die would have meant giving up the retrospective, giving up the films, leaving her garden, her friends, her family. They decided to stay at home. Dorothea thought she would need someone to help: to prepare the meals, to take care of the household, to see her through. She could ask a relative in New York to come, but they quickly ruled that out. Paul wanted to take care of her himself. She could get by with what he could prepare for her, limited as she was to soft stuff—soups, Jell-o, baby food, milkshakes. And their household worker would continue to come in to clean once a week.

The diagnosis of incurable cancer did not destroy her desire to go on with her work. As soon as she and Paul knew what they would do, she went about quietly informing her friends and telling them how she meant to live what was left to her. Early in September she wrote Szarkowski:

DEAR JOHN:
We have a matter to think about. I write you the main fact and ask you to consider what can be done.

This week I have learned that my working time is uncertain, because I have an inoperable cancer. There may be enough time to assemble an exhibition which could sum it up, but for this I require help.

Think about it, and telephone me when you are ready to give me your thoughts.

YOURS WITH LOVE,
DOROTHEA

P.S. I shall tell Steichen later.

This was a typed letter. At the bottom, in her hand, is the line:

Paul typed this for me, because I found it hard to do and say.

D

On top of her own came another loss. In a note to the Newhalls Dorothea conveyed both pieces of news:

In the last two weeks time has stood still. We lost our son Ross Taylor. He died last Thursday, inexplicably. And I know now that this time I shall not recover as I have been able to do so many times before, for I have an inoperable and incurable cancer of the esophagus, and the way ahead is unchartable. It grieves me to write this to you, and I do not wish you to answer it. I just wanted you to know. If it can be done, I am going to try to get my exhibition accomplished. I need to do this, for you know how long and how often I have postponed it. I should also like to leave in the collection at George Eastman House a small group of carefully considered photographs which represent me best. I just want you to know that I have this in mind too. Also, Beaumont, what does one do with one's negatives?

<div align="right">

YOURS FAITHFULLY, AND WITH LOVE,
DOROTHEA

</div>

Everyone responded gently, hoping her health would improve, offering to help in any way possible with the exhibition. Szarkowski arranged to come out and spend time with her, to start selecting the photographs for the show and to set up a system for continuing the work under the conditions of a continent-wide separation. He was prepared to advance the opening date, but he did not want to suggest too early a deadline for fear of putting an added strain on her energies. "I believe," he wrote her, "that it is very important that we do this show together, important for photography and for all the people who want to use it well and morally. Perhaps it will also be a great adventure for us."

It was just before the diagnosis of cancer that shooting began on the documentary film Dorothea had agreed to make. Nearly two years before, in the fall of 1962, Robert Katz, a producer for the Film Unit of the San Francisco educational TV station, KQED, had broached the idea to her. He had just made a series of films on Ansel Adams for KQED and National Educational Television, and their success had induced NET to ask for more documentaries based on the work of leading photographers. Ill at the time, Dorothea was not sure she wanted to do it, nor did she know where she would find the time or energy for it. When Katz proposed that Philip Greene, a former student and assistant of hers, be the cameraman on the project, she was more inclined to say yes. Before she left for Egypt, Greene came to discuss the proposal with her. She voiced some of her ideas about photography, obviously enjoying the chance to get them down on tape. "We are a trade without standards of excellence," she said. "We have no critics." To bring out the sharp distinctions between photographers is not easy to do. Most photographers are not themselves aware of what is their outstanding, individual, particular characteristic. She regretted that photographers did not talk to one another about their work. She

would welcome sharply critical sessions with other photographers, not to tear each other down, but to learn from the directions they were taking and the pluses and minuses of their work. She did not want those round-table discussions where the stars of photography (the "Success Boys," she called them) exchanged gossip of the trade and tried to top one another in tales of their personal adventures. As she talked, she grew enthusiastic about making a film to counteract the common notion that the photographer's was only a second-rate trade whose pinnacle of achievement was a spread in *Life*.

A year later, back from Egypt, she met once more with Katz. She was sixty-eight now, she said; if she had ten more active years, she would be very lucky. What commitments could she make? She could no longer say of something, All right, I'll finish this later. How was she going to be able to do what she could best do? "All I do is on the way to doing the next thing . . . I'm like an old carpenter shop, full of splinters." She was hesitant about taking on new things; she had less energy and time was uncertain. Still, she had learned we can all do much more than we think we can. "I know how elastic time is. We don't go to our own limits." When Katz told her he already had approval for the film project—it could be an hour's length or two half hours—and that it only needed her yes, she gave it.

With Katz, Greene, and Richard Moore, who shared in the direction and editing of the films and narrated them both, she agreed on a method of work. The crew would try not to interfere too much with her preparation of the MOMA show, while at the same time she would let them catch things as they happened. The living room was her work space now. Greene fixed lights on the ceiling beams and bought a white rug to lay over the wooden floor so that the light would be reflected upward. They would phone in the morning to see what she would be doing that day and if she was well enough to let them come. Or she might call to say Szarkowski or someone else would be in and that they should come over to film it. After the diagnosis of cancer, she offered to call off the film because she didn't know how long she'd last. No, they said, we'd like to continue. She went on, working all she could, every day. Mornings, Paul would bring up her breakfast and his on a copper tray they had brought from India. They ate in her bedroom, looking out at the trees. At the end of the day, if her strength was gone, she'd go up to bed and in a little while he would bring her supper to her.

When she heard her voice on the film unit's tapes, she hated it: "I sound slow-witted, dull, soppy, I don't like myself at all." But her slow manner of speech was good; it gave a true picture of how she thought as she spoke, and of the surprising way she stressed particular words. If they asked her to repeat something good which she had just said, she would refuse. She thought it would come out false; it wouldn't be the natural way she had said it the first time. Once she phoned Katz early in the morning to say she

had been thinking about yesterday's shooting and didn't want him to use it. It was no good, she insisted, it was sentimental, maudlin. He had to remind her their agreement was that KQED make the film, not Lange, and the producer decided what to use.

The crew hoped to be able to film her at work with a camera. She had said she wanted to complete a photo-essay on life at the Steep Ravine cabin. But she was never able to do photography that last year.

Work on the first of the two films was finished early in July 1965. Everyone on the project was jumpy: how would Dorothea take it? *Under the Trees* was put together from many elements. Any combination of them could have been chosen to make a film. She was never told what they would include or how they would shape it. They screened the film in her home. After it had been running about ten minutes, her voice came from the back of the room: "I can't stand her already." But from the tone they knew she liked it. She didn't stop the projector or walk out of the room. She wrote Szarkowski to suggest that he talk to NET in New York about the film. If it could be released at the time her show would open, "it might serve the purposes of everyone involved." She did not live to see a screening of the other film, *The Closer for Me*. Its editing was not completed until December.

By the early fall of 1964 Paul was taking care of all Dorothea's correspondence as well as her meals and her medication. He would take dictation directly on his typewriter, and when she was unable to do even that, he would write letters on his own to post family and the people she was working with on her condition and what needed to be done. In October her esophagus began to close at times, and her doctor had to open the passage with the bougie device so that she could swallow food.

Szarkowski wrote her his ideas about the form the retrospective might take, phrasing them as questions she should think about. He wanted the show to present her work as a documentary photographer, stressing the issues she had been most concerned with. It should be designed and produced to express the most important underlying ideas. And as a photographer who had taken responsibility for making the completed picture exactly right, her own original prints should be included. He suggested presenting the photographs as dependent elements of a continuity. But within that flow would be included islands of framed original prints presented as ends in themselves, as self-contained statements. He hoped there would be extensive caption material, taken from what she reported her subjects had said. The space set aside could contain about two hundred pictures, with room for many large prints.

He planned to come out in November for ten days. But early that month the trip had to be postponed: she was taken to French Hospital for cobalt therapy. The thrice-weekly treatments jolted her and she had increasing difficulty in eating. Her esophagus had to be dilated daily. In the two

weeks she lay in bed her emaciated body lost another seven pounds. They gave her Librium to lessen the pain. She was holding on, but it felt as though there was a mountain ahead that she had somehow to climb. She and Paul had a quiet Thanksgiving dinner alone, for the first time. She knew she would not be able to preside over another Christmas festival. She sent word out that there would be no Christmas presents for the children this year.

By now the Library of Congress and the National Archives had sent the negatives of her government photography out to Berkeley so that she and Conrat could proof up her selections. They also completed proof prints chosen from her own negative file. Szarkowski arrived in mid-December, and under the surveillance of KQED's cameras and tape recorders, he and Dorothea worked on the raw materials for the exhibit. He had arrived very worried about how to handle the discussion. He knew she was sick, dying; yet the usual fight between curator and artist had to be faced. He was relieved to find she met it directly. She understood, she said, that it would be a fight in good spirit with no holds barred. And in so saying she dispelled all fear he might have had of being unfair to her in this extremity.

The issues between them were the standard ones. The curator had his idea of what is good and the artist had hers. If he pointed out to her that this picture was weak or that one badly organized, she'd say, Listen to me, young man, you were in knee pants when that photograph was made. With great forcefulness she would tell him the circumstances of the photograph, how it happened, where, what it meant, improvising the most eloquent caption. And she would shamelessly draw in Paul to support her, showing the picture in question and asking did he remember it? Of course he did, and they'd start going over how important it was. And then, half-laughing, for she knew that what she was doing was transparent, she'd conclude, And don't you think, Paul, that this picture should be in the show? Of course! he'd reply. To which Szarkowski would say, Well, Dorothea, we'll include that picture if you will stand there next to it for twelve weeks and tell the crowd as it passes why it's in the show. Because without *that* caption it won't work. And they'd all laugh.

She thought what the curator was doing was singling out the perfect picture; looking only for the aesthetics of the photograph, missing the guts of the content. (As Szarkowski remembers it, most of the time he prevailed.) He thought she came to understand what his position was. The big question in his mind was how to handle her recent work. To the artist that is more important than the early work: no one likes to believe he has lost his touch. And in Szarkowski's eyes her most recent work was not as good. She was still a fine photographer in those last years, but perhaps because of the long illness that was now even worse, she had lost some of her energy. In his opinion, the photographer working in strange countries is unable to know instinctively what things mean, how people feel. A

stranger to the scene, he photographs more on the surface, more from the outside.

When he left Berkeley a week later, it was with the feeling that he would be lucky if ever again he had as instructive an experience. He had known when he came that it would be hard work, but he had not anticipated how exhilarating it would be. He assured her that he now had a strong feeling for what she wanted the exhibit to say and for the spirit in which she wanted to say it. It would be his job to make it her statement as clearly and strongly as possible.

From that week with Szarkowski Dorothea learned how much more there was to a retrospective than making the final choice of the two hundred photographs to go up on the walls. It was also to decide their relative importance, relationships, stresses. That was the heart of the matter. They had reached substantial agreement about the choice of categories and the pictures to go in each. And they had also come to tentative decisions about the sequence and relative weight of the pictures, and about the probable sequence of the sections. René d'Harnoncourt would lay out the basic spatial design and architecture of the show, while Kathleen Haven would handle the details. Dorothea was to send the museum work prints of the show as she now conceived it, divided into sections, numbered according to sequences, and with annotation concerning weight and treatment. With that material in hand, the museum staff would do a rough framework to present to her and, when this was approved, proceed to the detailed solution of the individual passages.

She had said there would be no traditional Christmas this year, but it made itself, or rather, the family nearby made it come out pretty much the same as always, taking over her old special ways of celebrating it. Now and then she felt a little spurt of energy, and twice in the early winter months left the house briefly to watch Paul shop at the Coop. Later that winter, to the surprise of her hosts, who knew how ill she was, she went with Paul to a cocktail party. She carried a small camera on a leather thong, but never used it. It was soon after that an old friend, visiting from the East, came to her home and found almost the whole house turned into a workshop for the exhibit. Dorothea calmly told her, "It's not so bad knowing you're going to die. It's been a very interesting time since I got the news. It gives you a chance to reflect, to take stock: I'm not displeased on the whole."

Occasionally she was able to write her own letters, letting her feelings take over her pen. "If I seem in my words effusive and strong on the side of human affection," she wrote Margot, "it is because my present situation seems to call it forth from me. My people and my friends seem extra near and dear to me. I see them clear and their values *shine* . . ." She slept very little at night and would talk to herself and think of others. The months ahead seemed like an uncharted sea. In February she was living through

each day as it came, still mustering the strength to put something into work. There was always discomfort, and sometimes pain. When it came, she had the drugs handy. How long will this go on? she asked herself. No one could tell her. Paul was her anchor man. "We have good days and good times together, but it is wearing on him and sometimes when I am hard pressed I am irritable. He understands it." There was bad news within the family, hidden from her for months. Her son Dan and his wife, Mia, had separated, postponing telling her until after Christmas. "I cannot yet believe that this has happened," she wrote. The last six months had seen such grief for the family she had thought her own strength would hold up forever. Observing Paul's response to each piece of bad news, she remarked that "he is finding out for the *first* time what life is like." She had always seen him as a man living almost entirely within his own intense concerns. Her hold on each ritual slipped: now she let the family birthdays go by, not forgetting them, but unable any longer to do anything about them.

22 SHE HAD PROMISED SZARKOWSKI TO HAVE the work prints in by March 1, but during the winter months she suffered so many bad periods she fell way behind schedule. When the prints were finished at the end of April, she delayed forwarding them, deciding to send with each category a statement that would help reveal her purpose. Evidently she still felt she had to convince Szarkowski and the designer of the validity of her choices, and was falling back on words to bolster her visual conceptions. She assured Szarkowski that she did not mean to be rigid: she knew changes would be made. She proposed also to caption each work print separately, "beyond time and place, sometimes with brief commentary. Only some of this will be used, but all of it must be done 'for the record.' " She even suggested— "but only tentatively . . . my malady is grave and my days are difficult"—that it might help if she made a short visit to New York after he had seen what she would send in. She hoped he would phone as well as write her often. She wanted to feel his hand on her shoulder. Sensitive to her need, he wrote, "There is no doubt in my mind that this will be more than a fine and memorable show—it will be important for photography. Nor have I forgotten my promise to you that I will not let the show go up until it is good and right. Please depend on me."

Not until the end of May did she have the material ready to ship to New York. She sent about 250 work prints, divided into nine categories, together with a group of unmoored and unclassified prints, many of these to be used in pairs. "It may be that out of these we will choose a group (perhaps 21) which will all be beautifully printed but quite small—a sort of obbligato which will speak in a different voice from the rest of the show and hang there like beads on a string."

Now she started reading through all her field and travel notes to extract from them material for the final captions. Every print would be captioned,

some for date and place only, but many with words "to extend, buttress, illuminate, and explain the photograph," she said. She wanted her pictures closely moored to the reality and circumstances under which they were made.

The pairing of photographs was an idea she had cherished for a long time. Back in 1958, when the Newhalls were assembling their *Masters of Photography*, she had made her own selections and indicated the sequence of their presentation in the book. Sending the photographs in pairs, she had written:

> I find that it has become instinctive, habitual, *necessary*, to *group* photographs. I used to think in terms of single photographs, the bulls-eye technique. No more.
>
> A photographic statement is more what I now reach for. Therefore these pairs, like a sentence of 2 words.
>
> Here we can express the relationships, equivalents, progressions, contradictions, positives and negatives, etc. etc. Our medium is peculiarly geared to this. (I am just beginning to understand it.)

"Putting this work together has been a great time for me," she wrote Szarkowski. "I postponed it for so long—years—as you know, and then it sort of all came together of itself, with the wonderful help of my family, each one in his way—and those who became my family through their involvement in this. I thank you for pushing me into it, at the right time."

In June she and Paul had cause for celebration when the president and the regents of the University of California conferred an honorary doctor of law degree on Paul at the commencement exercises on the Berkeley campus. Special pleasure came not only for the recognition to Paul but for the reason that he had never hesitated to take a public position on controversial issues generally unpopular with the powers-that-be, including the regents themselves. Nevertheless, they had approved honoring him. Dorothea would not let her illness interfere with such a great occasion and attended together with her two sons, a son-in-law, four daughters-in-law and six of her ten grandchildren. Afterward they all came back home for champagne and a buffet luncheon in the garden.

From that time on she withdrew into the inner circle of things she valued most—the work she must finish before she died. Always impatient of intrusion, now she became fanatical. Even the Fangers, who had come West with their three little children to spend the summer nearby in a rented house, were allowed to see very little of her. But when they had to leave for home in late August, she made their final parting special. She and Paul went to the Steep Ravine cabin and had the five Fangers come over for the day. They said goodbye in a peaceful way, the way they always used to when nothing threatened. At twilight, with the fog coming in, they walked away through the deep misty grasses and turned to see

Dorothea's slight figure, in white pants and Chinese jacket, waving to them.

Dr. Rogers told her he thought she would get through the summer, maybe longer, but she must stay on the quiet side. How could she? People her age, she knew, often lived in their past. But "I have not yet been able to break the habit of thinking that everything is ahead," she said. "That has been my lifelong attitude. I find that every day taken separately, with full weight given to every hour, has seen me through the last months, and in some ways, it has been a great time." If "quiet" meant passive, then her summer would violate her doctor's orders. She wrote Beaumont Newhall to ask what photographs of hers were in the George Eastman House collection, so that she could supplement them if she thought it necessary: "I wish to leave behind me a good representation of my years of work." She did not let Project One drop. She kept putting out feelers for the right person to take her place, hoping someone would become excited enough about its possibilities to see it through.

She seemed to size up the photographer-friends who visited her now with this goal in mind. One of them, Robert Frank, went to see her on a day she was very sick, and she lay in bed while they talked. Then all of a sudden she said to him, "I just photographed you." He understood what she meant. She had taken a last picture of him in her mind. When Ken Heyman stopped by, she told him he was the man to carry out her goal of a new photo-document of American life. He wondered how many others she may have said this to. She reshaped her proposal, sending it to the Ford Foundation and to influential friends. In her new concept, Project One remained intact but became part of a larger enterprise she called "A Photography Center"—really a teaching institution with laboratory, gallery, library, viewing room, open to selected students interested in "explorations and experiments with the visual image as a language in its own right." Through the center the knowledge of photography would be advanced, taught, and applied to other disciplines which could be visually enriched by photography. And photography itself, developing such links to education, would come to serve a larger function.

During the summer she restudied a group of photographs she had worked with, off and on, for some twenty-five years, revising and captioning them until she was satisfied that her essay on "The American Country Woman" spoke in its own voice. The collection consisted of fifteen "personages," as she called them, the portraits of all but two of them accompanied by photographs of the home or the environment where the women lived. In 1948 she had told the Newhalls she had been working on this essay but had put it aside because she couldn't make it hang together. Taking it up later, she prepared a version which the United States Information Agency bought to send abroad to Italy and France in 1960 and

1961. Bits and pieces had been exhibited or published here and there, most recently in the International Harvester magazine. "There is historical importance to this collection, I believe. The photographs are not pictury, they are forthright."

Romana Javitz, the curator of the New York Public Library Picture Collection, had just bought one of the two sets of prints she had finished, and now Dorothea offered the other set to museums, pricing the collection at $750. Money, she made plain, was not a primary consideration now, "but of course I am under heavy costs so it cannot be ignored." Finding the right repository was more important to her.

Seven portraits of the American country women had been made in the thirties, the earliest in 1931, three in the forties, and the other five in the fifties, the last of them in 1956. All the women were white except for the ex-slave photographed on one of Dorothea's Southern field trips for the FSA. Four of the women lived in California, four in Utah, and the rest were scattered among Alabama, Arizona, Arkansas, Nebraska, North Carolina, South Dakota, and Texas. "These," Dorothea wrote, "are women of the American soil. They are a hardy stock. They are of the roots of our country. They inhabit our plains, our prairies, our deserts, our mountains, our valleys, and our country towns. They are not our well-advertised women of beauty and fashion, nor are they a part of the well-advertised American style of living. These women represent a different mode of life. They are *of themselves* a very great American style. They live with courage and purpose, a part of our tradition."

Two of the women had a special personal relationship to Dorothea. Rebecca Chambers, photographed at the age of eighty-one in Sausalito, was the sister of Dorothea's first husband, Maynard Dixon. The other was Lyde Wall, the next-door neighbor and friend on whose generous arm Dorothea had often leaned.

Two years after Dorothea's death, the Amon Carter Museum of Western Art in Fort Worth published the photo-essay under the title *Dorothea Lange Looks at the American Country Woman*. The preface (at her request) was written by Beaumont Newhall and the book was designed as she planned it, with the pictures and text in the sequence and arrangement she desired.

Busy as her summer was, she looked anxiously to New York for word on what progress was being made on her show. "Can I imagine you working on my show and would I be right?" she wrote Szarkowski. Then, speaking of her cancer, "If only it would ease up, and it weren't so difficult to work. But it is." One of her concerns about the retrospective was the preparation of the MOMA catalogue to go with it. The photographs would be introduced by an essay, and at first her son Dan Dixon was considered for the task. His writing about her photography made Dorothea value him as "one of my best understanders." She thought he could do for

the museum and herself a unique piece of work. But with the short time set by the schedule, and considering his own personal problems, she feared the uncertainty of depending on him would be too heavy a burden for her. Szarkowski then proposed that George P. Elliott do the introduction. Elliott had published an essay on photography and a novel whose hero was a Bay Area photographer; he had known Dorothea for over twenty years. Liking and trusting Elliott, Dorothea agreed. His mind was not burdened with old and tired ideas about photography, she said, but she did think that he needed to be "informed and fed . . . educated into becoming what we so badly need, a Critic." She hoped the occasion would lead him toward "insights into our profession." Elliott knew Dorothea did not have the highest opinion of his understanding of what a photographer does, but that she did think well of his prose. He felt honored to be asked. Never having seen her at work or talked with her extensively about her working habits, he went over to spend a day in her workroom late in June. He found her busy with Conrat on the exhibit. The filming was not going on that day. Taking only twenty minutes to rest at lunchtime, she worked and talked steadily from nine until four, when her strength gave out. She looked terrible to him, her weight down to about eighty pounds, "but her energy and humor seemed miraculously unimpaired. Her talk was as intelligent and juicy as anyone's in this world. She had more true vitality then, despite her pain and imminent death, than most people ever have at any age: the same only more so, because of the pressure of getting the show in shape before she died."

A couple of weeks after the visit she complained to Szarkowski that she had not heard a word from Elliott. "I wonder if he got anything from his day with me. I had the feeling that he was unobservant, non-visual. I wonder what will come forth." Szarkowski asked her not to be nervous about Elliott. "We will not know what he does until he does it, and then we will see. In the meantime we really can't help him very much; we can't tell him what to see or how to react. What we hope is that he will go to the pictures altogether in his own way, and illuminate them in his own light. 'Non-visual' is not the same thing as 'unobservant,' and maybe it is a good thing that sensitive people with different sorts of tools should react to each other's work. Cats can look at kings, and poets should be able to criticize physicists. Most 'serious' writing about photography suffers from being written by and for people who know too well, and too narrowly, what it is they are talking about. Let us try to let some new air in. I'm not saying that Elliott's piece will be right; I'm just saying let's not decide what right is ahead of time; let's hope to be told something that we don't know. I'm sure that this is what you also want."

A month later Elliott turned in a first draft. It was evident he had enjoyed writing it. He has done well by me, Dorothea told Szarkowski, there are fine things in it, a few factual errors easy to correct, and some dis-

DOROTHEA LANGE

jointed paragraphs "where I am falsely lighted and the photography process misunderstood." She sent Szarkowski her comments to be combined with his own and forwarded to Elliott.

At the end of August, Szarkowski arrived in Berkeley to work again with Dorothea. This was to be a last meeting of the minds engaged in conceiving and producing the exhibit. It was a difficult, almost impossible situation, for Dorothea had her own strong ideas, and Szarkowski his, and then there was Conrat too, who, though he was her assistant, had opinions which he did not hide. They started going over a big batch of work prints already chosen and sized. How would they organize it for the exhibit? Inevitably the outcome could only be a compromise. She had certain categories or themes in mind, significant to her, but not necessarily of the same meaning or weight to others. If this was to be *the* retrospective of her work, it was hard enough for the artist herself to compose its elements into a coherent whole. But how to do it when she must meet the criteria of a curator who came out of a different generation, a different experience, a different training? The choice and arrangement of an exhibit is then the result of conflicting forces. One subject Dorothea favored as a section for the show was called "Home." It is not a subject the professional photographer is likely to pursue. But she saw as much reason for photographing one's family and home and surroundings as for photographing the people of Egypt or Alabama. Besides, as Paul Taylor has pointed out, she had stayed much at home in her last twenty years, able to leave it only at times and with difficulty. She photographed the crown of her grandson Gregor's head, the live oak outside her bedroom window, the marble-top kitchen table, Paul's hands on his briefcase, her garden—images that reveal her primary concern for the familiar things of this world. Before Szarkowski arrived, Conrat had taken the "Home" prints Dorothea favored and, working and reworking them in consultation with her and the family, had come up with a design they agreed conveyed substantially what Dorothea was after. But in the end, after she had died, Szarkowski did something different with it, making it less prominent than she had originally intended it to be, and leaving out some pictures. If she had had final authority over her retrospective, with the museum obliged to mount it exactly as she wished, it would have been a somewhat different show. Which does not mean it would have been a better one. The artist does not always recognize when he has done his best.

Szarkowski had agreed to have the exhibit prints made in California if they would meet certain specifications. Earlier that month Dorothea had enlisted for the job the printing expert who had done Steichen's "Family of Man," Irwin Welcher, who was now working in San Francisco. Welcher came to Dorothea's house to discuss the printing problems with her and Szarkowski. That day they were working on the Egypt section and prints were strewn all over the floor or stacked in boxes. Small-scale layouts of

various sections of the exhibit as well as guide prints for areas not yet completely designed were tacked to the cork wall above her worktable. The size of the exhibit at this moment was set at 170 prints, with the deadline for print completion December 24.

Dorothea explained her ideas about prints. None was ever good enough to be called the best, she said, because there is always something more in the negative than we can seem to print. So we have to be satisfied with less than perfection. She wanted to avoid glossy, stark, black-and-white prints. They had their place for reproduction use or in photojournalism. But for this exhibit she wanted viewers to be able to get into a photo and examine it without being conscious of the fact that they had to get past a barrier to do so. She thought a finish such as poly-contrast G would be most likely to achieve that affect.

Welcher had some reservations about the G-finish paper but he wanted to take some of her negatives and try printing them on it. She gave him a list of the negatives for the section on Utah and a guide print for each one. Then she talked about the Utah photos to help him understand the feeling behind them and the reason for them. Her remarks show what she was after:

> I took this photograph of old Mrs. Savage in the thirties. Years later, I photographed her tombstone. Her son, Riley Savage, now an old man, heard I had a photo of his mother and asked me for a copy. I took this photograph of him. Now, in printing this face make it dark and rich but keep the flowing silvery feeling in the wave of the hair over the ear. The print of the gravestone should have the same tonal values as the photo of Mrs. Savage, and the print of her son should also be kept in the same tonal scale.
>
> Here's a photo of a lap that is a lap. They don't have laps any more today. Print it and let them see what a lap looks like.
>
> These poplars have the same straight stiff-backed characteristics of the Utah people. And if you look closely you can see the old ones dying, and the new ones growing up straight and strong. Give the print this strong feeling.
>
> Here you see what I call "Ancestor Worship." In printing these two photos, balance both prints so the framed photo stands out with the same impact even though in the one photo it is much smaller and further from the foreground than in the other. Emphasize the straight lines of the building and the straight stance of the man standing proudly in front of his father.

Welcher was to produce two sets of prints of the negatives selected for the show, processed to archival standards of permanency, and subject to Dorothea's requirements as to mood, tonality, and contrast. Two weeks later he returned with test prints: she was delighted. He had been experimenting with various lacquers and was confident that he could spray the prints with a mixture that would bring back all the detail and brilliance seen in the wet-print stage. Later, when she saw samples of the coating's effect, she thought the finish had made a miraculous difference. He sensed

a powerful desire in her to live to see and approve all the prints before they went off to New York. It was apparent that she was in great pain, and many times she had to leave him to rest for a half hour. Paul was always standing by, administering injections and seeing that she drank the liquids prescribed.

Szarkowski left at the end of a week for a vacation on Lake Superior feeling the exhibit was 90 percent settled. Dorothea continued to work each day, and at night, unable to sleep, kept going over the prints in her mind. Toward the end of September the doubts she had experienced about the exhibit were gone. "I am now not unsure," she wrote Szarkowski, thanking him for "an immense partnership" and sending him a gift box. In it was a cake of soap (she spoke of it as "a ritual of mine, it greets all related newcomers, and dates back to my own childhood"), two Idaho potatoes ("the longer and slower you bake them, the better"), and a Buddhist gong from a Korean temple, one of the congregation of gongs which hung at the door of her home. A fever took over, and on September 30 she had to enter the hospital. Dehydration of the body required huge amounts of fluids taken intravenously. She was in great discomfort and pain. A staff physician noted on her chart: "This 70-year-old petite thin female very much on the ball and has much insight into her condition." From her hospital bed she dictated to Paul messages for Szarkowski. Wouldn't printing the "New California" section of the exhibit on a colder stock, white base, convey that story better? Paul added to the note his own guess that there was a fifty-fifty chance she would make the show's opening in January. She was sent home the next day, but five days later, on Friday, October 8, knowing she was dying, and wanting Paul to have the comfort of someone close to him, she had him call his brother Sterling Taylor to help get her to the hospital. They carried her to the car and drove to French Hospital. The doctors found the dehydration had continued, the esophagus was obstructed, and bleeding had set in. The cancer had infiltrated nearby tissues. She went rapidly downhill.

Her sons and daughters-in-law stood by with Paul. On Sunday, Helen Dixon brought her pine branches freshly gathered in the hills. Dorothea smelled their fragrance and smiled. At noon that day Dr. Rogers told Paul, "She has finished her work." A little later, she said to Paul, "Isn't it a miracle, that this comes at the *right* time!" Then, soon after, "How fast it comes . . ." She died at 4:30 in the morning on October 11, 1965.

She was cremated and her ashes carried to the cabin at Steep Ravine, where she had wanted them scattered on the sea she loved. Her family took the urn down to the beach and dropped the ashes into the water. But they would not sink. The flakes floated away. "We started to laugh," her son John remembers. "You couldn't keep her down. It was a bittersweet reminder. Even now she would not go peacefully."

NOTES AND SOURCES
BIBLIOGRAPHY
INDEX

NOTES AND SOURCES

The following abbreviations are used:

CSS "Paul Schuster Taylor: California Social Scientist," Berkeley, 1975. All references, unless otherwise indicated, are to the first of three volumes of transcribed interviews. Volume I deals with Taylor's marriage to, and work with, Dorothea Lange.

DL Dorothea Lange

JS John Szarkowski

MDP "Dorothea Lange: The Making of a Documentary Photographer," Berkeley, 1968. A volume of transcribed interviews.

MF Margot Taylor Fanger

MM Milton Meltzer

PST Paul Schuster Taylor

RS Roy Stryker

CHAPTER 1

page
3 DL was born . . . May 25, 1895 . . .: DL's baptismal record on file at St. Matthew's-Trinity Lutheran Parish, Hoboken, N.J.
4 He was born . . . in 1868 . . .: Information on Nutzhorn family derived from 1880 Census Report, State Library, Trenton, N.J.
4 They traveled in steerage . . .: MDP, p. 4.
4 "and then plump themselves down . . .": Ibid., p. 3.
5 "My grandmother," she says . . .: Ibid., p. 1.
5 John began giving cello recitals . . .: Minelda Lange Jiras and Joy Lange Boardman to MM, interview, May 3, 1976.
6 "No one who hasn't lived . . .": MDP, p. 17.
6 she came to her door . . .: Helen Nestor to MM, May 25, 1976.
7 Her daughters-in-law both thought . . .: Helen Dixon to MM, interview, September 28, 1976.
7 "Years afterward . . .": MDP, p. 19.

7 For many years her son . . . : Daniel Dixon to MM, interview, September 16, 1976.

8 called her "The Wuz" . . . : Constance Dixon to MM, interview, October 20, 1976.

8 Dorothea recalled her mother . . . : MDP, p. 6.

8 "My father abandoned us": Ibid., p. 12.

8 debarred, or indicted . . . : Her mother later petitioned for divorce on the ground of desertion and was granted the final decree on December 18, 1919. Upon her request, the court permitted her to resume her maiden name, Lange.

9 "I wonder if I could ever . . .": DL journal entry for January 9, 1959. Journal in Lange Collection, Oakland Museum.

9 "I couldn't pry into it . . .": CSS, pp. 224–25.

9 She found a job . . . : Personnel Records, New York Public Library.

10 "I was the only Gentile . . .": MDP, p. 13.

10 At Public School No. 62 . . . : Opened in 1905, P.S. 62 became Seward Park Junior High School in 1922, and was torn down in 1930.

10 "was hard in some ways . . .": MDP, p. 13.

11 the student paper, *School Sixty-Two* . . . : Complete set of paper, 1904–13, is in the New-York Historical Society.

12 "I was unhappy there . . .": MDP, p. 14.

12 "The room had windows . . .": Ibid., pp. 14–15.

12 "I could just see . . .": Ibid., p. 22.

13 "I remember how afraid . . .": Ibid., p. 115.

13 "I sat on the 23rd Street crosstown . . .": Ibid., p. 20.

13 When she was about fourteen . . . : Ibid., p. 19.

14 such "marvellous sympathy . . .": Isadora Duncan, *My Life* (New York: Liveright, n.d.), p. 224.

14 "into the upper reaches . . .": MDP, p. 60.

14 "I became a solitary . . .": Ibid., p. 22.

14 "When I went uptown . . .": Ibid., p. 24.

15 On Dorothea's Wadleigh record . . . : Record on file at the Louis D. Brandeis High School Annex, 165 West Sixty-fifth Street, New York.

15 The school was traditional . . . : Helen O'Regan to MM, interview, May 28, 1976.

16 "She upgraded a paper . . .": MDP, p. 26.

16 "how red and big her hands were . . .": Ibid., pp. 64, 68–70.

17 made friends with only one classmate . . . : Florence B. Hayward to MM, interview, September 21, 1976.

17 They often went to concerts . . . : Ibid.

18 "I was essentially neglected . . .": MDP, p. 26.

18 "I want to be a photographer . . .": Ibid., p. 27.

CHAPTER 2

19 "I remember my mother . . .": MDP, p. 59.

19 "She was reliable and good . . .": Ibid., p. 27.

20 "I must show you the portrait . . .": Ibid., p. 7.

20 her mother was leaning on her . . . : CSS, p. 226.

20 Aunt Caroline was an important . . . : Minelda Lange Jiras to MM, interview, May 3, 1976.

21 Joan . . . took care of . . . John . . . : MDP, p. 7.

21 John Lange's daughters . . . : Jiras and Boardman, op. cit.
22 she gave the date as 1914 . . . : MDP, p. 27.
22 But in a letter written several years earlier . . . DL to Konigsberger, May 24, 1957.
22 she went to the New York Training School . . . : Hayward, op. cit.
22 All it took to enter . . . : Sam Kronman to MM, interview, April 6, 1976. He attended school about the same time as DL.
22 How Dorothea did . . . : The school and its records no longer exist.
22 working in photographers' studios . . . : MDP, p. 28.
22 "I've never not been sure . . .": DL to Nat Herz, interview, *Infinity* (April 1963) pp. 5–11.
23 "My mind made itself up . . .": Daniel Dixon, "Dorothea Lange," *Modern Photography*, v. 16, no. 12 (December 1952), p. 69.
23 "I thought at the time . . .": DL to Richard Doud, interview, May 22, 1964.
23 "I wish you'd take . . .": MDP, p. 30.
24 "an unconscionable old goat . . .": Ibid., pp. 28–29.
25 He did give her one . . . : Ibid., p. 52.
25 The turning point was . . . : George P. Elliott to MM, interview, December 28, 1976.
25 Her mother had to accept . . . : Hayward, op. cit.
25 Born in Armenia . . . : Frances K. Goldberger to MM, telephone interview, May 14, 1976. She worked for Kazanjian for many years.
25 At Kazanjian's . . . : MDP, p. 32.
26 "It was the first big job . . .": Ibid., p. 34.
26 "Shakespeare's plays fall into . . .": Quoted in "Beerbohm Tree in America," by Leonard H. Knight, *Theatre Survey*, 8:1, pp. 37–52.
27 Dorothea's job was . . . : MDP, p. 35.
27 proud she had her own "studio" . . . : Hayward, op. cit.
28 "It was heartbreaking to watch him . . .": MDP, p. 50.
28 "I invented my own photographic schooling . . .": Ibid., p. 51.
29 "face the challenge of severe limitations . . .": Beaumont and Nancy Newhall, *Masters of Photography* (New York: Braziller, 1958), p. 10.
29 "His range was narrow . . .": John Szarkowski, *Looking at Photographs* (New York: Museum of Modern Art, 1973), p. 50.
29 At Columbia he taught . . . : Details taken from course description in Columbia catalogue.
30 She found him to be . . . : MDP, p. 39.
30 "During his long fruitful career . . .": Szarkowski, op. cit., p. 50.
31 "an uncanny gift of touching . . .": MDP, p. 44.
31 "It was a good trade . . .": Ibid., p. 75.
31 "this plus thing . . .": Ibid., p. 76.
32 "people I left behind . . .": Ibid., pp. 64–69.
33 Pleiades Club . . . : Details from Pleiades Club Yearbook, 1929–30, in New-York Historical Society.
33 the unnamed friend . . . : MDP, p. 79.
33 "I wanted to go away . . .": Ibid., p. 80.
33 Their cash was little . . . : Details of the trip from MDP, p. 81, and Hayward, op. cit.

CHAPTER 3

45 On their first day . . . : MDP, pp. 81 ff.

46 "Usually the girl behind the counter . . .": Roi Partridge to Rondal Partridge, interview, May 1976.

46 "There's a girl down at Marsh's . . .": Imogen Cunningham to MM, interview, March 17, 1976.

46 She would work at 540 Sutter . . . : Details in MDP and Constance Dixon to MM, letters and interview, September 24, 1976.

47 "They were great helpers . . .": MDP, pp. 118–19.

48 "They are a marvelous record . . .": Christina Gardner, "The Contemplation of Dorothea," unpublished typescript, 1966, pp. 3–6.

48 "I knew something about . . .": MDP, pp. 56–57.

49 "It never occurred to me . . .": Ibid., p. 92.

49 "Dorothea had a very good business head . . .": Elizabeth Elkus to MM, interview, March 27, 1976.

49 "Dorothea was exact . . .": Cunningham, op. cit.

49 "I used to try to talk people . . .": Daniel Dixon, "Dorothea Lange," *Modern Photography* (December 1952), pp. 71–2.

49 "No subject can hold . . .": MDP, p. 54.

50 "It was a kind of diffidence . . .": Ibid., p. 91.

50 "Yes, she went to school . . .": Cunningham, op. cit.

50 Yet Cunningham herself . . . : Hilton Kramer, *The New York Times*, August 1, 1976.

51 Maynard Dixon . . . : Biographic details from "Outline of His Life," a WPA monograph, unpublished, 1936, in Edith Hamlin Collection, San Francisco; Wesley Burnside, *Maynard Dixon: Artist of the West* (Provo: Brigham Young U., 1974); and MM's interviews and correspondence with Constance Dixon and Daniel Dixon.

52 and apparently told a reporter . . . : San Francisco *News*, January 22, 1920. The news item mistakenly credited her with a degree in art from Columbia and with instruction in portraiture by Baron de Meyer as well as Genthe.

52 The only decorations were . . . : San Francisco *News*, March 24, 1920.

53 the "Little House" . . . : Constance Dixon to MM, November 4, 1976.

53 "a very attractive woman . . .": Elkus, op. cit.

53 Imogen Cunningham remembered . . . : Cunningham, op. cit.

54 The first time Constance saw . . . : Constance Dixon to MM, June 21, 1976, and July 6, 1976.

54 Ignoring what the child . . . : Constance Dixon to MM, interview, September 24, 1976.

55 "I have never watched . . .": MDP, p. 97.

55 "I participated in that . . .": Ibid., p. 99.

55 "I think now . . .": Ibid., p. 101.

55 "I had a family . . .": Ibid., p. 102.

56 Monkey Block . . . : It was taken down in 1951. But the site still boasts the "tallest building in San Francisco"—the 55-story Transamerica office pyramid.

56 Anywhere you met him . . . : MDP, p. 113.

57 "the first group I ever sold . . .": Ibid., p. 115.

57 remembers Bender "as a prince" . . . : John Collier, Jr., to MM, interview, March 25, 1976.

57 "an extraordinary person . . .": Ansel Adams to MM, April 28, 1976.

57 "My thought was . . .": MDP, p. 122.

58 "Listening to Stieglitz . . .": Maynard Dixon, "Outline," p. 18a.

58 "A revelation of the ultimate . . .": *Photo Miniature* (July 1921).

60 She was interviewed . . . : Anna Sommer, San Francisco *News*, February 11, 1932.

60 But there are other views . . . : Collier, Jr., op. cit.

61 On one occasion . . . : Rondal Partridge to MM, interview, March 19, 1976.

62 He left Dorothea with the baby . . . : Constance Dixon to MM, September 24, 1976.

63 "Much more than my earlier work . . .": Daniel Dixon, "Dorothea Lange," p. 72.

CHAPTER 4

64 "something ominous and unavoidable . . .": Maynard Dixon, op. cit., p. 25.

65 "A few of us . . .": *Maynard Dixon: Artist*, p. 10.

65 The club's action . . . "is unjust . . .": Ibid.

65 Constance, now twenty-one . . . : Constance Dixon to MM, September 24, 1976.

65 They bought . . . a Ford . . . : Daniel Dixon to MM, op. cit.

66 "There was money enough . . .": MDP, p. 136.

66 John Dixon, a little child . . . : John Dixon to MM, interview, March 25, 1976.

66 "I learned many enriching things . . .": MDP, p. 138.

66 A San Francisco newspaper reported . . . : Unidentified clipping, October 25, 1931.

66 "It was the first time . . ." : MDP, pp. 38–39.

67 "mostly by keeping everything smooth . . .": Ibid., p. 139.

67 she had written to Eastman Kodak . . . : Rondal Partridge to MM, May 25, 1976.

68 In an interview Dorothea gave . . . : San Francisco *News*, February 11, 1932.

68 "John was only four . . .": MDP, p. 141.

68 For one or two hours before . . . : Daniel Dixon to MM, op. cit.

69 In the front yard . . . : Ibid.

69 "Although my mind was over . . .": MDP, p. 144.

69 "the 1932 prints are . . .": Gardner, op. cit. pp. 6–7.

69 "One morning as I was making . . .": Daniel Dixon, "Dorothea Lange," pp. 73–75.

70 "if the boys had not been taken . . .": MDP, p. 147.

70 She always insisted . . . : DL to Richard Doud, op. cit.

70 "the discrepancy between what . . .": Herz, op. cit., p. 9.

71 "Almost at once she discovered . . .": Daniel Dixon, "Dorothea Lange," p. 75.

71 When she got home . . . : Consuelo Kanaga to MM, interview, February 9, 1977.

71 "I can only say I knew . . . : Herz, op. cit., pp. 9–10.

71 She took the print . . . : DL to Richard Doud, op. cit.

71 "Don't let that question . . .": MDP, p. 145.

72 "her first photograph to become widely known . . .": George P. Elliott, introductory essay in *Dorothea Lange* (New York: Museum of Modern Art, 1966), p. 9.

72 The family was reunited . . . : MDP, p. 148.

73 It was in this season . . . : Willard Van Dyke to MM, interview, November 20, 1975.

73 bringing with him Preston Holder . . . : Jim Alinder, "The Preston Holder Story," *Exposure* (February 1975), p. 2.
73 "It was just beautiful . . .": Ibid., p. 4.
73 "a very lovely place . . .": Ibid.
74 One evening in the fall . . . : Van Dyke, op. cit.
74 Adams has said . . . : Quoted in *U.S. Camera* (August 1955).
74 Ben Maddow, says the group . . . : Ben Maddow, *Edward Weston* (Millerton: Aperture, 1973), p. 256.
74 Adams asked that membership . . . : George M. Craven, "The Group f/64 Controversy" (San Francisco: Museum of Art, 1963).
74 Van Dyke proposed calling . . . : Van Dyke, op. cit.
74 Group f/64 made . . . headway . . . : Craven, op. cit.
75 Technique and viewpoint . . . : Ibid.
75 Ansel Adams insisted . . . : Quoted in Nathan Lyons, ed., *Photographers on Photography* (Englewood Cliffs, N.J.: Prentice-Hall, 1966), p. 24.
75 Ansel Adams recalls that . . . : Adams, op. cit.
75 "She was friends with . . ." : CSS, p. 119.
75 "She didn't belong to anything . . .": Ibid., p. 122.
75 "other criteria were more important . . .": Ibid., p. 292.
75 Preston Holder (whose camera . . .): Alinder, op. cit., p. 2.
76 Commenting on Holder's statement . . . : Willard Van Dyke, in letter to the editor, *Exposure* (May 1975), p. 2.
76 "From them," wrote Beaumont Newhall . . . : Beaumont Newhall, *American Country Woman* (Los Angeles: Amon Carter Museum, 1967), p. 6.
76 Van Dyke recalls Dorothea . . . : Van Dyke, op. cit.
76 "I wasn't accustomed to jostling . . .": MDP, p. 149.
76 "I'd begun to get . . .": Daniel Dixon, "Dorothea Lange," p. 75.

CHAPTER 5

77 I said, "I will set myself . . .": DL to Richard Doud, op. cit.
78 "Maynard was so leery . . .": MDP, p. 151.
78 "I did everything that I could . . .": Ibid., p. 152.
80 he had "dodged the responsibility . . .": Grant Wallace, *Maynard Dixon* (San Francisco: WPA Project 2874, 1937), p. 82.
80 Dorothea . . . had photographed . . . "Slave Market . . .": Evidence for this is in the Oakland Museum's Lange collection.
81 Adams wrote Stieglitz . . . : Quoted in Nancy Newhall, *Ansel Adams: The Eloquent Light* (San Francisco: Sierra Club, 1964), p. 98.
81 Born in Iowa . . . : Biographical information on Taylor in CSS, passim.
82 "Paul Taylor's ability . . .": Paul Gates, introduction to CSS, p. iii.
82 As far back as 1850 . . . : *American Heritage* (June 1977), p. 4.
83 "always examining issues . . .": Van Dyke, op. cit.
83 "of course that's nonsense . . .": MDP, p. 146.
83 "It does seem as if . . .": Ibid., pp. 155–58.
84 *Camera Craft* . . . : (October 1934), pp. 461–67.
87 in *Survey Graphic* (July 1934) . . . : "Whither Self-Help?", pp. 328–31, 348.
87 When Van Dyke said . . . : Van Dyke, op. cit.
87 Taylor recalls . . . : PST to MM, interview, March 15, 1976.
87 a "heartbreaking effort . . .": MDP, p. 165.
87 "I didn't do it very well . . .": Ibid., p. 166.
87 "especially if they are talking . . .": Ibid., p. 167.
88 He used his notebook . . . : CSS, p. 125.

88 he noticed her, too: Ibid., p. 122.

88 Taylor arranged for . . . : PST to Robert G. Sproul, November 10, 1934.

88 experience of a "double standard": CSS, pp. 123–25.

89 Taylor . . . brought Dorothea . . . : Ibid., p. 238.

89 "Suppose a man to be . . .": *Science*, Vol. 16 (1902), p. 321.

90 She is "an extraordinary phenomenon . . .": Nancy Newhall, *Ansel Adams*, p. 82.

90 But the photographer John Collier, Jr. . . . : John Collier, Jr., op. cit.

CHAPTER 6

92 The counties responsible . . . : Lawrence Hewes to MM, interview, May 17, 1976.

93 "I would like a *photographer* . . .": CSS, p. 126.

94 "there was . . . a resistance . . .": Ibid., p. 128.

94 It seemed an impasse . . . : Hewes, op. cit.

94 Hewes himself is an example . . . : Ibid.

94 When Dorothea learned her job . . . : CSS, p. 129.

95 He told Dorothea not to worry . . . : Ibid., p. 30.

95 Right from the beginning . . . : PST to MM, interview, March 15, 1976.

95 "She was a small person . . .": Tom Vasey to MM, February 2, 1976.

95 "They looked very woebegone . . .": DL to Richard Doud, op. cit.

99 When the team came in . . . : PST to MM, op. cit.

99 He quickly decided . . . : CSS, p. 137.

100 Without waiting for Washington . . . : Ibid., p. 138.

101 "I don't know if ever . . . : Ibid., p. 140.

102 The shift delighted him . . . : Hewes, op. cit.

103 Taylor's promotion of housing . . . : Ibid.

103 On Tugwell's staff . . . was Roy Stryker . . . : Biographical information in Roy Emerson Stryker and Nancy Wood, *In This Proud Land* (New York: Graphic Society, 1973), pp. 10–19.

103 his new textbook . . . : *American Economic Life* (New York: Harcourt Brace, 1925).

104 It was in those first weeks . . . : Stryker began work with RA on July 10, 1935.

104 "This was a revelation . . .": Ben Shahn to Richard Doud, interview, April 14, 1964.

104 "Along came Dorothea Lange's pictures . . .": RS to Richard Doud, interview, January 23, 1965.

105 "the best job both pictorially . . .": Pare Lorentz to PST, August 15, 1935.

105 "Her still pictures . . .": Pare Lorentz in *U.S. Camera* (1941), pp. 93–98.

105 Dorothea . . . sometimes believed . . . : MDP, pp. 168–70.

105 "a gold mine . . .": Florence Kellogg to PST, June 4, 1935. The Paul Taylor correspondence with *Survey Graphic* is in the Social Welfare History Archives Center, University of Minnesota, Minneapolis.

106 Lewis Hine . . . : Walter and Naomi Rosenblum, *America and Lewis Hine* (Millerton, N.Y.: Aperture, 1977), p. 10.

CHAPTER 7

126 "One day she called . . .": Cunningham, op. cit.

126 Her older son recalls . . . : Daniel Dixon to MM, op. cit.

127 "To think that after all . . .": Laura Banfield to MM, interview, May 4, 1976.

128 "On the afternoon of . . .": CSS, p. 149.
128 It was a two-story house . . .: MF to MM, January 23, 1977.
128 "You did a splendid job . . .": RS to DL, September 19, 1935.
129 Stryker replied that his funds . . .: RS to DL, October 30, 1935.
129 "which I know is foolish . . .": DL to RS, December 31, 1935.
129 She solved her work-space . . .: Ibid.
129 Stryker agreed to budget . . .: RS to DL, January 1, 1936.
130 could she hire an assistant . . .: DL to RS, December 31, 1935.
130 The negatives must be sent on . . .: RS to DL, January 31, 1936.
130 Nor could he help . . .: RS to DL, January 14, 1936.
130 "some good slum pictures . . .": Ibid.
131 "four hardboiled publicity negatives . . .": DL to RS, February 12, 1936.
131 "Dear Mr. Stryker . . .": DL to RS, February 24, 1936.
131 "Feel expansive . . .": DL to RS, March 2, 1936.
132 But in Nancy Newhall's . . .: *Ansel Adams*, p. 124.
132 "It was raining . . .": Dorothea Lange, "The Assignment I'll Never Forget: Migrant Mother," *Popular Photography* (February 1961), pp. 42–43, 128.
133 "When Dorothea took . . .": RS and Wood, op. cit., p. 19.
133 "Ragged, ill, emaciated . . .": Editorial, San Francisco *News*, March 10, 1936.
134 It was printed full-page . . .: *Survey Graphic* (September 1936), pp. 524–25.
134 "Please, mister," she wrote . . .: DL to Edwin Locke, September 10, 1936.
134 Jack Hurley, a close student . . .: F. Jack Hurley, *Portrait of a Decade* (Baton Rouge: Louisiana State U., 1972), p. 130.
134 "Oh, what dreadful prints . . .": MDP, p. 199.
134 The best known of her photographs . . .: Margery Mann, "Dorothea Lange," *Popular Photography* (March 1970), p. 84.
135 "Most of Lange's pictures . . .": George P. Elliott, "Things of This World," *Commentary* (December 1962), p. 342.
135 "not all the wire-pulling . . .": Elliott, *Dorothea Lange*, p. 7.
136 "I am not a 'one-picture' . . .": *The Closer to Me*, KQED film, and "The Assignment I'll Never Forget," p. 42.

CHAPTER 8

137 "It was not altogether easy . . .": CSS, p. 149.
137 "harnessed to the house . . .": Ibid., p. 150.
138 "Gradually, as we could . . .": Ibid., p. 150.
138 ulcer symptoms began . . .: Dorothea Lange medical record, University of California Hospital, entry dated February 25, 1946.
139 The RA people . . .: MDP, p. 172.
140 Happily, his new chief . . .: CSS, p. 148.
140 "a good deal of the discipline . . .": MDP, p. 176.
140 "To know ahead of time . . .": Ibid., pp. 177–78.
140 "Sometimes you stick around . . .": DL to Richard Doud, op. cit.
141 "That's behind me . . .": MDP, pp. 178–79.
141 "I found a little office . . .": DL to Richard Doud, op. cit.
142 she saw Aaron Siskind . . .: Aaron Siskind to MM, December 29, 1976.
142 At that time a federal regulation . . .: Hewes, op. cit.
143 "This was not a preconceived . . .": RS to Edna Bennett, August 29, 1962.
143 "It sort of just happened . . .": Arthur Rothstein to Richard Doud, interview, May 25, 1964.

143 "a teacher who could . . .": Edwin Rosskam to Richard Doud, interview, August 3, 1965.
143 Stryker "knew more about America . . .": Jack Delano to Richard Doud, interview, June 12, 1965.
144 he was "particularly infuriated . . .": Quoted in William Stott, *Documentary Expression* (New York: Oxford U. Press, 1973), p. 281.
144 "that little rectangle . . .": Quoted in John Durniak, "Focus on Stryker," *Popular Photography* (September 1962), p. 80.
144 "Roy took it on . . .": DL to Richard Doud, op. cit.
145 "his deepest interest lay . . .": Collier, Jr., op. cit.
145 As Lange and Taylor moved south . . . : Details of this and other field trips, when not taken from specified letters or interviews, are drawn from study of DL's prints and captions, on deposit in Library of Congress, National Archives, and Oakland Museum.
147 How many poor farmers . . . : Sidney Baldwin, *Poverty and Politics* (Chapel Hill: U. of North Carolina, 1968). This is the most authoritative study of the FSA's successes and failures.
148 The special significance . . . : Daniel Dixon, "Dorothea Lange," pp. 72, 138.
148 "We are getting the greatest . . .": Edwin Locke to DL, July 7, 1936.

CHAPTER 9

151 "It was a hard trip . . .": DL to RS, September 3, 1936.
151 "the negatives are all flat . . .": DL to RS, September 5, 1936.
151 "I am not trying to make . . .": DL to RS, September 10, 1936.
151 "A lot of these proof-prints . . .": DL to RS, September 30, 1936.
151 "their negatives show not . . .": RS to DL, October 7, 1936.
152 She knew what she wanted . . . : Wayne Miller to MM, interview, March 28, 1976.
152 Rondal Partridge, who assisted . . . : Rondal Partridge to MM, interview, March 23, 1976.
152 "She could use an old . . .": Homer Page to MM, interview, May 2, 1976.
152 Partridge remembers . . . : Rondal Partridge to MM, March 23, 1976.
152 Christina Gardner, another young . . . : Christina Gardner to MM, interview, March 23, 1976.
153 "The print is not the object . . .": Ralph Gibson to MM, interview, March 8, 1976.
153 She didn't have great technique . . . : Van Dyke, op. cit.
153 "Today, with automatic cameras . . .": Rothstein to MM, January 21, 1976.
153 "I thought of photography . . .": Shahn, op. cit.
154 "No one else I know . . .": John Dominis to MM, interview, April 1, 1976.
154 "Lange was not a master printer . . .": Van Deren Coke, "Dorothea Lange: Compassionate Recorder," *Modern Photography* (May 1973), p. 2.
154 the photographer's *"only* function is . . .": E. P. Janis and W. MacNeil, eds., *Photography within the Humanities* (Danbury: Addison House, 1977), pp. 79–80.
155 "Politically much hinges on it . . .": DL to RS, September 16, 1936.
155 "the labor situation is so tense . . .": John Steinbeck to George Albee, Elaine Steinbeck and Robert Wallsten, eds., *John Steinbeck: A Life in Letters* (New York: Viking, 1975).
155 "my safety lies . . .": Ibid., January 11, 1937.

155 "The economy bug has hit . . .": RS to DL, October 7, 1936.

156 On a trip to New York . . . : Ibid.

156 Losing her job did not upset her . . . : PST to MM, October 29, 1976.

156 "not as an auxiliary . . .": RS to DL, October 22, 1936.

157 She defended herself . . . : DL to RS, November 19, 1939.

158 "I think we have a chance . . .": DL to RS, December 13, 1936.

158 Stopping off in New York . . . : Robert Katz to MM, interview, September 24, 1976.

159 "Photojournalism did not exist then . . .": MDP, p. 155.

159 *Life's* request . . .": Date of first issue was November 23, 1936.

159 "an extraordinary national . . .": Alfred Kazin, *On Native Grounds* (New York: Doubleday Anchor, 1956), pp. 378–81.

160 "I wonder if you . . .": RS to DL, October 22, 1936.

160 In an article of 1938 . . . : Beaumont Newhall in *Parnassus* (March 1938), pp. 3–6.

161 later he writes . . . : Beaumont Newhall, *History of Photography* (New York: Museum of Modern Art, 1964), p. 137.

161 "We rejected the word 'historical' . . .": B. Newhall, *American Country Woman*, p. 5.

161 "Documentary photography records . . .": As reprinted in CSS, p. 238A.

CHAPTER 10

163 "but now I cannot see . . .": DL to RS, January 27, 1937.

164 "I've worked on this job . . .": DL to RS, April 2, 1937.

164 "The idea on which . . .": DL to RS, February 8, 1937.

164 "but I hope you will not . . .": DL to RS, April 2, 1937.

165 "an Olympian . . .": W. Eugene Smith, "One Whom I Admire: Dorothea Lange," *Popular Photography* (February 1966), p. 86.

165 what goes on there . . . : DL to RS, February 16, 1937.

166 "After more than two months . . .": Quoted in James Rorty, *Where Life Is Better* (New York: Reynal and Hitchcock, 1936), p. 322.

166 The young fellow was Ron Partridge . . . : PST to MM, October 29, 1976.

167 "When she saw some activity . . .": Rondal Partridge to MM, taped communication, August 1977.

168 "are loaded with ammunition . . .": DL to RS, March 12, 1937.

168 "They have a fight on . . .": Ibid.

168 Their gripe is genuine . . . : DL to RS, February 18, 1937.

169 "I am not so anxious . . .": DL to RS, April 6, 1937.

169 She would not have it . . . : DL to RS, March 23, 1937.

169 "I am anxious to get out . . .": DL to RS, April 6, 1937.

169 she lamented she was left . . . : DL to RS, April 27, 1937.

170 trip was abruptly canceled . . . : RS to DL, April 16, 1937.

170 He spent an evening . . . : RS to DL, March 24 and April 16, 1937.

170 She was to start South . . . : RS to DL, April 16, 1937.

170 There might be some extra duties . . . : DL to RS, April 21, 1937.

170 "I wish I could have . . .": DL to RS, April 27, 1937.

171 "Another concern is over . . .": DL to RS, April 23, 1937.

171 As MacLeish recalled . . . : Archibald MacLeish to MM, December 16, 1976.

171 Stryker was assured . . . : RS to DL, March 23, 1937.

171 "watch out for ghost towns . . .": RS to DL, May 10, 1937.

172 Invited to come . . . : Margot Fanger to MM, interview, May 4, 1976.
172 Crossing into Arizona . . . : DL to RS, May 28, 1937.
173 Early in June she wrote . . . : DL to RS, June 3, 1937.
174 "To be sure, if you look . . .": Elliott, *Dorothea Lange*, p. 6.
175 "Landlords clash with . . .": PST to Tom Blaisdell, June 3, 1937.
176 "You went with Rothstein . . .": DL to RS, June 9, 1937.
176 again urged Stryker . . . : DL to RS, June 14, 1937.
176 "the accepted group . . .": RS to DL, June 18, 1937.
176 "Take both black and white . . .": Ibid.
177 "I need very much to be assured . . .": DL to RS, June 1937.
177 "Very disconcerting . . .": DL to RS, June 18, 1937.
178 "You couldn't find . . .": DL to RS, June 23, 1937.
178 "I could not believe . . .": Prentice Thomas to RS, June 21, 1937.

CHAPTER 11

179 "cloaked their ambitious goals . . .": Baldwin, op. cit., p. 193.
180 "I wish that I could work . . .": DL to RS, October 6, 1937.
180 "I am not yet through . . .": DL to RS, October 20, 1937.
180 "These newspaper-trained men . . .": DL to RS, October 10, 1937.
181 "I'm convinced of the effectiveness . . .": DL to RS, November 16, 1937.
181 Most of the month . . . : DL to RS, January 12, 1938.
181 "starving to death . . .": Steinbeck, op. cit., pp. 158–59.
181 "The suffering is too great . . .": Ibid., pp. 161–62.
182 Lange provided her photographs . . . : PST to MM, November 28, 1976.
182 Taylor made the case . . . : Reported in San Francisco *Examiner*, April 26, 1938.
182 She asked Stryker . . . : DL to RS, May 2, 1938.
182 "There is very little cash . . .": DL to RS, May 23, 1938.
183 "You will be encouraged . . .": Ibid.
183 "the America of how to mine . . .": Stott, op. cit., p. 50.
183 "I never give up hope . . .": RS to DL, May 17, 1938.
183 "It needs to be said . . .": DL to RS, May 23, 1938.
184 "What a reader feels . . .": Stott, op. cit., p. 233.
184 the book was a "double outrage . . .": Ibid., pp. 222–23.
185 Shahn called the pictures "inadequate . . .": John D. Morse, *Ben Shahn* (New York: Praeger, 1972), p. 139.
185 Bourke-White's pictures . . . : Stott, op. cit., p. 220.
185 "it is a collection . . .": MacLeish, op. cit.
185 "a rather interesting reception . . .": RS to DL, May 17, 1938.
185 "I give her chief credit . . .": Issue of April 2, 1938.
186 "These people are worth . . .": CSS, p. 217.
186 She said Stryker wanted . . . : Quoted in Hank O'Neal, *A Vision Shared* (New York: St. Martin's, 1976), p. 175.
186 "a brand-new territory . . .": Stryker and Wood, op. cit, p. 7.
186 It was the briefest encounter . . . : Marion Post Wolcott to MM, March 15, 1976.
187 "I'm very opinionated . . .": RS to Richard Doud, op. cit.
187 "I liked Dorothea . . .": Quoted in *Just Before the War: Urban America from 1935 to 1941*, Newport Harbor Art Museum catalogue, Balboa, CA, 1968, pp. 8–9.
187 "Others could judge better . . .": RS to Richard Doud, op. cit.

page
188 "Fischer was very much worried . . .": RS to DL, October 7, 1938.
190 It was "the tail end . . .": DL to RS, November 1, 1938.
191 She begged to have proof . . . : DL to RS, November 12, 1938.
191 "You know that we have . . .": Ibid.
192 "after the usual diet . . .": Springfield *Union & Republican*, September 11, 1938.
192 "I am astounded . . .": RS to DL, December 22, 1938.
192 "Do you and the staff . . .": DL to RS, November 22, 1938.
193 she turned to her darkroom . . . : DL to RS, December 7, 1938.
193 "You know that my book . . .": Ibid.
193 "I see no reason why . . .": RS to DL, December 22, 1938.
193 Paul and Dorothea needed . . . : PST to MM, interview, March 15, 1976.
194 The function each photographer . . . : CSS, p. 217.
194 "We were trying . . .": Ibid., pp. 218 and 295.
194 "thousands of families . . .": Margaret Marshall, *Nation* (January 20, 1940), p. 77.
195 "a bold experiment . . .": B. Newhall, *American Country Woman*, p. 7
195 "The real opportunity for . . .": Lange and Taylor, *An American Exodus* (New York: Reynal & Hitchcock, 1939), p. 154.

197 in a long, gossipy letter . . . : RS to DL, December 22, 1938.
198 "the depth of her observation . . .": B. Newhall, *American Country Woman*, pp. 7, 71.
199 But he also complained . . . : RS to DL, March 4, 1939.
199 He asked her to place . . . : RS to DL, September 7, 1939.
199 While Dorothea understood . . . : CSS, p. 124.
200 "The negatives were retouched . . .": DL to RS, May 16, 1939.
200 "I think I am going . . .": Jonathan Garst to RS, May 13, 1939.
200 "I don't see Stryker . . .": Rondal Partridge to MM, March 19, 1976.
200 "It wasn't true even then . . .": Quoted in *Paul Strand* (Millerton, N.Y.: Aperture, 1976), p. 34.
201 Dorothea said she knew . . . : MDP, pp. 202–03.
201 pointed out by George P. Elliott . . . : *Dorothea Lange*, p. 10.
202 "the Associated Farmers have tried . . .": Steinbeck, op. cit., pp. 187–88.
202 "While Dorothea Lange was the first . . .": Lorentz, *U.S. Camera* (1941), p. 94.
203 ingeniously traced by D. G. Kehl . . . : "Steinbeck's 'String of Pictures' in *The Grapes of Wrath*," *Image* (March 1974), pp. 1–10.
203 The director hired FSA staff . . . : Hewes, op. cit.
204 "Someone told her I could . . .": Quoted from Steinbeck Papers by Kehl, op. cit.
204 issued the publication . . . : *Photo Notes* file, Museum of Modern Art.
204 "We don't know what . . .": DL to RS, September 7 and 9, 1939.
204 Although Stryker had some trouble . . . : Hewes, op. cit.
205 "No one can forecast . . .": RS to DL, September 16, 1938.
205 "He has been interested . . .": RS to DL, October 6, 1939.
207 "but I don't believe . . .": RS to Jonathan Garst, November 30, 1939.
208 "Stryker did not understand . . .": Quoted in O'Neal, op. cit. p. 61.
209 "I believe that the method . . .": DL to RS, January 19, 1940.

242 "She complained of . . .": Gardner to MM, op. cit.
242 Twenty-odd years later . . . : MDP, p. 192.
243 "a powerful reminder . . .": Maisie and Richard Conrat, *Executive Order 9066*, pp. 110–11.
243 "Apparently," said Conrat . . . : Richard Conrat to MM, December 10 1976.
244 "the photograph as evidence . . .": Coleman, *The New York Times*, September 24, 1972.
244 the exhibit was "harrowing . . .": Hilton Kramer, *The New York Times*, September 16, 1972.
245 "When I was working . . .": MDP, p. 180.
246 "Everything is propaganda . . .": Ibid, p. 181.
246 "It's like working . . .": Ibid, p. 183.
246 "I was struck by . . .": B. Newhall, *American Country Woman*, pp. 7–8.
248 Dorothea had a better idea . . . : Daniel Dixon to MM, September 16, 1976.
248 Page at the time . . . : Homer Page to MM, interview, May 2; 1976.
248 The contrast in . . . : Gardner, "Contemplation," p. 13.
250 He felt the family . . . : Daniel Dixon to MM, September 16, 1976.
250 "After asking her to photograph it . . .": PST to MM, interview, March 15, 1976.
250 she was in bad shape . . . : University of California Hospital, medical record.
251 Coming in the door . . . : PST to MM, March 15, 1976.
251 Then she happened upon . . . : Elliott to MM, op. cit.
251 To one of them . . . : Ibid.
252 heard excruciating sounds . . . : Page to MM, May 2, 1976.
252 When she left the hospital . . . : PST to MM, February 19, 1977.
252 Friends remarked . . . : Priscilla and Alan Brandt to MM, interview, May 13, 1976.
252 The two women had . . . : CSS, p. 251.
252 Her son Daniel recalls . . . : Daniel Dixon to MM, September 16, 1976.
252 Dorothea's own taste ran . . . : Elliott to MM, op. cit.
253 "a total loss" . . . : *Under the Trees*, KQED film.
253 "Please keep my balance . . .": DL to Henry Allen Moe, December 26, 1946.

CHAPTER 16

279 With Helen . . . : Helen Dixon to MM, May 17, 1976.
279 Nancy Newhall asked her . . . : Nancy Newhall to DL, March 17, 1948. I am especially indebted to Beaumont Newhall for allowing me to draw upon his and Nancy Newhall's correspondence with DL.
279 "I'd like to contribute . . .": DL to Nancy Newhall, April 3, 1948.
279 Newhall wrote again . . . : Nancy Newhall to DL, April 7, 1948.
280 She wrote Newhall . . . : DL to Nancy Newhall, April 12, 1948.
280 Newhall began to scour . . . : Nancy Newhall to DL, April 28, 1948.
280 That fall Steichen . . . : *The New York Times*, October 16, 1948.
281 "In the past, events . . .": Daniel Dixon, "Dorothea Lange," pp. 140–41.
282 written to tell Strand . . . : DL to Paul Strand, November 27, 1940.
283 The Photo League . . . : *Photo Notes*, passim.
284 "I never did finish . . .": DL to Henry Allen Moe, August 30, 1951.
284 She had developed esophagitis . . . : For an understanding of this and other aspects of Lange's illnesses I am deeply indebted to Dr. Kurt Elias.

284 wrote Beaumont Newhall in a report . . . : It appeared in *Aperture*, 3:3 pp. 3–10. I am indebted also to Ferenc Berko, organizer of the conference, for background. Berko to MM, March 26, 1977.

285 "Photographing the Familiar" . . . : *Aperture*, 1:2 (1952), pp. 4–15.

285 It was Dan's idea . . . : Daniel Dixon to MM, March 21, 1977.

286 She did, said Daniel . . . : Daniel Dixon, "Dorothea Lange," p. 69.

287 "It's a strange thing . . .": Banfield, op. cit.

287 Joan left a surprising amount . . . : Will of Joan C. Bowly, filed in the County of Hudson, N.J., December 22, 1952. She died September 24, 1952.

287 interviewed by Jacob Deschin . . . : *The New York Times*, December 7, 1952.

CHAPTER 17

289 "She was marvelous . . .": Szarkowski, *Looking at Photographs*, p. 130.

289 Adams is not certain . . . : Adams, op. cit.

289 Paul Taylor offered . . . : CSS, p. 244.

289 Fresh from his experience . . . : Daniel Dixon to MM, September 16, 1976.

290 "We shared the work . . .": Adams, op. cit.

290 but *Life* gave no . . . : *Life* (September 6, 1954).

290 her friends the Banfields . . . : Banfield, op. cit.

290 Adams showed up . . . : Daniel Dixon to MM, September 16, 1976.

291 Once she told George Leonard . . . : George Leonard to MM, taped communication, August 1977.

291 Adams felt the trouble . . . : Adams, op. cit.

291 working for *Life* . . . : *Life*'s page rate in the early 1950's averaged about $200, with a higher sum for color. Some of the more eminent photographers were paid double that rate, and DL and Adams may well have received that much.

291 "She was not untouched . . .": Bernard Quint to MM, interview, April 5, 1976.

292 Asked once by Wayne Miller . . . : Miller, op. cit.

292 Her mood was buoyant . . . : Daniel Dixon to MM, April 3, 1977.

292 "Irish Country People" . . . : *Life* (March 21, 1955).

293 He had come to New York . . . : Daniel Dixon to MM, September 16, 1976.

293 "What was needed . . .": Edward Steichen, *Life in Photography* (New York: Doubleday, 1968), p. 15.

294 "Those hard-bitten bastards . . .": Shirley Burden to MM, interview, September 20, 1976.

294 "a dredging process . . .": MDP, p. 211.

294 "If anyone asks . . .": Charles Rotkin to MM, interview, April 16, 1976.

294 two people whose opinions . . . : Kathleen Haven Newton to MM, interview, May 3, 1976. I am obliged to her for many details of the exhibit's preparation.

296 He enjoyed a fight . . . : Homer Page to MM, May 2, 1976.

296 With Wayne Miller he rushed . . . : Miller, op. cit.

296 "He works up to . . . : MDP, pp. 211–12.

296 "No one," said Steichen . . . : Steichen, op. cit., pp. 16–17.

296 Writing in *Aperture* . . . : 9:1 (1961), p. 41.

297 A critic in *The Atlantic* : Phoebe Lou Adams, issue of April 1954, pp. 60–62.

297 Susan Sontag would echo . . . : *New York Review of Books* (November 15, 1973), p. 13.

297 Aline Saarinen . . . : *The New York Times*, February 5, 1955.

297 "established our mythic expectations . . .": *Artforum* (September 1976), pp. 43–45.

297 applied . . . to the Guggenheim . . . : PST and DL to Henry Allen Moe, December 15, 1954.

298 But the foundation did not . . . : DL to Henry Allen Moe, March 5 and March 9, 1955.

298 She found a perfect focus . . . : Martin Pulich to MM, May 28, 1976.

299 He watched her walk . . . : Pirkle Jones to MM, interview, March 20, 1976.

299 Perhaps that is why Magnum . . . : John Morris to MM, interview, April 28, 1976.

300 but George Leonard . . . : George Leonard to MM, taped communication, June 1977.

300 Emmy Lou Packard, was working . . . : Emmy Lou Packard to MM, May 18, June 6, June 24, July 30, and November 6, 1977.

301 Not far off . . . : "Death of a Valley," *Aperture*, 8:3 (1960).

301 Dorothea drove up . . . : Jones, op. cit.

302 "Damnit, it's getting . . .": Quotes from *Aperture*, 8:3 (1960).

302 *Life* was to see . . . : Jones, op. cit.

CHAPTER 18

304 "she chose . . . to meditate . . .": Collier, Jr., op. cit.

304 In both she described . . . : California School of Fine Arts, course announcements for 1957–58; Harry Mulford to MM, January 27 and 28, 1976. DL's seminar met for nine two-hour periods interspersed with four lab sessions. Enrollment was limited to 22 students. She was paid $225 for the term.

305 Remembering it one morning . . . : Margery Mann, in preface to *Imogen Cunningham: Photographs* (Seattle: U. of Washington, 1970), p. 20.

305 "She was uncanny . . .": Jerry Burchard to MM, interview, March 24, 1976.

305 In the notes kept . . . : I am grateful to Nancy Katz for a photocopy of her course notes, from which these details and quotations are drawn.

306 "I hate that foot!" . . . : Robert Katz, op. cit.

306 She chided one friend . . . : Cal Bernstein to MM, interview, September 20, 1976.

307 "What she had to give . . .": Miller, op. cit.

307 Those who came to know . . . : Ruth-Marion Baruch to MM, interview, March 20, 1976.

307 Burden showed his prints . . . : Burden, op. cit.

307 There is a reverse side . . . : Daniel Dixon to MM, September 16, 1976.

308 she heard from the Newhalls . . . : DL to Nancy Newhall, February 10, 1958.

308 "I constantly meet . . .": DL to Nancy Newhall, February 14, 1958.

308 The Newhalls quickly . . . : Nancy Newhall to DL, February 19, 1958.

308 "This is a list . . .": DL to Nancy Newhall, February 16 and March 18, 1958.

309 "two of the greatest . . .": Nancy Newhall to DL, March 31, 1958.

309 "as fully as my ability . . .": DL to Nancy Newhall, April 22, 1958.

309 a fairly steady correspondence . . . : I owe much to Margot Taylor Fanger (MF hereafter) for furnishing photocopies of the many letters used in this and other passages.

309 "No crisis . . .": DL to MF, February 14, 1957.
309 "It is because . . .": DL to MF, August 24, 1957.
309 the core of family life . . . : PST to MM, March 15, 1976.
310 "I thought how": Bernstein, op. cit.
310 The custom was to go off . . . : Dyanna Taylor to MM, interview, September 28, 1976, and Paul Taylor II to MM, interview, October 27, 1976.
311 "These are pictures . . .": From album in Helen Dixon's collection.
312 Still trying for . . . : Leonard to MM, taped communication, June 1977.
312 *Look* published a three-page tribute . . . : *Look* (March 3, 1966).
312 The Euclid house . . . : Leslie Dixon to MM, February 2, 1977.
312 Once she told . . . : Helen Dixon, op. cit.
312 "you could always count . . .": Dyanna Taylor, op. cit.
313 "This saddens me . . .": DL to Donald Fanger and MF, December 10, 1957.
313 "Paul has *wrecked* . . .": DL to MF, December 19, 1957.
313 "the Napoleon of the holidays" . . . : Daniel Dixon to MM, September 16, 1976.
313 "Just as you told us . . .": DL to Donald Fanger and MF, January 4, 1958.
313 A close friend . . . : Rondal Partridge to MM, interview, March 14, 1976.
314 To Dan Dixon, his mother . . . : Daniel Dixon to MM, September 16, 1976.

CHAPTER 19

315 From his long study . . . : CSS, III, pp. 386–92.
316 "It rains, rains . . .": DL to MF, February 6, 1958.
317 "They worked with a will . . .": DL to MF, March 18, 1958.
317 "That you should now . . .": DL to Nancy Newhall, n.d., 1957.
317 "So if we go . . .": DL to MF, April 18, 1958.
317 "hoisted on a plane . . .": DL to MF, April 8, 1958.
318 "my Liege is . . .": DL to MF, June 14, 1958.
318 she became so sick . . . : CSS, p. 225.
318 It may well be . . . : Ibid., p. 248.
318 "Paul and I are . . .": DL travel notebook, October 6, 1958.
318 He thought neither . . . : CSS, p. 257.
318 "To this you sacrifice . . .": DL travel notebook, October 8, 1958.
318 Further down . . . : Ibid., October 3, 1958.
319 "A beautiful dinner party . . .": Ibid., October 4, 1958.
319 The Koreans she found . . . : DL to MF, July 24, 1958.
320 Often when she started . . . : CSS, p. 254.
320 where, as Paul said . . . : PST to MF, November 10, 1958.
320 In contrast to the Koreans . . . : CSS, pp. 259–60.
321 "It's only grab-shooting . . .": DL to MF, September 27, 1958.
321 But two months later . . . : DL to MF, November 29, 1958.
321 She questions herself . . . : DL travel notebook, September 24, 1958.
322 "Is this something? . . .": Ibid., October 2, 1958.
322 "a *good* day . . .": Ibid., October 10, 1958.
322 "I wish I were . . .": Ibid., December 22, 1958.
323 memories flooded in . . . : Ibid., January 2, 1959.
323 "They were *good* Germans . . .": Ibid., January 5, 1959.
323 "Gruss Gott . . .": Ibid., January 8, 1959.
323 And it suddenly dawned . . . : Ibid., January 9, 1959.

324 "No one ever loved . . .": Ibid., January 13, 1959.
324 It looked much the same . . . : CSS, II, p. 431.
324 How fine it was . . . : DL to MF, February 25, 1959.

CHAPTER 20

325 "Paul and I have· . . .": DL to MF, April 9, 1959.
325 She watched him depart . . . : DL to MF, August 14, 1959.
325 "Speaking as DL . . .": Ibid.
326 "I watched the child . . .": Ibid.
326 In the darkroom . . . : Packard, op. cit.
326 Her periods of depression . . . : PST to MF, March 6, 1959.
326 She mailed Margot . . . : DL to MF, February 16, 1959.
327 "The city of the deprived . . .": DL travel notebook, n.d.
328 "I believe that I can *see* . . .": Ibid., July 28, 1960.
330 "What I wanted to do . . .": MDP, p. 196.
330 "as heavy and bulky . . .": Ibid., pp. 196–98.
330 Given the transcript . . . : Ibid., introduction.
331 her health was . . . : DL to MF, March 27, 1961.
331 "constantly, and hard . . .": DL to MF, November 16, 1961.
332 Two months later . . . : DL to MF, January 6, 1962.
332 Surgery was performed . . . : Dr. William Lister Rogers to MM, interview, September 28, 1976.
332 "There is time ahead . . .": DL to MF, April 9, 1962.
332 "I am left . . .": DL to MF, July 5, 1962.
332 Steichen came out . . . : DL to MF, July 27, 1962.
332 "I try to live . . .": DL to MF, September 22, 1962.
332 "miraculously improved . . .": DL to MF, October 17, 1962.
333 "For my own work . . .": DL to Nancy Newhall, November 19, 1962.
333 "She was getting back . . .": CSS, p. 277.
333 "Steichen had wanted . . .": John Szarkowski to MM, interview, April 27, 1976.
333 "Steichen is not hampered . . .": DL to Philip Greene, interview, November 1962.
333 He thought the time . . . : Steichen, op. cit. p. 14.
334 "so largely my own . . .": DL to MF, October 22, 1962.
334 Nat Herz pointed out . . . : Herz, *Infinity*, 12:4 (April 1963).
334 *Contemporary Photographer* . . . : Winter 1963.
335 "dirty, crowded, noisy . . .": DL to MF, December 24, 1962.
335 Another day . . . : CSS, p. 279.
336 Paul's colleagues . . . : Ibid., p. 278.
336 One day Paul saw . . . : Ibid., p. 280.
336 "anti-Israel sentiment . . .": Ibid., III, p. 455.
336 "It was a silent place . . .": DL to family, January 17, 1963.
336 "I am thin . . .": DL to family, May 1963.
337 Speaking in her place . . . : Report of talk in files of American Society of Magazine Photographers.
337 The first night in Tabriz . . . : CSS, pp. 281–83.

339 She remembered meeting : Richard Conrat to MM, op. cit.

340 He came to his job : Richard Conrat to Jacob Deschin, interview, *Popular Photography* (June 1972). I owe thanks to Jacob Deschin for providing the full transcript of the interview.

341 Szarkowski, pressed her : John Szarkowski (JS hereafter) to DL, February 28, 1964.

341 he proposed a Lange show : JS to Alfred Barr, March 12, 1964.

341 "You surely know . . .": DL to JS, March 9, 1964.

341 As early as 1952 : *The New York Times*, December 7, 1952, Section II, p. 32.

341 Today's young photographers . . . : MDP, p. 176.

342 "The new megalopolis . . .": From tapes recorded during preparation of the two KQED films.

342 "not for the sake of . . .": *The Closer to Me*.

342 to talk with Henry Allen Moe . . . : DL to JS, November 6, 1962.

342 drafted a one-page : Headed "Project One," and dated April 1964, it is reproduced in MDP, p. 250.

343 "our" exhibit : DL to JS, May 4, 1964.

343 "there are times . . .": DL to MF, March 15, 1964.

343 "No nation that I know of . . .": DL to Ansel Adams, March 15, 1964.

343 She had Szarkowski : JS to MM, op. cit.

344 They discussed family history . . . : Jiras and Boardman, op. cit.

344 "We are not enjoying . . .": DL to MF, May 4, 1964.

344 "Out of all these years . . .": DL to Nancy Newhall, July 9, 1964.

344 "I am working but . . .": DL to MF, August 14, 1964.

344 X-ray films revealed : Dr. Rogers, op. cit.

345 For a brief time : CSS, p. 287.

345 "Dear John . . .": DL to JS, September 2, 1964.

346 "In the last two weeks . . .": DL to Nancy and Beaumont Newhall, September 15, 1964.

346 "I believe . . .": JS to DL, September 9, 1964.

346 Nearly two years before : Katz, op. cit.

346 "We are a trade . . .": DL to Philip Greene, interview, November 1, 1962.

347 "All I do is . . .": DL to Robert Katz, interview, December 6, 1963.

347 it only needed her yes : She proved a good negotiator, asking and getting $2,000, the highest fee NET paid at the time.

347 When she heard her voice . . . : Katz, op. cit.

347 Work on the first : The first film was premièred by KQED on January 25, 1966, and the second on February 1, 1966. The films continue to be seen on television and on the 16mm circuit.

348 She wrote Szarkowski . . . : DL to JS, July 1, 1965.

348 Szarkowski wrote her : Letter undated, probably October 1965.

348 The thrice-weekly treatments : French Hospital medical records.

349 She sent word out : DL to MF, December 13, 1964.

349 He knew she was sick . . . : JS to MM, op. cit.

350 When he left Berkeley : JS to DL, December 19, 1964.

350 From that week : JS to DL, January 18, 1965.

350 Later that winter : Banfield, op. cit.

350 "If I seem . . .": DL to MF, January 10, 1965.

350 She slept very little : DL to MF, February 15, 1965.

CHAPTER 22

page

352 She assured Szarkowski . . . : DL to JS, April 28, 1965.

352 "There is no doubt . . .": JS to DL, January 18, 1965.

352 "It may be that . . .": DL to JS, May 14, 1965.

353 "to extend, buttress . . .": DL to JS, May 23, 1965.

353 "I find that it has . . .": B. Newhall, *American Country Woman*, pp. 9, 90.

353 "Putting this work together . . .": DL to JS, May 23, 1965.

354 Dr. Rogers told her . . . : Dr. Rogers, op. cit.

354 But "I have not yet . . .": DL to JS, June 7, 1965.

354 She kept putting out . . . : DL to JS, July 13, 1965.

354 One of them, Robert Frank . . . : Robert Frank in *Photography within the Humanities,* op. cit., p. 65.

354 When Ken Heyman . . . : Ken Heyman to MM, interview, December 14, 1975. Ten years later Heyman tried, and failed, to secure federal funding for Bicentennial coverage of the U.S. by some 200 photographers. It would have carried out in modified form DL's Project One.

354 She reshaped her proposal . . . : Headed "A Photography Center," and dated July 17, 1965, it is in MDP, pp. 247–49.

355 the International Harvester magazine . . . : *Harvester World,* 51:1 (November 1960), pp. 2–9.

355 "There is historical . . .": DL to Grace Mayer, June 30, 1965.

355 now Dorothea offered . . . : DL to Beaumont Newhall, July 29, 1965.

355 Seven portraits . . . : The photograph of the home of the Berryessa Valley woman was made by Pirkle Jones when he worked with DL on "Death of a Valley." Because she needed it now for *American Country Woman* (p. 65) he gave her authorship. Pirkle Jones to MM, May 5, 1976.

355 "These," Dorothea wrote . . . : B. Newhall, *American Country Woman,* p. 13.

355 Two of the women . . . : Rebecca Chambers, p. 15, and Lyde Wall, p. 41, in *American Country Woman.*

355 "Can I imagine . . .": DL to JS, July 18, 1965.

355 "one of my best understanders . . .": DL to JS, April 28, 1965.

356 His mind was not burdened . . . : DL to JS, June 7, 1965.

356 Elliott knew Dorothea . . . : Elliott to MM, op. cit., and letter, May 8, 1976.

356 "I wonder if he got . . .": DL to JS, July 11, 1965.

356 "We will not know . . .": JS to DL, July 21, 1965.

356 He had done well . . . : DL to JS, August 17, 1965.

357 At the end of August . . . : JS to MM, op. cit.

357 Conrat had taken . . . : Richard Conrat to Jacob Deschin, interview.

357 But in the end . . . : JS to MM, op. cit.

357 the printing expert . . . Irwin Welcher . . . : I am grateful to Jacob Deschin for a copy of the letter of February 26, 1966, from Welcher to him, providing these details and the quotations which follow. See Deschin, "Dorothea Lange and Her Printer," *Popular Photography* (July 1966).

359 "I am now not unsure . . .": DL to JS, September 21, 1965.

359 A fever took over . . . : French Hospital, op. cit.

359 Paul added to the note . . . : PST to JS, October 2, 1965.

359 The doctors found . . . : French Hospital, op. cit.

"at the *right* time . . .": She must have meant her work on the retrospective exhibit was done. The exhibit was on view at the Museum of Modern Art January 25–March 27, 1966. Later it was shown at the Worcester Art Museum, the Los Angeles County Museum of Art, and the Oakland Museum.

BIBLIOGRAPHY

THIS IS A SELECTIVE LIST OF THE RESEARCH SOURCES AND MATE-
rials used in the course of preparing this biography. It does not include many of
the contemporary newspapers and periodicals helpful to me, but specific refer-
ences to them may be found in the Notes. I should mention here especially the
San Francisco press: the *News*, the *Examiner*, and the *Chronicle*. They provided clues
to many of the more obscure events of Lange's early years in California. A good
part of this work—perhaps a third—deals with Lange in the America of the 1930's.
The literature on that depression decade is now huge and ever-increasing. Rather
than swell these pages with the scores of books I made use of, I direct interested
readers to two excellent bibliographic essays on that period: one is found on pp.
348–53 of William Stott's *Documentary Expression and Thirties America*, and the other
on pp. 395–410 of Richard Pells's *Radical Visions and American Dreams*.

In addition to the primary sources identified in the first three sections of the
bibliography, there are the surviving letters written by and to Lange. These are not
centrally collected; most are still in private hands. I made use of photocopies gen-
erously made available to me, and these are identified in the Notes, of course.
Other sources, private or institutional, furnished information through copies of
documents or records which are not listed here but are referred to in the Notes.
Finally, it should be pointed out that some of the bibliographic references could
be placed in more than one section.

Collections

The Oakland Museum, Prints and Photographs Division, Oakland, California.
 The Dorothea Lange Collection of negatives, prints, notebooks, travel journals,
 correspondence, covering all phases of her work. The most complete source for
 her personal photography.
Library of Congress, Prints and Photographs Division, Washington, D.C. The
 Farm Security Administration Collection: the most complete set of FSA photo-
 graphs by Lange, including caption material. Also notebooks on work done in
 1935 for California's Emergency Relief Administration and some Lange photo-
 graphs made for the War Relocation Authority.
National Archives, Audiovisual Archives Division, contains Lange's photographs
 and caption material made for the War Relocation Authority and the Bureau of
 Agricultural Economics.
University of Louisville, Photographic Archives, Louisville, Kentucky. The Roy
 Stryker Collection is the most complete source of letters and clippings on the

Farm Security Administration's Historical Section headed by Stryker. Contains the correspondence between Stryker and Lange.

The Museum of Modern Art, Photography Library, New York City. The Dorothea Lange file contains catalogues, clippings, correspondence, other material related chiefly to her exhibits here.

Archives of American Art, Smithsonian Institution, Washington and New York. Collection of interviews with FSA photographers.

Interviews
(arranged chronologically)

1. "Interview With Three Greats" (Lange, Ansel Adams, Imogen Cunningham), by Herm Lenz, *U.S. Camera*, v. 18, no. 8, August 1955, 84–87.
2. Lange, Dorothea. *Dorothea Lange: The Making of a Documentary Photographer*, an interview (conducted 1960–61) by Suzanne Riess, Regional Oral History Office, The Bancroft Library, University of California, Berkeley, 1968.
3. Interviews with Lange recorded by Robert Katz and Philip Greene (1962, 1964), preliminary to making the two films, *Under the Trees* and *The Closer for Me*, produced by the KQED Film Unit of San Francisco for the National Television and Radio Center. I have also made use of material recorded for but not included in the films.
4. "Dorothea Lange in Perspective," by Nat Herz, *Infinity*, v. 12, no. 4, April 1963, 5–11.
5. Interview with Lange by Richard K. Doud, May 22, 1964, for Archives of American Art, Detroit.
6. Taylor, Paul Schuster. *Paul Schuster Taylor: California Social Scientist*, interviews by Suzanne Riess and Malca Chall (conducted 1970–72), Regional Oral History Office, The Bancroft Library, University of California, Berkeley, 1975. The first of the three volumes of transcript deals with the thirty years of Taylor's marriage and work with Lange.

Other oral history sources containing material on Lange include Richard K. Doud's interviews with other members of the staff of the Farm Security Administration, later interviews with many of the same, conducted by F. Jack Hurley, Memphis State University Office of Oral History Research, Memphis, Tennessee; and an interview with Roy Stryker by Dr. Carl G. Ryant, University Archives, University of Louisville, Louisville, Ky.

In the Notes will be found frequent references to the many interviews I had with people who knew Lange, some for the greater part of her life, some for many years, and others for the briefer time circumstances brought them together. Most were seen, many provided additional information by letter as well as interview, and a few were interviewed by telephone or sent me taped responses to queries. The principal interviewees I list alphabetically: Ansel Adams, Laura Banfield, Ruth-Marion Baruch, Cal Bernstein, Rosalind Bernstein, Joy Lange Boardman, Alan Brandt, Priscilla Brandt, Philip S. Brown, Esther Bubley, Jerry Burchard, Shirley Burden, John Collier, Jr., Richard Conrat, Imogen Cunningham, Jacob Deschin, Constance Dixon, Daniel Dixon, Helen Dixon, John Dixon, Leslie Dixon, Mia Dixon, John Dominis, Elizabeth Elkus, George P. Elliott, Alice Erskine, Donald B. Fanger, Margot Taylor Fanger, Christina Gardner, Ralph Gibson, Frances K. Goldberger, Edith Hamlin, Florence B. Hayward, Ken Heyman, Lawrence I. Hewes, Jr., Romana Javitz, Daniel Jones, Pirkle Jones, Consuelo Kanaga, Robert Katz, Clark Kerr, Hope Lange, Minelda Lange Jiras, George B. Leonard, Katherine Taylor Loesch, Jerry Mason, Grace Mayer, Joan Miller, Wayne Miller, John G. Morris, Marjorie Morris, Beaumont Newhall, Kathleen Haven Newton, Emma

Nutzhorn, Helen O'Regan, Homer Page, Roi Partridge, Rondal Partridge, Martin N. Pulich, Bernard Quint, Dr. William Lister Rogers, Edwin Rosskam, Louise Rosskam, Arthur Rothstein, Charles Rotkin, John Szarkowski, Dyanna Taylor, Katherine Whiteside Taylor, Onnie Taylor, Paul Schuster Taylor, Paul Taylor II, Winona Tomanoczy, Willard Van Dyke, Sandra Weiner.

*Works by Dorothea Lange**
(arranged chronologically)
 1. Penny, Lucretia, "Peapickers' Child." *Survey Graphic*, v. 24, no. 7, July 1935, 352–53.
 2. "Draggin'-Around People," *Survey Graphic*, v. 25, no. 9, March 1936, 524–25.
 3. Taylor, Paul S. "Again the Covered Wagon," *Survey Graphic*, v. 24, no. 7, July 1935, 348–51, 368.
 4. —— and Paul Schuster Taylor. *An American Exodus: A Record of Human Erosion*. New York: Reynal & Hitchcock, 1939. Rev. ed., Oakland Museum and Yale University Press, 1969.
 5. "Documentary Photography," *A Pageant of Photography*. San Francisco: Crocker-Union, 1949.
 6. —— and Ansel Adams. Pacific Coast issue, *Fortune*, v. 31, no. 2, February 1945, 10, 116, 176, 178, 262, 264–65, 267–69.
 7. —— and Daniel Dixon. "Photographing the Familiar," *Aperture*, v. 1, no. 2, 1952, 4–15.
 8. —— and Ansel Adams. "Three Mormon Towns," *Life*, v. 37, no. 10, September 6, 1954, 91–100.
 9. "Irish Country People," *Life*, v. 38, no. 12, March 21, 1955, 135–43.
10. —— and Herb Caen. "Cable from San Francisco," *Pageant*, March 1957, 96–105.
11. "The Assignment I'll Never Forget: Migrant Mother," *Popular Photography*, v. 46, no. 2, February 1960, 42–43, 128.
12. —— and Pirkle Jones. "Death of a Valley," *Aperture*, v. 8, no. 3, 1960, 127–65.
13. "The American Farm Woman," *Harvester World*, v. 51, no. 11, November 1960, 2–9.
14. "Women of the American Farm," *America Illustrated*, Russian edition, no. 70, 56–61, November 1962; Polish edition, no. 47, 2–7; Arabic edition, no. 16, 18–23.
15. "Remembrance of Asia," *Photography Annual 1964*, New York: Ziff-Davis, 1963, 50–59.
16. *Dorothea Lange*, with introductory essay by George P. Elliott, New York: The Museum of Modern Art, 1966.
17. "Documentary Photography" and "Photographing the Familiar," reprinted in Lyons, Nathan, *Photographers on Photography*. Englewood Cliffs: Prentice-Hall, 1966: 67–72.
18. *Dorothea Lange Looks at the American Country Woman*. Commentary by Beaumont Newhall. Los Angeles: Amon Carter Museum at Forth Worth and Ward Ritchie Press, 1967.
19. —— and Margaretta K. Mitchell. *To a Cabin*. New York: Grossman, 1973.

About Dorothea Lange
(arranged alphabetically)
Coke, Van Deren. "Dorothea Lange: Compassionate Recorder," *Modern Photography*, May 1973, v. 37, no. 5: 90–95.

*All references are to the publication of photographs and/or text in books and periodicals.

[Deschin, Jacob]. "Miss Lange's Counsel: Photographer Advises Use of Picture Themes," *The New York Times*, December 7, 1952.

——. "Dorothea Lange and Her Printer," *Popular Photography*, July 1966, 28, 30, 68, 70.

Dixon, Daniel. "Dorothea Lange," *Modern Photography*, v. 16, no. 12, December 1952, 68–77, 138–41.

Dunstan, Mike. "Dorothea Lange's Time Exposure," in California Today section, San Jose *Mercury-News*, April 6, 1975.

Elliott, George P. "Things of This World," *Commentary*, December 1962, 540–43.

——. "Photographs and Photographers," in *A Piece of Lettuce*. New York: Random House, 1964, 90–103.

Gardner, Christina, "The Contemplation of Dorothea," unpublished manuscript, 1966, 19 pp.

Lorentz, Pare. "Dorothea Lange: Camera with a Purpose," *U.S. Camera 1941*, New York: Duell, Sloan & Pearce, 1941. 93–116, 229.

Mann, Margery. "Dorothea Lange," *Popular Photography*, v. 66, no. 3, March 1970, 84, 99–101.

Meltzer, Milton and Bernard Cole. "Dorothea Lange," in *The Eye of Conscience: Photographers and Social Change*. New York: Follett, 1974, 68–91.

Memorial Service for Dorothea Lange, Chapel of the Pacific School of Religion, Berkeley, October 30, 1965. Unpublished transcript of the memorial service, with tributes by Daniel Dixon, Christina Gardner, and Allan Temko.

Miller, Wayne. "Dorothea Lange," unpublished eulogy. Distributed by Magnum, October 1965.

Morgan, Willard D., ed. "Dorothea Lange," in *The Encyclopedia of Photography*, New York: Greystone, 1963, v. 11:1950–52.

Morrison, Chester. "Friend of Vision: Dorothea Lange," *Look*, March 22, 1966.

Newhall, Beaumont and Nancy. "Dorothea Lange," in *Masters of Photography*. New York: Braziller, 1958, 140–49.

O'Neal, Hank. "Dorothea Lange," in *A Vision Shared*. New York: St. Martin's, 1976, 75–77.

Page, Homer. "A Remembrance of Dorrie," *Infinity*, v. 14, no. 11, November 1965, 26.

Perrone, Jeff. "Women of Photography: History and Taste," *Artforum*, v. 14, no. 7, March 1976, 31–35.

Racaniochi, Piere. "Dorothea Lange," *Ferrania*, v. 13, no. 5, May 1959, no pagination.

——. "Dorothea Lange," *Popular Photography, edizione Italiana*, April 1961, 33–48.

Smith, Henry Holmes. "Image, Obscurity and Interpretation," *Aperture*, v. 5, no. 4, 1957, 136–47.

Smith, W. Eugene. "One Whom I Admire: Dorothea Lange," *Popular Photography*, v. 58, no. 2, 1966, 88.

Szarkowski, John. "Dorothea Lange," in *Looking at Photographs*. New York: Museum of Modern Art, 1973, 130–31.

Taylor, Paul. "Migrant Mother: 1936," *American West*, v. 7, no. 3, May 1970, 41–45.

——. "Paul S. Taylor," in *Photography within the Humanities*, Eugenia Parry Janis and Wendy MacNeil, eds. Danbury: Addison House, 1977, 26–41.

Van Dyke, Willard. "The Photographs of Dorothea Lange: A Critical Analysis, *Camera Craft*, v. 41, no. 10, October 1934, 461–67.

White, Minor. "Dorothea Lange," *Aperture*, v. 12, no. 3, 1965.

Weiss, Margaret. "Recording Life-in-Process," *Saturday Review*, March 5, 1966, 257.

(Anon). "An American Exodus," *U.S. Camera*, no. 9, May 1940, 62–63, 71.

Publications by Others, with Lange Photographs

Conrat, Maisie and Richard. *Executive Order 9066: The Internment of 110,000 Japanese Americans.* Cambridge: MIT, 1972. 27 photographs by Lange.

———. *The American Farm: A Photographic History,* Boston: Houghton Mifflin and California Historical Society, 1977. 28 photographs by Lange.

Davidson, Marshall. *Life in America.* Boston: Houghton Mifflin, 1974. 2 photographs by Lange.

"FSA: The Compassionate Camera," *Creative Camera,* London, March 1973. 4 photographs by Lange.

Garver, Thomas H. *Just Before the War: Urban America from 1935 to 1941.* Boston: Newport Harbor Art Museum, 1968.

Hurley, F. Jack. *Portrait of a Decade: Roy Stryker and the Development of Documentary Photography in the Thirties.* Baton Rouge: Louisiana State University, 1972. 14 photographs by Lange.

Issler, Anne Roller. "Good Neighbors Lend a Hand: Our Mexican Workers," *Survey Graphic,* v. 32, no. 10, 389–94. Cover photograph and others by Lange.

Kehl, D. G. "Steinbeck's 'String of Pictures' in *The Grapes of Wrath,*" *Image,* v. 17, no. 1, March 1974, 1–10. 4 photographs by Lange.

MacLeish, Archibald. *Land of the Free.* New York: Harcourt Brace, 1938. 33 photographs by Lange.

National Resources Committee. *Farm Tenancy: Report of the President's Commission.* Washington: GPO, February 1937.

Newhall, Beaumont and Nancy. *Masters of Photography,* New York: Braziller, 1958. 9 photographs by Lange.

Nixon, Herman Clarence. *Forty Acres and Steel Mules.* Chapel Hill: University of North Carolina, 1938.

O'Neal, Hank. *A Vision Shared: A Classic Portrait of America and Its People.* New York: St. Martin's, 1976. 31 photographs by Lange.

Steichen, Edward. *The Bitter Years: 1935–1941: Rural America as Seen by the Photographers of the FSA.* New York: Museum of Modern Art, 1962. 9 photographs by Lange.

Stryker, Roy Emerson and Nancy Wood. *In This Proud Land: America 1935–1943 as Seen in the FSA Photographs.* New York: Graphic Society, 1973. 31 photographs by Lange.

Taylor, Paul Schuster. "Again the Covered Wagon," *Survey Graphic,* v. 24, no. 7, July 1935, 248–351, 368.

———. "From the Ground Up," *Survey Graphic,* v. 25, no. 9, September 1936, 524–29, 537–38.

———. "Our Stakes in the Japanese Exodus," *Survey Graphic,* v. 31, no. 9, September 1942, 372–78, 396, 397.

——— and Norman Leon Gold. "San Francisco and the General Strike," *Survey Graphic,* v. 23, no. 9, September 1934, 404–11. Frontispiece by Lange.

Thornton, Gene. *Masters of the Camera: Stieglitz, Steichen and Their Successors.* New York: Ridge Press and Holt, Rinehart, Winston, 1976. 2 photographs by Lange.

Tucker, Anne. *The Woman's Eye.* New York: Knopf, 1973. 10 photographs by Lange.

U.S. Works Progress Administration, Division of Research. *Rural Migration in the United States.* Washington: GPO, 1937. 6 photographs by Lange.

Wright, Richard and Edwin Rosskam. *Twelve Million Black Voices: A Folk History of the Negro in the United States.* New York: Viking, 1941. 7 photographs by Lange.

Women of Photography: An Historical Survey. San Francisco: Museum of Art, 1975. 1 photograph by Lange.

The Years of Bitterness and Pride: FSA Photographs 1934–1943. New York: McGraw Hill, 1975. 8 photographs by Lange.

General References

Alinder, Jim. "The Preston Holder Story," *Exposure*, v. 13, no. 1, February 1975, 2–6.

Baldwin, Sidney. *Poverty and Politics: The Rise and Decline of the Farm Security Administration*. Chapel Hill: University of North Carolina, 1968.

Bourke-White, Margaret. *Portrait of Myself*. New York: Simon & Schuster, 1963.

Burnside, Wesley M. *Maynard Dixon: Artist of the West*. Provo: Brigham Young University, 1974.

Craven, George M. "The Group f/64 Controversy: An Introduction to the Henry F. Swift Memorial Collection of the San Francisco Museum of Art." San Francisco: Museum of Art, 1963.

Danziger, James and Barnaby Conrad III. *Interviews with Master Photographers*. New York: Paddington, 1977.

Dixon, Maynard. "Outline of His Life." Prepared for WPA Monograph. Edith Hamlin Collection, San Francisco. Unpublished, 1936.

Durniak, John. "Focus on Stryker," *Popular Photography*, v. 51, no. 3, September 1962, 60–62, 64–65, 80–83, 94, 111.

Genthe, Arnold. *As I Remember*. New York: Reynal and Hitchcock, 1936.

Gernsheim, Helmut. *Creative Photography: Aesthetic Trends*. New York: Bonanza, 1973.

——— and Alison. *A Concise History of Photography*. New York: Grosset & Dunlap, 1965.

Humphrey, John. "The Henry Swift Collection of the San Francisco Museum of Art," *Camera*, February 1973, 4–14, 23.

Lewis, Lynn Lopata. "The FSA Photographic Project: Its Effect on Photo-Journalism in the Sixties." Columbus: the Author, unpublished M.A. thesis, 1969.

Life, Documentary Photography. New York: Life's Library of Photography, 1971.

Life, Photojournalism. New York: Life's Library of Photography, 1971.

Lisca, Peter, ed. *John Steinbeck: The Grapes of Wrath*. New York: Viking, 1972.

McCausland, Elizabeth. "Rural Life in America as the Camera Shows It," *Springfield Union and Republican*, September 11, 1938, 6.

Mann, Margery and Sam Ehrlich. "The Exhibition of Photography: Northern California," *Aperture*, v. 13, no. 14, 1968, 10–17.

Moller, George L. *The Hoboken of Yesterday*, v. 1, 1964 and v. 2, 1966.

Newhall, Beaumont. "Documentary Approach to Photography," *Parnassus*, March 1938, 3–6.

———. *The History of Photography: From 1839 to the Present Day*. Rev. and enlarged ed. New York: Museum of Modern Art, 1964.

Newhall, Nancy. *Ansel Adams: The Eloquent Light*. San Francisco: Sierra Club, 1964.

Pells, Richard H. *Radical Visions and American Dreams: Culture and Social Thought in the Depression Years*. New York: Harper & Row, 1973.

Pollack, Peter. *The Picture History of Photography*. New York: Abrams, rev. and enlarged ed., 1969.

Porter, Allan. "Group f/64," *Camera*, February 1973, 3, 24.

Satterwhite, S. "Willard Van Dyke," *Photograph*, v. 1, no. 4, July 1977, 16–18.

Severin, Werner Joseph. "Cameras with a Purpose: the Photojournalists of FSA," *Journalism Quarterly*, v. 41, no. 2, Spring 1964, 191–200.

———. "Photographic Documentation by the Farm Security Administration, 1935–1942." M.A. thesis, Columbia: University of Missouri, 1959.

Snyder, Robert L. *Pare Lorentz and the Documentary Film.* Norman: University of Oklahoma, 1968.

Stackpole, Peter. "The Camera as a Sociological Weapon," *U.S. Camera,* May 1966, 16, 18.

Steichen, Edward. "The F.S.A. Photographers," *U.S. Camera Annual 1939.* New York: T. J. Maloney, 1938, 43–65.

———. *A Life in Photography.* New York: Doubleday, 1963.

Stott, William. *Documentary Expression and Thirties America.* New York: Oxford University Press, 1973.

Taylor, Paul S. "Notes from the Field," *Land Policy Review,* v. 5, no. 1, January 1942, 13–19.

Van Dyke, Willard. Letter to the Editor, *Exposure,* v. 13, no. 22, May 1975.

Wallace, Grant, *Maynard Dixon: Painter and Poet of the Far West.* San Francisco: California Art Research Project, WPA Project 2874, 1937.

INDEX